CONVERSATIONS WITH CONTEMPORARY PHOTOGRAPHERS

Joan Fontcuberta
Graciela Iturbide
Max Pam
Duane Michals
Miguel Rio Branco
Philip-Lorca diCorcia
Alex Webb
Bernard Plossu
Javier Vallhonrat

Umbrage Editions

ISBN 1-884167-48-9

10 9 8 7 6 5 4 3 2

Printed in Italy

Translations of interviews with Joan Fontcuberta, Graciela Iturbide, and Bernard Plossu by John A. Healey. Translations of interviews with Miguel Rio Branco and Javier Vallhonrat by Brendan Kolbay.

Published by **Umbrage Editions**
515 Canal Street
New York, New York, 10013
www.umbragebooks.com

Nan Richardson, Publisher

Amy Deneson, Director of Marketing and Publicity

Tanja Geis, Director of Design and Production

Emma Bedard, Editorial Assistant

Rebecca Bengal, Elaine Luthy, Copy Editors

Design by Tanja Geis

Contents

JOAN FONTCUBERTA

speaks with Cristina Zelich

La Roca Del Valles, Spain, 12 May 2001

FIRST STEPS

Cristina Zelich: Let's begin by talking about your origins. It seems clear that in all of your work there are a number of fundamental things that relate to your life, to your story.

Joan Fontcuberta: My interest in photography began early. When I was an adolescent I liked comics and TV cartoons, especially a series called *Hazañas Bélicas* [Facts of War] that attempted to explain adventurous things that went on during the Second World War and the Korean War. I became curious about verifying the actual facts behind the dramatizations; I wanted to see how much truth there was to these stories. I started to read books about war, going to various book fairs where I bought up issues of old magazines like *Signal* or *Victory*, cutting out photos to glue into albums in which I would write my own descriptions of what they depicted. I got to know the names of the key generals and the kinds of combat planes. This was my first contact with photography, with images that documented historical events. The first pictures I took were for school. My art history teacher in high school loved photography and had a photo lab set up. It was the first place I saw a picture developed. It seemed like absolute magic and it was then I got the bug.

CZ: It also turns out you come from a family in which advertising has played an important part.

JF: That's true. My entire family has worked in advertising in various ways, at a time

when it was not at all a consolidated profession the way it is now, but rather a work-in-progress, professionally speaking, something basically intuitive. I'm talking about the sixties when advertising in Spain was in its infancy. The world of publicity and communications has surrounded me my whole life and I am sure it provided the frame work within which my own work developed. Not only as a context that encouraged certain concepts that, over time, have remained more or less steady—photography as a factory for illusions, the development of an image, strategies for persuasion, the emergence of mediating screens, the differences between things and their shadows. But in addition to providing me with all of that, the advertising world provoked a need to react. I worked for three years in the business and learned a lot about creativity, information techniques, mass communications, etc., but there came a moment when, for personal reasons, I decided to leave it. My decision was not based entirely on a need I was feeling to experiment, to do things that were more artistic and less commercial, but was also for political reasons, ethical reasons, not aimed against the advertising world specifically, but at how a capitalist society uses that world. The world of publicity is programmed to seduce people with certain ideas and it is not necessarily the techniques that are questionable but the ideas they are promoting—the objectives and their consequences.

CZ: You started to think about the tools and the language advertising uses to transmit its messages quite early. You began to decode that language, to look for flaws, to look at the dark side of advertising. You began to put into practice a conceptual procedure that, later on, became a key factor in your work.

JF: Yes, the advertising business definitely provided me with a way of working, and what I tried to do in my first attempts at something more creative, leaving my amateur days behind and going towards something more serious and critical, consisted in making a parody of certain advertising techniques in order to deconstruct its purposes. I went about this method of deconstruction in an intuitive way. For example, publicity uses specific methods of communication designed to reach its audience quickly, with great impact and clarity. The need for impact is very important. An ad has to stand out and awaken our attention and leave its mark. My first works used similar paradigms; they were images with a lot of impact, shocking images that produced a strong, spectacular response. But instead of trying to sell you soap or detergent, the shock effect stopped right there. My images showed you only that and went no further and (I believe) the spectator understood the irony intended.

CZ: Speaking of your early work, I remember a certain vogue in photography that swept through the United States and Europe towards the end of the seventies. What was called "Fantastic Photography," that had its followers in Spain as well, you among them. An attempt was made in Spain to justify this movement both by citing the tradition of Spanish surrealism, and by viewing it as a form of disguised sociopolitical criticism of that period. In those days you used a lot of photomontage and your work was in synch with, for example, pictures done by Jerry Uelsman in the United States, and with work by Karel Fonteyne and Paul de Nooijer in Europe, perhaps. Done with a lot of irony and a sense of black humor that, in some cases, was pretty extreme.

JF: This category of Fantastic Photography you mention had a number of factors in play. To be rigorous, we should describe it as a movement that developed through the seventies, peaking in the middle of the decade, and, with a nod to the impulses of a whole series of actors on the photography scene, could be interpreted as a form of surrealism or post-surrealism. But many of the photographers that subscribed to this movement did so for very different reasons. On the one hand it was a movement that began on the tail end of the French May uprising in 1968, with a sensibility that argued for the exaltation of the imagination and fantasy, as opposed to a gray, anodyne, oppressive reality. The imagination became converted into a refuge where one could still feel liberated. Then there is a side to Fantastic Photography that exists as an ideological or political option, an option that permits the artist to position himself above or outside of the reality he is trying to combat. There are also photographers who experienced the underground, counterculture life with euphoria, exalting the antiestablishment attitudes of those times with drugs, rock music, a curiosity for alternative philosophies, and an entire series of social phenomena that led to disorder and to a search for new paths in diverse ways. Photography got involved with that scene, the same one, for instance, that revolutionized music, comic art, and experimental cinema. There was an entire range of disciplines, all maintaining parallel positions, and all of them searching for the magical, the dreamlike, and the unreal.

Another direction also existed that was similar to conceptual art and, to a certain erroneous extent, similar to the "fantastical." It could be that some results of this tendency in photography might resemble Fantastic Photography, but its postulates are very different. For example, Floris Neusüss in Germany and the whole group from the Kassel school are photographers that investigate the actual language of photography. They investigate, to give an example, the concept of realism and the paradoxes of representation, and, by doing it, understand that photography is fiction, and the results of their experiences lead again to the area of the fantastic, the unreal, the fictional, the inventive. Works with these characteristics are often included within the tradition of Fantastic Photography.

In any event, more than the formulation of a compact and coherent direction, within the denominated Fantastic Photography movement there was room for a series of photographers who were quite remote from the trend towards documentation that reigned during their time. The strictly documentary photography practiced then followed models that originated above all in the United States. It was documentary, almost mystical at times, in the tradition of Minor White, Harry Callahan, Aaron Siskind, all of these authors steeped the modernist movement that foreshadowed a return to the formal values of pure photography, scrupulously descriptive of reality into which the photographer projected himself. Qualities considered to be genuinely photographic came to the fore, and among those qualities was the respect for what the camera lens sees. So everything and anything in the world of photography that differed from this model, the model that was absolutely dominant, tended to be branded by exclusion as being part of the "fantastic" school, though I realize this kind of reasoning must seem a bit reductive.

CZ: I agree that, as you say, within the so-called Fantastic Photography school there were authors with ideas and objectives of enormous variety. It is true that what characterized

and defined them was that they were all developing a way of photographing quite distinct from the approach dedicated to those very American ideals of purity and directness.

JF: Yes, I remember that in 1976 there was an attempt to make this direction more cohesive in a roaming collective exposition and in some publications that accompanied it. The initiative was organized by Lorenzo Merlo, who at the time directed the Canon Gallery in Amsterdam, and was a charismatic individual, very active in promoting European photography. The exhibit came to the Spanish Museum of Contemporary Art in 1978, in Madrid, and it was an occasion to compare the different directions these works were taking. What was patently clear were the distances between the positions of the artists practicing that tendency. What also could be seen was that there was yet a fourth position, a political one. I am now referring especially to Jorge Rueda.

CZ: Jorge Rueda, of course.

JF: Rueda's work can be understood as a reaction against a certain suffocating climate that was around in those days. In this sense it is a perfectly understandable coincidence that at the beginning and middle of the seventies the Spanish aesthetic in photography visible in people like Rueda, Elías Dolcet, Manel Esclusa, the early Forminguera, etc., is very similar to that seen in eastern Europe, probably because those countries were also living with a form of oppression. In both cases the only possible mode of expression was one of evasion and "fantastic" pictures. The photographer had to hide within a private world and live there with his own phantoms. This was not work in any way belligerent, politically speaking, like that of, say, Josep Renau, who we only discovered at the Venice Biennale in 1976 and then from the book, The American Way of Life, published in Spain by Gustavo Gili. Strictly political photography would not have been tolerated, but I hold the belief that one can make a political reading of the iconography that so many young photographers in Spain and in other countries from that era, Communist countries especially, submerged themselves in.

CZ: Yes, I remember the group called Junji…

JF: From Ljubljana, in Slovenia.

CZ: Exactly, from Ljubljana, and a group you had contact with as well. I think you did a project with them. They invited you there. Perhaps your work underwent a change after that and, little by little you began to leave photo montage behind, moving on to create the same atmosphere, that same sense of visual impact that you achieved with your earlier work, but in a direct way. This transition was gradual, and, for a while you continued to make images that, before shooting them, require some styling and production design. These alternated with others done without any elaborate preparations, with the exception perhaps of the framing that, without a doubt, constitutes one of the principal instruments for interpreting reality. Do you remember (for example) those images you shot using ivy? In some you photographed the garden in your home, but in some cases you moved the ivy image from that context, took it to your studio and shot it there using other backgrounds. But this type of photomontage became less and less frequent as you worked more and more shooting things directly in their

original context. Your way of thinking at that time seemed to be aimed at showing to what extent reality surpasses the imagination, underlining the elements of reality capable of creating a sense of yearning and loss much more forcefully than something worked on in the studio.

JF: My first images were all about manipulating the very accoutrements that make up photography, and to do that I resorted to photomontage and to other manipulative techniques in the laboratory. What happened is that (as you described my evolution, which I agree with) there was a starting hypothesis that merits some attention. Let's say that it presupposes that photography has certain operative modes that make up an orthodoxy and that to vary from that orthodoxy is what characterizes the nature of certain work. As a counterpoint I believe that, above and beyond the types of techniques and creative methods used in photography, the important thing always has to be the objective being pursued, the discourse that is being ascribed to. For example, if instead of referring to photomontage, which is just one of various options one has in the laboratory, that is, the option of amplifying two or three negatives upon a single piece of photographic paper, if instead of this we were talking about using a particular sort of lens that distorts the image, or using a filter that distorts the color, we would not be asking if the images obtained with such a lens or with such a filter have a singular nature, one different from that obtained by conventional means, but with the use of photomontage we do entertain those doubts.

There exist a series of manipulations and methods that seem to have a more profound incidence than others when it comes to defining what is heterodoxy and what are acceptable rules of play. This continues to be the case today, especially in those sectors where there is a greater sensibility about ontological aspects, as in photojournalism. Among photojournalists there is still a sense that doing a photomontage is far graver than adding a filter. I am against this type of hierarchy that demonizes some options over others, demonizes them in respect to, what—ideology, or moral code? A bankrupt and fundamentalist ideology without doubt. Some years ago I visited the Center for Creative Photography at the University of Arizona in Tucson. It is an archive that has, among other things, the entire legacy of Eugene Smith. The person who took me around made the comment that, when assessing the original negatives, one could see that in some cases, Smith had made a montage of certain images everyone had assumed to be spontaneous and direct. While making this confession she raised her hand to her lips as if to ask me to keep it quiet. It was as if the revelation of this supposed secret should be kept to a limited number of specialists, as if we had the obligation to preserve the photographer's myth in the face of public opinion. Some years later Professor Jesús de Miguel revealed that many of the most famous shots one sees in the Spanish Village series had been staged and re-shot until Smith was satisfied with the results. For me, this type of information does not in any way devalue the humanistic or artistic merit of Eugene Smith. I have always thought that the photographer does artistic work and that art consists of working with fictional premises.

CZ: This is what I was trying to say in so many words: how you stopped using methods supposedly employed to create a separate category, and went on to use direct photography—the version of photography to which all the attributes of truth are ascribed, the

one that pretends to render a faithful reproduction of reality. You did that intentionally, in order to subvert that idea, and demonstrate the deception contained in that idea.

JF: It's true that towards the end of the seventies I began to get interested in certain "places," shall we say, where it is no longer necessary to fabricate contradictions, because they are right there in front of you; all you have to do is uncover and reveal them. And this evolution came thanks to a series of successive anecdotes. My method of working when I was using photomontage consisted in looking for appropriate backgrounds into which I would inject the action of some actors or fragments of other images. But a moment arrived when the backgrounds themselves interested me to such a degree, were so evocative and mysterious on their own that it felt like the addition of other elements would only diminish their enigmatic, poetic qualities. So I dedicated myself to doing a series of works where the manipulation or the condensation of information was controlled by the theme, by the moment of actual shooting, the light, etc; that is, by perfectly accepted photographic techniques that in common parlance can be summed up in the notion of "decisive space" as opposed to Cartier-Bresson's "decisive moment."

Little by little I moved into spaces that were not so innocent and that had certain connotations. This is when, for example, I started to dedicate myself somewhat obsessively to botanical gardens, zoos, science museums, all kinds of places where Nature appears in an artificial context. Whether these things were artificial for cultural, or scientific, or didactic reasons, they were always about taking something from its place of origin and putting it somewhere else and they always created a surreal sensation much like that defined by Lautréamont—you know, the fellow who brought about that fortuitous encounter between a sewing machine and an umbrella placed on a dissection table. When we find a dissected lion in the midst of modernist architecture, such as in the Zoological Museum of Barcelona, the situation provokes a cultural, ideological, and aesthetic shock without any need for the introduction of any additional elements. It constitutes a photomontage all on its own. It's not a typical arrangement using a laboratory and juxtaposing negatives but rather a scenographic photomontage, because someone had the idea of putting those elements together.

A moment arrived when my work basically consisted of the detection of these kinds of tensions in various places and then molding them; in this sense I became a documentary photographer, or, better put, I played at appearing as if I was a documentary photographer who made an inventory of these kinds of absurd situations. And this calls into question what it is that we call absurd. The absurd depends on the perspective from which one makes an analysis. I think it was the same thing Lynne Cohen did with other places, this is, picking out places that were apparently quite conventional, anodyne, trivial, but, because of how they were framed, focused, how the relationship between various and objects and shapes were viewed, they showed us scenes that seem amazingly artificial and thus create an enigmatic poetry of great force.

CZ: Yes, with tensions and a sense of threat that is pronounced. There is a book from this period (I think you bought a copy in New York) that went some way towards encouraging the sort of work you were doing.

JF: The book was called *Evidence*.

CZ: Exactly.

JF: I think it's from 1978 and it was a cool project put together by two artists from California called Mike Mandel and Larry Sultan. They brought together a series of images that, in their respective contexts, made perfect sense, such as the archives of the Los Angeles Fire Department, police forensic photos, photos from NASA, and images from chemistry labs. These were photographs that, kept in their respective places, made sense and were illustrative; telling and showing much about the area they pertained to. But what these artists did was to apply the surrealist technique of displacement, stripping the images of their context and putting them into an arbitrary order without any texts or explanation. Seen this way, without even the most minimal descriptions, the images in a way refuted the book's title.

CZ: It's true, they were anything but *Evidence*.

JF: They were only evidence for their own ambiguity. These pictures could have been of anything—montages, staged photographs, science-fiction film snippets, pictures taken by oneiric photographers—anything. The viewer is simultaneously moved and disconcerted by an inability to make sense of it. Habituated to the inverse process in which photographs validate what we see, the spectator here loses his balance and is teased by doubt. The process put in motion by these photographs clearly puts its finger on something. It was a really provocative project and I remember to what extent this book immediately became one of my Bibles. It influenced my work for a long time. This displacing of an image from one context to another provided me with another rule of conduct. The creativity involved had nothing to do with making the image and everything to do with what was done with the image. One can draw valuable conclusions from this concerning the construction of what is sensible. These kinds of issues have always interested me, and they still do.

We have all had similar experiences. In my case it occurred (and this is a story I tell now and then), with the NASA photographs of the first astronauts to land on the Moon. In 1969 these pictures had documentary, scientific value, accomplishing a strictly informative task. We saw them in the press, in magazines, in the media. But ten years later, in 1979, the Museum of Modern Art in New York, I believe, organized a photo exhibit about space because they believed these pictures opened up new fields of representation with their own minimal aesthetic that linked them to a more conceptual form of documentation rather than the merely formalist sort, that linked them with the New Topographics. In short, a whole theoretical presentation. But in practical terms they chose the same pictures, they matted them and put them in frames, they hung them in the institutional space of a museum and they were thus canonized as works of art. So already they have taken one step away from the purely functional to the artistic, from the environment of an archive to a museum exhibit on space. Photography begins as an informational medium and is transformed into a work that people go to see looking for aesthetic and emotional values as a way of participating in an artistic experience.

Then in a third phase and by accident, some years later, I went to the American consulate in Barcelona to apply for a visa and I found myself in a waiting room where the very same picture was on the wall, the one of the astronaut climbing down the little ladder to the moon's surface. In this particular place, in the waiting room of a consulate, the photo was transformed into a political symbol. It was saying, "Watch out. The country you contemplate involving yourself with is the only country that has landed men on the moon, which is to say, this is not just any country, this is the one with scientific, technological and military supremacy." It turned into an instrument and a symbol of power, of intimidation, of superiority. In all three cases we see the same picture, exactly the same, but the meaning has been radically changed in function of the placement. The book *Evidence* demonstrates this same process in a more subtle manner and some work that I did later on also played with this. A perfectly banal photograph from a family album, exhibited in a museum in the context of a show dedicated to the life of a Russian cosmonaut associated with the Sputnik project acquires an extraordinary dimension.

CZ: The same thing could be said about certain titles, the way in which texts that accompany photographs influence how they are seen. I am thinking about your *Constellations* series. If one looks at those images without any text titles, they could fool you. Just looking at them the viewer could think many different things, but with the titles you are leading them where you, the artist, wants them to go.

JF: I've always been interested in analyzing the elements that contribute to how photographs are read. The most obvious is the relation between the image and the texts found in photography books, at the bottom of the pictures, titles, etc. It is the first level and one very rich in the number of combinations there are of possible pairings between image and text. For me it is primordial and it is one of the areas I first started experimenting with, if only because I tend to look at photographs as a form of text themselves. Photography is written; photography has a narrative structure, it is articulated like any other system of signs. An individual photograph is, for me, a line of prose that should come before and come after others with the intention of stating something complex. The more we become aware of this mechanism the better we can bring out the ultimate meaning of our work. As long as we continue to believe that a picture is worth a thousand words and other such ridiculous clichés we shall remain prisoners of this notion that the image is somehow superior, which is not true, and we'll be left as absolute ingenues with respect to what meaning can be gleaned from photography.

THINKING ABOUT PHOTOGRAPHY

CZ: Now that we are talking about words and photographs, I'd like to remind you that when you started to work there was hardly any theoretical literature to speak of in Spain. One of the things you did was to encourage theoretical reflection concerning photography, about image and the photographic language, through articles and texts you published in numerous magazines, *Photovision* among them which you contributed to since its creation; and you also helped to spread around what theoretical literature

there was, like that first anthology you chose that was published by Blume.

JF: I should say a few things about all that. In the first place, when I started to work in photography, more or less at the beginning of the seventies, there were huge necessities in Spain just at the structural level. When galleries and publications, publishing houses, festivals, collections, schools, photography programs in universities all began to bloom, Spain was still submerged in its state of historical backwardness. This gave rise to a group of photographers who, in addition to going about their creative work, set about energetically founding and strengthening the fundamentals for photography. This was a great moment for the generation of this period who were as militant as they were generous. Collectives were formed that organized exhibitions, that created forums for debate, and that started publishing initiatives. There was a true collective effort, often in assembly form, unselfish and enthusiastic. Initiatives were launched to recuperate the historical past, to establish academic fundamentals for the teaching of photography as part of the humanities. Before then only the most ferocious sort of auto-didacticism had prevailed.

In this attempt to create an infrastructure the need emerged to provide future students with theoretical texts that analyzed photography with the sort of intellectual rigor that, curiously, was already being applied to much more recent disciplines, like animated and video art. It has always seemed paradoxical to me that video artists enjoyed more attention and favor from the university and political cultures than photographers. Perhaps this happened because photography was still considered pedestrian and its popular uses were so close to what Anglo-Saxons call "vernacular" that nobody took it seriously enough to study scientifically.

But getting back to your initial question, there was this movement, not only on an individual level but on a generational level as well, in which many of us who collaborated on the magazine *Nueva Lente* were immersed and that included many activities that grew up around the magazine. We didn't solely consider ourselves makers of images but activists as well, people dedicated to spreading the word. Seeing it with some perspective now I would add that we had an odd way of proselytizing; we were like apostles with a gospel. We experienced photography as if it was a cause. There are other things that explain this drive towards reflection, a need to distinguish ourselves from photographers of earlier generations or even from contemporaries who were stuck in the typical formula of: "I make images and these images should speak for me, and so don't ask me anything because if I have to explain it, it means I have failed." This position was an excuse, a protection against constructing a dialogue. Finally, returning to my origins, I should insist that I belong to a generation connected to the proposals of conceptual art, where we don't have to justify the works with a discourse but rather we maintain that the work itself is a discourse, that is, that the work of the artist is a discourse and the work illustrates that discourse. What is important are the contents, the ideas, the propositions, and, bottom line, the photographs we make, the works of art, are only a means of illustrating and making explicit those ideas.

CZ: Do you really believe that if an artist is not capable of verbally articulating a discourse about his work it's because he does not have one? Don't you think, just as

you said, that the works speak for themselves more effectively than words? Don't we run the risk of confusing theory and artistic creation? Might you not bring upon yourself the criticism Tom Wolfe waxed ironic about in his book *The Painted Word*—art so intellectualized and abstracted that it requires an instruction manual for the public in order to be properly understood?

JF: Those risks do exist, of course they do, but one must assume them, take them on, because not to do so would lead us to the mythification of the genius, of the purely intuitive that often only serves to camouflage the absence of content. Furthermore, the artist who renounces explaining his work leaves the task entirely to the whims of the critics and the curators. This is a phenomenon that has occurred frequently throughout the past decades. I am simply arguing for the need to make some attempt at reflection, to inculcate the need there is to clarify or to at least have some ideas about why one does what one does. In order for this to occur you have to know what people did before you, what others around you are doing, and why. In order to begin we could set up two lines of photographic action: photographers who use photography to learn about the world and those who feel they must first learn about photography itself. It's not about giving preference to one or the other, or presenting these two lines as antagonistic, because they are complementary and they enrich each other.

However, even with both approaches being legitimate and plausible I would subscribe to the second school of thought. That is, before focusing my camera upon the world I have to know how that camera works, to keep in mind that it is not an absolutely transparent instrument but one that will introduce a series of distortions, that imposes its own visual culture, its perceptual and configurative routines, that, in the end, embody a series of ideological characteristics born from the Renaissance, positivism, the industrial revolution and Manichaeism, capitalism, colonial philosophy, etc. I have to be conscious of all these values because as I attempt to explain to myself how the world is I have to first understand these distorting factors that I am going to introduce when showing the world through my camera. It is as if we were to say to ourselves: "Photography is a window and what interests us is what we can see beyond the window," to which one could oppose with: "Fine, but be careful, because when I look through a window, a piece of glass is in the way, and sometimes it is cracked, or gets dirty and ceases to be completely transparent, or it might be a type of glass that produces distortion depending on how it diffracts the light." So let us first analyze what is a window and what gets in the way between us and reality in order to be able to make a correct judgment about what it is we see out there while being aware of the "noises" that can appear.

There are, I repeat, two tendencies. One is aimed towards documentary, the other towards the expressive. This does not imply that the documentary cannot be artistic, or that the artistic cannot be documentary in nature. One does not have to be Manichaean. Both tendencies seem necessary to me and complementary in photography. My work, for example, which is conceptual or experimental, highlights and offers commentaries about the documentary nature of photography, analyzing how information is actually transmitted. So I need for there to be documentary photographers because my work is meta-documentary; it is a commentary about the documentary use of photography.

Anyway, I am drifting away here into other things. Returning to the theme of literary theory and all that, apart from these two tendencies I have been talking about, that is, the generational factor and the factor (shall we say) of chronological affiliation to a conceptual group that makes principal use of text and of discourse, there is another aspect that is purely personal, which is an inclination for writing and reading. I love to write and I wish I had the time to write more extensively. And not only critical texts about photography. I have locked away in my desk projects for novellas and fictional narratives. What I have pending above all are projects aimed at historical parcels of photography that, in my judgment, have not been treated with sufficient profundity or that have been subjected to a methodology that is out of date and which requires new alternatives.

CZ: There was a time when you dedicated a lot of energy to writing about the history of photography and then, little by little, you put that aside.

JF: If I am not mistaken, the first historical study I published that had any weight to it was in 1979 in the Swiss magazine *Camera* looking at Pla Janini as the axis of Catalan photography in the thirties. *Camera*, directed by Romeo Martínez and then by Allan Porter, had great prestige then. It was considered the publication of reference, especially in Europe where the North American journal *Aperture* had less penetration. The magazine, which up to that time had only published the work of one Spanish photographer, Cristobal Hara, all of a sudden dedicated an entire issue to Pla Janini, and to the photographic movements that flowered during the Second Republic. As might be expected it had a strong impact, because those types of monographs were few and far between. Later I became interested in the historical vanguards which led to the exhibit *Idas y Caos* [Goings and Chaos], that enjoyed an international itinerary that included the Folkwang Museum in Essen and the International Center of Photography in New York. I had also published an appendix about Spanish photography in the Spanish translation of the book by Beaumont Newhall. I have never considered myself an historian but rather a divulger. I have neither the proper background, nor the interest, nor the time to dedicate myself to historical study. At the beginning, as I have said, it was necessary to do a little of everything and it should be recognized that what we did we did with the best intentions in the world, but it was rather amateurish.

When specialists began to emerge at universities, people who had achieved doctoral degrees and who had theoretical and methodological training, it was time to pass the baton. This permitted me to concentrate on my own priorities, on creating. But for my creative work I declared myself an historicist, which was to say, that knowledge of the past laid down the rules vital for conceiving my projects. It's because of this that I did not view creation and history as if they were two isolated compartments but rather as disciplines in dialogue with each other. The interpretation of history requires a lot of creativity—it becomes necessary to invent modules of interpretation. I use the word "invent" very consciously. For example, in the text for the Newhall book, where I proposed a model that was followed quite a bit, what I did was to apply a previous historiographic scheme, one that was Newhall's to a large extent, and then allow the story to fall into place accordingly. In essence I was guided by a desire to link Spanish photography with what had gone on in other countries. Explained in so crass a way it perhaps sounds like an aberration, like purely scientific speculation with ideological

undertones? Well, I am convinced that all historians do exactly the same thing because it's the only thing you can do. History is nothing more than approximations, sketches, versions that we invent to verify whether or not we can come up with a convincing, useful explanation of the past. For this reason what I am most drawn to is not mere archeology, the excavation and enumeration of findings, but the phase in which an interpretation is constructed, when sense is made from the amalgam of data. It's about generating methodologies. For example, Publio López Mondéjar is, without doubt, the most prolific writer on the history of photography, and he has done a great deal. But if you pay attention to his texts he always makes categorical pronouncements: this happened this way, that happened that way. He does not dedicate a single line towards explaining or clarifying his historiographic line of attack, his methodology, his criteria. This does not mean he does not have them (of course he does), but he gives them no importance or he does not give them the importance these things have for me. Reading it, you realize he applies a sociological focus, that he is interested in photography for the social information it offers, and you understand he favors documentary photographers and condemns pictorialism and that he gets lost as he arrives at contemporary art. All options are legitimate but one should make one's argument, one should explain the rules of the game before starting play.

For a recent text of mine that will be published in a book about the history of Spanish photography (published by Summa Artis) I ask the reader to try a historiographic experiment in order to follow the evolution of Spanish photography between 1940 and 2000. I ask them to imagine that evolution revolving around the three great cultures of that period: film, television, and the Internet. There exists the possibility of a photography modeled after cinematographic vision (Català-Roca, Cualladó), another after the spectacle of television (Pérez-Mínguez, Ouka Lele), another modeled on virtual digitalization (Daniel Canogar, Marina Núñez). This allows one to envision a scheme, one of many possible ones, where we can speak of some authors and eliminate others. It is not that the eliminated ones have not contributed anything but rather that their work can only be considered when other schemes apply. I think it is vital to have people understand how relative this process is. And it is as important for the public to understand as the photographers, even if it injures the latter's pride.

Keeping this in mind I had an amusing experience not that long ago. Last year the National Art Museum of Catalunya had a show about the history of Catalan photography. A team of curators made a selection based on certain criteria and determined by the depth of the actual exhibit. The work of a photojournalist employed by an influential newspaper was not selected and, feeling insulted, he decided his exclusion was a flagrant injustice. He presented himself to the director of the museum's photography department and threatened to cause a scandal if he was not included in the show. "What difference will it make to add or subtract the work of one more photographer if it can prevent having a major daily against us?" The pressure exerted worked and the photographer was added to the exhibition. I would like to publish an article with a title like: "Cause a scandal to go down in history." I will write it someday.

CZ: We should touch on something implicit in what you are saying: the necessity of establishing a canon. How might such a thing be done—and by whom—in order to

determine which works of photography merit inclusion?

JF: This brings me immediately to the problem of criticism, something it seems to me that is even more lacking in Spain than historians. To begin it is important to distinguish journalistic opinion from the serious critical essay. The opinion propagated through journalism is the sort of thing we find in reviews of exhibitions in the media that, by their structure and extension, usually are limited to an evaluation that is superficial and that rests on the principle of authority. I would say we've been badly served by the criticism published in major newspapers because, with few exceptions, they are all in the hands of people with little knowledge and less inclination to seriously reflect on things. They tend to be more interested in maintaining their positions of power than making the effort required to truly orient the public. It has been discouraging to see how newspapers that take care with sections devoted to theatre and film and the arts use collaborators who are so-called specialists in photography matters who frequently give incorrect information, even with something as simple as getting photographers' names straight, or they write about exhibitions they have not actually seen. This situation has frustrated debate and thus encouraged silence. You've no idea how much need there is for a debate!

With respect to the more academic critical essay I am more hopeful as I can see more and more doctoral theses having to do with photography. This indicates there are universities providing the necessary means and conditions for proper theoretical study that will become a seedbed for future professional critics. I am thinking of the University of Valencia where Román de la Calle has spurred many studies; or the University of Navarra where, having received the legacy of Ortiz-Echagüe, publications and investigative activities have also developed there. I don't know, Bellas Artes in Barcelona also had a good moment; the Autónoma University in Madrid with Juan Antonio Ramírez and Jesus Vega, the University of Cantabria with Bernardo Riego or Carmelo Vega at the University of la Laguna. I am citing a few with whom I have had some connection or dealings with at one time or another but I am sure there are many other places as well. I should also mention the appearance of magazines like Papel Alpha, directed by Alberto Martín, also connected with the University of Salamanca, or Exit published by Rosa Olivares who, since publishing Lápiz, has done much for photography. These publications, each one from their own perspective, encourage and inculcate critical thought about photography.

CZ: Let's not leave Photovision out of the list (which you helped to found). How did that come about?

JF: I was just mentioning more recent goings on. Photovision, which first came out in 1980, has become the dean of periodicals devoted to photography, quickly followed by Foto Profesional. The initial idea came from Adolfo Martínez, Ignacio González, and Rafa Levenfeld, who came to see me and asked me to participate in the project. I remember how I told them that it seemed like a romantic adventure that would never work and if only for that reason they could count on my collaboration. I had contributed to Nueva Lente and when that disappeared, with Pere Formiguera and Manuel Úbeda, we worked for a while on Eikonos, directed by Josep María Casademont with whom I had stayed in

contact, visiting with him from time to time. If *Nueva Lente* had been a laboratory of ideas during the seventies, it became necessary to create an adequate platform for the new winds that were blowing in the eighties when in Europe there were magazines like *Creative Camera* in Great Britain, *Perspektief* in Holland, *European Photography* in Austria, *Photographies* in France, and others.

In contrast to *Nueva Lente*, *Photovision* was born thanks to a group of photographers. There was no outside editor or capitalist partner, there were no political contacts we were in debt to for providing us with public funding. We did it all ourselves—thus our independence and our shoestring budget. Our idea was to provide the Spanish and Latin American market, the Spanish-speaking readership, with an organ of analysis of culture and creative happenings as seen through photography. We wanted to speak about poetry, architecture, cultural politics, postmodernism, etc., using photography as the pretext, using photography as a bridge to many other things that interested us. We wanted to invite specialists from other disciplines to think about questions related to photography. Our first edition was an homage to Renau. We imposed upon ourselves from the beginning to make each issue a monograph, dedicating it to a single theme, whether it was put together by one of us or by someone we invited from the outside with the idea of making of each one a notebook that could stand alone like a little book. Deciding upon the content and who would contribute was never a problem. The hard part was the business side, administration, advertising, distribution, all of which we were not very good at. We never got to pay ourselves anything and we worked with great energy and enthusiasm with the water always up to our necks and with the constant uncertainty about whether we would have sufficient funds to get the next edition out. But thanks to the good work of Adolfo and then Ignacio it developed a dedicated following who were quite forgiving of our delays and who always applauded our re-appearances. *Photovision* functioned like a clandestine publication that prospered by word of mouth. But seen in perspective, there it is in libraries, the work completed, with some editions that are frankly very good with substance and ideas still very much alive and serving as a model for later publications like *Exit*, that I mentioned before.

CZ: Even before this you had been involved in other tentative publishing projects. I'm thinking for example of *La Titafolla*.

JF: All of that was typical of the seventies. Those publications like *fanzine* and the very short-lived *La Titafolla* that I did with Manuel Úbeda and the group at FotoFad, *Papel Especial*, put together by Pep Rigol, Pete Sans, and Jordi Sarrà, or *Anófeles* in Madrid with Pablo Díez Perpigan and Fernando Gil, were generational gestures that showed a will to speak with one's own voice, one not in conformity with the status quo gripping photography in those years. The development of these publications was very connected with the appearance of groups and collectives. In 1976 for example Manel Esclusa, Pere Forminguera, Rafael Navarro, and myself founded the Alabern Group. Later on Toni Catany, Mariano Zuzunaga, and Koldo Chamorro joined in. The group had come together around the Spectrum Gallery in Barcelona run by Albert Guspi and Sandra Solsona and for years it was a place for debate that brought together young photographers. It was like a window open to the world of international photography

at that moment. But Guspi was a character given to histrionics and the photographers ended up avoiding him. The Alabern Group was organized in a small, informal way in order to start common projects and to get the most out of initiatives we were able to make happen.

THE COUNTERVISUAL PROJECT: TRUTHS AND FICTIONS

CZ: I can't remember when it was that you first used the term "countervision" or "countervisions" but I believe it was even before the Herbarium series that, without a doubt, marked a crucial point in your trajectory. I seem to recall that you had used the "countervision" concept on some occasion before that.

JF: I think the first time was in 1977 in an article for a marginal Swiss magazine called *The Village Cry*, a title that made an ironic allusion to New York's *Village Voice*. It was a magazine in English and French, a kind of photography-and-literature-based fanzine, multidisciplinary, run by a fellow named Beat Presser. They had asked me for some text to accompany some photographs and it was the first time I used the "countervision" term. I began to develop it from there. The idea is based upon the certainty that language creates its own contradictions; and so photography as well has its own visual contradictions, that would be "countervisions," elements that provoke friction with a certain internal logic natural to photography's inherent language. The first of them might well be the photomontage. Accustomed as we were to a logic about vision established along the parameters of realism, that is, on a representation derived from the laws of central perspective, of analogy, etc., photography simply went along with that ideology of representation. Then anything that varied, or that stood apart from, or that provoked any questioning of that ideology's directives could be considered contradictory to the tendencies of that language. I proposed that, on the contrary, the future of such a language resided in the capacity to withstand and take advantage of these so-called contradictions—and with photography this all seemed very obvious to me.

CZ: Your work, evidently, as you say, is based upon concepts, on the idea, on reflections about photography and the photographic language. I think at the same time and without minimizing any conceptual validity, one can glimpse some autobiographical elements mixed in there as well.

JF: I'm sure you're right. It's inevitable. I've sometimes used a quote from Paul Valéry saying that in the origins of all theories and any work done with rigor, with personal commitment, one always finds autobiographical elements. Whether one looks at Freud or at Marx the theories reveal personal experience. In my case we've already mentioned my early connections with the world of advertising because of my family. I have always tried to understand why I do what I do and probably the idea of subverting the apparent truth inherent in information we receive and that is certified by the photographic image comes from a certain critical spirit, a spirit of contradiction strongly rooted in a time when Franco's legacy was still very much in evidence. I consider myself a product of "late-Franquísmo." My sensibility has developed as a function of the difficulties there were to get information, of the suspicion always present about the

information we were given, and the consciousness of the fact that much of the information had been manipulated, filtered, censored. I think my entire generation developed a sixth sense that kept us permanently alert, always reading between the lines. When we would organize protests at the university and the press would claim it was all due to just a few agitators, we who had lived through it, we who were eyewitnesses to the fallacious reporting, realized the vast distances there were between desire and reality: the desire the government had back then who used "his master's voice," [Translator's note: A reference to the old RCA Victrola logo] and the reality of what had happened. To make sense of this one always had to initiate a critical process that permitted you to decipher, reinterpret, and reconstruct the facts. It's clear that my work in this sense would not have had the same reasons to be and would not have developed in the same way if I had lived in the United States or Canada. My work is biographical to the extent that it responds to personal and historic, social, and political conditionings, whether I am conscious of them or not.

In 1984 I had a show at the Château d'Eau in Toulouse and the director, Jean Dieuzaide, wrote about my work in the catalog explaining it in an almost Freudian manner. He described an accident I had in my childhood, a wound I suffered to my left hand that required various digits of some fingers to be amputated. This accident, which obviously did harm to my body, might be related, according to Dieuzaide, to the lacerating iconography I would later recreate in which (and this is true) dismembered bodies and mangled extremities appear. The connection had never occurred to me until then, not even in the deepest recesses of my unconscious. There are biographical elements one is conscious of because you've been able to carry out some sort of introspection you can reason with, and there are probably others that are unconscious and that someday might reveal themselves.

CZ: We've known each other for such a long time, during which I've been following your work, and one of my favorite things to do is to go back over your pictures trying to identify some of those autobiographical details. Often they are objects, but they can also be facts and stories that appear that relate to your past; objects or images that reappear after a long time. I imagine you are aware of this. For example, in the series you did about Dalí, Picasso, Miró, and Tàpies, *The Artist and Photography*, you used some images taken at Cap de Creus at the end of the seventies. Those images produced some very specific photographic work. When you did it you were interested in the work of Max Ernst, the *frottages*, and years later you used the *frottage* technique for your Frottograms series.

JF: This makes me think of how one surrounds oneself with objects one finds pleasing, sometimes not knowing exactly why. After a while it becomes a particular universe filling your most immediate environment with artifacts and books and found objects. For someone with a creative sensibility it makes up a landscape difficult to renounce. Someone else might see it as just filling up your house with completely useless objects [*Laughter*]. Another factor that is interesting is that it turns into a personal archive. An archive supposes a collection of memories; memories of experiences, of experiments, of images that have worked for you and others that have failed, leading you nevertheless to new ideas. There is another aspect as well. If a photographer were to disappear,

how would posterity judge that personal archive? How does one consider or evaluate such a thing? To what extent is it really part of the photographer's serious work? Is it potential work? Are there sketches there that permitted you to do something else? It's a topic that preoccupies me. I think a lot about it.

Recently there have been some controversial cases, like what happened when Gary Winogrand died leaving some ten thousand undeveloped negatives behind. The head of MoMA's photography department, John Szarkowski, decided to develop them, make contact sheets, make a selection and then mount a show. According to Szarkowski the selections were made based on criteria extrapolated from Winogrand's former work. Putting moral questions about rights aside, it seems to me that this process is typically postmodern in that the act of creation is not brought about by the artist but rather by a strata of viewpoints: that of the actual photographer who shot the pictures, that of the curator, that is to say of the critic who analyzes the work, and then the viewpoint of the public as well. In the end it is hard to attribute the work to anyone, given the condition that no one decides, "This is mine, this is something I have done and that I stand by." Rather it is the sum or the melding of those three points of view. It's an interesting and a controversial process that is beginning to proliferate.

In the last issue of *Photovision* we analyzed the case of Virxilio Vieitez, a photographer with a fantastic archive and with an intuition and sense of image of high quality. He came on the scene out of nowhere in the sixties and he left behind a magnificent social documentary about rural life and immigration in Galicia. The issue was, how to situate him within the history of Spanish photography. How to place someone who had no pretensions or designs, who managed to create a body of work impressive from a plastic point of view and socially penetrating as well. My feeling is that with these kinds of materials we tend to "re-create" them, we cast a view on them turning them into artistic photographs even though the photographer had no such intention. It is a problem that affects the nature of what is artistic and the dialectic that photography brings to that debate. The multiple facets of photography and its very changeable nature makes the debate as interesting as it is complex.

CZ: Exactly. I remember another case from some years ago when Toni Catany recovered Tomás Monserrat's archive and we made prints from it and showed the images around. I remember one of the arguments we had then: Would Tomás Monserrat have left this or that detail within the final print or would he have cropped it differently? What to do? It's an issue that continues to be important. Keeping all of this in mind, what will you do with your Cap de Creus images? [*Laughter*]

JF: Not only those images! The archive issue is one I'm giving a lot of thought to and I have not reached any conclusion. The easiest solution would be to burn everything, to destroy it, because it could lead to false impressions later on.

CZ: False impressions?

JF: Yes. I would say destroying them would be the most radical solution and the one that should be taken. Another possibility, more contentious, would be to review and

revise it all, making it clear which have been experiments and which are finished works. This would permit future investigators to better sift through the origin of one's work. Many Americans have done this and it's a way of saying: "No, no, I'll sell the lot of it to a museum telling them it's all "studies" [*Laughter*]. Anyway, it's important to separate the two. Then again, another possibility would be to say, look, in the end how we categorize what is a finished work is fairly subtle. The notion of a finished work is a concept that varies with time; for example this picture made at Cap de Creus in 1976 in Cadaqués was part of a series of pictures that, for me, practically constituted a dead end at the time. Then, all of a sudden a project emerged for which they were perfect because by happenstance it turns out they are landscapes that compliment Dalí's imagery. There is no reason this kind of thing could not happen again with other images that in the context of another project might work perfectly as well.

Who knows? I think the ideal would be to make the decision on your deathbed. The danger is that frequently, when we decide to destroy things, we choose the wrong ones but the act is irreversible. I would like to reserve the right to change my criteria at any given moment, to suddenly give preference, if I wish, to images I once thought to be mediocre. No, not mediocre, but rather representative of certain kinds of problems in a perfectly adequate way. These processes have taken place often in the history of photography. You'll remember when the Dutch photographer Harm Botman found boxes of pictures taken when he had been twelve years old, snapshots that revealed the concerns and the world of a child. Then he recycled the negatives and edited them and made prints from them from his perspective as an adult, a mature and seasoned photographer imbued with an aesthetic from the 1980s. Large prints were made, impeccably done so that they exuded quality while still managing to convey a kind of infantile spontaneity. The result was extremely seductive. So who can deny that with renewed appreciations we can successfully recuperate former images? I think it is a fascinating theme and it will stay that way precisely because there is no clear answer. There are many roads available.

CZ: I would imagine that the option of destroying or of burning one's archive is very difficult. It would amount to killing a part of oneself, no? Even though it does not represent finished work, even if it is only material that has helped you to develop other things of greater value?

JF: Not only that. There is another dimension to this idea of destruction. You could look at it as a form of creation, an idea many conceptual artists have abused of late. Take the English artist Michael Landy who, at a gallery on Oxford Street, the most commercial street in London, publicly and minutely destroyed everything he had in his house, namely his car, his appliances, everything, including his own artistic work and all the art that had been given to him by other painter friends. An inventory was made of everything and then a team armed with hammers and chain saws went at each and every object. It was a gesture of an artistic nature, perhaps a bit haggard given the number of times it has been done. But it was still intended to impact the viewer, to surprise and provoke the spectator, especially as you keep in mind where he chose to do it, in the most consumer-driven zone of one of the greatest cities in the Western world. There have been many artists who have decided to burn their work at some

moment because of a radical change in direction. It seemed to them like a declaration of ethical and aesthetic principles with respect to the new work they were embarking on. In my own case I don't know what I will decide—in any case I feel much of my best work is still lies ahead. Even though I have already left behind numerous things I always have the sensation that the best, the really interesting stuff, is still to come. I have worried sometimes about what would happen if my archival materials were ever burned by accident or destroyed in a flood. Ana Casas, an Hispanic-Austrian-Mexican photographer who did that wonderful autobiographical book called *Album*, described to me how she came home one day to find her house inundated under a meter of water with all of her negatives floating around in it. Instead of going mad she adopted the attitude of thinking: "Ok, well, let's just start from scratch, from a fresh slate." What would happen if a fire were to destroy my whole archive? Probably nothing. Something maybe, but it would not be so crucial so that I would feel I had to start again from zero. My work continues to be seen. It is out there present in collections, in publications, in museums, and in the memory of people who have seen it and appreciated it.

CZ: You sent me some pictures a few months ago. One of them, I assume you will remember this, was shot in the house of a woman who lived in a small village in Empordá, in Llofriu. This creature or plant or whatever it is, rests on top of a refrigerator. When I saw it again I wondered what relation the thing sitting on the refrigerator might have with a work you began at more or less the same time. I am referring to *Herbarium*.

JF: *Herbarium* has been one of the projects that has best introduced my work to a public interested in art in general, not just in photography. It's a series with historical resonance and with a wink towards the past. It coincides chronologically with the rise of postmodernism in artistic production, reflecting a series of preoccupations with the ironic recycling of the past with references to history, quotes from modern art, an appropriation of an artistic model. Anyway, I did it at the beginning of the eighties and it shuffles together a whole set of elements that appear in an absolutely intuitive fashion—especially since I was unaware of the theoretical implications it had back then.

I remember the photograph you are referring to perfectly. It was taken inside a whitewashed farmhouse, white walls, a white refrigerator, and on top of the refrigerator some nuts and dried fruits arranged in such a way that it looked like some kind of animal, some sort of strange, monstrous creature. That this example of popular ornamentation had been done by the lady of the house, a woman on in years, fascinated me, because I could not understand how such an eccentric and sinister thing could be thought to be decorative by a woman like that. It was one of those fortuitous encounters, an absolutely surreal found object, no? And I took the picture. It's a picture that still seems valid to me today and that defines the issues I had in mind back then.

Two years later in 1982 I started work on *Herbarium*, making these ephemeral sculptures blending organic fragments with synthetic ones, making collages. It allowed me to revisit the idea I had found staring at me finding that refrigerator in that little farmhouse and to adapt it and give it a smooth background and a framing style reminiscent

of the work of Blossfeldt. This way of doing things happens frequently in my work. I consider myself very receptive, like a sponge, very open to influences and to things that happen spontaneously. I try to accumulate as many experiences as I can and then to digest them and to translate them all into my own work. It's not about copying, which is a word with very negative connotations, but about taking effective advantage of these encounters and being open to any ideas that might emerge, that might show me a new way to go.

CZ: I think that starting with *Herbarium* you stopped being a photographer in the strict sense of the term and you became a creator who uses various mediums, like the installation you did with *Moby Dick*. You no longer merely opt for two-dimensional imagery. You go down other roads, you use three-dimensional objects, photographic languages of another nature taken from other environments: the aesthetic of the Soviet propaganda posters with Sputnik, technical scientific descriptions with fauna, the "New Objectivity" photographic language with *Herbarium*.

JF: It's true that *Herbarium* defines a specific path that I later developed with some profundity and that got me started in working by way of particular projects. As you so well put it, the project is the work, the installation is the work, and the image is no longer autonomous but rather a piece put there to help the project. Before this my images functioned independently, each picture could be read and analyzed by itself, but then I crossed over into an area where the whole mattered more to me than its constituent parts. In the end, the entirety of my work can be looked at from two perspectives. From one perspective I explore the photographic image by itself, as a fingerprint, a convention for reality. The results are more experimental and about plasticity. From the other perspective I confront the conditions of interpretation of the photographic image as an informational support that can be inserted into a given institutional framework, be it a science museum or a mass-market magazine. In this case the project tends to adapt to the form of an installation. There is no divorce between these two perspectives and, in fact, they meld together. In order to better clarify these two possible areas I could elaborate by saying that, in the small monograph in the series PHotoBoslillo [Pocket-photograph,] I bring together a series of works that look into the notion of photographic fingerprints, while the book *Contranatura* [Against Nature,] published with the exhibition at the University of Alicante Museum, could be seen as a compendium of the installation, project-based perspective.

With respect to the whole issue of terminology, what differences there might be between photographers and artists has been a topic of virulent debate in artistic critical circles since the eighties; that is, the differentiation of artists and photographers, the *plasticiens* as the French refer to the latter, and the "creative" photographers. It supposes that there are artists who use photography as their medium and then there are photographers who aspire to make art. The former group would be considered the hotshots while the others would be viewed as basically pathetic. I think it is a badly formed controversy because the concepts of art and photography are not antagonistic but rather they pertain to different spheres. Photography implies a mechanical way of looking at something, art implies certain propositions. In the modern age means and propositions can coincide. It's very simple: today we realize that art can be made many different

ways and one of those ways is via photography, in the same way that words lend themselves to many different uses; poetry, novels, philosophical essays, crossword puzzles, scientific studies, advertising, newspaper articles, etc. Photography provides a means, materials, instruments. Art however is defined as a framework for intentions, a framework for aesthetic and semantic experimentation, a metalinguistic framework, etc. This being the case I have no problem calling myself a photographer because I handle photographic equipment and because, for me, the photographer is an artist. There are photographers who work in the information industry and who are journalists, and others who work commercially in advertising and fashion. It may be that these confusions have benefited or damaged the art market, especially when, without warning, photography has achieved extraordinary notoriety; a series of painters and sculptors start to use cameras as well and it becomes still more confusing. We remember when, fifteen or twenty years ago, many galleries didn't want to have anything to do with photography; now they are the first to join the bandwagon at art fairs and in the international market.

CZ: Let the record show I am not attempting to put labels on anyone or to place anyone in a corner. Photography is a medium that can be used for very different ends.

TOWARDS A PHOTOGRAPHIC CULTURE

JF: I'd like to say that what really interests me, more than photography itself, is the culture that gives rise to it. The photographic culture is an ample concept for me, taking in a whole series of elements not only instrumental and mechanical in nature, but also ideas of visions, cultural, ideological, historical visions that have to do with the reasons photography appeared in the nineteenth century. The whole techno-scientific culture that was propitious for a type of procedure whose characteristics were known long before but which only then became necessary. Why were they necessary? Because we are talking about a climate of thought, of sensibility, of philosophy, an economic system, a colonial expansion, a time of scientific expeditions, etc., that all required the values that photography incarnated. And those values are the ones that kept it going all through the twentieth century. Photography mirrored the will towards rigor, towards defining details, the need for miniscule description, for long-distance optics, for a technology at the service of truth, for concepts of credibility, of objectivity, the need to archive, for the consolidation of institutions like the museum, in short, towards a need to control memory, responding to all of the utopias of the nineteenth century and positivism. All of these values I mention reflect the nineteenth century and photography helped transmit them all through the twentieth century, no? I'm not interested in photography because of the cameras, the lenses, and the developing processes but because it is the repository for all of those intellectual conflicts, all of the problems humans have had to live with in these last decades. I think the twentieth century has been defined by that vision, the photographic culture. Using photography in this sense is absolutely necessary and a priority as a way of expressing the spirit of the twentieth century. Photography, Casademont said, is the metaphysics of the modern civilization of the image and, in effect, photography and the mediums based on its principles, like cinema, the video, and television, have constituted the defining elements of the century.

So I repeat, my involvement is not with the technical end but with that whole universe that revolves around the photographic. For just this reason it should not be a surprise that I would embark on projects like *Moby Dick*, for example, in the Tinglado at the Port of Tarragona, where I did an installation in which photography did not physically intervene, something which caused quite a bit of reaction, as if I had sold my soul to artistic fashions. Not at all. *Moby Dick* was filled with elements pertaining to the photographic culture: there were projections, there were relics. This is not a restrictive way of looking at photography but an expansive one.

CZ: There is a work you did in the eighties. In that epoch I lost contact somewhat with what you were doing because I was living outside Spain. I remember that during a visit I made to Barcelona I went to the Angels de la Mota Gallery, where you were showing new work that surprised me and interested me very much because it was hard for me to situate it within what I considered to be your customary trajectory; these were the *Palimpsestos* and *Madonna Inn Majestic*.

JF: As you know, I studied information science. I don't come from a Beaux Arts background. We learned semiotics, the sociology of communication, information theory, a range of disciplines aimed at the analysis of the messages we receive. I consider the Palimpsests series a scrupulously semiologic work because it scrutinizes photographic signs; specifically the still photograph. The still photograph has had an immense importance in my work because it our ground zero, the technological and ontological foundation everything else is built upon. Photography occurs when light strikes a photosensitive emulsion. This is the one thing we cannot eliminate from the process. If we take this away we are talking about a different medium, different kinds of images. It is the quintessence of photography and when we begin to speak about the nature of truth in photography we have to start with the still photograph. To a great extent then, my work is all about the utilization of the still picture. Not in the documentarian sense the Victorians spoke about, not in the formalist sense either, that the vanguards got into, but as the basic conceptual tool.

As I tried to explain before, my work always revolves around problems of representation that can take those two directions, one about the image itself and its inherent, let's say, sign-related problems, the relation between a denotive element and a formal element as seen in all still photographs, and another where the analysis of the signified in the image has to do with the context from which it derives that significance. In series like *Fauna* or *Herbarium*, the image can be disgustingly conventional, but its value comes from how it is being used, how it can call into question the very conventionalism we ascribe to it. So in this series of palimpsests I was trying to relate different levels of interpretation. Palimpsests are, literally, writing over other writing, the superimposing of two kinds of signs, in this case the photographic sign, the fingerprint, the still image, and on the other hand the symbolic sign, pictorial, decorative, that would correspond to the illustrations found on industrial wallpaper, images reproduced on posters, etc. The technique is very simple; I got hold of some wallpaper or posters with reproductions from museum stores and in my laboratory I coated them with photographic emulsion and once dry but still enshrouded, in the darkness of the lab I placed flowers and plant leaves or whatever was needed, making sure they resembled as much as possible the images on

the paper. Then I exposed them to light and made a picture, but instead of appearing on bland, impeccable white paper, it was on this paper already rife with imagery. The final result was a sum of the stratification of two kinds of images: one painted, one photographic; one achieved by the impact of light and the other reproduced by the pen and skill of the original illustrator. It would all suggest a margin of deciphering and speculation (of a theoretical nature, shall we say) very suggestive because obviously the two images did not coincide at all and the distance, the asymmetry between the two became for me a metaphor for the distance between reality and fiction. The procedure also brings other things to mind. Normally the light reveals the image, it is the active agent for the vision. But with *Palimpsests* the light covers, darkens, puts a veil over one level of information while favoring another. One's eye then has to look through a kind of mascara in order to arrive the base image. Light and opacity symbolically articulate the protocol between transparency and opacity that are two conditions of the truth.

CZ: What has marked your most recent work is this persistent questioning of the truth in photography, framing it within those different areas you've been talking about, like the scientific perspective or the museum environment. I wanted to ask where you think your work is going. Have you ever thought that the concept might be exhausted in the sense that you have already done a number of works built around the same idea? Have you given this any thought? Do you think it can still take you somewhere else? Or are you going to make some sort of radical change and concentrate on other aspects of image culture?

JF: I'd like to say a few things. First, sometimes colleagues and critics have complained of an overabundance of projects I do that are fictional in nature, as if, after *Herbarium* and *Fauna*, that line of attack was exhausted and used up and that I was repeating myself, only minorly altering fields of application. This criticism seems too reductionist and superficial to me because it's like saying that Tàpies has painted too many crosses, or that Miró has gone overboard with those little stains of color. One always has a certain predilection for certain forms or themes and it is only normal that one has an inclination to keep at it, refining and improving the end results. This is what I believe I have been doing with the succession of my projects, because each time I do a project of this sort it's like I am writing a novel made up of pictures. And just like each novel a writer does, even if done in the same style, the plot, the issues, the endings will always be different. But even so, I do believe that from one project to the next there are important differences, profound differences. With *Herbarium* for example, what I did was to appropriate an historical aesthetic model, a parody of the "New Objectivity" aesthetic, but as a project that I presented and signed. In *Fauna*, with the impact already of post-structuralism with its theories about the death of the author, I didn't present myself as the author and in truth I should say it was the work of two people, but neither Forminguera nor I presented ourselves as the authors but rather as people who had run into the archive by accident and then decided to show it to the public.

There is an artistic strategy here that consists of hiding authorship in order to make a fictional project seem more realistic. *Sputnik* was an absolutely anonymous project. That is, my notoriety as an artist who falsifies things had grown to such an extent that any work associated with my name was taken by those in the know, those who follow the

art world, as fictional. So I had to come up with a strategy that would allow me to dis-appear as the author and come up with something else, in this case a foundation, the Sputnik Foundation, which was virtual, nonexistent, but which had an address in Moscow and an e-mail address that allowed me to communicate with the outside world. I got e-mails and notifications, solicitudes, etc., that I responded to as the Sputnik Foundation. But I never appeared in the project except to give it the face and the name of Ivan Istochnikov, which is what I called the cosmonaut who disappeared but is how you might translate my name into Russian. It was a small gag, a wink to those who knew the story behind the story of the project.

In each project there are always elements that vary. In the last one for example, the one I did about mermaids in the Geological Park of Upper Provence, near the Alps, it was an installation of fake fossils that has now become a permanent feature of the park. It provokes the state of ambiguity between the true and the false, not only during a period of time but on a fundamental, definitive level. This is not an exhibition that travels but rather an implant that remains embedded in the park, a place visited by two hundred and fifty thousand people each year. These visitors are confronted with these fossils, the authenticity of which they have to decide upon. Next to actual ammonites, an ictasaurus, and vestiges of other prehistoric species, you find hydropitic skeletons, a term I came up with that might be translated into something like "sea-monkey;" its remains are mixed in with human bones and dolphin bones and fish fins.

In this and other projects I have also worked on another facet that is confrontational, which has been to bring the story of the project into another medium of communi-cation. I negotiate with the director of the weekly magazine supplement that goes with newspapers to allow me to publish a story on the project, but not one in which the project is discussed for its artistic merits but rather where it is reported like a news story. The public expands from those who just visit the theme park to those who read the newspapers and the project gains in terms of theoretical density through having jumped into a whole other medium. Because, even though the truth is revealed at the end of the article, the article itself is carefully presented in the style people are used to seeing in these publications, as an actual report, down to the last detail. It is designed to place a seed of doubt about reporting in general. Which is to say, that here as well, there is an additional element, which is the utilization of formats that are not neces-sarily artistic or museum-related—keep in mind the geological park can be described as an open-air museum—but rather information formats that are absolutely quotidian.

Where will I go from here? I think there will always be something that will allow me the pleasure of innovation, of looking for different solutions. At present I would like to see what might happen if I were to take on a strictly documentary project, a straight, truly rendered treatment of something strange and little known, presenting it with my reputation as the great falsifier. I wonder what the public's reaction would be?

There are two things I would like to be very clear about. Those who follow the art world may associate my name with a certain genre of projects, but, in general, the projects I do are really aimed at a much more generic public, not one made up necessarily of special-ists. I would like for my own work to be seen and experienced by the general public,

by children and adults, by the experts and the profane, by science students and art students. Each group brings their own interests and cultural sensibilities. The idea I pursue is that of seeing my work as a screen each person projects their own individuality upon. I like creating a dialogue: this for me is the real goal an artist should aspire to. I am not against works of art that are excessively hermetic and that require some interpretive effort but I think there has to be a possibility for dialogue and feedback with the spectator, with any kind of spectator, because you have to keep in mind that dialogue can occur on different levels with different vocabularies.

One more comment on this question. Sometimes colleagues say to me: "What you were doing a few years ago made sense because analog photography did have the kind of charismatic authority as a document that you were claiming for it. Today with the electronic culture, with digital techniques, computers and the Internet, people's sensibility and awareness have changed so much. Everybody has Photoshop at home and even children have fun distorting their own snapshots, so that the notion of respect for an image as testimony does not have a leg to stand on because we have learned how easy it is to manipulate images." To this I reply that, "Yes, it's true that a cultural change has taken place, an authentic epistemological revolution in the field of knowledge and in the communications media because the eruption of digital techniques for treating images tosses aside the photojournalistic values that have reigned up until now, but even so, and even looking at other areas that are not exclusively photographic, there continue to exist elements of authority that impose a determined notion of what the truth is." Don't you think? That these new elements come propitiated by a technological platform we call photography or whether they are generated by some other types of technologies is all the same to me. I continue to focus on why we tend to believe, to deem credible, one model of information over another. What are the conditioning factors that elicit certain reactions when looking at images?

In an interview moderated by our friend Angelo Schwartz, Rudolph Arnheim said something fundamental. Schwartz asked him: "What is the substantial difference between photography and other types of imagery? How might one in essence define photography?"

The definition problem is something absolutely crucial. We are, after all, talking about photography but in practice we can't agree on what it is we actually consider "photography" to be. And Arnheim said that photography is a kind of image that produces a certain experience in the viewer, that is, that it is not so much about what we do or with what sort of mechanical device, with this kind of light or that kind of lens, but rather the effect it has on the public; conveying a sensation of verisimilitude that is not questioned. It is for this simple motive that we carry photos around in our wallets to show the face of our daughter, or why we use photographs on passports, or why the police use photographs as forensic evidence, or why a biologist will use an electron microscopic photograph to show what a cell looks like. If we did not have this kind of a relationship with it, it would not be photography. And so it is paradoxical because, according to Arnheim, what characterizes photography is not anything intrinsic to its own language, nothing that participates in its own technique or formation, but only an attribute that is social and cultural, something historically and ideologically stamped.

What defines photography are its own atavisms.

CZ: Is it your belief then that what the photographic image projects is so strong, that its roots run so deep that it will be difficult to erase, even though, as you point out, everybody knows about Photoshop and virtual images?

JF: Yes. I had a revealing experience not that long ago. I was in London and I went to get an ID picture taken using one of those machines. In the old days these machines were built so that you would close yourself within them and draw a curtain closed and drop in a coin and it would take your picture and then give you the pictures a few minutes later. It was a kind of primitive, instant photography. But the machine in question has evolved considerably or at least the one I used has. First of all it was digital. It allows you to frame the picture you want, to try different compositions before having to actually have the picture taken. Once you are satisfied the machine then asks you if you would like just this image done or if you would like as well to have the image inserted into pictures of famous people, like with Lady Di, or with a soccer star from Manchester United, or with Prince Charles, the Spice Girls, etc. The machine will integrate your headshot, making a composite picture with various famous people whose images are stored in its memory. You can spend money getting your ID picture taken and spend more still having it appear with the celebrity of your choice. Fantastic, no? This is happening with a machine that traditionally was designed to make photocopies of our face, pure reproductions, nothing interpretive involving any special lighting or points of view. No, a pure photocopy; in frontal perspective, a burst of flash, white background, an ironclad close-up. Machines that were conceived as the paradigm of the documentary, no-nonsense photograph are now the first to introduce this new option of image manipulation, digital image mixing, allowing you to create a photomontage. What is the relationship the public has today with photography when you can go to get an ID picture taken and be offered all these other options? Evidently it confuses our notion of the photographic even though there continues to exist confidence in the technology, in the way in which information is condensed and transmitted.

It could be that occasionally we lose some of the confidence we normally concede to photography but we pass it on to another element. The question is, where did that dose of confidence we had before in photography go and did it really merit such confidence in the first place? In the final analysis I believe my artistic role consists in being an observer of what it is that gives us that sensation of confidence and to call into question the mechanisms that seem to guarantee it.

CZ: Flying here in the airplane I read an article by Umberto Eco about the possible victory of Berlusconi in the Italian elections this Sunday. The danger posed by a Berlusconi victory, according to Eco, is that he will end up controlling all of the information broadcast in the whole country. On top of the television stations he owns he will also be in control of the state broadcast media as well. The people who vote for Berlusconi are not the critics who are skeptical of information and its manipulation but the people on the street who enjoy Italian television filled with life and garish color and who knows what.

JF: For this very reason I believe that a certain kind of critical work devoted to the image

is never out of date. The only thing that changes are the forms the propaganda takes, its methods of persuasion, but skepticism needs to be transmitted with the same intensity as always so that we can be less submissive to the media or to the politicians that capitalize on it. It is in circumstances like these, when we feel it is time to go back to the trenches, that the political subtext found in many of my projects comes most to the fore. People sometimes react to them saying something like: "Wow, what a great story, what a cool idea." And I reply: "It is great and cool and amusing because I provide just enough clues so that you can see that it is fraudulent." What I do is try to keep our sense of perception alert to the daily sorts of fraud perpetrated that goes to great lengths to hide its true condition, something that happens all the time in the communications media controlled by powerful interests.

CZ: Eco made another interesting observation: why do Albanians clamber aboard rotting ships and cross the sea to try and get to Italy? It is probably because in Albania they get a very clear signal from Italian television stations and what they see is a kind of paradise filled with happiness.

JF: People awash in abundance.

CZ: Eco says that if Italian television were constantly showing films like *Roma Città Aperta* or other films from the neorealism days, the Albanians would not make the effort to reach such a promised land. These are the kinds of cases that distinguish the unidirectional flow of information that television sends out and the multidirectional sort found on the Internet.

JF: I have already launched some initiatives that have been channeled through the Internet, like the project called *Topofonía*, one I did with some colleagues at the Institute for Audiovisual Communication at the University of Pompeu Fabra, a group who call themselves the Virtual Gallery. I am currently preparing another project to present during the PhotoEspaña 2001 exhibition at the Telefónica Foundation. It's called *Securitas* and apart from being an installation it will also have an interactive component on the Internet. It is a very valid medium with fabulous potential and, naturally, I want to work in it and I have some ideas about that I will get to little by little. I also follow projects done by other artists, like Antoni Abad, who have done things using the Internet that I find interesting. My problem continues to be a technical one because living in the countryside as I do, so far away from a big city, I am still crippled by slow transmission rates. The Internet will function better and better as more and more people have broadband connections but not like it is now for me, where it still takes a few minutes just to download a normal page of something. In any case I'm convinced it is where we are all going to end up. I am not an apostle of the Internet but it is absolutely true that more and more people are getting into it, although perhaps at the cost of becoming physically isolated. I look at it mainly as a social and cultural phenomenon that has changed our lives. With respect to art it favors distribution and interchange, and like almost everything in this electronic age, it favors image over careful study, it favors information over physical objects. If the Internet really gets going, as I suspect it will, art will tend to mobilize its most conceptual aspects. Once, that is, we are able to get over the somewhat pretentious digital mannerism we are stuck in at the moment.

Joan Fontcuberta was born in 1955, in Barcelona, where he still lives. Joan Fontcuberta is one of Spain's most prominent and innovative artists, best known for exploring the interstices between art, science, and illusion. Where science reaches its limits in his works, the imagination frequently finds a creative space in which to flourish.

Joan Fontcuberta's photographs explore the relationship between reality and representation, notions of truth and authenticity. Blurring the boundaries between mediums of representation, Fontcuberta subverts expectations about the purported reality of photography in his series Frottograms (1989—90) and Paper Gardens (1989—90). In Frottograms, photographs are manipulated by physically rubbing them on the surface of their subject, rendering traces of the body onto the photograph. In Paper Gardens, Fontcuberta combines photograms of three-dimensional objects (a bouquet of flowers) with their two-dimensional, printed representations on everyday objects (floral wallpaper), creating a conversation between different forms of representation.

In Hemograms (1998—2000), and Lactograms (1999—2001), he photographed samples of blood and milk, bodily fluids that are metaphorically rich, elemental materials. Blood, long associated with birth and death, generation and regeneration, as well as with AIDS, has recently become charged with additional layers of meaning in an age of advanced techniques of DNA analysis. In Lactograms Fontcuberta replaced the blood with drops of milk from nursing mothers. This series is a tribute to the Vaso de Leche (Glass of Milk) movement, which provides free milk to children and pregnant and breast-feeding women in poverty-stricken areas of Peru.

Joan Fontcuberta's work has been shown internationally in solo exhibitions at the Zabriskie Gallery, New York (1986, 1991, 1993, 1996, 1998); the Museo Espanol de Arte Contemporaneo, Madrid (2000); the Museo Nacional d'Art de Catalunya, Barcelona (1999); the Musée Redpath, Montreal (1999); the Musée de l'Elysée, Lausanne (1999); the Visual Arts Center, M.I.T. (1988); the Museum of Modern Art, New York (1988); and the Folkwang Museum, Essen (1987). His work is included in the collection of several institutions, including the Museum of Modern Art, the San Francisco Museum of Modern Art, and the Art Institute of Chicago. He contributes regularly to scholarly journals and has published numerous books, including *Twilight Zones* and *The Artist and the Photograph*.

Cristina Zelich was born in Barcelona in 1954. She lives and works in Salamanca, Spain. An independent curator, critic and translator, former director of the Fotomania Gallery in Barcelona 1977 to 1983, and co-organizer of the Jornadas Calatas de Fotografia at the Miro Fundacion in Barcelona in 1980. She is a co-founder of the Primavera Fotográfica da Catalunha, 1982, organizer of the Festival de Fotografia IMAGO from 1997 to 2002 in Salamanca, and organizer of exhibitions for the Centro de Fotografia da Universidade de Salamanca in 1998 and at the Centro de Arte de Salamanca 2002 to 2003.

SELECTED BIBLIOGRAPHY

The Artist and the Photograph. Barcelona: Actar, 2000.

Hagen, Charles. "No Cameras: It's Object to Image Direct." The New York Times, December 3, 1993.

"Joan Fontcuberta." Aperture, 155, Spring 1999.

Joan Fontcuberta: Micromegas. Cuenca: MIDE, 1999.

Joan Fontcuberta: Twilight Zones. Barcelona: Actar, 2000.

MacLeod, Chris. "The Deep End of the Gene Pool." Our Town, October 19, 2000.

Tager, Alisa. "Joan Fontcuberta." Arts Magazine, September 1991.

Tager, Alisa. "Joan Fontcuberta at Zabriskie." Art in America, May 1994.

www.zabriskiegallery.com

www.zonezero.com/exposiciones/fotografos/fontcuberta/default.html

GRACIELA ITURBIDE

speaks with Fabienne Bradu

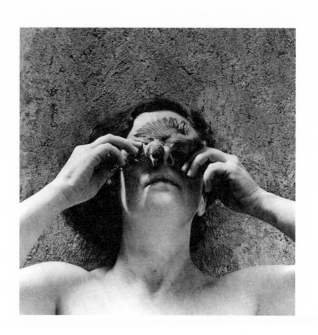

BEGINNINGS

Fabienne Bradu: You abandoned film for still photography. Could you talk about how that happened?

Graciela Iturbide: At the National Autonomous University of Mexico I began by studying film. Originally I wanted to study philosophy and become a writer. I was already married and had children. I heard about the film school by accident and had such a strong desire to do something with my life that I applied and got in. The visual arts had always been compelling to me, but I never considered studying film. I fell in love with it. I directed two movies, acted in another, and received the Best Actress of the Year award! But my great stroke of luck was meeting Manuel Álvarez Bravo. He gave a course to senior-year students that hardly anyone attended because everyone there wanted to be a film director. Still photography was considered the poor cousin of film studies and nobody was interested in it. By chance, I owned a book by Bravo, a catalog of his photographs from the 1968 Olympics, edited by Miguel Cervantes and Juan García Ponce. One day I came across this book in the Lagunilla flea market—I had no knowledge of his work before that. So I went up to him to see him if he would sign the book for me and asked him if I could take his master class, a standard photography course. Manuel Álvarez Bravo not only let me take the course, he also immediately asked me to be his apprentice. [The word she uses here is *achichincle*, and then goes on to say: "You know, in Mexico, the *achichincle* is the worker's helper, the carpenter's aide. I could not believe it."]

FB: Why do you think he did that?

GI: I think he responded to the interest I had. Given the reigning circumstances at the film school, he probably said to himself: "Here, at least, is one who fell into my lap and who wants to take my classes!"

He really understood the emotion I felt when I talked about his work. I had good teachers at the film school, but there was something special about the still image that attracted me. Perhaps I should go back a bit to explain this better. There is a precedent in my life. When I was a child—we were a lot of kids—my father took pictures of all of us with his own camera. There was a bureau in our house with a drawer filled with my father's photographs. As a little girl it was a great thrill for me to go to that drawer and to look at those pictures. There was something special about it that is hard to describe: in fact a number of times I stole some of these pictures and was punished for it. For me it was a great treasure hidden in our household. When I turned eleven I was given my own camera but never felt that I might become a photographer. Maybe because of the oedipal feelings I had for my father, seeing the book of photographs by Manuel Álvarez Bravo, then getting to meet him and having him ask me if I wanted to be his assistant—maybe that changed my whole life.

FB: How old was Manuel Álvarez Bravo when you met him?

GI: Don Manuel was sixty-seven. In 1969 he was a serious figure, without question the most esteemed photographer in Mexico, but by then nobody assigned much importance to his career. He became very famous during the twenties and thirties when he formed close relationships with the muralist painters. Then Cartier-Bresson came to Mexico and they had a show together. That was a very decisive moment in Bravo's career, a time when he was associated with the Gallery of Mexican Art along with Lola Álvarez Bravo. He also worked in film. But when I met him in the sixties, despite the esteem and friendship of Juan García Ponce, there were no Manuel Álvarez Bravo photography books in print. It's possible that his work was more respected at that time in the United States. For me, meeting him was like a gift from heaven. This man was not only a great photographer, but also imbued with a sense of poetic time, so Mexican, that was so much a part of him. "Graciela," he would say to me, "there's no need to rush, there is time. There's no hurry to exhibit. One just has to work hard." All the time I accompanied him he gave me the opportunity to be close, to observe how he worked, to buy books with him, to listen to music with him (mostly Bach). He began to open up a whole world for me. It was much more than simply learning a craft. In fact, he was never my professor. He was a *maestro* in the best and deepest sense of that term. I would watch how he made his prints in the laboratory, but he would often say that in order to print photographs one had only to follow the instructions provided by Kodak, that that was enough. In those days Manuel Álvarez Bravo worked in the publishing division of the *Plástica Mexicana* and so he was in contact with the work of Velasco, of Clausell, and the muralists. So I was thrust into that world as well, a world he knew intimately and that was rich and fascinating for me, because I was not really a terribly cultured person.

FB: Was Manuel Álvarez Bravo's rejection of technique believable or just a pose?

GI: He was not particularly skilled in technical matters. Telling me to simply follow the instructions on the Kodak box was a way of telling me to experiment on my own. It was a very smart way to introduce me to technique, making me appreciate, for example, the beauty to be found in blacks and grays. But he was not technically proficient the way the North American photographer Ansel Adams was, for example. Adams dominated the entire gray scale. With Manuel Álvarez Bravo there was more emotion and intuition involved in printmaking than technical precision. It was a magical experience for me, being able to observe how the tones would emerge. When I started to work with him, the Museum of Modern Art in New York asked him to make a series of Tina Modotti prints. He knew Modotti very well and he interpreted her negatives with loving care. All I did was observe. I never collaborated with his printmaking. He always let me watch whatever he did, whether in the laboratory or in the countryside.

The first time we went into the countryside he said to me: "Like the Gospel says: 'and some copied others'," meaning that I couldn't make the picture he was trying to take. I learned to find my own path. When one is confronted with a personality as strong as his, it goes to your head. After being with him for a year and a half I felt the need to cut the umbilical cord and strike out on my own. As he would say, one needs influences and models to follow but one also has to reject some of them and acquire one's own language. His very personality helped me to avoid imitating him. I had, and still have, many influences from him but I have gone down other roads. I have to admit that his way of looking at the world fascinated me, the presence of the pre-Hispanic universe in his work, the influence of popular art that penetrates his themes and images. His house was filled with little figures we would buy in villages. He had great respect for folk artists. To see and to get to know Mexico through his eyes was a huge help.

FB: Is there a particular photograph of Bravo's that really stayed with you?

GI: More than any particular photograph of his, I remember one I took of him. He is in front of his large format camera, thinking and waiting for something to happen. What I remember above all is how, whenever we would go out to the country, he would position that large camera toward a grand landscape—and then he would wait there for something to happen. The patience, his ability to simply wait, after finding the right spot where something could happen, really impressed me (although I do not do it myself). Of course I have also worked with many photographers who have been in a rush and who have been as good as he! He usually did not take many pictures. Even if he only took two, he would never lose patience. We went to villages and fiestas, and I would see how, almost invisibly, he would photograph what interested him without ever bothering people or getting in their way. That was a great lesson for me.

FB: Do you think you saw the same things he did while he waited for something to happen?

GI: Though I concentrated on what he was photographing I was always discrete. I

watched and saw what he did, and many times he would say afterwards, "Graciela, did you notice this or that?" He was always very moved by what he saw and we would always comment on the results as they were developed. And yes, there would be surprises in the lab for me because there would often be differences between what I thought he was shooting and what he actually was taking a picture of, the composition he actually chose.

FB: I have to ask you something that has always intrigued me: I have observed a disconnection between your being distracted by everyday life and then, when it comes to photography, how you apply an absolutely certain eye. In other words, when you and I walk by the same place, why are there things I do not see that you do?

GI: One is surprised by what one sees, but also by what one remembers as afterthought. Many times you think, 'What a great photo I've just taken!' but regardless of how long you've been perfecting your technical proficiency and your eye, there are, fortunately, surprises. There are moments when you ask yourself, 'When did I take this?' and you are surprised. Of course, pictures can also disillusion you sometimes.

FB: Do you think that is where the main difference lies in the pursuit of knowledge—between someone who learns through looking at books, seeing only the end product, and someone who sees the whole process the way a maestro looks at the world?

GI: Fortunately for me, my apprenticeship with Manuel Álvarez Bravo covered all of those areas. From the moment we would get into the car he would evoke landscapes, earlier trips, festivals he had attended, a myriad of things that formed part of an apprenticeship that was very complete. I learned to listen to all of his views on life, read what he was reading. Or, arriving home, I looked at books of paintings, because he felt that in order to be properly educated visually one had to see lots of paintings. Or we would go to exhibitions. All of that time I was on the receiving end of all that information; it was a banquet for me. It was not just a question of observing how he worked, how he took a picture and how it came out afterwards, but to take part as well in his unique sense of Mexican poetic time, as I like to call it. I would never have received this kind of an education going to a school. Over and above his images—because his style changed quite a bit throughout his life—the most important thing for me was learning his way of experiencing the world. I have a clear memory of a picture of his: a wall with a light. I think that in the time I worked with him he went through a thematic change. He began to favor city themes over the countryside and take more abstract pictures. It was his sensibility that left its mark in me.

FB: Does it bother you now that you are so often referred to as his disciple?

GI: Not at all. It makes me proud. It's not an inheritance that weighs on me in the least. It is something I feel I have already digested, and in spite of how quickly I cut the umbilical cord that connected me to him, I continued to see Manuel Álvarez Bravo up until very recently. Curiously enough—and this was very important to my formation as a photographer—he never told me whether he thought my pictures were good or bad. He never spoke to me about my work. I know he spoke to others about it. When

I started to take pictures, he would send his wife, Colette, and me to the market to see what we would do, and afterwards he would look at our contact sheets and maybe he might say, pointing to one or another: "Go back to this place," but nothing more. When I began to publish books that I would take to him he would never react with any commentary. On the other hand I remember I went to Panama once and took a picture of some children with their fists raised. I didn't do it for political reasons but only because in Panama children lift their fists up in the air to get their picture taken, but a publishing house here used the shot for political ends. And Manuel Álvarez Bravo told me, the only time: "Graciela, everything in life is political. Don't go out there deliberately taking pictures of things like that." It was very good advice because he was right, even an abstract photograph can be political depending on how you use it. He was never paternalistic or overly protective with me. I understood that he was never going to tell me anything and so I learned not to ask him anything.

FB: Didn't you ever feel the need for a pat on the back?

GI: No. I never worried about that. I was so delighted by the work every day and later on by the conversations we had about his life; when he met Tina Modotti and Diego Rivera, or about anything. It was such a rich relationship that I neither expected nor missed getting encouragement.

FB: Did you feel then that you had your own eye rather quickly, the way a writer finds her own voice?

GI: Perhaps what I felt with the level of teaching I was receiving was that I could go out into the world and see what would happen to me. Working alone is impossible if you are making a film, and one of the things that drew me to still photography was the discovery that I could work on my own. Thanks to Manuel Álvarez Bravo I had the great opportunity to discover my own country through photography. I have always thought that the camera was an ideal pretext for getting to know the world. In a way he gave me the key with which to discover my country and its different cultures.

FB: Is that because going out into the world with a camera obliges one to see more?

GI: I think it is a great pretext, because you interpret reality through the camera. The photographer interprets reality and, above all, makes her own reality in accordance with her knowledge and emotions. It is complicated, sometimes, because the process can be somewhat schizophrenic. Without the camera you see the world one way, with it, you see the world another way. Through the lens you are composing, dreaming even, with that reality, as if through the camera you are synthesizing who you are with what you have learned from the place. So you make your own image, interpreting. What does happen to writers and photographers alike is that it becomes impossible to maintain an objective truth of life.

FB: How do you interpret something at the same time you are seeing it?

GI: Because your training and your intuition are working together unconsciously, the

surprise is always instantaneous. Say I am in a garden or at a fiesta. Why do I go to a specific area when there are so many to choose from? Because there, in that place, the sense of surprise is active, it's calling. I cannot work if there is no surprise, if the spark of the wondrous is not present.

THE INDIGENOUS WORLD

FB: I would like to talk about the pictures you made of the Zapotec Indians in Juchitán.

GI: I was lucky enough to get a call in 1979 from Francisco Toledo who, without knowing me, offered me the project. It is a mythical place that had been visited by Cartier-Bresson, Eisenstein, Tina Modotti, Frida Kahlo, something I did not know when Francisco Toledo called me. He wanted me to take a series of pictures that would later be kept in the local *Casa de Cultura* [Cultural Center]. I then spent long periods of time living there. I was able to support myself thanks to the lithographs Francisco gave me as presents to sell, because in those days I was completely broke. In the Juchitán I spent a lot of time at the public market, hanging out with the women there, these big, strong, politicized, emancipated, wonderful women. I discovered this world of women and I made it my business to spend time with them and they gave me a certain amount of protection. Obviously my being a woman helped and gained me access to their daily world and to their traditions. The work I did there dragged on for six years with various interruptions. At the beginning I was not thinking of a book, as the project was initially conceived of as a photographic essay, really, but I became more and more fascinated by the place and the people who lived there, and I read many texts about Zapotecan history. Then Francisco Toledo suggested we make a book out of it. And so I went back and was able, for example, to photograph El *Rapto* [The Kidnapping] thanks to the relations I had developed with the people there who told me about this tradition. Nobody had ever photographed it before. El *Rapto* refers to a country custom, when a young couple wants to live together. The young man kidnaps the young woman, but with the help and cooperation of the whole community. The young woman is brought to the young man's house and he takes her virginity with his finger. Then his family is told that he has taken the young woman, while her family does not know yet. His family comes to his house the next morning to see if there is blood, to see if the girl really was a virgin. This sets off celebrations with erotic songs and they go looking for the young girl's family to show them a handkerchief with the spot of blood on it. Once this happens the girl stays in bed for eight days until the wedding takes place in the church.

FB: There is a photo in this book called *La Señora de las iguanas* [The Iguana Woman]. Is this the picture that begins your fascination with the relations between the human and animal kingdoms?

GI: In Mexico the Zapotecs and the indigenous world in general live closely with animals. By chance I caught an image that—again by chance—attained mythical status in a way. The Zapotec people have many fiestas and traditions that have to do with lizards and iguanas that are perhaps part of the unconscious, that are in their history,

but when they go to the market to sell iguanas they are not conscious of these symbols. I read some amazing things in a magazine once, a magazine called *Guchachi-Resa* that Francisco Toledo published in the Juchitán. For example, that blindness can be cured by applying iguana feces to the eyes. There are many legends built around the iguana.

FB: Do you think you read the same things, looking at this picture, that people from the Juchitán do?

GI: Each person will read something different according to their own culture and to who they are. Although I have read and listened to many things about the Juchitán culture, my own interpretation, obviously, is going to be distinct. When I visited Japan to receive an award they were unable to put a picture of me on the invitation, and so they put "The iguana lady" on the invitation instead with my name underneath it. The other five photographers had pictures of themselves next to their names. When I arrived, the museum's director said to me: "What a pleasant surprise! You've come without an iguana on your head—and you're not fat!" He was trying to be amusing but he really did think I was going to be like the picture: from Juchitán and perhaps with iguanas on my head.

FB: Isn't this image a prime example of the different ways there are to look at the world? Does it make you happy that the Juchitán natives have taken to this picture as something of their own?

GI: Yes, although I am not so sure they really see it as something authentic, something part of them. I think they have taken possession of it, as you say, to a certain extent because it grabs their attention or it amuses them. Elena Poniatowska wrote a text for the Juchitán book that was an interpretation as well. Many feminists in Japan and in England thought a matriarchy existed in the Juchitán based on Elena Poniatowska's text. They went and interviewed Zoraida, the iguana lady, and asked her: "Are you a feminist?" and she answered: "Of course I am. Ever since my husband died I have taken care of myself." Many myths are propagated in such a way. I talk about this picture because it has gone all over the world and has been subject to numerous interpretations. Some feminists in Hollywood even made a film and stole the image of the iguana lady! And I ask myself, why would feminists in Hollywood want to fashion themselves after this woman with her iguanas?

FB: Might not the reason be that it is an image that each person can interpret in their own way, an image that melds together the power of the indigenous world, great plastic strength, universal myths, and the fusion of the human with the animal world?

GI: Of course. And, above all, each person's fantasy can just glom onto it. It is something you can never calculate or control. If anyone looked at the contact sheet I had for *The Iguana Woman* (and it might be interesting to publish it some day) they would see how the woman is laughing, that the iguanas were dropping their heads down. It was a miracle I got to snap a frame in which they were resting placidly for a moment. I never imagined it would become a photo that might really interest the Zapotec people themselves.

FB: How can you be sure that you don't betray the indigenous community?

GI: My interpretive capacity does not operate solely in the indigenous world. It comes into play in the city as well, or when I take a picture of say, a writer. I want to be clear that I do not work in the indigenous world if there is not complicity and respect. I don't like it when they refer to my work as being magical—it makes me furious. It would interest me more, and I don't know if I ever will get there, if my work had some poetic qualities. It never would have occurred to me to say to the iguana woman, "Come to my studio and I will place some iguanas on your head." I simply found her at the market. I think all photographers make documentary photography, but, afterwards, it all comes down to how each person interprets what they see, whether it has more or less poetry or imagination. But if I insist on the importance of a sense of wonder it is because this is the quality that most connects with who you are, with the world you carry around within you.

FB: When you were speaking of complicity and respect with the market women in the Juchitán, you also mentioned they had protected you. What exactly was the relationship you had with your models?

GI: They are strong women, large, even physically. The whole time I was in the Juchitán they were telling jokes and dirty stories—sometimes they would translate them for me, sometimes not—and I had the luck of having been sent there by Francisco Toledo [Painter, sculptor, ceramicist, born 1941 in Oaxaca. A patron and guardian of regional arts] whom they knew and loved. I lived in their houses. They took care of me and took me with them to the market. They adopted me in a way. They let me take my pictures and let me know about the various fiestas. I would go on pilgrimages with them. They regaled me with all kinds of pertinent background, about lizards, for example, which is another tradition of the Zapotec natives few people know about and that persists within the isthmus. It wasn't only that they gave me permission to take photographs, they also suggested themes and showed me things. I discovered the Zapotec people through their eyes, and through my own at the same time. Macario Matus, who directed the Casa de Cultura [the Juchitán Cultural Center] at that time, also took me to many places, to the saloons for example, but everywhere I went I always found a woman who would adopt me and show me things. It was in this way I entered into the Zapotecan world.

FB: What do you think it is they saw in you that made them want to adopt you?

GI: I think they realized I was respectful with my camera and that I sought genuine complicity with them. There are aggressive photographers I respect. In order to get good war pictures, for example, one has to be aggressive. What they saw in me was, above all, that sense of complicity. They are still my friends and when they come to Mexico City they visit with me. One of them, Marcelina, "cleans" my house, which means she goes through a ritual of cleansing it of evil spirits, or she sometimes brings me little holy icons from Guatemala. I never tried to imitate any of the Zapotec women, dressing like them for example, although occasionally I would wear something they gave me as a present. At the fiestas they would make me wear a traditional blouse and skirt and flowers in my hair.

FB: Does your idea of doing a photographic essay consist of becoming invisible and blending into the community you are documenting?

GI: Very much so. It involves that sense of time I learned from Manuel Álvarez Bravo, but it also has to do with my own personality. I have been in many places and situations where I realized I had an interesting photo available to take, but I did not do so because I was talking with one of the women. It would depend on what felt most important at any given moment. Perhaps I lost many good pictures, but it was just as important to be with the women who were at my side. The truth is I have no memory of having sacrificed any key opportunity for a picture, but I do remember having interesting situations at hand and of having to let them go.

FB: Poets say that in order to be good, it is necessary to sacrifice poems. Do you think it is necessary to sacrifice pictures in order to become a good photographer?

GI: Of course. It is indispensable to become invisible. It is far more important to learn about the environment I am in. That kind of knowledge is so appealing and compelling that the pictures become almost secondary. It's why I sometimes say there is a bit of schizophrenia in the process, a feeling that can provoke anxiety. When taking a picture, actually taking it, something happens that is very different from when you are learning about yourself, about the place in question. I do not understand what makes me take a picture. Cartier-Bresson talks about the "decisive moment," the necessity to function with "lynx eyes and silk gloves." Perhaps what happens when you press the shutter is an intuitive act infused with all you have learned.

FB: Why did you take pictures of Francisco Toledo with animals?

GI: All of Francisco Toledo's paintings have to do with Juchitán legends. Then, when you get to know what daily life is like there, you feel that these legends are filled with his work. His vision influenced me considerably. Some pictures I took of him are quite casual, and some, like the one of him with the bat, were calculated, taken with more care. I bought that dissected bat in New York. Francisco Toledo loves bats and so that helped loosen things up. We began to play a bit and that was when I took the picture that, you say, shows a resemblance between them. But none of that was intentional. The rapport between us came completely from the fact that I understood his work and he understood mine.

FB: Why do you think he called you to do the book about the Zapotec Indians in Juchitán?

GI: He didn't know me at the time. I had a good laugh one day when I said to someone, in front of him, "Francisco called me because he knew my work," and he said: "Nothing of the kind, I didn't know your work at all; I just called you." It was obviously a joke. He had seen some pictures of mine that I had taken in other regions of Mexico. Francisco Toledo and Manuel Álvarez Bravo resemble each other a lot. Maybe that's why Francisco never told me what he thought of the work I did in the Juchitán. They are both very Mexican in the best sense of the word. There is a sense of silent complicity that is never spoken.

FB: It is a complicity that the two of them have as well, with photography.

GI: Francisco Toledo took up photography just a few years ago. I was with him when he bought his first Polaroid. He told me he wanted to be a photographer even before he became a painter, so his respect for photography goes far back. His Polaroids are pictures that are very constructed and that have an erotic edge. I content myself with just keeping the ones I have and, from time to time, with his consent, publishing some of them in publications we decide are appropriate.

FB: Are you flustered at all by comments people make about your work, ones, for example, that Francisco Toledo might make?

GI: Not at all. I don't take pictures to instruct the world about the indigenous populations of Mexico or to have people tell me whether they are good or bad. If they like what they see, then that's great. It's a passion, or, better put, a necessity, for me to prowl about with a camera. It's a kind of therapy.

FB: And why the interest in the indigenous world?

GI: When I was first starting out I took pictures of Mexico City. My entry into the indigenous world came through Manuel Álvarez Bravo, fascinating me to such an extent that I felt a great need to know it first hand. In Mexico, unfortunately, that world is very marginal and being able to live and share in it has been difficult for reasons of class. My interest has its dark side as well. For example, people live pretty well in the Juchitán, but there are other regions in Mexico where marginalized populations live in terrible conditions. Something must be done there, but on another level, not with photography. As a photographer I do not attempt to change the world. I've done what I can in other ways, but never with my camera, unless I have been asked to. I took pictures of numerous political events in the Juchitán and I gave them the material. Given the degree of alienation and poverty, it's incredible; people put more time and effort into the fiestas and traditions so that they might be preserved. It's a bit paradoxical.

FB: What do you think of the argument that says one should try and extract photography from the blind alley of excessive realism?

GI: The dilemma between image and imagination is a false one, a cliché. A photographer with no imagination is, by definition, a bad photographer. One shouldn't fall into the other extreme either, into the baroque, which is also horrible. If by imagination some people mean putting a crab or something on a person, well, that is adorning reality, but it is not imaginative. The important thing is the combination of intuition with discipline, because you have to be extremely aware and invisible at the same time. The eye has to be highly vigilant, capturing everything at once. I don't know how to describe it. What the eye sees is a synthesis of who you are and all you have learned. This is what I would call the language of photography. For example, Strömholm photographed very dramatic things, but when you see one of his pictures you don't say, "What an amazing place!" What intrigues you is to know what he was

feeling standing in front of that chunk of ice thrown into the middle of that street. It's what he has inside of him, all of the culture that intervenes and that permits him to capture that chunk of ice in just such a way. There is also a picture of Strömholm's taken in Paris of a stream of water spurting from a pipe, a picture we have seen a million times, and it produces a sensation of angst. The work of the photographer is then to synthesize, to take something ordinary and to create from it something that is strong and poetic.

FB: Putting artistic concerns aside, what did living in the indigenous regions give to you as a person?

GI: Knowledge about the culture of my country and an awareness of its isolation. I learned from them that their culture is different from mine; other worlds exist far from us, worlds that are close at the same time. Perhaps I learned a bit to see things through others' eyes. That changed me. When I was starting out, I had a hard time dealing with people's questions about "why," and I did feel like an intruder. I carried around a record of my travels, notes, perhaps as a way to explain my motivations. Afterwards I realized that I was a photographer, and that I had no reason to feel ashamed of my profession. Being a photographer can be lonely at times, leading to much contemplation while you are traveling.

DREAMS AND DEATH

FB: Could you tell me about the images you first saw in dreams and then later came across in reality?

GI: I've had some dreams connected with my work. One day, back in the eighties, the phrase, "I will plant birds in my earth," repeated over and over in a dream I had. In the dream, as I listened to the phrase, I saw a man with many birds flying around him. I don't know what the words meant, but it was something I later ran across in reality. I went to an island in the State of Nayarit near the María Islands, a place inhabited only by birds, and there was a man there who took care of the place. There's a well-known photo of mine of this man looking at all the birds. I relate it to the dream I had. What I have yet to learn is whether the repeating phrase had to do with me as a photographer, or simply as a person. When I began to print the photograph I remembered the dream and it made an impression on me. Did I force the association or did the dream actually influence me in some way? Or was the image captured by the dream?

There is another work-related dream as well. A relationship of mine had come to an end and I dreamed my house was on fire and I saw my negatives dissolving in the flames. It was a nightmare. I felt desperate, thinking, "My work is being ruined." The amazing thing in the dream is that all of a sudden the subjects of some of the pictures began to emerge, to walk out from the burning negatives: the woman with the tape recorder, the iguana woman. I haven't been able to interpret this dream either but in some way it was about saving my subjects. Maybe it meant the people were more important than the negatives, but in the final analysis they were people invented by

me. Which is why I ask myself whether they were the actual subjects being saved or my interpretations of them? I'm not sure if it's about sacrifice, about preferring to save the people rather than the photographs because the images in the photographs are not entirely real. Or maybe it is something as egotistical as "even if the celluloid is lost, my images are saved."

Dreams have always been important to my work. I dream at night about what I've done during the day, I dream about things I'm going to do. I have premonitions. Brassaï has had a decisive influence on me. The Paris-at-night pictures especially; his work just overwhelms me. His way of looking at bordellos and the streets at night is so strong, rude even, direct, poetic—all at the same time. It is not only the photos that impress me, it's what he wrote as well, his conversations with other artists, things about his daily life. For a long time now a phrase of his has had a major impact upon me: "Life cannot be captured by realism or naturalism, but only through dreams, symbols, or the imagination." A photographer like Gilles Peress shot pictures in Iran with a very strong symbolic element. This was not the case, for instance, when Abbas covered the Iranian revolution. There is a clear difference between their two books, both of which seem to me to be equally good. But in my own work I want dreams and the imagination to be present. That phrase of Brassaï's struck me not only because I would align with his way of seeing, but also that I would like to be identified with his vision of the art of photography.

FB: What is the emotion you feel when you see something in real life that you have seen in a dream?

GI: In the moment it happens it has no impact on me because it is an unconscious process. It is not until later, when I am looking at my contact sheets, that I realize a series of pictures may have to do with something I've dreamt. It's a bit scary, or, better put, it's very surprising when it happens. I'll tell you about another episode that has to do with death. When I lost my daughter, Claudia, I became obsessed with photographing death, especially through children, dressed like little angels the way they traditionally are here in Mexico. I had a need to confront the death of other people, probably as a way to come to terms with my own pain. Then something happened to me that was so strong I stopped taking pictures of anything that had to do with death. I ran across some people in the Mexican countryside carrying one of these little angels to a cemetery. They gave me permission to take a picture and in fact the whole family posed for me. They also opened the casket and had me photograph the dead child. And they let me follow them to the Dolores cemetery in Hidalgo. During the procession to the cemetery the father looked back at me, clearly upset, because there was a dead body blocking the road. A body that was half man, half skeleton. The birds had been picking at it. It was still dressed, with pants and shoes, but the vultures had been busy feeding. It was as if death were looking at me and saying: "If you want to photograph me, here I am." I took pictures but I never printed them. It was then that I started my series on birds. In the cemetery all of the vultures started to flap their wings and my bird pictures began right there, with the sky filled with them. All of this proves that in life everything is connected, your pain and your imagination; that, perhaps, can help you to forget about reality. How you dream and how you live are

linked, and then what you dream and what you do ends up printed upon paper.

FB: You say you took pictures of the cadaver in the road but you didn't print them. Does that mean there's nothing you're not afraid to photograph?

GI: I photograph what I encounter. I print the contacts where the whole story is contained and then keep it safe. It is probably true, I was afraid to print the photos I took of that dead man because all of the others in the series have come out in one place or another. I abandoned my photo essay about death because I was afraid, in my own way, to find death itself. I didn't print the pictures of that cadaver because it wasn't the right moment, and I was afraid I might discover death again by having to look at it. Later on, in Chalma, I went about taking pictures of the fantasy world that hovers around death: people dressed like figures of death, the pregnant bride wearing the death mask who is in fact a man. These are well-known pictures. But these images are about Mexican fantasies about death, and probably mine are as well. I never took pictures again of those dead little angels like I had during that period of five years.

FB: But in Benares, you took pictures of death again.

GI: It wasn't my intention. As a rule I don't have that obsession. I feel ashamed to take pictures of people who are dying. But in Benares my friend Arahadna Seht took me to a place called "the house of death" on the banks of the Ganges, where people go to die cared for by their families. As soon as they die they are cremated and their ashes are tossed into the river. I was very moved by this place and had no desire to work there, but various families asked me to take pictures. The most amazing thing was the peaceful atmosphere that reigned there. In each room there was someone dying with their children and their siblings there tending to them, carrying out Hindu rituals, ringing little bells, applying oils, putting out flowers. The picture I printed for that book about India corresponds to the moment when this woman is just about to die and is being helped by her daughter. I prefer not to photograph these things because it feels like a tremendous intrusion, but because the family asked me to, I did it. I don't know why they asked, and I actually didn't wish to continue doing it. Other photographers would have stayed and kept working but I was not able to. Maybe I had already settled my accounts with death's pain.

FB: Doesn't a photographer have an obsession with certain instants in life, especially moments like these?

GI: I had it for five years. I also did a series of a man who had just died in the Sierra de Puebla. They gave me permission to document the whole process, starting when he entered his final moments. Curiously enough, I took those pictures in color because I was working for the ethnographic archive of the National Indigenous Institute. Films were being made about the rituals found in that part of Mexico. I found this man, an Indian farmer, as he lay there dying, resting upon a sheet, and they gave me permission to document the whole process: how they arrange the candles and the flowers and his personal effects, and then the procession to the cemetery with very specific pauses along the way. I have not published these either. I am intrigued by them but they scare me.

There is a phrase Cocteau used about film that I like to use when talking about photography. It says that photography is the only way to kill death. I had this idea in mind when taking all those pictures of funeral rites and cemeteries. Although the paper you print on will only last 150 years, the portrait I make of the person who is about to pass away is an image that will stay with that person's family. It will stay in their memory, in an exhibit or a book, or in history. I am thinking, for example, of the picture of Maximilian being executed, a famous photograph that continues to be seen. Photography has many roads, all of them legitimate, even the kind seen in *National Geographic*, because there are stories and places in the world one can see and learn about, even the typical family album of pictures found in almost every house, or photographic expositions, or historic photos like the one taken by the Casasola brothers. There is a Casasola picture that fascinated Cartier-Bresson, a man smoking a cigarette before being killed by a firing squad. I've sent Henri that picture two or three times for use in his personal archives or his books. So you see, Cocteau's phrase is valid all the way across the board.

FB: How do you feel when you are asked to do a portrait—that there are people who want a portrait done by Graciela Iturbide?

GI: It's great because it means I will automatically have the complicity I need that helps my work along. I like to do portraits but it is very hard for me to do a good book of portraits. So many have been done…even so, I have a project in the works for a book of portraits, but I would like for it to be different. I did many portraits working out in the countryside. Like the one of Magnolia, the transvestite in Juchitán, who asked me to do it and whose complicity in the process was a huge help. It's a picture that became very famous, published in *Le Monde* among other places. My work is not at its best capturing movement. I'm not good in all genres.

Yesterday I was looking at a book of photographs of Proust taken by Nadar's son; Proust's whole family came to his studio, and it was boring to look at. Everything depends on circumstances. There's a picture of Carson McCullers that I love. It was taken by Cartier-Bresson. She's in her garden. He found just the right moment to capture this writer whose work I so admire. But other portraits, like those done by Nadar, bore me even though they have historical value. Once again I return to the theme of how important it is that there be some complicity between the photographer and her subject, whatever or whomever that subject may be. I did a picture for a book of the painter Julio Galán, and his imagination is so vast that it helped make for a great series of pictures. He got the idea to have some wings made and he posed with them by a river. There was a complicity with him and all of his paraphernalia that has a lot go do with his work. The same thing happened to me with José Luis Cuevas. It's enjoyable when my subjects are telling me what pictures to take. I made a film with Cuevas when I studied cinema, and later on photographed him. At one point he got into bed with all of his self-portraits, or I put the self-portraits on the bed with him—I don't remember which of us took the initiative. It's wonderful to work with people who have an imagination, bring something to the process; one reaches a level of cooperation that way that often leads to very good results. This is what happened with Francisco Toledo and with Julio Galán because they are people who get into it. There are people who

don't collaborate and then it is up to the photographer's talent to transform something boring into something interesting. They are people who are very shy and who are uncomfortable with the idea of being photographed; I'm one of those, which is why I like to do self-portraits. In India I took pictures of Vikram Seht and his family. It was interesting because I had a certain familiarity with his parents. I took pictures of them from the time they got up in the morning, out in the countryside, in the garden of a palace in Delhi we went to. Vikram and his brothers wound themselves up in a big shawl. The pictures came out well because I was let into the family.

FB: You often use the verb *entrar*, "to enter" or "to be let into," when talking about your work. Does it mean something like, "opening a space"?

GI: I see reality in another way with a camera. Looking through the lens I peer into another world. In Cuba you use the word *tirar*, "to toss" or "to throw" or "to shoot," which is the opposite of *entrar*. Perhaps what I am looking for, thanks to a machine, is to enter into a world that is foreign to me. I never use a telephoto lens. I need to be close to people. I need their complicity; I need them to be aware that I am there taking their picture. I hate paparazzi.

FB: Many people say Indians are often suspicious of photography, that they fear their souls are being robbed. Did you find that to be true?

GI: It is true. The people fear that when you take their picture you are taking their soul. Now, if the same Indians use a camera themselves that superstition tends to disappear. I took a series of nude shots of a Juchitán woman bathing herself in a toilet, which is what they do in that region. Afterwards, in exchange, she asked me to take a picture of her boyfriend so that she could stick needles into it to prevent him from leaving her. I didn't do it because it frightened me. But I definitely ran into those kinds of superstitions only ten years ago in the Juchitán. In the houses of many *curanderos* [Translator's note: medicine men or healers] I would see small photographs on the walls with needles stuck into them. This is probably why, for two reasons, Indians look at photography with such suspicion: because you can rob their souls and because you can do them harm through a photo. Paradoxically, when someone dies in indigenous regions, a photographer is often called to take pictures of the deceased. Romualdo García for example, a studio photographer from Guanajuato at the beginning of the twentieth century, has many pictures of dead people and dead children who were brought to his studio. This sort of thing went on much earlier still. When Indians would resist my attempts to take their picture they would say one of two things: that I was going to rob their souls or that I was going to take them to a foreign country. They also think you are going to make money from them. In the nonindigenous world I never ran into these kinds of superstitions, but what is in play there is vanity. The photographer seduces and plays on people's vanity. Manipulate and seduce, but unfortunately it's what you have to do. I should say that the indigenous world is not exempt from vanity either. When you show them the pictures you have taken they love it. They put them on their altars and in their living rooms. With the series I did in the Sonora desert near Hermosillo, most of the work was portraiture because daily life there is so minimal that nothing happens. The men go to fish, live in the desert, make sculptures, while the women

gather sea snails and make necklaces. Their life is very austere. I had to be with them the whole time. There were only five-hundred Seri Indians left when I did the study. I have pictures of practically all of the families. It was a time when they used to make themselves up with brilliant colors. The portrait of the Angel Woman with the tape recorder is part of that series. I went into the desert with them because they wanted to show me rock paintings in some caves, and I was so involved with them at that point I don't even remember when I took that photo. I took a rough version of the book from this series to show to Pablo Ortiz Monasterio. It was he who found that picture in my contact sheets—I never saw it! Sometimes I think maybe a friend of mine who had come along with me took it! I was lucky to have such a good composition since I have no memory of setting it up. The way the Seris behaved was quite different from the amused way the Zapotec people in Juchitán took to my pictures. They had become accustomed to being photographed in color by North Americans and their Polaroid cameras, so when they saw my pictures at the exhibition, framed and in black and white, they said "Not good." We had to close the exhibit! Each one took their picture and brought it back home with them. Photographers have to deal with issues of vanity. It's exasperating but I have such a good time when I work that I don't let it get to me. You forget about it. I don't work with people who don't collaborate. Why should I bother them, or myself, not to mention that the result is almost always absurd.

FB: It's curious that nobody seems to escape from issues of vanity with respect to their image. What we call superstition when talking about the indigenous world might correlate with a fear we have ourselves; to get trapped in a pose or to look a certain way for all posterity. Our fears have mostly to do with time. What is the photographer's relationship to and treatment of time? How do you deal with it?

GI: I am more obsessed with composition, with the image itself, than I am with time. For many others capturing a particular instant is what is most important. The element of time is indispensable because time is movement. But seeing as I have very few pictures with movement in them, the element of time takes a back seat. There's a picture I took of a bicycle with chickens in Tlaxcala for example. I was really taken by the sight of the chickens with their legs tied together hanging upside down. When I began to take this picture, fascinated by an image that was almost abstract, two newlyweds walked by, older people, covered with the dust of Tlaxcala, with the mother of one of them walking behind. I was so taken by it that I did not photograph them, and I've regretted it all my life. It was like a vision of Pasolini in Mexico: covered with dust, with her veil, next to the bicycle. I could have said to them, "Could you stop for me just a moment?" Or I could have taken their picture right away, quickly. There I lacked the ability to step back and take the picture. It was a beautiful and soulful image—and I lost it. Maybe if I had taken it quickly it would have been out of focus, or maybe it was just my imagination, unduly influenced in that moment by Fellini and Pasolini. Those instants are gifts from reality, which are, at least, fantastic to be able to live firsthand. Your eye and your imagination should be attentive, but I was unable to capture that offered instant. Maybe I am lacking that "eye of the lynx" that Cartier-Bresson talks about. I am calmer. I prefer to deal with something static there in front of me. More than time, what interests me most is the plasticity of the image.

INDIA

FB: Is traveling a way for a photographer to refresh his or her eye and sense of wonder?

GI: It seems to me that traveling is important for photographers, tourists, writers—for everyone. In my case it is about the need to know and to be surprised. Once again, I employ the camera as a pretext for learning. But it's a double lesson: when you travel you discover things about the external world and about yourself as well. You confront your own loneliness. Traveling means a significant amount of loneliness for me even though I am in contact with a lot of people. I'm talking about a loneliness that is conducive to reflection. When you travel, you're exposed to the unexpected. Whether or not I have a camera in my hands, unconsciously, my eye is framing. It is a professional deformation.

FB: Did previous work in indigenous regions make your arrival in India any easier?

GI: I don't know. It may have helped, in the sense that it accustomed me to see other worlds that were foreign to me. There were certain similarities in India to what I had seen in Mexico. But, in spite of those similarities, my initial reaction when arriving there was tremendous. When I arrived in Rishikesh, it was like arriving in Chalma, because I saw those same kitsch Christ figures you see in Mexico, but made with the features of Shiva. The indigenous world I came to know in Mexico served as a kind of first filter for India. In any event, the people in India were easier than those in Mexico. Indians love to have you take their picture, to such an extent that it becomes difficult, because everyone wants to get into the shot. Sometimes you have to take a picture just to please them, and then you can take the one you really wanted. In the Lucknow horse market, the number of people following me around who wanted to look through the camera made it impossible to work. There were at least two-hundred people following me, trying to look through the camera.

FB: Was it always the idea to join India together with Mexico in the same project?

GI: From the beginning, because of a book by Octavio Paz called *Glimmers of India*. I was not always in agreement with the people funding the project because once I began to really get into India I saw more differences than similarities. Now, the dialogue established in the book between the two countries did emerge once it was edited. But I was not looking for similarities when I was photographing in India. Nor was I motivated to take another look at Mexico, to make more pictures there, when I returned from India. I used the material I already had. I would not have been able to consciously search for correspondences in one place or the other. In fact, the India pictures correspond more to objects, to more symbolic things. I didn't want to fall into the cliché of what had already been photographed there. I tried to look at things that you don't find in other books of photographs taken in India. In Mexico and in India there are ways to take pictures that will grab a foreigner's attention, like those Cartier-Bresson made, but seeing as how I am Mexican, I belong to a country that, due to its marginality, is quite distinct from other industrialized developed countries. I don't know how to escape entirely from the clichés one might encounter in India, but at least none of them got into the book. For example, I chose the hand of Fátima, which

is the symbol of the Communist Party in Calcutta you see in many places there, or the picture I took of The Times on the ground with the earthen pot on it for people to throw coins into, instead of photographing the actual beggar. I tried to concentrate on the symbols that spoke to me of India. Instead of taking a picture of the beggar begging, something that bothers me, I took a picture of The Times on the ground and the prosthesis tossed next to it, because you know there are people in India who have a limb cut off so that they can beg. I tried to do something symbolic with what I saw in India.

FB: Do you mean you gave preference to a vision of a strange, weird India over a more pedestrian view?

GI: India is unusual, period! There's a photographer, Max Pam, whose pictures of India are wonderful and who perhaps has influenced me. I mean that in a positive way, not that I went about taking the same pictures Max Pam did. But let's say that among the people who have worked there, his pictures of India are some of the best. For me, the beggar, the leper, these are clichés. But there have been photographers who have gone with Mother Teresa who took wonderful pictures of lepers. There's a New York photographer who did a whole series about the saddhus that is fascinating. But if it has already been done, it seems a bit absurd for me to do the same. And, for some time now, I've been working less and less with people. In Florida, almost by accident, just before I left for India, I started taking pictures of landscapes and of objects. Perhaps I was so engrossed in my travels along the highways, seeing the loneliness one encounters in the United States, that when I got to India I preferred to take pictures of a jacket hanging from a tree filled with birds.

I took the trip to the United States in October and in December I left for India. I was looking for something new: landscapes, objects—something completely contrary to what my attitude had been before, an attitude based on contact with people. I began to see things I had not noticed before, things I would never had stopped for. On my first trip to India, all of my work was centered around objects and symbols. Fortunately I also ran into lots of birds. You rarely find birds when you are looking for them. I'm not interested in birds per se, but rather in certain situations, like in Khajurhao, next to the military jacket hanging on a tree, or the birds swirling around in the air above the line of dogs. Maybe if I had gone to India ten years earlier such landscapes would have left me indifferent.

FB: You don't find it somewhat paradoxical to eliminate the human element when taking photographs in India?

GI: Sure. But this is where the photographer intervenes, because the photographer will choose or give preference to some things over others. For example, they invited me to Allahabad and I did not want to go and be confronted there with multitudes of people. The work I did with birds comes from the writings of Saint John of the Cross about the qualities of the solitary bird, something revisited again with the Sufi poets in India. The first trip I made to India was with my family, and each of us found things that interested us in different ways, according to our inclination: Estela as an historian, Mauricio as an architect, Manuel taping music, and me taking pictures. Now why, if

I am doing a book about birds, do I run into birds? It was fantastic; it's just what fell into my lap as I wandered about India.

FB: How does one look for surprise in a country so full of surprises and extremes?

GI: Perhaps I looked for surprise within what was the most normal and commonplace one finds anywhere. The unconscious obsessions we photographers carry about make it inevitable that we find our themes no matter where we go. The birds I was searching for were the solitary birds of St. John of the Cross by the Sufi poet Attar. They exist in reality, but above all they are inside of me, or one could say, they exist spiritually in literature and so they are difficult to find in reality. Literature inspired me to seek the journey of the bird by Attar, birds that end up finding themselves in the mirror. I had read the story of Simurgh in Borges at a time when I had no plan to work with birds at all. But I was interested enough to send the story along to Abbas, and he, an Iranian also known as Attar, returned to his country thanks to this tale, to photograph Islam. For my part, the story motivated me to look for birds. By way of this long chain, when I went to India, I made selections, perhaps fearing to fall into cliché, looking for whatever was most symbolic. When traveling, one looks for the unknown in order to find oneself, or one's obsessions. Looked at this way, it doesn't matter much where the photographer goes because you can find what you're looking for around the corner. But as a person it is fascinating to see the cultures of other countries, and that always helps you find what you are looking for. When I went to India I read Mircea Eliade and Pasolini, which was enlightening, but India fascinated me on its own as well because it is a mad country. India came to me by accident. I had no idea what it was like, and my knowledge and my passion for India came about because of that first trip. My nostalgia for India is so great now I would go back to work there. I want to know it better. At the beginning I wasn't sure how much I liked it. It was too much, overwhelming, which is maybe why I limited myself to the symbolic. On my second trip I got very interested in the transvestites. I would find them in the street and they would take me up to a room and undress for me. In the India-Mexico book, there are some strong photographs of them masturbating. They let me into that room in a spirit of play. It's a fascinating thing about photography because, if I had not had the camera, it is more than likely they would not have gotten into such a playful mood. My camera protected me and gave them something to play with. The same thing happened to me with the transvestites in the Juchitán. The similarities between the two countries you see in the book have more to do with the obsessions of the photographer than with any actual likenesses. This is what happened to Sebastião Salgado and to Raghu Rai.

FB: Was your work affected in any way by knowing the book would contain pictures by three photographers?

GI: No. We worked independently. We never showed each other what we were doing. They were three separate essays within the same book. While in India, I never thought of the others, or of the final result. It is a firm policy of mine to never think about a book I might be working on in general. I know some other photographers who do. I am obsessive about my themes, themes I hope to encounter, but I never go looking for specific pictures. I don't want to go to an island filled with birds for example. The

obsessions provoke apparitions. Better put, they encourage a mental state that helps to see what you are looking for. I hope to find them, appearing in my path. The birds were born from pictures of death, and that is how various projects go, one to another. One day, way before my bird project was underway, I went with Francisco Toledo to visit a radiologist and by chance there was an X-ray in the office of a bird, and I had the idea to photograph the actual bird, Francisco Toledo's hand, and the X-ray. I also have taken self-portraits with birds in other periods in my life, and I have no idea why. In one picture I put two birds over my eyes, one dead, one alive, and it looks like my eye is dead. The photo is called Ojos para Volar [Eyes for Flying] and has to do with a difficult time in my life, of breakups when perhaps all I had available as therapy was seeing. I don't know why I did a picture with a desiccated bird and a live one I bought at the Coyoacán market. My self-portraits are very unconscious and have to do with my moods. But, obviously, birds have to do with flight, with freedom, with spirituality, although I don't know if my pictures could be called spiritual.

FB: It's clear that literature accompanies you on many of your photo-essay journeys…

GI: It's a form of nourishment, as a photographer or not, a way of discovering the world and awakening one's imagination. It just happened to me recently with the film El Instituto Benjamenta [Institute Benjamenta, or This Dream People Call Human Life] (1995). After seeing it I got the book by Robert Walser and now find myself obsessed with the movements and gestures of servants and valets that I would love to explore and capture some day. Perhaps I won't take any pictures of actual servants—although I curiously enough I have already—it may be that I just limit myself to trying to capture their gestures with forks and knives. I am also obsessed by the woman professor with her goat-foot wand. Now, I never, obviously, think of using photography to illustrate scenes found in literature. Bryce Echenique's book Un mundo para Julius [A World for Julius] brought my own childhood back to me. I come from a very Catholic family and I have always derived pleasure from the ritualistic side of religion: that they would dress me up as an angel, the Virgin, putting flowers in my hair. I boarded at a Sacred Heart school, and I remembered that world in special detail after seeing some of Fellini's films. Thanks to Bryce Echenique's novel, I was motivated to do my photo essay Recuerdos de infancia [Childhood Memories]. Not that the photos have to do with my childhood specifically, but they address it vicariously.

FB: Do you tend to see things in pictures when you read?

GI: A little bit. I don't think in images I would try and make myself in photographs, but yes, I read in a very visual way. Lampedusa (who has written some beautiful poetry about birds, by the way) filled me with multiple images that I found in real life when I visited his home. There is an auto-feedback process in play, to some extent, which is the sort of thing I also look for when seeking writers to do texts to accompany my photo essays. Critics, in the end, have to refer to my pictures, to my work, when they write their reviews, but when I do a book I prefer to choose writers whose world I like, and then I let them write about the effect my work has on them. In general I prefer that these texts be independent from my photographs. In my book En el nombre del padre [In the Name of the Father], Oswaldo Sánchez came with me to a place where goats

were sacrificed, but our impressions were very different. It was an erotic world for me, filled with the blood of sacrifice. The Indians make the sign of the cross and ask for forgiveness before killing the goats. It's practically biblical, but erotic at the same time because everyone is very excited by the blood. It was overwhelming for Oswaldo. He could not bear it and left. But I stayed and finished my work and ate mole with them afterwards (made with one of the goats that had been sacrificed). Through my camera I found myself immersed in a biblical world I found there and perhaps idealized or made up. Oswald saw something very different and wrote a wonderful text about it. I am sure that if I had gone without my camera I would have had a reaction similar to his. There is a kind of trance one gets into once a camera is on your hands. One time, the newspaper *Liberation* asked me for a photograph on the theme of happiness to accompany a text by a philosopher. I sent them that picture of the little girl, who may have been a bit retarded—her face is odd in that way—caressing a small dead goat. It was sheer happiness for her. It was an image of happiness for me. But the trance I mention only occurs in situations like this because, like with the goats being sacrificed, everything transpires very quickly. You can't ask for permission because they already gave you that at the outset, you can't interrupt their work because they are paid very little to do it and the whole family is into it; the children carry away certain parts of the dead animal, the women handle the business end with knives held in their mouths, the man is the one who does the actual killing. There is a need to work very hard and a spiritual need to ask for forgiveness, to offer prayers, and thus there occurs this strange relation between death, eroticism, and spirituality. For a long time the Spanish, who are the leaders in shepherding herds of goats, would contract Mixtec Indians to do the slaughtering. It's a job that pays little, but there is a spiritual side to it that gets manifested in asking for forgiveness and prayer. Perhaps the Indians need these rituals to help forget the miserable conditions they live in. To do the work I did, I had to enter into an almost obligatory trance in order to see quickly, shoot quickly, and not interrupt the event at hand. I worked for very few days. The trance helped me to ignore the pain suffered by the animals and the Indians.

FB: Why is it that you too need ritual? What does it mean for you?

GI: As far as I'm concerned it's what saves man, what saves humanity. It is the only way we have to transcend the mundane in life. In India for example, rituals help you to cry but they also dignify. In the cremation *gaths* in Lucknow, along with all the pain, the rituals were there to help people live their lives with dignity. I don't know if I'm right but it's what I believe. Perhaps I've been marked by my religious education. When I was a girls, in order to get away from my family, I went to a convent to act. There was an atmosphere there filled with disguises one can find years later in my work: the transvestites, the figure of death, the two faces of Janus. I don't pretend to mythologize indigenous peoples like many people believe I do, but what I love about them is their way of mythologizing the mundane. Maybe, when you come down to it, photography serves as a ritual for me. To head out with a camera, to observe, to make pictures of the most mythological sides of man, to enter into darkness, to reveal, to choose the symbolic is part of that. I don't believe in anything, but I seek the rituals of religion, the heroes of religion, the gods. In India, once, I went into a temple where people were praying to a silver serpent. I don't know what the rite signified but I was

astounded by the cave where it took place in which only a thin sliver of light filtered in. Even in everyday life, in the world of Brassaï, for example, it is a ritual to go to a bordello, or just in the relationship between a prostitute and her client.

FB: Lastly, what are the photographs you most hate?

GI: The ones taken without any talent.

Graciela Iturbide was born in Mexico City in 1942. She studied film at the Centro Universitario de Estudios Cinematográficos of the UAM, where she apprenticed with her photography professor, Manuel Álvarez Bravo. In 1979, Iturbide began her project on the culture of the Zapoteca Indians of the Juchitán—the women, in particular—for which she was granted the Eugene Smith Award in 1987. Her work, in which she molds interest for the traditional culture with a contemporary and revealing expression of the symbolic power of the images, has earned enormous recognition, both in Mexico and internationally. Iturbide received the Guggenheim Grant in 1998, the Grand International Award of Hokkaido, Japan in 1990, and the award for Rencontres Photographiques in Arles in 1991. She has exhibited, on numerous occasions, in large international centers such as the Centre Georges Pompidou (1982), the Philadelpia Museum of Modern Art (1988), and the Museo San Ildefonso in Mexico (2002). She is considered one of the great photographers of Latin America.

Fabienne Bradu was born in France in the year 1954, and lived in Mexico until 1979. She is a writer, critic, and translator. A doctor of Romance-language literature at the Sorbonne University in Paris, she is currently a literary researcher at the Universidad Nacional Autónoma in Mexico. She has written literary criticism for various Mexican and foreign cultural publications, and was a member of the editorial board of the magazine *Vuelta*, directed by Octavio Paz. She is a French translator for poets Gonzalo Rojas, María Baranda, Fabio Morábito, and Pablo de Rokha. Some of her books include: *Señas particulares: escritora* (1987), *André Breton en México* (1995), *Benjamin Péret y México* (1998), *Las vergüenzas vitalicias* (1999), and *Otras Sílabas Sobre Gonzalo Rojas* (2002). Her first novel, *El Amante Japonés*, was published in 2002.

SELECTED BIBLIOGRAPHY

Individual Books

Austin, Alfredo López, and Roberto Tejada. *Images of the Spirit*. New York: Aperture, 1997.

Barjau, Luis. *Los que viven en la arena*. Mexico City: Instituto Nacional Indigenista, 1981.

Billeter, Erika, and Verónica Volkow. *Fiesta Und Ritual*. Bern: Benteli Werd Verlag, 1994.

Medina, Cuauhtémoc. *Graciela Iturbide*. London: Phaidon, 2001.

Monsiváis, Carlos. *La Forma y la Memoria*. Monterrey: Museo Marco Monterrey, 1996.

Poniatowska, Elena. *Juchitán de las mujeres*. Mexico City: Ediciones Toledo, 1989.

Rivas, José Luis, and Bruce Wagner. *Pájaros*. Santa Fe: Twin Palms, 2002.

Sánchez, Osvaldo. *En el nombre del padre*. Mexico City: Ediciones Toledo, 1993.

Volkow, Verónica. *Sueños de papel*. Mexico City: Fondo de Cultura Económica, collection Río de Luz, 1985.

Collections

Carrière, Jean Claude, and Natalia Gil Torner. *India-México*. Mexico City: DGE, 2002. Also, Madrid: Turner Publicaciones, 2002.

Mettner, Martina, and Jayne Anne Phillips. *In Their Mother's Eyes: Woman Photographers and their Children*. Zurich and New York: Stemmle, 2001.

MAX PAM

speaks with Pablo Ortiz Monasterio

Max Pam: I'm going to speak clearly, as clearly as I can.

Pablo Ortiz: That's very good. Max, how did you get started with photography? When did you begin? Why?

MP: You could say I began when I left Australia.

POM: So this was when, 1970-something?

MP: 1970. Yeah. Along the way I went overland, via the hippie trail into Katmandu, and that changed me forever. When I arrived at Katmandu I was nineteen years old, like a sponge. I'd always felt that something was missing in my life and realized, as soon as I got to Asia, that *that* was the big missing piece. That realization fueled twenty years of travel and photography. I mean, it was *that* fundamental. So it was a lucky thing I had this photographic skill, and could pair it with this love. You know. So if you take some photographic ability and some understanding of how to make visual language (it was pretty basic when I was nineteen) and you put it in bed with some passion for something, well, you can get a good result, eventually.

POM: Two things come to mind. People very often say that the first time they see the process of printing photographs, when suddenly the image appears in the liquids, that's a key element in their attraction for their decision to do photography. You were the blind man in that darkroom. Did that happen to you?

MP: I know exactly what you mean. You're talking about me losing my virginity, right? Well, that didn't happen until art school in London, when I'd changed—I'd got rid of my Pentax Spotmatic because I wanted to be Edward Weston. My teacher was a woman called Roslyn Banish who had studied under Aaron Siskind at the Chicago Institute of Design, and I was really privileged to have this woman teaching me at art school at London. She was an American, a young woman and she gave me the *Mexican Day Books* of Edward Weston and just blew me away with this work. The fact that you could be this fabulous visual artist, with all this milieu of people like Diego Rivera, and you could sleep with these gorgeous, amazing women, that you could live that life—that photography could deliver you that life. So, I asked my father to give me some money to buy a Hasselblad. He was very obliging, I bought a second-hand model then, and I went to Paris in April of 1970, and it was for me the great cathartic moment. I came back with about ten rolls of 120 film that I'd shot à la Edward Weston and it was then when I was developing, when I was in the darkroom—that I had *exactly* the experience you described: the print was in the dish, it was about a 12 x 15 [about a 20 x 30 centimeter] print, and it was an image of the girl I was sleeping with in Paris. Beautiful—Georgina. She comes up in the dish and *that's* when I lose my virginity. I saw it float up—bang!—I knew I'd arrived. I knew that 6 x 6 was the format for me, I knew I could photograph like Edward Weston, I knew I had an infinite set of possibilities of photography—in that moment.

POM: You were interested in Weston (obviously, you just said it) because of his life, the kind of life you can have by being a photographer, surrounded by interesting people. An existential life, you called it. But were you also influenced by his specific work, the work he did, the way he changed? Because Weston's Mexico pictures were different, a departure from his older work. There he turned back to photography-photography: very sharp, very detailed, focusing on the beauty of objects, modernity, all these elements. Were you shocked by what he said and wrote—and was that the important element, or was it more? Because I don't see that trend in your work—I don't see in your work the work that he developed in Mexico in the twenties.

MP: It was that modernity of his work, yes, absolutely. The existential life seemed very attractive as well, but it was the product. It was this notion of shooting f22, full sun, you know that formula? I loved that, that was big for me, it just hit me hard and, yes—there is not much of Edward Weston left in my work. Simplified, he broke down the elements of photography. He got rid of the complexity of the pictorialist stuff. He broke it down into some very clear elements and for a photographic student at that time who's young and evolving fast, it was good to have a really very clear idea of making pictures.

POM: This is a key element in modernism after all: to see all we are looking at, but from a new vantage. So *were* you interested in that? *Are* you interested in that? To show reality from a new point of view?

MP: No, I don't think at any stage I felt like I was reinventing the wheel photographically. If you look at my production in the last thirty years, I'm not changing the way we make visual language. I'm not that kind of person. What I'm doing is using photo-

graphy as a tool for reexplaining life back to myself because I'm a visually driven person. That's what it's about for me. There's no ideology at work, belief that I would alter the way we see things, like, for instance, Diane Arbus did. She changed the way we create visual language; she's *that* significant.

POM: Why do you think *she* changed?

MP: She was playing in the same ballpark as Weston but much later. I mean, she was using the human element of the people we ignore, the things we ignore because we don't want to confront them. Weston is a modern master of photography, and Arbus is as well. Weston took (as you suggested) commonplace things like a toilet or a capsicum and redefined it, and re-represented it to us. Arbus took damaged goods, damaged people, and re-represented them as something there, constantly, in our gaze. I would say I'm on the Arbus side of the divide of the creative borderline, because I'm interested in the human condition more than objects. In 1970 I saw a Bill Brandt exhibition at the Hayward Gallery in London. Again, this is a guy who not only reinvented the wheel photographically, but put wings on it. The issue, for me, at that time was to be as good as I could get in doing what I wanted to do. It was my main purpose in life, I'd discovered after the first year of art school. Therefore I didn't complete school, instead I left for some travel. To travel was my first interest. Photography was a passenger. Photography was a camp follower. Photography was what you did to memorialize the spirit of travel. So that was it, always: first the journey, then the photographs. If photography got between me and enjoying my journey I'd put the camera away. And so I think that when you look at the body of my work it's good solid photography, but it's not redefining the way we look at stuff. In a sense it's a little different because I'm using it as a reportage tool, borrowing visual language from fine art and mixing it with the language of photojournalism.

POM: If traveling was the main goal of enriching your life, giving you elements to then photograph, did you change the way you shot by using the camera that you bought immediately after your arrival in England, at college? I have the impression that, especially in this, you followed Diane Arbus's style, and her defining area, that is, portraiture. By letting people see your face, not covering it with the camera, the act of shooting is rendered passive. That definitely changes the way people behave. Were you aware of that when you started using that camera, or was it just that physically it felt better? Or was it the quality, larger negatives, or the square format, which for some people is just comfortable, or was it a combination of all of them?

MP: Yes, it was just what you've said: a combination of all these elements. You pick up the camera and know this is the camera you're meant to have. There's no intellectual thing, you know, no conscious modernist or post-structuralist rationale behind it. You pick up the camera, it fits, it's waist-level, you can compose; it just feels right, you know. It was only afterwards, after quite a few years I realized that a lot of photojournalist friends ran around with a mask in front of their faces with their cameras, and came to recognize the machine supplies the aggression of the photojournalist working that way, the often unnecessary separation, because what they're photographing is unpleasantness, right? I mean, I'm walking down the street in Calcutta, it's about eye

contact, it's about a silent agreement. I look at somebody, I smile, I like what they're doing. They look at me. I'm different, they're different, it's a collaboration. We don't say a word but it's a collaboration. I've got the camera, I'm ready, they're ready, we play our game, we play our role, and there's this lovely exchange and you can do it with a waist-level finder, you're not hiding behind anything, and so it goes. I think it's very perceptive of you, those words you used. You must have used a waist-level finder and felt that, yeah?

POM: I have and I did.

MP: Yeah, for me it was an invitation to that existential life that was first revealed to me through Weston's voyage south of the border, to the "Other," a trip to another culture, a culture where things could be different, and you could be different. When I went back to India after I'd been to art school, and been through my catharsis with photography, and saw myself as a visual artist—it was the existential life I was after because we're talking again early seventies, we're talking about the legacy of Allen Ginsberg's Indian Journals. This guy, you know, made his trip in the early sixties, and in the journals he's writing poetry, he's taking drugs, he's sleeping with his boyfriend; it's a cruisy exis- tence. It was fashionable to do it then, it was about the hero's journey and it was very attractive. It was really like a big call, to keep doing that, to keep on that groove and enjoy that lifestyle. All you had to do was have some little bit of money in your pocket and you didn't have to report to anybody. And so I hitchhiked from London to New Delhi and just standing by the road.

POM: What do you mean, you hitchhiked? You literally hitchhiked ten thousand miles?

MP: Yeah, I hitchhiked.

POM: What year was this?

MP: 1971. September, October of '71.

POM: How long did it take you?

MP: I think it was about two months. I had a lot of lifts as far as Greece—no, as far as the Yugoslavian border. Then a bunch of hippies picked me up in a purple transit van, and the first thing they offered me when I got into the van with them (they were going to India, too) was LSD. So I got in, I'm in the car five minutes and I'm tripping. We drove through Yugoslavia, and just that trip we had a lot of adventures. But at Thessalonica they decided they were going down to Athens to sell LSD to finance the rest of the trip, because these people were dealers, drug-taking athletes. So I left them in Thessalonica because I wanted to go to India, and I didn't want to go play games with the Greek police. And so I hitchhiked again on the road to Istanbul, out of Thessalonica, and again I get picked up by an even bigger bus of hippies, but this bus is going all the way. And so I arrived in Afghanistan during Ramadan, just before the last Indo-Pakistan war—1971. There was a huge buildup of tanks on both borders. Ramadan in Afghanistan was something! There was still a king in Afghanistan and there was still a

shah in Iran. It was a different world, it was a very different world. Actually, you know, it was falling: the temple was falling down behind me as I went east. I got across the border from Pakistan into India two days before war broke out, and the world changed after that. But that was what I wanted. I wanted India, I wanted to go back there. I wanted to be Allen Ginsberg and Diane Arbus, I wanted to be a few things all at once. A very eclectic, esoteric kind of philosophy was driving me. This very famous Bengali poet called Rabindranath Tagore wrote romantic poetry, and his book was my guide to India. Not *Lonely Planet*, because it didn't exist then. Rabindranath—the collected works of Rabindranath Tagore. That was my journey, and it came to a big end about six months later with a serious bout of typhoid fever in South India. That's where the hero's journey ended.

POM: The first journey, because that kept going on for years, didn't it?

MP: It did, but that was a defining journey, the second one. When I got back to Australia I was crushed it was *not* a hero who met his parents at the airport. It was a person who had to regroup.

POM: It was because of all this that you took existentialism to an extreme? But did you have many negatives to process? Did you capture all the memories? Was the product of that first enlightenment interesting? Did you produce work that at this distance you still find interesting?

MP: Yes, that period was great because when I look back on it now, I came back to a dark place for me. I didn't like Melbourne, I didn't like it as a kid, even. And I was back to Mum and Dad. I love Mum and Dad, but I could never go back home again. The trip to England and the existential life had ruined me for staying home with Mum and Dad, but I *had* to stay with Mum and Dad because I had no money and I had to recover. But I had my negatives, and I would slowly process them. I had no lab. I had to use the bathroom at home, which was inconvenient because we only had one bathroom. My parents didn't have an awful lot of money. It was difficult, I processed my work, I proofed it. Now, in Melbourne at that time there was not much happening photographically, but I took my work to the museum. The curator of prints and drawings and photographs looked at it and said: "Well, you know, really this work is quite basic, not very good. If you want to improve yourself photographically you should take a good look at *Camera* magazine." (*Camera* published then in Switzerland.) He said, "Look at that, get an education from that." And I said, "OK, thank you." At that time also there was a big photo competition organized by the museum, and first prize was a lot of money, so you can imagine the competition! The advertising was all David Hamilton soft focus pedophilic pictures. So I took my best Indian pictures, I put them in the competition, but they didn't even get to be hung, were not even hung on the wall! They called and said, "Your pictures are here, come and get them." I went to the gallery, I picked up my pictures, I looked at the other photos that had been chosen. And I thought, "What's wrong with *me*? Do I smell bad?" Before I left the gallery I went into the downstairs area where they show prints and drawings. There was a whole series of Goya aquatints on bullfighting. I was stunned by his work. You know the work, right? Absolutely stunning. I thought, "Fuck it, I'm going to give up photography," because *A*, nothing's happening for me. I

began to believe that I had no talent. After art school where people thought, "Oh, this guy's fantastic, this guy's really happening," yeah? After being the best boy in school at photography, you know? And B, I saw that as a visual artist you could work in this print medium of painting, and here's Goya, one of the great practitioners in the history of the visual arts in the world, and I figured that maybe that's what I should do. Give it away, give photography away, choose some other visual art form. So I was committed to that course. I went home and the next thing I knew was I was working in a Toyota motor-car factory (a lot of bad things happening here, right?) Back in my house in the suburbs, I got a letter from my old photo teacher, the one who'd studied under Siskind, saying, "Max, I saw your photographs in *Creative Camera* last week and your picture's on the front cover!" Right? This is the *same* stuff I put in the competition. And that changed everything. I knew I had it right because at that time *Creative Camera* was like the Bible. I knew somebody loved me. And I also knew that it was always going to be tough for me in Australia. That was the defining moment. After that I could put up with any criticism from Melbourne, because, Jesus! I'd been published in *Creative Camera*! What do these guys know here? That was good timing.

POM: That seems to be a repetitive element in everybody's life. We have a saying in Spanish that you can never be crowned in your own country. This idea that they are really hard on you at home. Exactly the same thing happened to me: I was published on the cover of *Creative Camera*.

MP: No!!

POM: It was later—what was it—1975. Right after that I had a show with Plossu and I was in Mexico, desperate because I couldn't get a job, nobody liked my pictures and I was depressed. It was difficult. I had spent some time in London and met with people, Pete Towne saw my work and thought it was fantastic and said he'd do it. Actually Pete was the one who did publish my work, but you know, that is a pattern that happens over and over again: to be recognized in your own country takes some time and, especially once you're recognized somewhere else, then people tend to think, "Wow! He must be terrific!"

MP: For real!

POM: For real. But then, that recognition comes with resentment, "OK, we'll take it," but in a peculiar way. But, listen, Max, what I want you to talk about is how much of that work, from the very first trip to India, got into this book that you published well after *Going East*. How much of the work of that first trip is in that book, how many other trips did you make, and how did you get to the point of getting together the first *Going East*?

MP: *Going East* is twenty years of work, that's the subtext of the book. So we're talking really from 1970 to 1990, that period, with a strong bias toward 1970. That book is really more about the seventies than the eighties. Because the eighties was a period where I didn't photograph an awful lot. I was incredibly productive in the seventies. There were peaks, there were two big peaks, actually, a big spike and then a flat period,

and then a big spike. And the two big spikes were this 1970—72 journey. It was Rabindranath Tagore, and Diane and Edward in the same bus with me. The next peak was 1977—78, after a long period of traveling in Asia and having another defining moment in Japan, about how to use a 6 x 6 camera. I'd sold my Hasselblad. At the time when people were saying, "Forget it," in Melbourne I figured, "Look, the only way that I'm going to be understood is if I use a rectangle, because everyone uses a rectangle; why do I need a square camera?" After a lot of traveling with my girlfriend in Southeast Asia—a beautiful trip, beautiful, an open-ended trip with the love of my life—we arrived in Japan, this strange culture, in 1976, midwinter. One day in a book-shop in Kobe—they have great bookshops in Japan, and books on photography that you never see anywhere else in the world because it's a Jap culture and they don't care about the rest of the world too much. So I see this book: *People of Benaras* by Tadayuki Kawabito. It's an unbelievable moment for me because what he's saying is this is how to photo-graph India, square format, full, classic, fifties flash-photography visual language. And it was a great designed book with full bleed pictures, a picture of the baby Krishna on the cover, light years ahead of his time in a sense. This one book, that was it. I went straight to the camera store and bought a square camera, a Japanese version of a Hasselblad. We headed back to India. I figured now I had the idea and I had the equip-ment. It took me back to my roots of the early seventies. And so in *Going East*, a lot of that production is about 1971—72, and 1977—78. And some pictures from the eighties, but that was, for me, a period of living in Asia, a period of playing with other formats, a period of playing with being a photojournalist. And really a very easy life for me through the eighties. You know, my wife's a doctor, so I was a kept man, we had a big house by the South China Sea in Borneo, we lived in a coconut palm forest. I would spend a lot of time drinking Bacardi and green coconut water with my Indian buddy next door in the palm trees. My wife became pregnant and we had our first child. It was a beautiful existence, really–it was free. I had no pressure. I was in Asia, I had a great Asian community of Chinese, Indian, Malay people, I could speak the local language, which is Indo-Malay, a dialect of Indonesian. And life was very good, and life was adventurous. I'd invent little photojournalistic jobs to keep me occupied. I'd go off to make a boat voyage through the Philippines, do magazine stories on Manila nightlife, which was entirely enjoyable, a chance for me to indulge in every sexual fantasy I'd ever had. But then after my wife became pregnant I needed to stay at home more and so I traveled less. The arrival of my daughter Eko in 1981 was the end of an epoch for me, the door closed on long open-ended journeys, and opened on sharper engagements with Asia. And you can see it, it's kind of massaged through the book a bit. But the book is more monolithically about those long open-ended journeys. That's why *Going East* is a particular kind of book. And even the design of the book is an homage to the design of those French photobooks of the fifties. I modeled the design of *Going East* on those books.

POM: Did you do the design of the book? Did you do the picture editing? Was your maquette changed along the way, or was it close to what we see now published? Tell us the story of that.

MP: The publisher took the maquette completely as it was. It wasn't a great maquette, it was just made on a twenty-cent photocopy machine. But I was lucky inasmuch as

the thing that has privileged my career as a photographer has been friendships, and always friendships. Without my friends I would never have gotten anywhere. And there's no bigger friend in this sense than someone like Bernard Plossu, a great French photographer with an incredibly generous spirit in terms of helping his friends in photography. So he cleared the way with Marval in Paris for me.

POM: Marval is the publisher?

MP: It's the publishing house. But the guy who owns that publishing house is Yves-Marie Marchand. And Bernard had the ear of, as we say in English, Yves-Marie, and said: "There's this great photographer, you've got to publish him!" Marval has a family printing works in Alesia. When I went to see him in Paris, he was ready. He said, "Sure, we're going to to do the book." And about a year and a half later it was there. And for me Marchand is like Jesus Christ for publishing my first book. I mean, what a feeling, what a moment! But it's also due to Bernard, on so many levels, for helping me like that, and for the discipline of sitting down and making a maquette. I still owe him a lot. I learned a lot from Bernard, you know. I met Bernard when Bernard saw my pictures in *Creative Camera* in '73. He wrote to me in Australia, said, "Hey, I love your work, let's exchange pictures!"

Bernard showed me how to deal with the photographic community. I just watched him and I learned everything from him; he's like a big brother. I went to Paris the first time, I met him in '77. His Tunisian girlfriend met me at a bus stop, and said, "Hi, I'm taking you to Bernard's place." What an introduction! He lives in this beautiful house, he introduces me to his milieu of friends, who are all fascinating. I couldn't have had a better introduction to the whole privileging system of photography that exists in France. That was a great period for me. He looked at my proof sheets, he picked out what was strong in my work consistently, and believe me, at that time, I didn't know how to read that stuff. But he had this marvelous, mature, eclectic taste in photography and in visual art, right across the board. I'm a good sponge, you know; I see people and I say, "Yeah, I want to be like that guy." I want to be Bernard Plossu, but never in a competitive sense, just to follow as he shows me the way. Anyway, that's how it works for me, photography. Friendships.

POM: I know Plossu well and I've heard him talk about you a lot. Yes, he has this intense beautiful sense of friendship. But also he's very acute visually and very "*exigente*," as the French say—demanding. He only wants the best. I know that your friendship has grown a lot. But I am also conscious that he has all these other friends, that he's great friends with many people, and helps them, but not necessarily feels the admiration for their work that he feels for yours. So in a sense there is a great affinity and you have grown into your mutual friendship. But the admiration that he has for your work is in a way different from this. There are affinities, places where you almost touch but then go very far apart, that is very enriching for him. I am sure that through the years he has also learned a lot by looking at you. Bernard also wants to be like Max Pam. That's how things grow, you know, friendships can hardly grow if you don't give back. So obviously I see Bernard helping you in this book that is printed in France. What happened with that book? What responses did you get? Did your life change because

you suddenly had this book that has become a classic?

MP: Yes, my life changed. So in 1992 the book is there. We were living in England at the time because my wife had got a job with the Wellcome Trust, working on a big tropical medicine project. She's a pediatrician who specializes in tropical disease. And at that time the book had been released, the exhibition at FNAC was also happening, and the result was, for me, I'd got an invitation to join Magnum. François Hebel had given me a big exhibition in Arles, in 1986, and really that was also a big moment for me. It was my first big show, more or less, and Arles, well, it was brilliant, it was all that's good about France and French photography, and it was a festival. So by the early nineties I got this invitation to join Magnum, with Hebel, and it was on the strength, not so much of *Going East*, because it hadn't quite come out then, but there were a lot of good things happening for me and when *Going East* came it just solidified everything. I didn't join Magnum because I was living in London and Hebel said: "Go to the London office because you'll be working with these guys." It was pissing with rain in London, and I'm taking my portfolio case in the office, and you feel kind of naked always in this situation—it doesn't matter if you're a student or you've shown your work. So I walk into the office, and it's like the office of the *Daily Planet* newspaper, you know, computers, people with beepers on their belts, and I'm thinking: "Ooh! This is kind of different," right? "I don't know much about this!" And two guys come to me and start talking with me. The guy who's the bureau head, I don't know who he is, I forgot his name, and Chris Steele-Perkins. So, we sit down at the table, Perkins cracks open the portfolio, and he's flicking through the portfolio, flicking, flicking, flicking, flicking, and it takes five minutes. It's twenty years of my work and he takes five minutes. He closes the box, and he said, "Well." This is Chris, right? I don't know Chris Steele-Perkins, that's how I met him. He said, "It's not about anything." Okay, so I'm thinking: "You can't defend your work, you can't do that!" Right?

POM: There is no point?

MP: Right. So all I said was, "Yeah, it's not about anything. End of story." And he said, "Let me tell you the other thing is—you have to bring clients to this organization." And I'm thinking: "Fuck! I've never had a client in my life!" So I say, "Look, Mr. Steele-Perkins, I don't have any clients." So it was kind of inconclusive. It was one thing for François to say, go work with these guys. It was another thing entirely for them to say, "Welcome to the club, baby." Clearly I couldn't work with these people, forget it, I'm not interested. There's this problem that Australians have with the English anyway. I'm not saying England's not a great place. I was invited to join Métis at the same time in Paris. I went with Métis, and Bernard, *again*, opened the doors for because at the time he was represented by Métis—and still is, I believe. So I went with Métis, a new agency, nice people, groovy city, Paris in the early nineties was just fantastic—it still is. So that was a great period for me. I got lots of interesting work, I did a lot of work for *Liberation* in England, they sent me on projects. Things came up with going, with working for the project in Pakistan, and every second month I was in Paris, and it was a beautiful thing for me. Of course it was the perfect choice. To work in London with Magnum would have been a nightmare. So it was a great and productive period for me. For the first time in my life I was actually working as a photojournalist and people wanted me

for the style of work I did, not because I did a photograph this way for this magazine. I got a lot of pictures out of that, which normally I wouldn't really have engaged with, but because the magazine said they wanted a picture of homeless kids in London I could go and do that, and work that way. It was really a fertile period.

POM: I wanted to ask you if you could talk a little bit about how you put a book together. Maybe we can talk specifically about *Going East*. How do you decide which picture should go with the others? Is there any overriding logic, any pattern that you went through? Is it formal, it is thematic? Did you organize it in terms of going with this idea of geography, like a trip? What, for you, is the art of putting together pictures in a book?

MP: Every book is different for me, and shows a different purpose. In this case it's like editing a movie. The editing style, ergo the movie style, is going to be different. You're not going to repeat… you're not going to stay with the same book over and over again if you want to do something different. With *Going East* the question was, which way to do it? I think I cracked the code by making it an eight-chapter work, a series of sub-texts within my big concern for Asia. The book opens with pictures of that journey to Asia: Afghanistan, Syria, Iraq. And then it moves on to an experience in New Delhi with these observatories that were built by Maharaja Jasingh in the seventeenth century, unbelievable structures in a small park. I was always drawn to this park, every afternoon. I set a discipline for myself to return every afternoon and take photographs like Edward Weston: f22, full sun, big set squares, big circles. I would smoke a joint with some hippies on the grass, then go do some more pictures. Not too much smoking because it affects your credibility as a photographer. So that's a chapter of work. Then, my other concerns with India were to spend time in the Himalayas, and with the people at the Himalayas. A lot of the thing fuelling these journeys in Asia was also, not necessarily a complete sense of the existential, but the big notion of being romantic as well, and the romanticism of travel. I'm drawn to Rajastan, to the desert, the camels, the guys with turned-up slippers, the cities straight out of 1001 *Nights*. So the Himalayas, a chapter on that, and then my sex life in Asia, which for me is an entirely enjoyable part of my life. That time I spent with female Asian sex-workers is a period I look back on with a lot of delight because they were such fun to be with, and it got me closer to Asia, so there's a chapter on that. Then the book more or less revolves around two big cities: Bangkok and Manila. Then there's a section about just traveling in Southeast Asia– king of cruisiness, and last, a section on China, which is a very different set of geopolitical elements presenting an entirely different trip to you.

POM: Could you say something about how you look to get a picture? Is it thematic? Is it because they work well, or that they have to look well? Because actually, the putting together of a book turns on this idea, you know, that you begin with two pages, and there you can sort many little pictures, or two big ones or one double page or so on with the multitude of choices. You have, for that specific book, why are those pictures together? What was the emphasis, or was it always that, you know, to construct the whole chapter it needed to be like that, or do you think you constructed it as pairs or as groups to put in two pages? Where did you learn that? Why didn't you go to an editor to do the book? Because that's something photographers face all the time. Take

a huge body of work that they've seen over and over again and suddenly have to reduce it and make it into a *mise en page*, as they say in French: put it into pages. It's a very primitive, thick object, that visual language that you're using and recycle this thing, the book, because it was invented basically for text and a few images. Although there've been illustrated books for many years it's only since, I guess, the fifties, that there was a whole revolution of how to do visual books. We photographers want to have our books and to belong to this enormous trend of photographic books, this enormous richness, so how is it that you decided not to have an editor, to edit it yourself? What was the experience of your again looking at the pictures? I'm sure you had friends who looked at your dummy and commented. But I had the impression that it was you that finally did the work. This is very powerful when it works, very elegant.

MP: Yeah, you know, I honestly think that photographers have to do their own books. A lot of photographers present photographs through an editor and say, "Please make some sense of it." That's a cop-out. You've got to get the body of your work and see who the driver is–it's very, you know, hard. But you need to spend time on it, you need to be printing your work. I do all my own work. I know I'm very offhand with my negatives, and I know where they're all located in my own little anarchy of filing systems, right? So, the discipline of a lot of photographers in Europe is to have a pro-fessional print your work, and then maybe to have a professional edit your work because it's not you. I'm a photographer, I'm not a printer. I want the best prints, so I give it to the people who really know what they're doing. And that's fine, but I think you really miss out in understanding exactly what you've got in your files. So I think printing your own work helps. Another issue is discovery—in this I learned a lot from Bernard. Because Bernard is always playing with pictures, you know: "Hey, Max, check this out!" This is a great double!" I've heard Bernard say that to me very often. The understanding he gave me was that a book is most often a whole series of double pages, just the symbiosis of one page talking to another. And then in the late eighties, I met a Dutch photographer, Machiel Botman. I don't know if you know this guy?

POM: No, I don't.

MP: Well, okay, you should meet him—he's great. And he introduced me to the whole book culture, the great books, the classic books, because he's also a book collector and a book dealer. He introduced me to Peter Beard's *End of the Game*. You can see that influ-ence in *Going East*, the way Peter Beard grids up his pages. I got that from Peter, the design of whose book is so way out in front, and so I thought: Okay, so I'm going to use that a little bit. So I took a bit from here and a bit from there, influence always referring to the history of photography. Whenever I'm looking for visual language, whenever I'm looking for a way through to design I look at my history of photography, and it's there, it's there in the past, it's in what's happened. So *Going East* was a mix of elements that made that book's design. But for instance in *Indian Ocean Journals*, I have to say that it's very much like this book called *Evidence*, where Avedon doesn't give a shit, you know, what page connects with what other page, he's just bouncing one image off another. And so I used the Avedon idea—Avedon's total disregard for a the-matic flow of pages—to lay out *Indian Ocean Journals*.

POM: I cannot agree with you that Avedon doesn't give a shit about what's next to what. Actually it's because he's so obsessed, because he works so much in magazines, in that book, Evidence. In Autobiography, a huge book, again he repeats things by contrasting things, you know? Theoretically two pictures that don't go together, but were very powerful, like Henry Kissinger next to the existential poet Allen Ginsberg and his boyfriend, naked, both of them: a close-up for a portrait, and then the other two, with naked bodies. What happens is explosive because of the contrast. That is the formula of his way of working and it's very powerful. It's not that he doesn't care—he cares a lot and he has this strategy. I think that his editing, his putting together of pictures is quite surprising and produces an extra strength and something new that is nothing that either of the two pictures—or the many pictures sometimes—that you see together have separately. I also see in your book that opposition is very surprising sometimes. When I saw your book first, I was walking in Paris, I had an appointment with Plossu, and I'd heard of his friend. This was right after the book came out. Plossu had sent me to see Marval. He insisted that they had needed to see my book—in person—well, you know Plossu. So I get there, I see this yellow book, Going East, that I hadn't seen. I didn't know your pictures. I saw it and looked at it and bought it immediately. I had this strong identification with it, among my own experience as a young traveler going to visit foreign places. As you said, the otherness we're faced with and the experience of belonging nowhere, offers the possibility of being more. In your city you're someone, you belong to a specific society, a caste, you were born to place, you have all these references that make you three-dimensional. In this situation one can be limited, but also all this drug culture that we were part of in the seventies and eighties carries this memory of images with movement, kind of blurred. It's completely documentary, completely straight documentary photography, but at the same time conveys how we felt about the range of dreaming it offered. What struck me about the style is how you describe this feeling of traveling, of tripping. Was that something you were conscious of when you were producing the book?

MP: No, not the tripping thing, although it does look kind of trippy. It's more an homage to nineteenth century photos, using real slow film and so everyone was working with a tripod, and you see these set-piece pictures. In Samuel Borne's work, for instance, there are some people standing still, some people a little bit blurry. Of course they would have been seen as failed images by Samuel Borne; he would have said, the blurry thing, that's not working for him. But in the twentieth century we got to see all the bad pictures too, which became fascinating pictures. You've got this energy of someone swapping from one foot to the other—because it's a five minute exposure and it's a little long—and another person being very conscious of the process and the need to stay still, so I wanted to play with that in a nineteenth century way. The third element here is the existential life, the romantic life but also the time machine life. And in India there is a time machine. I love the nineteenth century and the stuff of the nineteenth century, and you can go back to India. As you say, you're anonymous, you have no history there beyond that time. You're in a tenth-century city. It's still honest to a tenth century scenario. There are no cars there, just donkeys and camels in the narrow streets, not one modern building. It's a time machine. I wanted to respond to the time machine, I wanted my pictures to look like the nineteenth century. So I shot on color film stock, printed it in black and white, and I played with it, and it was a con-

scious playing with it. But it was not so much the trippiness of being there—although it's just trippy to be in India because it's so powerful and so different, and so much of the "Other," but more about great, it's the history that's telling me which way to jump, what to do, how to do it. I think I'm very sensitive to all that. I want to be a conscious part of my visual language.

POM: That's very interesting. We should also talk about education, but that would be like the third or fourth chapter. Finishing this idea of the books, you have so far published Indian Oceans, Going East, and Ethiopia. Are there any more books?

MP: Yes, there's a book published by Filigranes, you know, this small publisher in Brittany, on kids. There's a whole series of photographers on children and I was the first volume of that series and I think the second photographer was Shoyi Veda. I think there's four or five books now in that series. There's a book called Visual Instincts which is really my first book. We did a series for the ethnic TV station in Australia called SBS, which is a great station. They commissioned a six-part series on Australian photography, and one of the films was about me, and then there was a photo project on the aboriginal communities, and then four other photographers. So it's a book in six chapters that went with the series and that was marketed on TV. So you've got Indian Ocean Journals, you've got Going East, and then you've got a book that was published in the same year as Going East called Human Eye which was a catalog for an exhibition I had in Japan at the Nara Sogo Museum. They contacted me in London—I was living there then. It was a big show, I think two hundred pictures, and they said, "We want to do a catalog." And I said, "Well, how many pictures do you want for it?" And they said, "We want to put every photo in." And it was incredible, it was just incredible! So Human Eye is a book that has never been circulated, it was only ever sold out of the museum. I think they printed two thousand copies, and is quite rare. I mean, I've got a copy.

POM: Did you do that book? Did you edit it? How big is it? I mean, the size.

MP: You haven't seen it?

POM: No!

MP: Oh, okay. I think Chantal left a copy there, and I'll send on a copy when I get home.

POM: I'd love to have one.

MP: It's very different from Going East and it was published in the same year, but I'd gone through a revolution in book design by that stage and I was totally sold on full-bleed books and I was lucky I had a chance to just do it. And so I made a book maquette, took it to two hot young book designers in London, and they did the graphics for me. They work for RandomCentury[publishing]. So that's the fifth book and the sixth book. And then, what's the next one?

POM: Ethiopia.

MP: Exactly. Published in France by Les Imaginayres (Michel Paradinas).

POM: I've been reading it and I find that really great. It's very much like a diary. How was that book put together? How could you write and have the picture that you're writing about? Did you do it as you traveled?

MP: What happens is that these days when I go on a journey, I'll do a journal, a hand-made journal because I love that. That's more about the loneliness of travel and con-fronting it than anything else. It's a little thing that when you live with a family as closely as I live with my wife and children, and you go away on a short trip, you do it. To travel alone was the air that I breathed for a lot of my youth, and then it stopped for a long time. One moment I'm living with my wife and kids in Perth, the next minute I'm in Addis Ababa in Ethiopia, and it's a laugh. It's night, you're in a hotel room, you're by yourself. It's lonely. So I get my little book, my little dummy, and I write about what happened to me during the day. The pictures are all visual autobiography, anyway. Something happens to me while I'm designing the book in my head. I'm going to put a block of text here, and I write it down, and I know the picture that is going to go here…and so the whole book is about placing the text, right through from Day one to—in that case—Day twenty-eight. So the flow of the book is immediate. One day after another and the pictures are added later, after I've been to the darkroom at home. So in a sense there is a real immediacy, a freshness of the book about travel that already existed, because it made the whole journey with me, and the pictures traveled in my head. That's the only difference.

POM: But then, we were talking about the pulling together of pictures and doing the book and the logistics of the mise-en-page, so here you do that—I'm surprised and I find that very interesting. Because, okay, yes, you've taken the pictures that day, you leave a space for it, and then the next day something different happens, and it's already quite difficult to imagine how the pictures going to look: are you really going to like it and find that it's true to the moment you lived, what you expressed? Because maybe it doesn't happen to you but it does to me—sometimes things just don't go well or some-thing changes. So it's really strange to leave the spaces with writing that you actually did in the place and that you imagined. Then there is also this thing: that you have a picture that you haven't seen next to another you haven't seen either and it's only the texts that relate. They are there, they are rather open—several pictures can go there. The idea is a reflection on putting together. It's not a diary, so what do you call it?

MP: A journal.

POM: A journal, that is at the same time a photobook. And in this book there is a com-bination also, not only of strange pictures together—some of them could meld very well, they are designed to be born already and working very properly—but some of the others are really in very big contrast. Even to the point of using images that you got from here and that you reproduce next to the photographs, changing and playing with the tones of the black and white prints, some in sepia, and some bluish. An eclectic kind of editing, some blue with straight black and white. Tell us about it. What do you think? How do you feel about that?

MP: When I got home I was excited about this book and I wanted to play with the monochrome tonality of sepia and blue and black and white. I want it to look different, you know, each journal I want to have some design element in it that is just significant and unique to that journal. This was the game I played with the printing of Ethiopia. It's a nice little game, you know, where you set yourself a printing agenda and you're like a chemist, you mix a certain potion. Or you're like a barman who's mixing a certain kind of cocktail and you figure, "Well, I'll put a little bit of this and a little bit of that and make it somehow different." I like that game. You can play it if you have the opportunity to make books, and we can all make our own books because it's not a mysterious process or technique. But you actually have to sit down and do it. I was kind of excited about the design possibilities of the book. As for the flow of pictures you can just use the system of the flow of images. And you think, "Well, you know, if the writing's there, in the end the image can go there and if it looks out of place, well, it can look finally out of place, it's a journal, and probably the main concern is that the text and images should reflect the flow of the journey. With Ethiopia, it was a very intense journey for me, and a fairly somber one that reflected the recent history of Ethiopia, and also, was simpatico with the people. They're not exuberant, they're kind of sad people, and I'd pick up on that. I kind of couldn't fly at the same altitude as they're flying, which is asking a lot, really. But it's not reflected so much in the pictures. It is reflected in the text, and again, I think that's where a journal can be wonderful because it can show in text a more layered experience.

POM: Have you made any other projects that are not about traveling? Photographic projects, I mean. Because I know that you have a very complicated, wonderful family life. Could you talk about that?

MP: Sure.

POM: Have you ever created any photographic projects that did not involve the actual going or getting to places?

MP: Yes, in 1988 some colleagues and I did a six-part series on Australia at the university. Nothing had ever been done before that, and, of course, nothing's been done since, because it's complicated and expensive. But we got a lot of support from the SBS network in Australia, as I said, a really great, great TV network. Government funded. That project was new for me. It was about working in film, it was about working with a film crew—but a film crew that was totally sensitive to photography. I have worked on projects with friends of mine, done book maquettes for them. A French photographer named Philippe Salaun—I went through all his proofs and did a maquette for him, and I am still confident that this will be published and take its place in the ranks of fine books because I believe in Philippe as a photographer and a friend. And with my students, I put in a lot of energy because I need to be a good teacher, otherwise, what are you doing it for? Every year—because I'm in charge of the final-year students— we have a graduate show, and we make that graduate show as big an occasion as possible because it's really their passing out. It's a chance to see their work deified inside a gallery, and the university puts a lot of funding into it, so it's a nice project as well. And it's a chance I have to give some service and to put something back into photography.

That's how I look at my teaching, I suppose, that whatever I have from photography I can reinvest in all of that process and maybe try and help somebody else. So these are the kind of projects that we do. They're still about photography, ultimately. But not necessarily about me.

POM: I've heard you teach and I know you're very eloquent and you can go deep into things. This is an opportunity to hear your voice, you know. What is it photographers need to learn first, or in whatever order you want, what is it photographers need to learn, from your point of view? I would also like to hear what it is you think teachers have to know about this relationship of learning to teaching?

MP: I have no explanation for that. I mean, let's talk about your Mexico book. You were explaining to me just a little while back, that the thing about Mexico City is you're walking down the street, you know the city, part of your cellular structure almost, and you turn a corner, and you get given a gift. A visual gift.

POM: Can it be taught?

MP: No, I think you can prepare the groundwork for it but in the end you have it—or not. My students come to me, and they're frustrated. I have students who love this medium, yet they never get a good mark, it's always average. They try, they bang their head against a brick wall, and they come to me and say, "Look, you know, this is my last unit, it's not happening for me and I want it, I want it badly." So I tell them, finally, "You've got a six week break: Spend two hours a day out on the street, walking and photographing. It's your discipline to go out every day. You walk and you photograph. And over a six week period, five days a week, two hours a day, that's going to give you a big enough body of work to actually squeeze twenty-five strong pictures out of it." Because that's what they've got to do. The next class they then give me twenty-five pictures. The subjects you work with are...the human condition, OK? That's all I'm asking for, for the walk: it's about architecture, it's about people, and it's about what we eat. And I say, "You can have a portrait of your boyfriend on one page and a cheeseburger on the other and it can be magnificent." And I tell them, "That's the way you work, you work with the human condition, but you do it for two hours a day, five days a week; I'm not even asking seven days a week. I can think of no other formula for making it work. Because, in the end, it's also about time in the field. When I think about my own experience as a photographer, because I fell so deeply in love with Asia, I would spend six months in the field, and I'd be out every day. If it's about anything, photography, it's about spending time. If you're not prepared to spend two days— sorry. Two hours a day for five days a week out there, then you might as well give it up, because you're actually not doing it. I think about my life now and I mean, what do I do? Ninety-nine percent of the time I'm not a photographer. I'm a teacher at university, I'm a commuter on the bus or train, reading. For one month of the year I'm totally a photographer. I'm a father. But the point is, all of that stuff that I've been doing becomes part of the material that I'm producing in the field now, where, on the other hand, just about everything I do is going into some kind of image bank in my head. There's a lot of different ways to make the soufflé rise, but, you know, in the end it has to be time in the field.

POM: Max is, very kindly, dedicating his book, Ethiopia, to me, with a pen I have just given him as a present. This is a very enchanting moment, in the shade of a lovely park in Madrid, a city foreign for both of us, and we're not far away from where Max is showing his wonderful exhibition, and this place is called—

MP: Reel Hardeen Boutahnikowe.

POM: [corrects the pronunciation] Real Jardín Botánico, which has a very long history, and it's really a wonderful moment.

MP: And the pavilion is by the guy—the architect—who designed the Prado!

POM: So, it has a lot of history, and you can definitively feel it in the enormous trees. You know, this park was abandoned during and right after the Civil War—so for many years it was closed.

MP: Like a jungle.

POM: Like a jungle. The trees did not die, but all these beautiful flowers did. Then they recovered it. Max, I've been—like you—photographing for very many years. Because the way my country is, Mexico, I've had to do some other kind of work to survive, and not only to survive, but to be a father, to be a commuter, to be a traveler, to go to festivals, to do all sorts of things. That has given me a point of view certainly. So my question to you is, how do you improve your photography? We have acquired the elements to understand new techniques. Although there are all these electronics—these computers and devices are completely new—we have the eye of understanding that means maybe someone will have to operate it, but I know what to ask him and I know where I'm going, so in terms of the image and the quality and the production I have the tools to control. What you photograph of the human condition helps you to become a better photographer, to go deeper in whatever direction you want. Instead of reading about techniques and things, I have the impression, by looking at my friends and by understanding what I like the most, and that I can look and see who did them instead. They are wonderful people. People have ethics, have this moral standing, have these political points of view which—I'm sure they were already very good—but they have grown. They have become better, in the sense that they are doing and behaving in the way they think they should. So, you know, my question is, can this be taught? I mean, I learned that, I wasn't naturally that. When I learned this, instead of looking at more photographs, I started searching for people and for situations I thought were going to influence me, were going to give me tools to be a better photographer. So instead of going to lots of shows, I would instead go with two or three friends to the desert every year, and go with no camera and walk and walk and walk and walk. And then after that, spend money and visit my friend and have this kind of bittersweet situation. He would comment on my photographs, and would comment on other things that I was searching for, like how to be a better person, to relate to the human condition. Now perhaps I have something to say, like a cable, a conductive wire. Now I can send. You're good at it, you just give it the shape that is needed to be presented over there. So, with your work—and this is going to be a compliment but I deeply

believe it (and now that I know you personally I am more convinced)—you have a quality of transmitting things that are honest and direct but also intelligent and humorous. You have the ability to see the "Otherness".

MP: I'm a lucky person. You could go through your whole life with this unbelievable, unrealized skill that's your birthright. A flower that never opens, that never got warm enough to see the whole thing, you know, the true potential. It's the human condition, I know. Some people are born to be, for instance, serial brilliant lovers. They somehow connect to the soul of a female and can do it brilliantly and beautifully and positively. I read about it in literature because literature deals with these nuances better than photography. Photography's about the surface, what's happening at the top of the sea. Literature's about all the stuff below. And literature can explore those talents, those propensities we have, some of which people will say are weird, some of which are obvious and you can plug them into a sort of Monopoly game we play in the city, some of which are absolutely useless but you're great at. It could be you have this incredible ability to win at cards all the time. There's no intellectual, rational, linear reason why you should be good at it, but you are, you just have it, and that's why the human condition's so very interesting. Like the guy at lunchtime, okay? We were having lunch in a restaurant and a guy comes in. He's in his mid-sixties, and he's a pretty cruisy guy. His hair's slicked back, he's old, but that's not bothering him. He's very flashy, he's got a bunch of young chicks around him. The guy's sixty-five, right? And he's got six girls around him and they love him, okay? Maybe he's their boss, but if you've got a boss like that, hey! You know, more power to him! I just love to observe that. I just love to see it in people. I love to see that people would go to the trouble to put on gold cuff-links, to have a gold Rolex hanging around on their wrist, to put a certain hair oil on, and to offer it to all the women you meet. Open. Open-minded. And, you know, you see people who won't do any of those things and often they are spoken of or described as conservatives. They're not necessarily conservative people but they're people who have not had the chance to go under the surface and see what's worth playing with, you know, what's in the suitcase.

POM: You just said something that caught my attention. Do you really believe that literature goes deeper than describing the surface? Can photography go deep? Can photography reach the essence?

MP: I think that is true and it's particularly true in the case of pictures that give us pain. You know what happens when things go wrong in Asia. Ethnic cleansing is a big issue in Asia because you would consider Asia to be the most racist and most racially unsettled political region on the planet. People in Yugoslavia are amateurs compared to what goes on in Asia. I have a friend, Philip Blenkinsop, he lifts the cover of this horror story constantly and when I look at those pictures they give me physical pain. I can't look at his images, I can't scrutinize them closely—because they burn me. His book, *Extreme Asia*, is an example of photography going right under, diving deep. I think his pictures come back to our tribal roots, probably, like in New Guinea, putting on a feather head-dress to make you look good, or putting on body tattoos or paint. I can buy that formula; it makes a certain amount of sense to me, though it may seem banal. Only when you look at it, that could be a very happy hunting ground for a magazine like *Vogue* and

for people like Helmut Newton or Nan Goldin, for instance. When you're thinking about contemporary photography, think about the last three big things in contemporary photography: Nan Goldin is the last big thing in contemporary photography because of the impact she's had on global visual language. You look at it, it's everywhere. It is traceable to a line straight back to *Ballad of Sexual Dependency*—in 1981 and then going backwards you had Cindy Sherman. Cindy Sherman and that whole thing about fantasy. Go back a little further and you've got Robert Mapplethorpe, and with Robert Mapplethorpe you have this unbelievable influence of a guy whose photographic technique was utterly meticulous hooked up with a guy who wanted to privilege and deify and define his own sexuality. All three had their work ripped off by the utterly amoral and voracious fashion cartel. All three created work that dips below the veneer of culture that the ethnic cleansers adhere to, and that the Fashion Police adhere to.

POM: That's quite interesting and your view is, I think, very enriching. I see in the work of those three a very strong sexual element. They all come from the east coast of the United States, it's American, and obviously there is this whole industry because suddenly those prints reach incredible prices. I just heard that Nan Goldin promised she would never print them again, or she was going to retire the negatives. So there is high status involved in this new way, not only of representing the world, but now entering the huge museums. The biggest effort of all for these institutions who spend money on photography (that was once this fragile medium, eh, but still was collectable and was so important) has been on sex. Why? What was happening in Europe? What was happening in Latin America? What was happening in the Orient? I mean, weren't these other photographers as good as that? Or is it that the launch and the power of the Imperium privileged the work of those few? With your friend Philippe, I was fascinated with his work but definitely he lives in Thailand, so he's an outsider to this East Coast element from America. Though his work or someone else's can be very interesting, it's just not *there*, and not linked to Cindy Sherman, ergo, less valuable.

MP: Yeah. You know, I don't think there's any clear answer on that one simply because the art market *is* America. We *all* have to live with America, and what happens in America. Look, I think what happens in America is just incredible because those three people had a profound effect on the way a lot of people use photography—not me, and perhaps not a lot of other people—but the general dialect of visual language. So it's really a big picture thing, and it's always the big picture that gets privileged.

POM: You know, sorry to interrupt you but, you said *those* three. If I had to choose my three I would choose, well, Graciela Iturbide in Mexico, Bernard Plossu in France, and Max Pam in Australia. Three places that are not America though Bernard is living in New Mexico. It's their body of work that is *very* interesting, goes very deep, exhibits very different styles. I can easily say that these three are as good as Mapplethorpe, Cindy Sherman and the other one, so why?

MP: But that's just your opinion, you know. I would agree: these are not *my* three. If I had to choose my three big moments in photography, they'd be different, but what I'm talking about is the big picture. I'm talking about when you crack open the first magazine, bang! What have you got? In the eighties you had Mapplethorpe, then later you had

Cindy Sherman, and then now you've got Nan Goldin, right? I'm talking about the mass-print thing because we both deal in that industry: I teach it, you play in it. And that's all, I'm talking about the big picture. If you want to look at the nuances of photography then, no—we saw enough Mapplethorpe a long time ago. And I don't care that much about dressing up and Cindy Sherman's fantasy life, and all that bunch of practitioners that followed her. It's something you either care for or you don't. And with Nan Goldin there's too much saturation. But when you think about the print media, I understand exactly why they go for it. And when you think about Curator-land that's the other story, and Curator-land has its own set of dictums and rules and understandings and, as you suggested, it's got money. And it's about the *curators* being sensitive to the big picture, okay? It's always the big picture because these are people who never take a risk, okay? They won't take a risk simply because they don't know what they've got. These people are academics, they're not visual artists, and nine times out of ten they are hack art bureaucrats who've come up from an academic discipline and so they're always going to look good: the big picture's to cover their ass. Like, for instance in my town, right? In the Art Gallery of West Australia they paid a quarter of a million dollars for a Jeff Wall picture two years ago, and it's a picture of a guy polishing his shoes, and it's totally banal! You can stand in front of it—I'll stand in front of it, and someone—a pensioner from the suburbs—will stand in front of it, and we will both—because I've *had* this conversation and because you can't be unaware of that, because it's on the front page of a newspaper—we both say, "What's it about? What's the point?" You know, why? I polish my shoes as well, okay, tell me something I don't know. And, you know, I have a really good relationship with the guys that bought it, and I really respect them. These guys have *great* visual taste, and their argument is that Jeff Wall is one of the ten great visual artists on the planet today. And my argument to them was the Goldin/Sherman/Mapplethorpe argument. These are the three last big things in photography, so if you're looking at it in photographic terms, hey, it's *not* Jeff Wall. Jeff Wall has had almost zippola impact on photography, and in point of fact comes back to the Americans, and sometimes, you know, you've got to hand it to them, they get it right, hegemony. They do get it right. And not only that. Behind these three practitioners there is, I think, about every two months, another major body of work being created in the States. The States is a real powerhouse of photography.

POM: We can talk over this thing, which I think is quite fascinating, but I would like to move to talk about writing, calligraphy, photographs, titles. With your work I see that, you have used writing in your journals. It's quite interesting because I feel that after all what you're photographing is yourself, and with *that* writing you're putting it even more to the foreground that it's even more important not only to see the picture but to see it from a specific point of view, and you're giving me elements to feel that, to understand it, to like it. But I also feel that your writing has a graphic element, it's not just giving me information and typing "this print" next to that photograph. Even on the cover of *Indian Oceans* you write on top of the photograph. That is quite a statement. I'd like to have your opinion on that.

MP: It comes back to an appreciation of books, and especially the history of text and image. Medieval texts are not available to me, I don't scrutinize them. But in India I did. There are a lot of illustrated books in India, with brilliant miniature paintings—

quite photographic in their impact and power. It might be a work on the Kama Sutra, it might be a work on the sex life of a maharaja, because, clearly, years ago in India there were the same elements of interest: sex, death, and fashion. A blind person could see it! But the other element is calligraphy. I looked at the Sanskrit written on those paintings, over the top of the paintings, on the page next to it—gorgeous things! And then you go to Japan, like I did in the late seventies, and you look at Japanese photography, such a particular school of photography. You see it's totally hooked up with ukiyo-e, the tradition of wood block printing, which is a thousand years old in Japan. And that's all about text and image. Text *across* the image. Or perhaps the reference is to the tradition of body tattoos that goes back a thousand years in Japan and so, again, there's that obvious link, and you could see it patched through to manga comics in Japan, and they directly relate to ukiyo-e. All directly relating to the kind of visual language used in Japanese photography, and that's what makes it unique. It has all of these elements, drawn from those Asian traditions of fine art, of text and image. Japanese cinema in the fifties had a great influence on me, with text and image as well, because you often saw in a cinematic Japanese ghost story, the monk flung his robes off and the ghost saw that he had the Diamond Sutra written all over his body; and so, of course, the ghost took off. A great Japanese fable made into a film and, calligraphically, it's unbelievably sophisticated and smart.

POM: Let's jump to another subject. What is it that one should write? You just talked about style and either you go to the actual print or you go to the borders, it's underlying. I was very surprised to learn how the book *Ethiopia* was made, that you just left these blank spaces for images. As children in Mexico, we had these albums to collect stamps with bread and you would buy one because it was the cheapest—one Mexican cent, three stamps, and you would collect them and exchange them. It was our obsession to fill the album, so I understand that book was a bit like that. You wrote things with some image in mind, and then you went back home and worked on it. The atmosphere framed it. And then, what got where? I mean, obviously not everything could be included—there were some choices. Why black and white? Why not green? Brownish, sepia, bluish? I find that very fascinating. You know, you talked about Duane Michals and he also writes to build up a narrative, to give you elements to think about, so you follow the photograph in a series of photographs in one specific direction. What do you write about your pictures?

MP: There's more to it than the photograph. There's more to it—but the photograph can pull it all in. The photograph can't deliver the whole and in the end, we come back to: what are you doing? What do I do? It's autobiography, it's about my feelings, it's about being a storyteller. Finally it comes down to that thing that you were talking about as a kid: the album, the sharing. I go there and, well, this happened to me and I retell it in visual language. And I want to retell it in text too because some of the nuances will be missed in the visual language. We can get all the promptings we want from the picture, but finally people are saying, "*What* is going on here?" Take this picture here: She can either be screaming at the top of her voice or she can be yawning, right? Of course, she's yawning [*laughter*]. I could write "Girl Screaming," right? And that wouldn't be true. But if you saw it you'd assume that it was totally true. So, that's why, I mean, "Facts are stranger than fiction."

POM: In the Ethiopia book, there is color. Actually, it is reproduced black, and you find that because you see the texture of the pictures, the images themselves are monochromatic, black and white. But then you decided to go sepia, to go blue or to keep them black and white. And now here in your show in Madrid, for the first time I see this wonderful, beautiful color work. So I was trying to go back to an idea. Monochromatic prints, but then you started looking for tones and colors and obviously it's a way of saying things, it's a way of creating atmosphere, a way of expanding your range. The specific question is: color, when? For what?

MP: Actually I shot color work for a long time, I just haven't gone with it, you know, because I had stuff to work out with black and white still. It ran for a long time, the black-and-white movie, yeah? And I wasn't finished with it, and I wasn't prepared to work with color because for me it wasn't right, I wasn't ready, it wasn't going to say what I wanted to say, and I wanted to create a huge distance between myself and a color reportage: *National Geographic*, that kind of thing. So, I'm teaching for a living and I'm constantly—part of the deal with teaching is there's a downside that's really an upside too—being challenged by my students showing me unbelievable color stuff, cross-process stuff, funky stuff. I'm thinking, "Color is changing." What I'm seeing these kids do is take hold of the objective notion of what great color is and putting it in the rubbish tin, because it's just not an issue. The sky doesn't have to be blue, it can be purple or pink or whatever. That's why black and white is so great, because really you make the colors in your head, you know? You don't want Kodak telling you the bush was green because they don't give you the right green anyway. So all of a sudden teaching at university at home in Australia, these students just loosened me up. They say, "C'mon, man, what are you doing?" Working in color is problematic because it's very expensive, but I'm at the university and they have millions of dollars to spend a year on infrastructure. We've got this unbelievable lab, and I can use it. So, oh two years ago, I go in there and, Bang! I start my printing and printing color's easier than black and white! It's like a revelation to me. You're in total darkness. It's funny, you're in there with the rest of the students; some people have got, like, fluorescent stars on their heads, you might run into a beautiful girl all of a sudden by the processing machine [POM *laughs*]. It's funny! I had a lot of color in my files because of this thing that I was talking about previously: looking for that chromatic look of the nineteenth century that I really failed to get control of in the end. With my new book, which is supposed to be coming next year, I wanted to use a big component of color in it. It uses a lot of material from the seventies that I shot in color then but always printed in black and white. It also uses a lot of color transparency material that I shot when I lived in Borneo and when I was working as a photojournalist for magazines. Quite recent stuff, where I've been playing with the notion of flesh. You know, the book's about Asiatic bodies, it's about body-centric cultures in Asia, and it's a three-hundred-page story for me, for this new book. One chapter is about iconic bodies, and about the iconography of Asia, which is *unbelievably* sophisticated. The way to represent that for me is to do it in color, because there is a certain color funk that goes with it. Whereas in the past I didn't have the confidence to play with the notion of color because I felt I wouldn't be able to deliver what I wanted to deliver, now I know I can because of what I've seen in this last decade, or these last five years, teaching—this whole elasticity of color. For me color is my new, you know, box of chocolate.

POM: Great. So I think we should join you with chocolates and squeeze them. Thank you very much for your conversation. It's been absolutely wonderful.

MP: No, it's been a real pleasure for me as well. It's the industry we're in, you know. Meeting another writer, another musician—it gives you, creative satisfaction. It's about love and it's about who you sleep with, yes? Well, let me rephrase that, it's about who you had dinner with.

Max Pam was born in Melbourne, Australia, in 1949. He made his first trip to India in 1970, constituting the start of a personal and photographic link with Asia marked by twenty years of travels and stays across the continent. In his youth, he studied photography at the Harrow College of Technology and Art in London. He has since photographed in Afghanistan, India, the Philippines, Thailand, Hong Kong, Bali, Borneo, China, and Japan. In 1986, Pam was invited to exhibit in the Rencontres d`Arles, and in 1992 the Nara Sogo Museum of Art in Japan dedicated a large individual exposition to him. The results of his work in Asia are collected in the book *Going East* (Marval, 1992). Pam has collaborated on a wide range of public photography projects in Australia. He first taught at the University of Sydney and, since 1995, has worked full time at Edith Cowan University in Perth. In 1999 he published the book *Max Pam* (Filigranes), followed by *Ethiopia* (Les Imaginayres) and *Indian Ocean Journals* (Steidl) in 2000.

Pablo Ortiz Monasterio was born in Mexico City in 1952. He studied economics at the Universidad Nacional Autónoma in Mexico and photography at the London College of Printing. He now works as a photographer, graphic editor, and artistic director. Since 1978 he has directed three editorial projects: *México indígena* (Instituto indígena), *Río de luz* (Fondo de Cultura Económica), and *Luna cornea* (Centro de la Imagen). Monasterio was also the photography editor at *Letras Libres* magazine. He was cofounder of Consejo Mexicano de Fotografía and founder of the Centro de la Imagen in Mexico City and guest director of PhotoEspaña 2001. As a photographer, he has published seven books, notably *La última ciudad*, which received the award for best photographic book of La Primavera Fotográfica de Barcelona in 1998, and the Ojo de Oro of the Festival des Trois Continents in France.

SELECTED BIBLIOGRAPHY

Bauret, Gabriel, and Max Pam. *Max Pam.* Trezelan: Filigrane, 1999.

Dufor, Gary, and Max Pam. *Indian Ocean Journals.* Göttingen: Steidl Editions, 2000.

Pam, Max. *Ethiopia.* Toulouse: Les Imaginayres Editions, 2000.

Pam, Max. *Human Eye: Max Pam Photographs, 1970-1992.* Nara: Nara Sogo Museum of Art, 1992.

Pam, Max, and Tim Winton. *Going East.* Paris: Marval, 1992.

Visual Instincts, Contemporary Australian Photography, Canberra: Australian Government Publishing Service, 1999.

DUANE MICHALS

speaks with Enrica Vigano

Enrica Vigano: You are the recipient of a very distinguished award: the PhotoEspaña 2001, and right now you have an exhibit at Max Estrella Gallery of Madrid. A couple of years ago, the Reina Sofia Museum organized a retrospective of your work and you've had innumerable exhibitions all over the world. It can be said that Duane Michals is also an artist with tremendous commercial success. But you don't work with the expectation of being "successful." Nowadays, young artists organize their work in order to achieve one thing only: to create something that sells. Could we talk about that? I'm referring to how you feel about the new environment of contemporary art, that is, its commercialization.

Duane Michals: Well, I think I've been lucky, because as far as I'm concerned, money has never really been a part of my artistic work, except for my commercial work, but I wouldn't be a part of any kind of business enterprise. I've never maintained a studio, or a staff, or six assistants. I've always done my own work, even when I did commercial art. I worked one or two days a week, and with that I was able to earn enough money to support my own personal work. So, I've never depended on my art to make a living. Nowadays, artists—the new generation of artists—want to be famous at twenty-five, and in fact, it's very possible to achieve that and to have a retrospective by the time you're thirty-two. These young artists expect to live off of their art, but I don't. That's why I've always had the luxury of doing only what interests me; I haven't had to do anything according to the demands of the market.

EV: You haven't had to be successful monetarily, but then, what is success to you? Is it

personal satisfaction? It doesn't seem that you've sought this kind of success either—I wouldn't say that you were the kind of artist concerned with self-promotion.

DM: No, I've never done that.

EV: I'm referring to what you call your "personal work."

DM: My personal work, yes.

EV: It's a sign of your humility that you never refer to it that way—as your "artistic work?"

DM: It's more than that—I hate that term. I think what happens today is that young artists have this need to be famous, to be very successful. What I needed was to express something. But they have to come up with a product driven by this need for fame and success. What happens is that they really don't know what they should be doing, so what they do is take some idea, no matter how trivial, aggrandize it, and then repeat it a hundred times in order to make it noteworthy. What interests me are certain ideas that incite the passions, ideas that allow me to express very personal feelings. I had no desire to satisfy the demands of any market, nor to make myself rich or famous; what I needed was to express ideas.

EV: But I suppose that it's less important for you now to do that.

DM: Well, nobody wants to be a failure.

EV: I want to say that what's happening to you now, these days in Madrid, is very connected with your idea that everything has its moment.

DM: Of course. You have to remember that I'm sixty-nine; this sort of thing wouldn't have happened when I was twenty-four. Now it's my turn. I have a forty year history of work behind me, so it makes sense that this happen to me now at my age because I'm a mature artist who has fully developed a personal vision, and that takes time. What the younger artists don't understand is that this takes time. And that's why their work is so banal—because they haven't enough time to develop a vision.

EV: Whenever I meet with young photographers, I always tell them the following: "Don't try to be an artist. Limit yourself to doing your work, and if the work is true and authentic, it will become art. But you have to feel it. It's not something you can explain to a young person.

DM: It's not that you can't explain it, it's probably that they don't want to hear it. Nobody wants to hear someone telling them that if they're twenty-six, they're going to have to work at least ten years in order to develop an authentic point of view; it's not something that's easy to accept. This is what's so inconvenient about being young. Everyone envies youth so much, but the truth is that being young is terrible.

EV: Is that really what you believe?

DM: Yes, it's frightening; you have to make many very serious decisions. It's a marvelous period in one's life, but terrible at the same time. I wouldn't want to go through it again, aside from the fact that I was very clear in what I wanted to do, but at the same time, I could have been mistaken.

EV: You are satisfied with your life.

DM: Yes, I'm happy. I'm sixty-nine, and it's a very happy period in my life. I've never felt as free as I do now, and I'm in an enviable position. I can do whatever I want. Regarding my exhibition next fall, everyone keeps saying, "How courageous! Look how daring he is to do this work." I don't see it that way.

EV: Actually, I wanted to ask you about that exposition in New York. Have you done other projects like that one in which you parody Cindy Sherman?

DM: Yes, I've done the same with Gursky, Tillmans, Serrano, Gober (the American artist who was in the Venice Biennale), Sherrie Levine—I have a complete series of them. They all lend themselves to it—and it's so easy to satirize them because their work is so ridiculous that you don't have to do practically anything.

EV: You're right. It's easy satire, but nobody's done it till now.

DM: Yes, I know—but. . .

EV: Almost everything that's written about these artists leaves you with the impression that they are words that support a nonexistent work of art—that they are there precisely to construct something as such.

DM: I think it exists only insofar as its construction depends on a structure dictated by the critic that legitimizes it. I mentioned to a friend of mine in an earlier conversation, that small ideas need exaggerated reproductions. On the other hand, great ideas can survive very well in a small reproduction. I think that the more trivial the work is, the more you have to do to realize it. In this sense, at least, size matters.

EV: You've said that art must elicit an emotional reaction.

DM: It's the raison d'être of art. If it doesn't affect you, it's not art, it's decoration. Bonnard once said something amazing where he explains that there are two kinds of paintings: sentimental and decorative. I think a vast amount of art is mere decoration. Whatever piece of art that is no more than sufficient in size to encase in a frame and hang in the vestibule of a bank or in a museum is decoration. But I think passion, intimacy, whatever makes you feel something, it doesn't have to be enormous, it has to affect you in some way. When you see it, it should make you think: Yes, I know what this is. Look, poetry is an act of recognition. The poet writes what one has always felt but has not been able to express in words, so that when someone reads the words, he

recognizes them, he knows what they mean. And the more intimate the words are, the more deeply they move you. But we live in a world today where the louder you scream, the more attention you get, and there's no room anymore for the whisper, for intimate sensuality. We're surrounded by constant noise. I think art galleries and museums have all turned into amusement parks.

EV: What kind?

DM: They're full of visual tricks, and of every kind of ingenuity to surprise the spectator, but they've lost their contemplative character, they're no longer spiritual places.

EV: And do you think the kind of critic we talked about writes in this way in order to take on a protagonistic role?

DM: Yes. There is an egocentric delirium, a kind of verbal and intellectual elitism; and if you don't understand them, it means there's something wrong with you—you're not on the same level. I think this is completely ridiculous. I would love to see what it would be like to have an exhibition, not of works of art, but just to have the words of the critics, framed and mounted, to have an exhibition only with. . .

EV: The criticism.

DM: If you limit yourself to framing the words of the critics, you can at least spare yourself the rest. I would love to mount just parts of the texts of what the critics have written about Robert Gober on the walls of a gallery. I once saw a piece—a statue of the Virgin Mary, I think it was—and they said that he had put a tube in her stomach—I don't know exactly what kind—a spout of some kind, to collect water falling from the roof, I'm not too sure. But this critic wrote that this statue was a work of art more spiritual than Matisse's chapel in Provence!

EV: Are you serious?

DM: More spiritual. How could you satirize that? It's absolutely grotesque in itself.

EV: So are you going to frame that? Would you show it alongside your photographs?

DM: I haven't arrived at a very clear idea, but I'd like to have some of the writings of these critics on the wall—with the piece.

EV: Your commitment to human rights, to social and political issues in the broader meaning of the term, is very present in your work.

DM: The truth is that there are an enormous number of works of this kind that no one has ever seen. I'm referring to the fact that even people who know me, don't know a lot about my political pieces even though I've always published them. And I have many, but it's more difficult for the public to be aware of the more political aspects of my work.

EV: Were you more political at one point in your career?

DM: No, I've always been political. There was a time when I did more political works, but there's always been a political element in my work.

EV: I remember *Sarajevo*, for instance, from a few years back.

DM: Yes, it was published. I like it very much. I think it's one of the best things I've ever written. I'm very happy with it. I tried to publish it in *The New York Times* when all that was happening, but they wouldn't do it. But ten years ago, I did a slightly polemical editorial in *The Times* with a piece I called *Salvation*.

EV: What was it like?

DM: They called me and told me that for the day after July 4, they were going to ask four photographers to send in a photograph of where they thought the country was from a political perspective—and they also wanted the photos to be accompanied with a bit of text. The other three were photojournalists. I sent a photo of a priest pointing a crucifix at an innocent-looking man as if it were a gun. Then I wrote a short text entitled *Salvation*, but it dealt with the political influences and the presence of extremely conservative churches, and the great influence they had on the lives of ordinary people.

EV: And when it was published, a lot of people saw it.

DM: I think it upset a lot of people. Including Cardinal Spellman, who wrote an angry letter to *The Times*. My mother went to Mass in Philadelphia and they mentioned it in the sermon. So she asked me: "Did you publish a photo in *The New York Times* with a crucifix or something?"

EV: Poor woman.

DM: But it's interesting, with all these people like Serrano, trying to be so outrageous with all this pissing on religion and everything. My photo of a crucifix went much further. What I put forth was a political problem—how the church is used—and this is much more dangerous in terms of a political statement.

EV: Your work and political ideas have nothing to do with activism.

DM: True, I'm not one to go out on the streets.

EV: But you leave very interesting political messages on your answering machine.

DM: Yes, I do.

EV: It's something I wanted to touch on in this interview because it's a lot of fun to call you at home when you're not there!

DM: Yes, I know. A lot of people would agree with you because many call just to hear the message.

EV: When and why did you start doing this?

DM: I've always done it. There are just so many boring messages out there.

EV: How often do you change it?

DM: Every once in a while. About once a month, I'd say, maybe a bit more often.

EV: Of course, you're a very busy man. Your commercial work, artistic work, the inaugurations, writing, reflections, trips to the country. . . so I would think finding time to think about the outgoing messages on your answering machine is not high on your list of priorities. You have an energy and perseverance that are admirable.

DM: Well, I think in order to understand most of what I do, we'd have to go back and talk about my father. My father was the kind of person who would always say he was going to do something and then never do it. He was always saying: "We're going to go hunting together." We never went once. The "We're going to's" never came to be. I learned very early on that he was never going to do what he said he would. As a consequence, I am the kind of person who does absolutely everything he says he's going to do. To the extent that if I say I'm going to do something on Monday, by Thursday it has to be done. I hate disappointing people. Why? Well, I suppose so that others not go through what I experienced. So, I do what I say I'm going to do. I don't want anybody to be left waiting for something that's not going to happen. I always say to my students, In this life, either you're engaged or you're not—there's no middle ground. There are two kinds of people in this world: those who say they are going to do something, and those who actually do it.

EV: Do you believe that your social and political struggle for human rights has offered anything to society?

DM: I don't think that's very important. I do it more than anything for myself, because of the anger that some of these issues make me feel. That's why I wrote those pieces.

EV: How would you want to be remembered?

DM: Well, I'm not sure I care. . . after death.

EV: You don't care?

DM: Not really. I've always found it strange that people are so obsessed with controlling how people will perceive them after they're dead.

EV: But as an artist, you will leave something very important behind.

DM: For me, the fulfillment lies in doing the work. I can't explain to you how exhilarating it is when I have a new idea. The creative moment is a revelation. Like when I thought of satirizing Cindy Sherman—what an amazing idea! I wanted so badly to start right away. This is the moment I love the most. Then, it's always very rewarding how the people respond. But when I die, I'm not going to be around to see that, so that's why I don't care much about my legacy. This idea of earthly fame is so ridiculous from a broader point of view. Moreover, everything will disappear, every generation. All you have to do is look back through history at all those who have been so famous. I remember once I was interviewed by someone about Andy Warhol and they wanted to know what I thought about his changing his name. What do I care about Andy Warhol's name? So I said to them: "It seems incredibly superficial to me. In a hundred years we'll all be dead and that won't mean anything." In a world of Milosevics, of so many assassinations, who cares that Andy Warhol was a great artist?

Satisfaction lies not in achieving fame, but in doing art. As long as new ideas keep coming to me that I enjoy, as long as I don't repeat myself as many artists do—like Cindy Sherman reproducing her portraits. In the last ten years, I've written a children's book, the project *Questions Without Answers*, and I wrote the history of quantum for [French] *Vogue*. And I just finished writing a cookbook.

EV: A cookbook?

DM: It's called *Second Helpings*. They told me they didn't want pictures of the dishes, because people see these amazing photographs of the dishes and then it never comes out the way it appears in the picture. So, I did eight sequences—all very funny—of things that happen in restaurants. So you see, I love doing different things, trying something new.

EV: And you do it with a sense of humor.

DM: A sense of humor is essential, it's what keeps us sane. I think that people who don't have a sense of humor are demented. That's what fascists are lacking in. If you lack a sense of humor, you are less human. It's very healthy to see the ridiculous side of serious things. Like what we were just talking about a moment ago, about how you want to be remembered. The Carnegie Foundation in Pittsburgh bought my archives and I'm very happy about that because I'm almost seventy years old, and when you get older, you like to take care of things. I'm happy that I don't have to worry about where this work will go, that I don't have to think about what would happen to all those damned negatives. I've only kept copies of them.

THE FRUSTRATIONS OF THE MEDIUM

EV: Why did you choose photography to express yourself? You studied art, you like writing, you are a poet.

DM: True.

EV: Why, then, did you choose photography, with all of its limitations?

DM: Well, I think there are fields of energy, magnetic fields. And I think that each one of us, in tune with our own personalities, have our own fields of energy. There are children who at five years old are playing the piano; they have a field of musical interest. Others at the same age are dribbling a soccer ball and the institutes are making them captains of a football team; these have an athletic energy field. And there are others who are defined by what I call a field of aesthetic energy. They are immersed in writing, painting, and beauty; they belong to the world of art. I was one of these, but I didn't realize my particular craft until I traveled to Russia when I was twenty-six. It was there that I discovered photography and realized that it is what I needed to do. I was very lucky, because that trip changed my life entirely. If I hadn't gone, I never would have become a photographer.

EV: What made you go to Russia at twenty-six?

DM: When I was at the institute—I remember that my father was a laborer in a factory and we didn't have many opportunities—so I said to myself, "You will go to New York, you will make amazing friends, and you will live an adventurous life." And that's what I've done, even to this day. I'm still living adventures and I have amazing friends. And going to Russia was a great adventure. Can you imagine what that was like, at the height of the cold war?

EV: Of course.

DM: You couldn't fly to Moscow. I had to go to Finland and from there take a train.

EV: That's why I asked you why you chose Moscow. If it were there, it must have been because Russia was precisely the one place you wanted to visit. Did it have anything to do with your ancestry?

DM: Absolutely. You know, they always ask me the same question. I'm almost regretting having mentioned once that my grandparents were from Czechoslovakia. Today someone asked me a couple of times in what part of Czechoslovakia I was born. People don't pay attention to what they read and they ask these kinds of questions all the time. Even Slovak journalists who've come to interview me wanted to know to what extent my Slovak roots influenced what I do. Well, they don't.

EV: You once said that photography was an instrument of invention, not for capturing reality. In what way do you think a camera should properly be used?

DM: The camera is like a typewriter, in the sense in which you can use the machine to write a love letter, a book or a business memo. I mean, it's nothing more than an instrument, like a camera. Some are used simply to document reality: a face you pass on the street, a car accident. I think a camera can also be used as a vehicle of the imagination. Photography is an art, but it will always be a lesser art, always, because of the way in which the majority of photographers use a camera. They lack the most essen-

tial ingredient: total invention. A writer sits in front of a blank page and everything that he puts on that paper comes from his imagination. A painter uses a clean piece of cloth, and even though he may be copying something, he's still inventing. We have a virgin film. Cartier-Bresson might not have been there, but that man would have leapt over the puddle just the same, in that famous photo from the shadows. It was an event that he captured elegantly, but that would have been produced in exactly the same way without his being there. With true invention, what you produce is something that never would have existed without the invention of the artist. So that while photographers continue to commit themselves to "encountering" photographs instead of "inventing" them, they will continue spending their lives looking for something. They will continue cutting up visual reality into little pieces, always dedicated to "encountering"their photographs. The artist doesn't come across a painting, and the writer doesn't find his novel; they are works of invention—they are made by them.

EV: And you don't think recording events in a particular way is any form of invention?

DM: No, it's a selection—what they do is choose. It's not an invention, what's more, what they see is, more often than not, something that's been told to them by John Szarkowski or Richard Avedon. They see what the history of photography has told them must be a photograph.

EV: It's an interpretation of reality that doesn't go beyond zero.

DM: If Cartier-Bresson had taken these people and said to them: "I want you to sit there on the edge of the Seine and eat lunch on the side of a boat; I'll stay here, and you guys eat," that would be inventing a photo, and not observing it and encountering a moment. Not that there's anything bad in what he did. One of the best aspects of photography is that when one's memory fails, photography is there to offer faith in things. That's why photos become more and more precious the older one gets.

EV: Is that why you consider photography to be a kind of second-tier art?

DM: Not even: it's not a great art. And right now there are innumerable young artists trying to transform it into great art by way of making huge photographs, because they think the size of the photo gives it grandeur.

EV: Well, in fact, that also happened with painting.

DM: True. Paul Klee was always considered a lesser artist because he worked in a small format. I was in a museum in Cologne and they had three walls in one of the rooms covered by enormous pieces. One was like an electric chair reproduced twenty times, and the other was a figure of Elvis Presley standing. Then I entered a smaller room, where there were twenty paintings of Paul Klee. Each one distinct. Each one admirable. Each one was a surprise; no two were alike. So tell me, who is more imaginative, who is the true genius? I love creativity, the imagination, mental games. I like surprises, but in photography exhibitions, there are none. You just find yourself looking at the same picture reproduced forty times in one room.

EV: When did you start doing sequences? Did you know another photographer who did them?

DM: No. There was no precedent for my sequences. I'd only seen what Muybridge had done with the captured stills of moving objects. That was the only series I knew.

EV: Minor White had done series like that before but that had a different structure. I think they were more about displaying a group of photographs together and then calling them a series.

DM: It's a totally different idea even though it carries the same name. His dealt with photographs that didn't necessarily have to be mounted in relation to one another, but mine definitely formed a kind of unitary cohesion, almost like the photograms of a movie, those in which one thing depicts the other. But I arrive at the frustration of having produced only half. The truth is it was an interesting process because at that time, three circumstances coincided with one another. I began to notice the photographs of Atget. I loved them—they were like scenery. They had the potential of being awful. Well, I woke up early one Sunday, when nobody was there and I put my camera against the glass so there wouldn't be any reflection. It would be an empty barbershop. On one side were the armchairs and on the other, the towels they put around your neck. There was also the white coat that the barber wears, hanging on a hook on the side. I could visualize a man entering the shop, putting on his white coat and practicing his trade. In this way all these empty spaces were like scenes from a stage. It was like having the front seat at a theater, watching scenes where anything could happen, at the initiation of a concept of theatrical construction.

Besides, I was very interested in Balthus, who looked like me, and continues to look like me. Marvelous. He has those street scenes, that aren't too artificial, though you knew full well they weren't real streets and all of his personalities, with their frozen poses. And there was somebody else. . . But this made an impression on me, and one day I thought maybe it would be interesting to include people and construct something—make something happen. So, I got a group of my friends together, and I brought them to a spot underneath the Brooklyn Bridge. It was somewhat reminiscent of (or better, based on) Balthus's The Street. I made everyone stand in a very artificial pose, but something wasn't right. I didn't like it at all. Of course, what I should have done was to let them move around. I had a man and a woman crossing the street with umbrellas, a young kid on a motorcycle with his girlfriend on the street, another man is reading the paper. What I should have done was have the motorcycle going down the street, the couple across the street and entering a building, and the other guy throwing the newspaper toward the stationery store.

EV: What you needed was action.

DM: But later I said to myself, why not just let them do what they want, and then I was a liberator. The second sequence is called The Violent Act, and deals with violence. In war, you have three thousand men trying to kill another three thousand, but essentially what happens is the same: one man trying to kill another. So that I had them all naked, and

there was a man standing in an empty room and another comes up behind him and strikes him on the head and throws him to the ground.

The second was called *The Woman is Frightened by the Door*. It's a woman seated on a sofa next to a door. I had to find a room with a door that opened into the room, so that she wouldn't be able to see who or what was entering the room. She's naked, reading a book, the door slowly begins to open. She raises her eyes but continues reading. The door keeps opening and she can't see who's entering, and of course, being naked makes her very vulnerable. The door keeps opening and she becomes more and more alarmed. Finally, she jumps up out of the sofa and everything becomes blurred. They're all like this. Very simple.

EV: How many of these have you done?

DM: Well, let's see, in 1966 or '65, I don't remember exactly. I think my first exhibition of this kind of work was in 1968 at the Underground Gallery.

EV: And how did it go?

DM: It didn't work very well. Gary Winogrand and Joel Meyerowitz came and then left right away. Because it wasn't photography. Everything according to plan. Remember you are a photographer, that you can be a reporter, but you can construct scenes, etc. It was a complete rebuke. Moreover, I appeared in some of the pictures. "Look how ridiculous! Since when. . .?" Even the *New York Times* critic came up to me and said: "But, what is this?" He didn't write a single word about the exhibition. I had very few critics because nobody knew what anything meant. In those days, what I was doing was very revolutionary.

EV: And with Sidney Janis, your first gallery, when did you begin collaborating with them?

DM: Not right away. What happened was a bit of a surprise. I had a friend who went to Switzerland—you know, of course, there was that beautiful Swiss magazine called *Camera*, that was edited by Allan Porter. So I said to him, "Since you're going to Zurich, would you mind bringing these photos to the editors? He did it, and I later received a letter from Porter saying that they loved them.

EV: And they were the sequences?

DM: Yes, he spread them out, enlarged pages, it was incredible. I think it was 1969. Later Doubleday called me saying they had seen the number and if it was all right with me, they would edit a book of my photographs. So I published the book, and at the same time.

EV: What book was it?

DM: The first was called *Sequences*. At the same time, I went to see Peter Bunnell at MoMA

[Museum of Modern Art, New York.] He loved my work and told me that he would mount an exhibition. So my first big exhibition was at MoMA, with the *Sequences*, in 1970. I think it was 1972 when the Photokina of Cologne dedicated an entire gallery to the series. Everything happened very quickly—it was incredible. But I was also very lucky—the trip to Russia started everything.

EV: If you think how just a few years earlier Gary Winogrand left the gallery saying, "This isn't photography," and then, just a few years later. . .

DM: The truth is that with this series, I radically changed the paradigm of what was considered photography. Everyone wanted photojournalism, but as soon as my work was recognized, which was totally distinct from what had come before it, it legitimized the idea of constructing something, of invention. And again later, when I started writing text to accompany the pictures, it was another example of my frustration with the status quo.

EV: You started writing much later.

DM: Yes, around 1974. But I started writing because, as in the photo of my parents and my brother, what interested me wasn't the expression on their faces, but what was happening between and among them. That summer, when my father died, I wrote five pieces. It was like opening a pair of floodgates; breaking through a dam; a dam burst; a huge breakthrough. Everything I've written has been a kind of release for me; it's not that I plan it that way, but just because the writing has allowed me to express myself better, in a more complete way. I've always done it out of necessity.

EV: Are you referring to *A Letter for My Father*?

DM: Yes. It's a true story, and I wrote it as soon as he died. It was such a release. I wrote *This Photograph Is My Proof*, during the same period. It's amazing.

EV: Was that also therapeutic for you?

DM: Up to a point, yes. I found a way of dealing with those problems. So I no longer needed always to be running around with a camera in my hands. I did *The Spirit Loves the Body* because I was interested in the theme of death. I suppose I could go to a cemetery or a funeral parlor and limit myself to sitting down and imagining what it would be like for my soul to abandon my body. [*Laughter*]

EV: To record reality.

DM: The freedom it gave me was incredible. If I could conceive it, I would do it. And I had no reason for being Szarkowski's boy. The truth is I never was; he was a mentor to Winogrand, Diane Arbus, Lee Friedlander. But I didn't have anyone who was promoting my work like that.

EV: You represented a great change in the history of photography, and it's not a little bit strange that in a city like New York, you never had anyone promoting or supporting

you. It's strange, no? Perhaps it's a question of character, perhaps because you are so independent that you never gave anyone the chance?

DM: No, it's not that. I would have loved to have someone helping me. But by the time I arrived at the Sidney Janis Gallery, I was already completely formed as a photographer. They didn't "make me." I was already very well known.

EV: I wanted to ask you if the act of writing by hand on a photograph was from some need or was it also some act of provocation?

DM: No, it was completely out of need. Everything I've done can be explained by a need or a frustration I've had with still photography. The writing came out of frustration, from the need to say something more than "look at this image." It seems to me that photographs are very static; when you talk about still photography, it's truly that, still. I wanted a photograph to do something more. If you showed me a photograph of a woman with a certain expression I ask myself, "Is she kind? Is she a mother? Is she a bitch? Is she sexy?"

So I had different needs, I didn't want to limit myself to looking at someone's face, but also to have more information about that person. And I began to feel so trapped that I had to find another avenue. So that when my father died, that summer, I wrote a bunch of texts, the first was *Letter for My Father*, that was about him.

EV: In a way, what you write is poetry.

DM: Yes, where the photo ends, the writing begins. There's a symbiotic relationship. That's why the text and the image, when you view them at the same time, say something that neither individual element could say on its own.

EV: In a certain sense, writing by hand functions like a signature, but it's also part of the aesthetic of the text. Does that have to do with your handwriting or is it something more intentional, in order to achieve a certain aesthetic effect. Because it's very beautiful.

DM: No, I've never even thought of that. But I love writing by hand. I have a book by Magritte with his handwriting in it. I like it very much, because the photographic print is something very mechanical, a piece of paper made with chemicals, so impersonal. I've always hated that, the anonymous copy whose author you don't know. It's not that it gives me problems, but I like the idea of actively participating in the piece in such a way that nobody can copy it.

EV: You rewrite the text all the time, every time you make a copy.

DM: And what I write is exactly the same.

EV: But sometimes you make mistakes. There are errors that you erase, then you return to rewrite—this makes them special and unique.

DM: Yes, I don't want to be perfect. And the day will come when nobody will write. I'm not even sure that young people know how to write script.

EV: Are you referring to the predominance of typewriters?

DM: Yes, and in the future, there will be less and less writing. What's lovely is the intimacy of handwriting. I like writing by hand, I love seeing people's handwriting. I think it expresses something of one's personality.

EV: You always say that the key word is "expression," not painting, writing, or photography. It's what you teach in your classes. Are you satisfied with what you've been able to express through your work? Can you say that you've been successful in expressing what you've wanted to?

DM: When I do something I'm always surprised at how clear it is in terms of what I want to say. For example, I do a sequence, I see a photograph, and it always happens that the result is exactly what I had in mind. It never ceases to amaze me, to conceive an idea and be able to see it realized. And I always have the sensation, when I write something, that it's very clear in my mind, that the idea is transparent.

EV: There's a lot of transparency in ideas and also in the language that is used to express them. In some sense, language is very ingenious, direct, comprehensible.

DM: I'm lucky not to be a better writer. If I were, it would be much more complicated, but I write very simply. If I had any literary talent, I would probably write much more elaborately and perhaps more interestingly, but I'm a primitive writer.

EV: With such language, you could write some amazing books for children.

DM: *Upside-down, Inside out, and Backwards.* It was lots of fun. I used the same kind of language I use in my writing for photographs. It's not that I try to express myself in any different way when I write for children. Actually, I speak the same way to adults! [*Laughter*]

EV: It's the same kind of language and very similar themes, but the "magic" that you put in the words for your photographs is sometimes more obvious, perhaps it's accentuated in the children's books. It's like returning to a childlike feeling of trust that I like very much.

DM: The wonder you experience at things—I think that that capacity is extremely important. We don't express wonder when we should; we are creatures of wonder, and we live in a universe of wonder, such that to reduce our lives to constant work and worrying about taxes. . .

EV: Do you think your books reflect your work better than your exhibits?

DM: Much more. I love them. You can appreciate my work much more in a book,

which is something that one reads in solitude.

EV: You only do portraits by commission. They're not part of your personal work.

DM: Not all the portraits I've done of famous people have been commissions. Some people, I've really wanted to photograph, like Balthus, de Chirico, Magritte, I knew full well I wanted to meet them. But yes, others were simply for magazines.

EV: You wanted to photograph them because you wanted to meet them personally?

DM: Because they meant something to me. I admired the fact that they were real people. They always have this mythic quality. You're standing at a door, and you see next to the door a nameplate that says "Magritte." Can you imagine going up to a door and seeing the name William Shakespeare? "Hello, Mr. Shakespeare, I've come to take your picture." These people were, in fact real, even though they are part of our mythic imagination.

EV: Were you nervous?

DM: Yes, I was very nervous—it was really exciting.

EV: You spent a few days with him.

DM: I was with him for a week. I went to his house every day, we ate together and at night he showed me his favorite films. He was a wonderful man. That was in 1965, before Magritte became so famous—I mean, he was already known, but I only knew admired his work because of a few pictures that had come out. I'd never seen a complete catalog, but the few pictures I had seen were wonderful.

EV: Did you prepare yourself?

DM: No, I already had in mind what I wanted to do—I always know beforehand. I love doing double exposures, and the portrait I did of him with his easel is one of the best I've ever done in my life.

EV: I see that among all your heroes, Magritte, Balthus, de Chirico, perhaps your experience with Magritte was the most satisfactory. I've heard that photographing de Chirico was a bit difficult for you.

DM: I have an interesting photo of him. I would have liked to have had an even more interesting one, but he didn't cooperate at all.

EV: You mentioned that he wasn't very easygoing when you were in his house, with his wife.

DM: Yes, but later we went to a café and we began speaking in English and he became quite charming. De Chirico is the only one of all those I photographed where I appear in the photo. I would have liked if someone had taken a picture of me with Magritte—

standing at his side, holding his hat. It would have been wonderful, but I was so nervous that the thought never occurred to me. Well, it's a presumptuous idea anyway. My short visit with Balthus was also fantastic.

EV: I know you don't like technical questions, but I wanted to ask you about the use of light—especially of natural light. When you do portraits, I think that in ninety percent of the cases, the light is natural, which makes it that much more difficult. I mean, you have to conform yourself to the conditions of the moment in which you do the portrait.

DM: The moment I enter a room, I notice immediately what kind of light it is—even before I say "Hello"—and I know from where it is coming. More than anything, I don't delay for a long time, like in the case of Balthus.

EV: That's what I thought, if you wait fifteen or twenty minutes and you bring lights, it's much easier.

DM: No. Nowadays when people come to photograph me, they take thirty minutes to set up their lighting. If you enter a room with someone, and immediately start setting up camera equipment, you instantly create an artificial environment. But if you just put the person where the good light is coming from, you avoid all that interruption in your contact with the subject and you can begin to establish a more personal connection with him or her. From the moment you turn on bright lights and open an umbrella, the whole thing becomes very mechanical, so it's just much easier to work with natural light.

EV: And in some of your pictures, the light even takes on the character of being the theme of the photograph.

DM: Well, I'm a great lover of light—I like it very much. I can't stand photographs taken with bad light. I also like the fact that light can make one look beautiful. I've never tried to make anyone look ugly. Light is an essential part of the vocabulary of photography.

EV: Are you still doing commercial work?

DM: Each day I'm more engaged in my own work, and I finally realized that I no longer needed to do commissions.

EV: For economic reasons?

DM: I don't need the money. I'm still finishing some projects, but only because I'm interested in doing them—not for the money, but because they give me the opportunity to express something I want.

THE QUESTIONS THAT HAVE NO ANSWER

EV: Death is without a doubt an important theme in your work.

DM: It's the main theme of my work. I really believe that a great part of my specula-tions have the goal of preparing me for my own death within ten years, when I'm between seventy-something and eighty-something years old. Hindus and Buddhists (I'm not exactly sure which) believe that a man, or a woman, when they are old and their children are grown, begin preparing themselves for death. Which means they put all their affairs in order, which is what I try to do. They meditate, reflect. This is an idea that I find very attractive.

EV: The idea of preparing yourself for death? Putting all your affairs in order?

DM: When the moment arrives—yes—to stop running around. I think this is very spiritual. For me, it's the foundation of any true spirituality.

EV: But I don't think anyone's ever really ready to leave this world. When will it happen? When you're eighty-five? Ninety-two?

DM: No—it's already begun.

EV: Really?

DM: Of course. In small ways—it begins very slowly. It's not that one day you wake up and say to yourself, "That's it! Tomorrow I'm going to die. I guess I'd better. . ."

EV: . . . go out standing up?

DM: Ha! Yes, it's 9:30 in the year 2012. God, If only I'd set the alarm clock. [Laughter]. No. It's a kind of philosophical process.

EV: Explain that to me. I find this very interesting because the truth is, with my personality, I'm not sure I'll be ready when the day comes.

DM: You say that because you're young. You're in the middle of your life, you still haven't had a child. Why would you be prepared? Death wouldn't be appropriate for you. But when you're eighty-five or ninety years old, imagine if you had cancer, and all your family has already died and you have no future. Look, when you're young, there is so much in front of you—and when you're old, everything is behind you. So in this time of your life it's easy for you to say that, but when you're a grandfather and your son Diego has children, and when he becomes a grandfather, then it will be appro-priate. But it's the kind of concern that doesn't make sense when you're young, you can only think about it when you're old, and you're preparing yourself for this great *acontecimiento*. There are two central events in life: birth and death.

EV: And then?

DM: Compared to these, nothing matters. There's a wonderful book by a man named Becker called The Denial of Death, that the most important thing in life is not sex, as you know, and allow me to say that sex is not unimportant, but the most important thing is that we recognize our mortality. Here we are, talking, when everything that we see, that we think, that we hear and feel, everything will someday cease to exist.

EV: Do you believe in life after death?

DM: It's very possible. I don't believe in traditional religions: heaven and hell, punishments, and all those idiocies. I have a Buddhist perspective. I think we are prisoners of the senses, we are defined by a world in three or four dimensions, but I think there is much more. What happens is that because of our material, physical nature and our energy, we can't experience all things. We are matter and energy that is manifested in conscience. But at the same time, I think it's possible that when we die, we advance to a different level of energy and enter the world of the spirit. And I think there are many, many worlds; It's like the onion, which has layers and layers, and most of us live in the most outer layer. But if you meditate, you advance to a deeper level of awareness, you begin to be conscious that there are distinct levels. I think energy is transformed in another form of consciousness that we're not aware of.

EV: You said that the religion you feel closes to is Buddhism.

DM: Yes, it's the one I most identify with.

EV: How did you come to feel so close to Buddhism? I know there was a time when you practiced meditation.

DM: I practiced for eight years. I stopped doing it not because I thought it wasn't good for me, but because it had become a way of life.

EV: You believe that?

DM: Yes, I meditated every night, but it was like, "time to go meditate, brush my teeth, and put on my pajamas." It would have lost its purity.

EV: How old were you when you meditated?

DM: I was in my thirties. I went to the gym from the time I was twenty-six to the time I was thirty-eight and then I began meditating from when I was forty until I was about fifty years old. It's something that I'm still very interested in, but I don't practice it.

EV: I ask you these questions about religion because unlike other photographers, it's a theme that appears in your work. It's very present in your artistic work, in many forms, from different perspectives, with a very open attitude, but it's a fact that your work is full of religious references and specifically references to Catholicism.

DM: Well, it just so happens that that's the vocabulary with which I speak, but I'm

more interested in questions of spirituality. When I think of religion, I think of build-ings, institutions, ritual, sin, and I don't believe in any of that. I really believe that there are more spiritual people outside the churches than within them because those who are in the churches believe they've found something and they abandon the search for a broader perspective of reality.

EV: So you use references to Catholicism in your work simply because it's a kind of language that is easily interpreted.

DM: I grew up in a Catholic family and it's a kind of vocabulary that most people can identify with. You can become too arcane or use obscure references, as I did in The Illuminated Man, which dealt with the idea of enlightenment, nirvana.

Interestingly enough, Newsweek had an article on the cover about the mind of God. The piece said that they've isolated the area of the brain in the frontal lobes where there is a cosmic awareness, or whatever you want to call it. They know exactly which part of the brain experiences it. And I say it's very interesting, and of course it must be expe-rienced in the brain—where else? So we know where and how it happens in terms of electronic impulses, or whatever. But the fundamental question is: Why are we pro-grammed by nature to have this capacity? Why are disposed to it? In the brain, nothing is gratuitous; everything responds to some part of us; there is an economy of means. The brain is functional. And this specific function has existed always and has a reason for being. The fact is, they are preoccupied with determining the where and how, but it doesn't occur to them to ask the question why, which I think is the most important question.

You know, time is so fundamental in our way of experiencing life, our knowledge of reality, that we take it for granted, we don't even notice it. We're not aware. One of the things that fascinates me is the question of what is the true nature of what we call "reality," and time is an essential aspect of that.

But if we begin to consider the question, we will begin to realize that, in a very strange way, time doesn't exist, because there is literally no past to speak of. The only thing we have of the past is whatever we decide to preserve through memory. But the fact is that memory is very selective and when you're young, life is getting better and you begin accumulating many experiences. Look, it's always seemed so ironic to me that young people have such sharp memories and older people forget so much, but when you're twenty years old, you only have to remember those twenty and that's nothing. But when you become sixty-nine like me, you'd have to travel back to 1948 to remember what happened then, well, it takes you fifteen minutes. So our head is full of memo-ries: when you are young they aren't many, but I'm so old, they ooze out of my ears.

When you talk about time, you also realize that there is literally no future, it doesn't exist. What there is, and what exists continually, is the once and always now. But the more you try to understand it, the less understandable it becomes. Because of its very nature, there is no "now." There is nothing more than a series of successive points of occurrence and others that have already occurred. The moment of the occurrence is

like a clap—so quick. When your son was born, he was born in the now. And you wonder when I am going to die, and when you are going to, and we're not going to die tomorrow or yesterday, but we are all going to die in the now. But if you consider this moment of now, already it is over. It's something pretty extraordinary, a mental construction, and one primordial part of reality shaped by the senses is time. I think dying is falling out of time to a kind of intemperantality.

EV: Returning to vocabulary and language, it can be said that the language of your work is quite ingenious.

DM: Yes, it's very simple.

EV: So simple that sometimes one could say it's too basic to explicate such complex and difficult themes. Is it a choice you've made for the sake of communication or simply. . . ?

DM: It's my nature. It's not any kind of choice—it's just the way I am. That's why it works, because it's not affected. And I don't have to force myself. I can only express myself in such a simple way—I'm not an intellectual.

EV: You're not?

DM: I think that intellectuals are those who deal with philosophical problems in a sinuous and complex way, make use of verbal language, whereas the same ideas could be expressed for the most part in a much simpler way.

EV: I don't think the intellectual is someone who deals with philosophical questions using a complex language. Intellectuals deal with philosophical themes, period. And this is what you do. Think, for example, about Questions Without Answers.

DM: Yes, I'd really like to see that published. It's the most philosophical work I've ever done, and it has a lot of mistakes.

EV: How so?

DM: Well, it's got errors—it's not perfect. But it's an impossibility—just proposing this challenge was in itself absurd. Somebody once said to me: "Listen, I don't know if you know that philosophers have been writing about this theme for three thousand years. What demons do you have inside yourself that make you think you can tackle them?" And I answered saying, "No, that everyone should reflect on these questions." It's not something exclusive to philosophers, nor to a little superior class of men. It's a basic question of daily life, and everyone should think about it. Plato said the unexamined life is not worth living, and this is absolutely true. The vast majority of people don't even know that they're alive, they don't have the least idea of who they are. It's as if you need a truck to roll over you in order to realize that you exist.

EV: When and how did you begin working on the project Questions Without Answers?

DM: Five years ago. I said to my assistants (we spend a lot of time together), "Why don't you ask me some questions and we could have a dialogue." But they didn't ask me anything so I began asking myself. I was in my early sixties by then, and I decided that it seamed reasonable to do this. The questions were: "What is God?" "What is death?" "What is old age?" "What is humor?" and "What is time?"

EV: Not "What is desire?"

DM: "What is homosexuality?" "What is nothing?" I like "What is nothing?" That one was hard. It was difficult to do, and most of it is written in rhyme. But I make a lot of rubbish. My rhyming is very compulsive. Sometimes I make terrible rhymes, so stupid [laughter]. But I don't mind because I enjoy doing it. It's a pleasure.

EV: But does it try to offer answers or just. . . ?

DM: No, it's about forcing me to think about the answers. But it's only for myself. I never offer answers to the public, I really only do it out of curiosity and for my own entertainment. Like when I wrote about homosexuality, and I said in the first sentence: "Homosexuality is the same as heterosexuality, only different," so I could later continue from this premise. And it's true. Basically that is the real underlying theme.

EV: You dealt a lot with the theme of the unknown. You did works such as Questions without Answers. Isn't it a bit difficult to deal with such themes using photography? I mean, you could have written books.

DM: Yes, it was pretty complicated in general, but it was easy to do the photographs; the images are much more fluid, the text much more interesting. I believe I can be much more intimate with the written word.

EV: But the photographs from these sequences don't offer an explanation.

DM: No, they're more illustrations of the concept. What's important is the idea itself.

EV: And the photographs reinforce the idea.

DM: Yes, they help, and with photographs like mine as a foundation, this is appropriate.

THE INTIMATE CIRCLE

EV: Going back to more basic questions: what is desire?

DM: We spoke about how in Questions without Answers when I arrive at these fundamental questions. . . they are very important, the most difficult thing is to find an answer. The difference between love and desire is that love is an experience of giving and desire is about self-gratification. When you love someone, it's an expression of giving, when you desire, what you experience is possession.

When I wrote *What is Love?* I said that passionate love is the adolescence of love. When you go crazy for love, it's like you become an adolescent, but when you truly love someone, adolescence matures, the craziness disappears and becomes profound love. I don't thing you can ever say: love is this or that. But you can describe something through its attributes.

EV: When did you realize you were gay? When did you accept it and make it public?

DM: A couple of days ago! *[Laughter]* I thought to myself, "How can it be that I'm living with this guy for forty years?" But, all joking aside, its very interesting. I was very naive. Remember, I belong to another generation. I took it for granted that I was heterosexual, and I had no reason to believe otherwise. I didn't even know there was anything called "homosexuality." I knew there were sissies, and of course, nobody wants to be a sissy, but I still didn't really know what it meant to be one. One year, you're playing baseball, and you're not even interested in girls, and the next winter, things start happening to your body, and the next year, you want to play with girls' breasts. So I said to myself: I'm fourteen—I guess this is going to happen to me when I'm fifteen; well, no, okay—it will happen when I'm sixteen. But even trying to always be with girls, I had girlfriends when I was at the institute, and I was always going out with women all through university. But then it became very obvious that two and two is four. And you begin to understand that your interest, it's not that you don't like women or their company, or that you don't think they're beautiful, but that, very simply, you don't desire them.

EV: You're talking about an instinctive desire.

DM: It's very funny, not until the end of your life, when you're eighty years old. My mother called me up one day to talk and she says to me: "I think I'm a lesbian." "What do you mean, you're a lesbian?" I answered. "You know, my experiences with men haven't exactly been out of this world." I told her, based on what she'd experienced (and I meant her marriage) I could imagine it. And I asked her: "But do you desire women?" She said no. "Do you find Marilyn Monroe attractive?" She told me she thought she was gorgeous and I insisted: "Yes, but would you like to sleep with her?" Again she said no. And I said to her, "Look, mother, if you don't have a desire to sleep with women, then you're not a lesbian. If every woman in this country who had problems with men became lesbians, there wouldn't be any straight women."

EV: When exactly did you realize you were gay?

DM: I simply realized with perfect clarity one day that I was more attracted to men. I didn't know what to do with them *[laughter]*, but they seemed more attractive to me. I think it's legitimate to feel affection for people of the same sex, and if you express that physically, well, to me, that's stupendous.

EV: How have you lived your homosexuality?

DM: Well, I've been with my companion, Fred, for forty years, and our lives have

revolved around different themes. We're not particularly promiscuous, in the way that, if I'm in Berlin and Fred is in New York, neither of us has any reason to think the other is out on the streets or going to bathhouses—it's just not the way we are. But we weren't angels, either, but we didn't belong to the kind who knew thirty people suffering from AIDS. I know four people who died of AIDS, but we were at the margins of that whole culture.

EV: How do you explain homosexuality?

DM: I realized, because my mind is very curious, that there had been two traditional arguments against homosexuality. The first says that it's abnormal. But actually, it's not; normality is something that is culturally defined. In 1864 in Alabama, it was thought completely normal for whites, "good" Christian people, to enslave black people, to treat them like property. And if you lived in Berlin in 1932 and you were a Nazi, it was normal for you to beat Jews and break their shop windows. Today, if you live in certain areas of Africa, it's normal that you subject your daughters to genital cutting with a piece of glass or a rusty knife, so that they never enjoy sex. And if you're Taliban, it's normal to shroud women from head to toe in a mantle, captive in their own homes, without receiving any education, without being able to go to the hospital or receive any kind of sanitary assistance. That's what it means to say that homosexuality isn't normal in societies that we know.

EV: And the other argument?

DM: The other argument is that it isn't normal, but it is. Everything in nature is abundantly diverse. Nature created twenty thousand different butterflies, thirty thousand different beetles, and, right now, it's creating every kind of new species. The essence of nature, through evolution, is to author variants. Every culture has had a range of sexual expression, and one small part of this range has always been homosexuality—in every culture. Which means that such people are not anti-natural, or evil, but that they are different, simply a variation. To punish someone for being different is criminal. You don't decide to be gay, just as you don't decide to be straight. People never ask "Why did you choose to be heterosexual?" If sexuality is a matter of choice, why would it only be so for gays? And the typical thinking is that the only legitimate sexuality is heterosexuality, and whatever strays from that is considered dysfunctional, when it's simply a different sexual expression.

EV: I completely agree with you, but the point of my question was to understand how a person of your generation accepts it and declares it, and in what way has it influenced your artistic expression?

DM: Well, for example, Minor White was gay. But he always hid it, he never came out of the closet; and for me it was perfectly understandable considering the generation he belonged to. At the other extreme we have Mapplethorpe, whom I don't like, even though I think what he did was good because he needed to. But from a political point of view, it's a complete disaster that someone so professionally homosexual not open up new perspectives on the issue.

On the contrary, he photographed everyone and each one of the topics, the worst of the antigay religious fanatics could not have described him better. He satisfied each and every idea that antigays have about homosexuality. Now you know that gays like to put whips up their bums, dress like women, wear leather underpants. The most minimal affect never appears in his pictures of men.

EV: When did you come out of the closet?

DM: I knew I couldn't be honest without dealing with this issue, so in 1978 I published the book of Cavafy's, which in my opinion was a beautiful book about this theme. And one of the complaints that came out of the gay community was that there weren't any pictures of men fucking. They reduced it all to that.

EV: Have you been a part of the gay community, which in New York is very large?

DM: It's the capital of the world.

EV: Do you have much of a connection to it?

DM: No, not any more, though I've done political pieces about the theme, like *The Unfortunate Man*. I think it's a very powerful piece, it speaks about the nature of homosexuality, of the disgraced man who can't touch the person he loves, because to do so is prohibited by law. It doesn't matter whether it's the law of the state or of the church, the fact is that little by little his fingers become toes, his hands become feet, and, embarrassed, he tries to cover them up using shoes, which means that he hasn't come out of the closet. And it's never even occurred to him to break the law.

EV: Your relationship with Fred is good, and it's lasted many years.

DM: And it's never been better than now. I feel that my partner and I have a very strong bond. For me, this story of gays wanting to marry, if you get into that, then you take on the very worst face of heterosexuality, which doesn't have anything to do with you; why not invent a new way of relating as a couple?

EV: How did you meet?

DM: In the gym. I was very interested in architecture and he was an architect, so that coincidence attracted me immediately, and I also found him very attractive, of course. And it was mutual. In this world, to find your partner is an amazing thing, regardless of what his gender is. And it requires you to change, which is why I think so many marriages break up, which has nothing to do with its nature, but because people have this romanticized idea of what love is, they think life is going to be a series of romantic moments. I think a lot of men are like adolescents in their relationships because they don't want to take on any responsibility, they only want to have a good time, not to be strong and mature, they only want to have fun. They are immature adolescents.

EV: Enough commentary. What was your family like? What kind of environment did you grow up in?

DM: My father was a factory worker and we were very poor, though I didn't realize it until I was grew up. The house I grew up in was on an unpaved street. We didn't have a car until I went to university. My family had a strong sense of the value of hard work. But my parents never should have been married. In fact, I think they married for me, because they didn't have any options.

EV: Are you sure?

DM: Almost. It's not that they've told me, but I've deduced it from allusions. My mother was a very beautiful and ambitious woman and my father was also attractive. The two of them were both very vain, they spent a ton on clothes, they loved to dress well, which is why I'm not very interested in clothing. They believed that one always had to be impeccably dressed, that people always judged you by your appearance, so you always had to wear shoes at every hour of the day and nice jewelry. They also believed in education and in work, and both were intelligent. My grandparents came from Slovakia and my parents were born in the U.S., so I'm second-generation American.

When I was young, my mother worked in the homes of very wealthy people, and she followed the fashions of respectable people. One day, she told us that the Shars had a sofa that was worth more than what we earned in an entire year. I always called them "the rich people." They lived in style, their son went to an elite university so my mother knew them quite well. I was named after one of their sons, Duane Shar, who ended up committing suicide, and was also gay. So it's all very strange.

EV: What a coincidence.

DM: In my house there was always this idea that one had to be responsible. My parents let us make our own decisions, so if some issue came up, we had to make our own decision. For example, when I went to the university in Colorado I was seventeen, and most kids graduated when they were eighteen, so I was a year younger. They didn't want me to go, but they said, "Fine, you'll see, but if it doesn't go well it's your problem." They gave me their opinion and then I did what I wanted, but this implied that once I made a decision, I had to live with the consequences. "Don't come back crying, it was your decision, so now live with it." And that's how it was with everything.

EV: They had money to send you to school?

DM: No, I went on scholarships and I lived on sixty dollars a month, and my room cost twenty. I was left with forty dollars for all my other expenses, so I had to work, and I always did, throughout my studies. I have a very strong work ethic. I worked at the institute, and when I was a kid, I delivered newspapers. We've always worked and always had to save money. In fact, we didn't mind it at all, and in spite of all the problems we had— that my father drank—they were essentially good people, though very dysfunctional.

EV: I had the idea that your father wasn't a very good person.

DM: Yes, that was true. What happened was that he was a victim of his circumstances, of his personal trajectory, but I think underneath he was a very generous man.

EV: Yes, but he always made you promises that he never followed through on.

DM: Of course! I hated that, and I hated that he drank. Vacations were a disaster because he was always drunk. He was upset every Christmas. But when I wrote that that text about the city of Pittsburgh, *I Remember Pittsburgh*, which spoke of him, I said that he drank, but that he had his reasons. I refer to what I understand as the reason why he did it. He hated his job, his marriage was horrible, and I think he was on the verge of being an alcoholic.

EV: And the physical environment?

DM: My mother kept an immaculate house. She had exquisite taste. She dressed beautifully, and though we didn't have any money, I was proud of how she decorated the rooms. She had a lot of style.

EV: Pittsburgh is where Andy Warhol is from. Is there something unique about this area?

DM: The water—it's the chemicals in the water. A perfect combination, from the steel mills, there's so much copper in the water that it makes you crazy [*laughter*]. Andy was first-generation Slovak. When I met his mother in New York, we spoke in Slovak because since my mother lived in houses where she worked as a maid, my grandmother raised me and so my first language is really Slovak.

EV: Your mother died just a couple of years ago. Was she happy about your success?

DM: Yes, I think she was. I fulfilled all her dreams; I even drive a Mercedes, and for her own son to drive a car like that and own a couple of homes, I mean, for someone coming from our circumstances, the most we could hope for was to teach art classes in an art school, have two or three kids, and live in the suburbs.

EV: Have you ever considered writing your autobiography?

DM: No, it's something I don't think I will do. But I enjoy reading biographies. I like seeing how people became who they were. Nobody was born famous, people evolve, make decisions, which makes them become who they are.

EV: It's obvious from your work, in your writing, that you are extremely well-read and this makes your writing more profound. What other types of books do you read?

DM: I love to read, it's one of life's great pleasures. I read books of physics, when I can understand them. I'm very interested in the nature of consciousness, and I read books

about that. I also like to read poetry, but it often deceives me.

EV: So you don't read novels.

DM: I almost never do. I really like Borges, he's my favorite writer, absolutely brilliant. What an amazing facility he has with language—amazing metaphors! I love people like Lewis Carroll, who writes very simply, but he writes about very profound themes in many senses. I like William Blake and, I'm sorry to say, this is precisely why photography bores me, when somebody comes to show me street photography, of people positioned to look into the camera. Because there are many other more interesting things than going to Africa and taking pictures of people in traditional dress with their faces painted with mud. I should say again, they don't deal with how things seem, the important thing is precisely what you cannot see. So now you see the wide range of my interests. I don't buy books of photography anymore.

EV: What can you tell me about philosophy?

DM: It's interesting. It's not easy to say this, but the fact is that philosophers basically come up with two or three great ideas, and then write twenty books about them, very dense books. Trying to read the philosophy of logic is impossible. Nietzsche interests me, even though his writing is so archaic and difficult, but his ideas are very interesting.

When I was working on *Questions without Answers* I wanted to know what other people had thought about the same themes. The truth is that philosophers dealt with the most important questions two or three thousand years ago, like "What is beauty?" And they still haven't come up with an answer.

It seems like these are questions only for philosophers. Well, no—thinking this way is a mistake; they concern everyone and everyone should think about these questions. Questioning is a right that belongs to every living being, the natural development of knowledge and awareness. How can one grow without pondering such things? And there comes a time in life when you really think about these things, except when you are completely affected by all the noise and desires that are created by a society that tells you what you're supposed to want. But if you're not like this, if you retain some element of childlike curiosity and you really want to know. . .

Duane Michals was born in McKeesport, Pennsylvania, United States, in 1932. His career in photography didn't begin until 1958, after traveling to the Soviet Union with a borrowed camera. From this moment, he discovered his true artistic vocation, and began an intense apprenticeship taking photographs of friends using only natural light, a trademark of his work that remains true today. In 1966, he began using the technique of sequences in his work, a series of photographs that follow both a temporal and narrative progression. Beginning in 1974, his photographs were accompanied by short, handwritten texts to reinforce his message. His work became more reflective while at the same time retaining political messages. His portraits of famous surrealist painters such as de Chirico, Balthus, and Magritte are famous. Michals has received numerous prizes and has been the subject of retrospective exhibitions in the United States and in Europe.

Enrica Vigano was born in Milan in 1961. She is a journalist and organizer of exhibitions of photography. From 1992 to 1997, she was director of the Diaframma-Kodak Cultural Gallery of Milan, and organized eighty-two exhibitions of artists such as Andres Serrano, Gisele Freund, Inge Morath, Lewis W. Hine and Luis Gonzalez Palma, among others. In 1997 she founded Admira, an agency specializing in photography, many of whose exhibitions have traveled internationally, including those dedicated to neorealism in Italian photography, the Photo League, and the individual show of Duane Michals. Since 1998, she has collaborated with PhotoEspaña on commissioned works and publications. She is currently artistic director of Foto&Photo, the Festival of Photography of Cesano Maderno in Milan.

SELECTED BIBLIOGRAPHY

Sequences, Doubleday & Co, New York, 1970.

Homage to Cavafy: Ten Poems by Constantine Cavafy, Ten Photographs by Duane Michals, Addison House (preface in English by D. Michals), Danbury, 1978.

Duane Michals Photographies de 1958 a 1982, Musee d'Art Moderne de la Ville de Paris (text in French and English by Michel Foucault), Paris, 1982.

Duane Michals, Centre National de la Photographie, Photo Poche (introduction in French by Renaud Camus), Paris, 1983.

Album: The Portraits of Duane Michals 1958-1988, Twelvetree Press (introduction by Duane Michals), Pasadena, 1988.

Duane Michals: Fotographias 1958-1990, Edicions Alfons el Magnaním-EVEI, Valencia, 1992.

Upside Down, Inside Out and Backwards, Sonny Boy Books, New York, 1993.

The Essential Duane Michals, Thames and Hudson-Bulfinch Press (text by Marco Livingstone), London-Boston, 1997.

Questions Without Answers, Twin Palms, Santa Fe, 2001.

Second Helpings, Harper Collins, New York, 2001.

MIGUEL RIO BRANCO

speaks with Tereza Siza

Portuguese Center of Photography, Oporto, September 2001

BEGINNINGS: Painting and Cinema

Tereza Siza: Your life, since you were a child, has been divided among many different countries: are you Latino, a citizen of the world, a person who doesn't feel conditioned by your roots, or do you consider yourself the product of many influences?

Miguel Rio Branco: I was born in 1946 in Las Palmas on Gran Canaria, which is part of Spain, where I lived until I was three. My father was a diplomat, so I spent my early childhood in many different places: Buenos Aires, Lisbon (I studied for a time at a French lycée), Rio de Janeiro (between 1956 and 1960), and then in Switzerland, where I was a student at the Florimont Institute of Geneva. It was there where I understood for the first time what it meant to be part of a society.

I was an illustrator for the local newspaper, I did set design for a theatrical production, and I began to take painting seriously. I was deeply influenced by my painting professor, whose name, unfortunately, I can't recall. At the opening of my first exhibit on drawings and paintings (which I shared with the ceramist Chiffon) at the Anlikerkeller Gallery in Bern, to my great surprise my art professor, the director of Florimont, and a number of other professors, all attended. It was then that I became aware of the importance of culture. It was also at Florimont that a friend of mine, Jean Yves Rey Millet, the son of an artist, gave me an appreciation of photography, and of cameras in particular. He was using a Swiss-made camera then, an "Alpha Reflex."

I am a Latino *and* a citizen of the world, but more than anything, a "Latin," not just a Latin-American. I feel most connected to Portugal, France, Spain, Brazil, and other countries in Latin America, but I guess, more than anything, I have the capacity to feel very much at home in many different places. I don't consider myself to be the product of many influences, in spite of being very aware of different cultures, of diverse ways of thinking and seeing. I don't have the same kind of identification with northern countries (Germany and Denmark, for example) perhaps because I don't know them so well. When I lived in Switzerland, I adapted more to the French culture, I had no desire to learn German, which to me, was a language too much associated with the horrors of the Second World War. I'll never forget the picture books of the concentration camps I saw in my grandparents' house when I was twelve years old. Japan was a country as brutal as Germany in that war, but I don't have the same feelings about Japan, perhaps because of their traditions, perhaps because of the sophistication of their aesthetics and rituals, or maybe because of Kurosawa or Mizoguchi, who exposed me to a more sensitive way of life—more interesting, certainly, than that of the Germans. I've always been struck by the contrast, so typically Japanese, between a very sophisticated way of struggling and an extreme sensitivity.

Between 1964 and 1967, I lived in the United States with my parents, where I attended high school at the Lycée Français in New York. It was a very influential time for my drawing and the time I began to do photography more regularly. I took a technical course in photography at the New York Institute of Photography, which lasted a month. I used the pictures I took in those years primarily as a reference for my drawings but sometimes I used them for collages in paintings. From 1967 to 1969, I lived in Brazil and attended the School of Advanced Industrial Design (ESDI), where I stayed just six months. I soon realized it wasn't what I wanted to do, but more than anything, I realized I didn't want to be at a university. I already had the notion that in order to be creative, one needn't study in academia. Anyway, I had already taught myself enough so that I felt I had an adequate foundation.

This time at ESDI in 1968—during the student uprisings and the debate surrounding the university's curriculum in relation to the realities of Brazil—was important for me, because I realized that industrial design in Brazil didn't have much to do with the needs of the people, with the enormous social disparities, with the misery and ignorance of the time. Perhaps as a function of this awareness, drawing lost its importance for me. It seemed superficial compared with the powerful need to communicate in a less elitist medium. I wanted to reach people in a different way to open their eyes to the problems around them.

During this time, I designed book covers, was director of the photography department at a public relations firm (where I actually did very little work), and I began to take pictures both for pleasure and as a means of survival. I also had my first contact with film-making through a colleague at ESDI named Lauro Escorel, who showed me how to work with a 16 mm camera—an Éclair. I was the director of photography for a film directed by Carlos Goes, called *A Juala*. Later, at the invitation of the director Afonso Beato, I did still photography on the set of his film for three months on the island of Itaparica (near Salvador, Bahía), a place that was still very wild and a bit detached from

everything. Goes was filming *Pindorama*, by Arnaldo Jabor. I worked in various formats —35 mm, 6 x 6. I also did the photography for an as yet unfinished film by Antonio Calmon, who was then Jabor's assistant director. These experiences were my real apprenticeship. I began to feel a true passion for filmmaking and for the audiovisual arts—for light and color. On the nights we filmed, I would project slides of the sequences, work scenes, and other images of the filming. I would mount them in a way I liked and then show them to the whole crew. That helped me tremendously in the sense that I was able for the first time to see photographs as fragments that could be used to create a narrative and not simply as individual elements. Though they could still function autonomously, I always found them more satisfying when they were part of a sequence. It was my first real experience in editing.

Photography and cinema became important to me at almost the same time. In Brazil, I was immersed in a very creative environment and I learned intuitively. I learned by practicing. In general, one would start out as a camera assistant or photographers assistant, but I was never a camera assistant. So I actually went from working as a set photographer to a director of photography. I would have been a disaster as a camera assistant because I knew next to nothing about theory. I was guided by intuition. At the same time, though, I never much liked following someone else's orders (which would not have been well received in a camera assistant). By doing still photography, I had much more freedom.

Between 1970 and 1972, I again went to New York with the intention of furthering my study of photography, so I enrolled in a three-year course at the School of Visual Arts. For someone who didn't believe that art can be taught, the experience was like having a relapse. After one month in the program, I wanted to advance immediately to the next course. The beginning was too basic. I was already doing photography, I knew how to work in a lab after my three months on the set of *Pindorama*. I felt like I was wasting my time. They gave me the money that was left over from the rest of the semester (my father had paid in advance) and I stayed in New York. Thus ended my experience with any kind of academic training. For me, school is essentially about the professors. Whether or not one says that as a rule, they teach you something there. They can give you a certain foundation. But I think it depends a lot on the student as well as the teacher. In the case of art schools, they bureaucratize creativity, impart the whole history of art and produce perfectly good professionals, but very few artists. They don't teach you how to look inside yourself.

I returned to Brazil in 1972; my mother had died, and I decided to stay there. My mother's side of the family was from Rio and my father's was French. No one in my family entered the diplomatic field; my father never wanted to impose on his children his own ideas of what they should do. I only say that because the name Rio Branco is very well known in Brazil. My great-great-grandfather was a viscount of the Portuguese empire; my great-grandfather, the Baron Rio Branco, founded the Brazilian diplomatic corps and was a central figure in the peaceful consolidation of Brazil's borders. My paternal grandfather lived most of his life in France, where he was director of the Franco-Brazilian Hospital. My father, my uncle, and my aunt were diplomats, but the tradition ended with them. Actually, I've always felt I inherited the sensibilities of my mother's family.

Her father, José Carlos de Brito e Cunha, was the extraordinary drafter and cartoonist J. Carlos, known even today as one of the greatest artists in Brazilian history. So I think because of that, my parents were not averse to the idea of their son being an artist.

From 1972, I stayed in Rio, though I traveled occasionally. I was in France between 1981 and 1982. I also stayed in Bahía on a few occasions. They were very restless periods in my life—beginning in 1976, when I started dating Kady Cravo, Mario Cravo Neto's sister, and when my son with her, Jerónimo, was born in 1977.

In 1979 I did a project for an American magazine, *Geo*, about children living on the streets in various parts of Brazil. It was the first time I saw the Maciel red-months visiting Maciel, in Pelourinho. I was a portrait artist and I photographed women, children, and some men. But the project really consisted of scars, nudes, colonial ruins and the energy that pulsated underneath them. The project completely absorbed me and ultimately caused my marital separation.

TS: Those trips and wanderings through Spain, Portugal, Switzerland, France, Brazil, New York, were they the result of some artistic urge? Were they professionally motivated? Did they come from a desire to experience the world or were they simply due to restlessness?

RB: I think they came from the experience of meeting many different kinds of people when I was a child. As the son of a diplomat, I was never lacking in opportunity. It started in Portugal, when we lived in Lisbon. There had always been a lot of meetings, parties, and debates at home. My father always maintained relationships with writers and artists. He himself was a poet—very connected to poetry. There had always been a lot of activity in the house but not strictly professional or business-related, or always for pleasure. But I never participated in them; I stayed on the sidelines, watching. Nowadays, no doubt, the children would be involved, but in those days, children were expected to remain out of sight. I only began to participate more actively in my family's lifestyle after we left Bern, and especially in New York. I don't remember the names of the intellectuals that came to the house in Lisbon, but I do remember some of their paintings.

As I was saying before, the school I attended in Switzerland had art teachers who recognized the potential in their students. At that time, they also gave me a lot of encouragement. Moreover, when I went home on weekends and vacations to Bern, I watched the gatherings and activities organized by my parents and I began to show a greater attraction to more intellectual pursuits. My first exhibition was there, in 1964. I was by then convinced that I should be a painter. I arrived in Switzerland thinking that I was going to be a geologist; in reality, what attracted me were the rocks themselves—the objects. When I remember this today, it occurs to me that my interest had more to do with the aesthetics of rocks and their diversity than with any scientific question. Next was the period in which I arrived at home and painted. At school, I painted a lot. For sure, I already was doing some painting in Brazil—I did it during classes—but it was in Switzerland where my desire intensified. The truth is that while I didn't give it a lot of importance, I knew deep down I would follow this path, in spite of the fact that I didn't

know any artists. I knew a lot of diplomats, writers, and musicians in New York, and some of the more important figures in Brazilian music regularly visited my home, but I knew very few visual artists.

I continue to travel constantly for business, exhibitions, and personal projects. The act of leaving the place where one lives from time to time is very important, even if only to distract oneself from one's day-to-day problems and stresses. Often this "inward look" allows one to develop ideas more freely—no one is calling all the time, there is no rigid daily routine. But this, too, is changing. Lately, I haven't felt the same need to travel. Nowadays, I look for a place where I can stay and rest, do some short wandering, perhaps, but of another sort. I've spent my entire life moving from place to place—four years here, four years there. I think what I am missing are journeys inward. My photographic voyages in the nineties are more and more interior ones, and that, to tell you the truth, relieves my need for physical travel.

TS: You arrived at photography through painting.

RB: Yes, you're right, I started out painting.

TS: Are you completely detached from painting today?

RB: No, no, I'm not—quite the contrary, I keep thinking about it. From the way I look at what I photograph, to the way I find the things I photograph, many times it implies a search connected with painting. I miss the physical act of painting; it represents a biological need that no machine can replace. I don't paint because I'm immersed in a plethora of commitments that only lead to other projects. But in no way have I abandoned painting, because its physicality is something that offers a freedom that photography doesn't and will never have. Photography is full of limitations—the light, the framing. When I photograph people, I feel a real lack of connection to them. It's difficult to identify with them, and my heart is not always open to that. The limitations are many, and what's worse, I don't even work in a studio where you can control light conditions and the position of the subject, even though, for these very reasons, the result becomes more artificial. One of the things I like about photography is the possibility of working within limits but always from a commitment to the truth, to reality. One is inevitably faced with taking photographs in conditions that aren't ideal, but this sometimes has its advantages. It's a bit of a high-wire act between reacting and the act of overcoming the indomitable. The moments present themselves to one magically, but truly. Painting, sculpture, the object, these all ask questions that make me very restless and constitute a great motivation for me now. The theme of "the object" is part of many of the installations that I have created. Some might think this attitude is a bit dramatic, but actually, it's necessary for achieving interferences, for creating layers.

In my paintings from the period 1960—64, I was already creating interferences. They were oil paintings with collages of photos or objects, and I created textures by burning fabric. Lately, I've been feeling this need for the object, so my work is moving in that direction, which I suppose many consider to be a much less pure form of photography.

TS: Is it possible at some point for the process to be inverted, that is, that some photographs incorporate painting?

RB: Perhaps. But in my case, I think it would be very difficult. I think that certain images that I make are, for me, like paintings, and I am sometimes criticized for that. Not because I intend to make a painting, but because I think that, sometimes, I do painting with photography for the greatest possible contradictory result.

TS: Do you agree with the idea that painters like Goya and the expressionists have influenced your subjects and your use of color or would you deny this kind of pictorial influence on your work?

RB: I can't deny it. I do think those influences exist, as they have said, because there has always been a parallel with painters in my experience of life. Goya, especially in his dark period completely fascinated me, though more by his feelings of revulsion and pessimism than for formal reasons.

When I lived in Switzerland, I was interested, for example, in the subject of the running of the bulls. The color red of the blood, and the black. These colors constantly repeat themselves. In truth, my work is very monochromatic, and occasionally appears red or pinkish, or the color of skin, but there are not a lot of blues and practically no yellows. In the end, it's not an entire palette. If you look at a Goya from his dark period and some of my photos, you will see something of his palette in my images, but I think his influence was something a bit more unconscious.

TS: Those who know your work cannot help evoking an "imaginary museum" of a certain range of colors local to southern Europe, resulting from that local air, and, of course, the exoticism of your travels. Do you see the color of your photographs with the eyes of a painter or with the eyes of a photographer?

RB: I think with the eyes of a painter, but with the speed of a photographer. My formation was much more tied to painting than to photography and I haven't known many photographers. At the School of Visual Arts, I began studying the history of art and I left before we got to the history of photography. I was in New York for two years and I didn't meet a single photographer, except Cravo Neto, who at that time worked more with sculpture but already had an extensive body of work in photography. Alfonso Beato, who was director of photography in the theater, did very little still photography. I had some contact with a few artists, some Americans, like Lee Jaffe and Gordon Matta-Clark, and the Brazilian Helio Oiticica, who didn't have much use for painting. Photography and movies were part of the instruments that they used, always in a documentary format. During this time, I also met Antonio Dias and Carlos Vergara, two Brazilian painters who used photography to document their experiences.

At that time, I didn't see much photography done in color, and very little in black and white. One would only see color photography in *Time* and *Life* magazines, which weren't really media specialized in photography. Nor did I go to exhibitions; the only thing I saw was life around me. The photography I did then, during that time, was

primarily in black and white. Color was more expensive, so I used it less.

TS: When you did color photography, did you feel you were missing something?

RB: Well, my photography is grounded in black and white, it has a monochromatic structural foundation. In many of my photographs, the colors are easily recognizable, if they are engaging enough. I've already tested them. I also have black and white pictures printed from color film. But when I started using color, I gained sensuality and emotion. In other situations, color creates tension. Obviously this is an added element in many of the images, in others, a delicate subtlety. Color is very important to me. But if you look closely at many of my pictures, you will see that, actually, they don't always have much color.

TS: Now let's talk about the cinema: has it influenced your work in terms of its texture, or the image series that you choose to do?

RB: I think it has influenced more the idea of image as a series, the act of constructing a discourse with various images. The influence consists more than anything in the images potential as a discourse.

My preferred genre in the cinema is "poetic documentary." Music is always an important element, especially in the way it creates rhythm. I am most interested in rhythmic montage. The films that I could show you, that were salvaged from the fire of 1980, are two: *The Electric Float* and *I Will Carry Nothing With Me When I Die, and To Those Who Owe Me Money, You Can Repay Me In Hell* (a title which echoes the strange synthesis of a sentence painted on the wall of a bordello). The first was made in 1977 and its subject was an illuminated float: it was a lighted truck that carried musicians followed by people dancing. I filmed it in the midst of the crowd and from the top of the float. It gave one the sensation of being on a boat surrounded by a sea of people. Actually, in Salvador, there are always huge traffic jams of these illuminated floats during Carnival. In contrast, in 1977, there was a truck, the Saborosa, which was a bottle with lights surrounded by a huge crowd of people dancing. The men in Bahía sometimes dance very aggressively, they raise and drop their arms and practically punch their way through the crowds. It comes through very clearly in the film that there is a kind of channeled violence there. The potential for rebellion was very much oriented toward dance—dance that borders on aggression.

On these barges, these floats, you could detect the hidden presence of a leader of the masses, but the dance didn't end in violence because of the influence of the music. Everyone remained in the realm of play. This film is only thirteen minutes long and consists of movement and music only. It was filmed on 16 mm and produced by Thomas Farkas. That's how I met him. One of my pictures—one that I had taken standing on top of the float, of a black man clearing a path through a dense crowd with his fists, was published in the magazine *Fototica*. The original print was torn during printing and when I went to ask for compensation for damages, I met Farkas. I spoke to him about the film I wanted to do, and he became very excited and enthusiastic about it. He decided to participate in every way aspect: the developing, the

copies, etc. That's how the film began. The other, *I Will Carry Nothing*, was made later, after we had become friends. I used to screen them as much in Brazil as abroad. *I Will Carry Nothing*, which we filmed in the Pelourinho district, combines photography and moving images and was a project I did during a six-month period in 1979. It's twenty minutes long and will be shown at the Museum for Women in the Arts in Washington, together with the piece, *Door into Darkness*. My creative process is somewhat syncretistic. I don't possess a language that pertains strictly to traditional cinema. It's made up of disparate fragments. It acts like a montage, as is the case with my books, my installations, and my exhibits.

DOCUMENTARY PHOTOGRAPHY

TS: We know a lot of photographers who've come to their craft through large agencies, such as Magnum (where you also were). Some create their work as a function of the objectives and aesthetic of these agencies. What were the circumstances that led to your participation in Magnum?

RB: The Magnum issue is a bit strange because when I went to New York in 1972, I brought them a portfolio of my black and whites and when I went there, I met Charlie Harbutt (without knowing who he was). He liked my pictures but it didn't go any further than that. I returned to Brazil and one day I received a call from Magnum asking me to do a kind of anthropological project for an educational foundation, in a small village of sugar planters and farmers. I had to go for a year and spend about ten to fifteen days every three months doing portraits of a family in their natural environment. I did them in color and they came out well, nothing exceptional, a bit classical. But some other pictures in black and white emerged, pictures which to this day I really like—and I made them while I was doing the Magnum project. During this time I was familiarizing myself with the cinema. The truth is that I didn't know too well what Magnum was all about. For me it was a photography agency, but I hadn't realized what kind of agency it was—even less, the quality of the photographers who were part of it. I had no idea about the history of photography. This may sound like an exaggeration, but I truly had no idea who Cartier-Bresson or Robert Capa even were. In the end, I submitted my project and forgot all about it. It was presented as a slide show for part of an education project, but was never published.

So, I didn't really have any contact with anyone from the agency until 1980, when I was passing through Paris and brought them a portfolio from Pelourinho. They liked the pictures very much but they weren't sure how to use them—because Mary Ellen Mark's work on the prostitutes in India had also just come out. I thought the two projects had very little to do with each other, but in the end I became a correspondent for Magnum. In 1981 I went to live with a woman in Paris, and so I couldn't really continue being a foreign correspondent for them. But before I could become a member of the society, I first had to complete a two-year candidacy as a correspondent, and then work for a period as an associate. So, I was a candidate for two years, during which time I realized that I wasn't as interested in becoming a member because of my desire to pursue my own projects and personal interests. I didn't want to box myself into a certain cat-

egory, nor did I want to travel constantly and work so that I could prove to the members that I was good enough to become one of them, not to mention having to sell ideas and projects to the press that weren't really my own. I was never much under the mystique of Magnum, though I did have friends there, some of whom I am still close to. At that time, Sebastião Salgado was the one who encouraged me to stay. There was also Gilles Peress, Josef Koudelka, René Burri, Alex Webb, and Raymond Depardon. But in the end, while we encouraged each other, I never felt any "familial" connection to Magnum. Magnum is an organization that tries to monopolize a project more or less connected to the press—which, in my case, was something becoming less and less interesting over time. In 1983, I finished a project that ended up in the hands of *National Geographic*. After a year in Paris as a candidate I broke up with the woman, separated once more, and, I decided to go to Brazil to try to do a history of the Indians. It was something that I had attempted to do years earlier, to make a portrait of a society existing within Brazilian society. Sebastião loaned me some money and helped me get to the Gorotires Indians with the help of some miners looking for gems in the south of Pará. I was able to produce a very energetic, very beautiful, and traditional project. I had recorded a war party initiation ceremony of extraordinary visual power. I was able to convince the Indians to return to their village so that I could photograph them in the context of their daily lives at home.

On this occasion I went with an anthropologist who wrote a very didactic piece to accompany the photos and the editor for *National Geographic* took his descriptive vision and expected something much more journalistic from me. He didn't understand what the photographic essay was really about. In those days, you had to turn in all the materials for editing at the magazines, so I had to send in the film for them to develop, which meant I couldn't create a more personal edition of the project. Only later, when the project was published in other magazines (and I had more control over the editing process), did the guy who edited the *National Geographic* piece call me up and apologize to me, explaining that he hadn't approached the material with an open mind. It was the only time in my entire career that anyone had called me to say something like that! There was—and I think there continues to be—a great problem in magazines with regard to their giving consent to the photographer's being involved in the editing process, but for me this involvement is essential. There are many interests behind the media. We live immersed in a world of clichés represented through the same images, images that are very deceptive. One can create projects that are very important, but they are often ruined by these interests. It has happened in the past, and it continues to happen today.

But the idea of doing a photo-essay wasn't foreign to me—I worked very well in this medium because it allowed me to create something more poetic, different, without ceasing to have a documentary purpose. The photo-essay was like a foundation, almost like a notebook. I still believed in those days that what was published in a magazine could raise the consciousness of the public. Today, television has a much greater influence than this kind of publication, but the information that TV conveys is under very strict controls. We don't even have the possibility of creating underground TV channels that could be beamed by satellite independently. Everything is controlled now, the magazines as much as the newspapers. It is almost impossible today to publish a

convincing piece, in a complete way, with text that deepens understanding and delves into various questions.

TS: Does your disillusionment with documentary photography have anything to do with the political forces that prevent the possibility of penetrating the media with some other format?

RB: I think so. I was in Paris in 1981 and 1982, photographing the neighborhoods where there were "okupas," Africans and West Indians living in densely occupied areas, especially in the fourteenth *arrondissement*, a neighborhood that was literally falling apart. This essay had a very intense aesthetic part in color, but it was also a very dramatic story of real people in the midst of a real struggle. There was an organization made up of West Indians who offered assistance to the black children of the neighborhood. These people were doing very important social work at the time. It was a project I like very much, but I never published it. I was at Magnum, and they didn't distribute it to any magazines. They didn't want to, because it wasn't a subject that dealt with the exoticism of other countries. The situation was right there (in Paris) which bothered them, and my pictures were in color which bothered them even more. Prior to this, I had done some outlines of books based on this subject. I also did a very classical maquette of the photographs of the Caiapós Indians. It's a project that doesn't completely avoid the cliché of the Indian but, as a book, it opens a much more profound vision of them. (This one wasn't published either). At the time there were people in France who wanted to write something about what was going on in the fourteenth *arrondissement*, but they didn't know where they could do it. For my part, I didn't feel like holding on to see what editor would be able to publish it, so I just decided to continue doing more photographs and continue with my project before focusing on that one. The more documentary material is still at Magnum. The funny thing is that the only agency with which I've had contact in my life is different. It's not run by a manager who decides everything that should be done. This was also one of the reasons that made me continue there—the freedom to be able to design my own projects. Magnum has an impressive potential and an impressive collection of quality images.

Look, the last Venice Biennale showed a lot of documentary-style projects done by "artists." But many of them didn't even know how to adequately use photography. A lot of photographers at Magnum have done stories that are probably more powerful, but the common thing today is for someone to come and say: "No, I'm an artist, I'm not a photographer, but I resort to photography for my projects. I make conceptual proposals." What happens is that these kind of people don't even know how to do photography—or they only know how to do with it with an automatic camera and a flash, which is something I consider really lame. If you were to study the history of photography (which I finally have just done myself) you would see that projects from the 1920s and '30s are much more convincing. We are living in a age of decline of the language of photography.

TS: Do you ever attribute to yourself this attitude of: "I am an artist who only resorts to photography?"

RB: Sometimes, when people annoy me, I just say I'm a painter. I've also gotten to the point where I sometimes say that what I do is not photography at all. I don't think of myself exclusively as a photographer. My interests lean more toward other forms of expression. I'm an artist, and so were Brassaï, Cartier-Bresson, and many others who never left photography. They know the craft, they know how to do it. Nevertheless, I see myself as a person who sees with the eyes of a painter (as I said before) but with the speed of a photographer, perhaps with something of the sculptor added. I bring them all together, like a composer.

TS: Regarding the works you did for Magnum: Did you consider them "Magnum projects"? Did they offer you a wider distribution, new resources, better documentary guidance?

RB: The majority of my subjects were at the fringes of what the press really wanted, except in the case of the Indians and the street children, which are both clichés of Brazil. The most interesting projects were the result of contact I made with Rainer Fabian, who was a reporter for Stern in Brazil and with whom I had collaborated a number of times. He had excellent and original ideas. We would edit and send the photos directly to Germany. The photos weren't even seen by Magnum. The final product would then be sent to the agency for distribution. The distributions by Magnum never went very well in my case, which was probably due to my use of color prints for subjects typically photographed in black and white.

TS: In interpreting your later works, I would say that your time at Magnum didn't much influence your photography, which tries, more than anything, not to be "documentary."

RB: Sure, what I've been doing since 1990 isn't really documentary. In a certain way, between 1981 and 1983, I tried to tell stories with my work, and in this narrative style there were certainly overlaps with the work of several other photographers at Magnum. But in 1983, when I did the project on the Indians, I was invited to participate in the Saõ Paulo Biennale, thanks to the support of the artistic director, Esther Emilio Carlos. I mounted an installation based on my second trip to the indigenous village. It was a circular piece, like the dance of the Caiapós, and I used one of their songs of initiation. There was a principal personality, the Joker, and a deaf-mute Indian boy named Amaú, basically an outcast in an eminently vocal society. In the audiovisual installation, Amaú would communicate with images that represented the realities of life in Brazil. The work was partly documentary, but also there was a very poetic and artistic element to it. I was living in two parallel universes. In 1974, I had done a project which was a collage of photos called Strangler in a Strangler's Land, which was recently shown in the Fundación la Caixa in Spain. In 1978, the same project was shown for the first time in an exhibition called Negative Filth. All the photos were mounted around each other on rough paper and were shown as if they were a huge notepad. So the act of having an aesthetic and a particular point of view to show certain themes came from far away and was very intense.

I would have liked for some of the work I did for Magnum to have been published, the more traditional stuff, perhaps, but, with rare exceptions, such as with Stern, it was

always very difficult. The end product was always very frustrating. My place in the Gorotiré village among the Caiapós was what made me think of that duality of expression. But my most personal projects still seemed stimulating to me.

I think that you can still do projects that are published well, but they tend to lack a personal identity, to offer a personal vision. Actually, right now I am considering doing a project with a Brazilian editor, using the material from the Caiapós, in such a way as to reflect much more of a connection to my own experience of living with the Indians. I was looking for an alternative society in Brazil in those days. On various occasions, I tried to get into the village to shoot pictures, but I couldn't, not without permission. But with Alceu Massar, with whom I had been director of photography for three films about Indians, I was able to. So, you have a subject in black and white, photographed with color film; you have individuals from distinct periods of time that reveal the process of maturation (in relation to my own discourse) which came to a conclusion in 1983 with the installation *Dialogue with Amaú*, which was at the Saõ Paulo Biennale. This book is still just a project, and it will have a structure and format, a kind of reading, which will be nonlinear. I don't want it to function solely as a documentary about the Indians, even though that's partly what it is, because photography, in every case, is always a kind of documentary.

TS: What, in your opinion, is the role of documentary photography in general, but also in light of the contemporary status of representational photography?

RB: The documentary impulse will always exist. The desire to see into the future, what happened today, will never go away, whether as photographic representation, strictly speaking, or as historical documentation. In the recent festival in Perpignan, at Visa pour l'image, they showed a series of stories, the majority of which were unedited. Sometimes you photograph specific human situations for months, but you're only able to publish four or five pictures. We should have other arenas to show certain projects, even though something like that would show the kind of photography more tied to history, sociology, or anthropology. Nevertheless, you can't confuse this with art. I think the greatest mistake of the Venice Biennale was the juxtaposition of different kinds of photographers who were all presented as artists, when in fact many of them weren't. Which isn't to say that they're bad photographers, but they were out of place there because their work is more thematic and topical, rather than expressing something of the artist through the art itself. For the artist, the subject is merely a pretext for expressing a much more profound internal framework, a framework that transcends time.

TS: And this tendency is the result of the "'museumification" of many projects that began as pure documentaries?

RB: I'm not sure. Cartier-Bresson has some work from the thirties that isn't pure art. There are many photographs that, in spite of being documentary, have that timeless aspect that's appropriate to the province of art. The problem is that the popularization and excess of art commissions that we are experiencing now stifle creativity by emphasizing the subject over the artist.

CRITICS, SUBJECTS AND THE MEDIUM

TS: *Dulce Sudor Amargo* (Sweet Bitter Sweat) is a very pictorial book. When they talk about a new expressionism and of colors that recall Goya they are talking about this book. The photography on the cover alone is a dictionary of Postimpressionist paintings.

RB: In this book, the most appealing series to me is the one of the prostitutes. They are all outdoor colors from Salvador, so special, with moments of absolutely captivating light. For me, they also allude to another era, or a more contemplative attitude, like when you smoke a joint, then, continuing to smoke, you contemplate the light—something like that.

I edited this book with Jean Yves Cousseau, who also did *Silent Book*. He is a very important person to me. Our conversations about photography, back when we first met in 1984 or '85, were always incredibly stimulating. I chose the photos for the book jacket. In general, I'll do a first edition, and only then will I work together with the material to create the final dummy, very similar to the process a film director goes through with his editor. I love editing. During my first few years at Magnum in Paris, Jimmy Fox would send me to edit, re-edit, and edit again. With the project on the Indians, for example, I edited it numerous times. I changed the pictures, removed some, put in new ones; it was a continuous process of maturation. This means you eventually end up with a final product that doesn't contain the pictures that the editors of magazines would want left in. This makes them a bit insecure. What I would do is make several versions of the same project, beginning with the one that was most personal and, for me, the most interesting. Look, the author of a project must know how to edit his photographs. If he doesn't, then he doesn't really know what he's doing and what he produces is going to be something unconscious or merely accidental. It's always seemed odd to me that some photographers do not know how to assess their own work. It's incredible to me that someone could be able to create an absolutely extraordinary image and then, when he puts together his exhibit, choose a bad one.

TS: Did this book represent the beginning of your future explorations? I keep thinking of Magnum and of your subjects: did this project represent your farewell to the agency?

RB: I wouldn't speak of a departure from Magnum. What I propose through the book is a kind of thematic subversion. Aperture was interested in publishing one with the prostitutes of Pelourinho as the subject, but I had already made the film *I Will Carry Nothing* which concerned them. When I decided to do the book, I was interested in moving forward. I tried to present the harder side of the prostitutes without surrendering, without sacrificing or obscuring, their sensuality. I wanted to juxtapose these two aspects of the prostitutes, which I hadn't been able to do until four or five years after having begun the project in 1984. They were two distinct periods in my life and the act of mixing both stories was a way of deconstructing a straightforward subject into a more subtle and fluid form. I wasn't interested in doing a book exclusively focused on the terrible aspects of prostitution. In *Sweet Bitter Sweat*, I focused on the themes of pain and pleasure. I like to explore these contradictions. The installation, *Dialogue with Amaú*, was composed of five projectors controlled by a computer which

created random sequences. After fifteen minutes the tracks started over but they didn't return to the beginning, instead they created different connections among the images. It was like a game where the cards get shuffled every fifteen minutes. It's much more difficult to do something like this with modern equipment.

Sweet Bitter Sweat then, represents the beginning of the second phase of my work and it was especially important to initiate it with a book. A book endures. Unfortunately, few people saw it because the distribution wasn't what I had hoped. I also have another book, Negative Filth, done in black and white, with one part in color, that was never edited. The idea emerged as a result of an exposition I did in 1978 which traveled to a number of Brazilian cities and to Milan. Another, Nakta, won the ex aequo prize in Arles, but it's not very well known. I would love to see all these unedited books re-edited, and just a bit more well advertised. Sometimes it seems they don't even exist.

TS: You photograph these incredibly dark worlds, where ingenuity and perversion always go together. Is this the way someone with your education and background sees the world, or do you think this is one of the constructs of photography?

RB: In part I still hold onto the belief that things can improve, get better. I still have hope for humanity and at the same time, I see the perversity, I know it, I've lived it—in many different ways. Innocence and perversity are always present in life. If they weren't, humanity would cease! But there was a time when I thought that one of the functions of photography was to demonstrate the drama of being human. Today, I believe that this is one of the functions of art, together along with the attainment of pleasure.

TS: To bring about change, to denounce, to moralize through photography—do you believe in this or not?

RB: I believe that in the history of photography there are many examples of works which helped to change things in some way. In my case, it only happened once. During a project in Santiago de Compostela (in Spain), I photographed an unlit reading room in the dark. It was completely finished in wood, and had in it sculptured skulls and paintings of naked women. Naturally, there was a portrait of Franco on the wall, next to the skulls. The photo was published and they later removed the image of Franco from the hall.

There was actually another time in 1985 or '86. The City Council of Salvador called me to do a project on the crumbling architectural decadence of Pelourinho. I took new photographs and used some old ones. I created an audiovisual presentation that was shown to the president of the Republic, who at that time was José Sarney. I incorporated an excerpt from Mahler about opulent churches in the midst of poverty and misery; it was pretty dark. The governor at the time, Antonio Carlos Magalhaes, and the archbishop both left the place fuming. About one year later, they initiated a "clean-up" project in Pelourinho and in the entire region. Some of the girls were left there, but many others were transferred to other neighborhoods.

Photography can do that: you denounce something and you believe that it will help

people, but sometimes the result is exactly the opposite of what you hoped for. I think that, instead of helping, I ended up hurting those who were forced to move.

TS: Another determining element in your work is your confrontation with power and the exercise of power, even when you only show its consequences. You don't express yourself through the use of symbolic elements, nor do you force the images themselves to express them, but you do it through an effect, through the evidence of something that is real. It's a situation we all can recognize, and if we feel any connection to it, it forms part of our personal imagination. Regarding your search for representations of either the popular or marginal world, stripped of the advantages of the dominant sectors, does this have anything to do with your reflections on power, whether it is arbitrary or not?

RB: Yes, it does have to do with power, because the truth is we are completely surrounded by power, and power is always an oppressive force. In Brazil, this oppression is very apparent. You feel that power doesn't do anything good, nor does it make life any easier; quite the contrary. Power does everything possible to make life more oppressive. One time, for example, when I was studying at ESDI, during the dictatorship in Brazil, I saw how the government demolished a group of houses under a viaduct where a tram passed by, in the middle of the Lapa neighborhood. They destroyed everything just so they could create a new intersection and a larger space so some sculpture in an adjoining park could look better. For me, this is the exercise of power: moving people by force. I did a project in 1973 where I juxtaposed the architecture of Brasilia with that of the favelas, the "fringe cities." My photography, from the beginning, has always had this side—not to condemn, but, perhaps, simply to observe. I did a lot of projects incorporating a certain level of irritation with a desire to say something; this slant is very much a part of my work.

TS: For ideological reasons?

RB: No, not exactly ideological reasons. I've always had a tendency to be a bit anarchic. Creating these images has been a way for me to attempt to elicit some reaction in people. To this day, my work is considered both violent and highly politicized. Mario always said this about my work—ever since Pelourinho—since we met in the seventies. In 1975 and '76, when I began to photograph the northeast of the country, where they are constantly entangled in an extremely precarious situation, where the struggle to survive is the most extreme, alongside an incredibly rich humanity, the politicized and violent made up part of my daily life. Today in Rio, for example, I don't see things the same way. In large cities today, the question of poverty, which is sometimes connected with a simpler lifestyle and a richer humanity, is already deteriorated. I don't know how it will be now in the northeast of Brazil because I haven't been back.

My more recent works deal with the same thing in a different way. In some of my projects, such as Silent Book and Porta da Escuridão [Door into Darkness], I reflect on the fear associated with human sexuality. This aspect appears on a secondary level of the book, but in Porta da Escuridão, I included a projection of pornographic images taken from a video scrambled by Canal Plus, so there was a lot of static and interference. The same

thing happens with my project on the boxing school; in spite of what its title might indicate. I was awarded a grant to do that project because I presented it to the school as a microcosm of Brazilian society. If it had been presented in any other way, they wouldn't have given me the grant. If I had said I was going to work there the way I did in a studio, making observations about that world, about its state of decay, about the theme of time and the body—the body as a dead spirit—they definitely wouldn't have given me the grant. But photography is still associated with these kinds of subjects, and that continues to be a problem.

I did the project at the boxing school with the help of Marcia Mello, who was at the time director of the photography department at the Museum of Modern Art of Rio de Janeiro. It was then that we began our relationship and, thanks to her knowledge of the history of photography, to the collection of photos at MAM, and to our long conversations, that I began to develop a less unmediated, more immediate vision of descriptive photography. It was about that time that part of my work began to take on a somewhat less harsh tenor. This happened after 1992, after that awful piece, the installation *Pequeñas Reflexiones Sobre Cierta Bestialidad* [Little Reflections on a Kind of Bestiality].

TS: Did the gradual use of video to interpolate sequences indicate an intention to approximate cinema, a strategy of conflict, or simply highlight your facility with communication?

RB: Cinema is certainly a part of it. I've always thought about the question of images accompanied by sound. The combination of either fixed or moving images, on a flat screen or in some kind of dimensional space, creates a much more complete and involved discourse. In all my installations, I've utilized sound as an element of sedimentation in the work.

TS: And regarding your use of video (no longer a technique unique to your work, since many photographers today use video), do you think this is experimental or do you see it as being part of the future of photography?

RB: At least for now, it represents an experiment. I don't have any videos, strictly speaking. The two that I directed focus on the Brazilian sculptors Waltercio Caldas and Zé Resende. I haven't finished editing the videos that I'm currently working on. I will use them for the first time as part of a project called *Gritos Sordos* [Sordid Screams], which is going to be shown at the CPF [Portuguese Center of Photography]. I'm going to set up the installation in such a way that the exhibit will be in itself an experimental video. I will use it as another audiovisual record that will enter the exhibit will as part of a vision of time and its decomposition. Basically, it's going to be very labyrinthine, representing an element of power. The video won't occupy the photographic space—it will have its own differentiated place.

I prefer not to see too much—I haven't seen much. . . I'm not always aware of contemporary trends in art. I extract the information that I need from museums of natural science or from older works especially regarding video or photography. Street markets and flea markets create much more interesting situations for me than museums of contemporary art. What I do see has to be something that I'm drawn to. My portfolio is

quite distinct from what would be considered a trendy portfolio today, that is, technical, cold and more than anything part of the world of plastic art. The so-called culture of the north is rubbish to me. An artist like Gursky, for example, who only has ten interesting pictures, and thirty that are totally useless, doesn't do anything for me. Criticizing indifference must be done in a very forceful way; it should be accompanied by a work of real power. If not, the result will be obvious: abandoned streets with empty houses—a commonplace. The hyperrealists have already done this—they don't offer anything interiorly new. They try to present themselves as something completely novel, but they're not, except for the fact that they sometimes manipulate a few of their images on a computer—but that doesn't mean anything.

TS: Would you say your formal interdisciplinary approach and your use of multimedia is a consequence of your eclectic artistic formation?

RB: It's possible that it comes from this mix. The work that I will exhibit in Portugal will be very interesting because I'm going to try to push all the limits, from the reliance on collected objects in the exhibition hall to the multiple projections. I'm not trying, nevertheless, to continue along the same path. I see it as much as an end of a phase as a beginning. I think that everything related to technology (DVDs, CD-ROMs) is interesting. I haven't mastered technology and sometimes that's very frustrating for me, because there is a huge time lag between the conceptualization of a project and its execution through a computer. I feel, in contrast, a greater focus on the subject and the materiality of things. A return to painting, perhaps, independent of technology.

TS: But doesn't it deal with a certain fascination with technology, the way works by other artists do?

RB: Not at all. I much prefer the kind of project I did with equipment that was already quite old at the time. To work with that keyboard was better than with new technology, which needs to be programmed in a computer minute by minute, second by second, all about the timing of each image. But with a Rollei you get a kind of fetishism associated with time and an old, used object.

TS: Are you bothered by the idea that, with modern technology, it becomes possible not to make any mistakes?

RB: Not only does it become possible not to make mistakes, but it becomes impossible to incorporate any kind of randomness in your work. It just ends up becoming something very controlled and I like to work in a vortex of imbalance. In my pictures, nothing appears completely straight, for example. If you analyze my project from Pelourinho in terms of how it is framed, you can see that there's always an imbalance to it and that the crooked lines are very pronounced. Playing all the time with this perspective creates as a consequence its own equilibrium. In my opinion, this is what's interesting.

TS: And how have you been influenced by the language of postmodernism?

RB: They are works in which photography is used as *performance*, as a support to the text, but they don't use the language of photography in an interesting way, as in the case of the Germans. And a documentary which is purely technical, for me is a road leading to nowhere, not at all unlike that aspect of American culture which borders on the perverse: a kind of eschatological inclination combined with Mickey Mouse. I don't share too much of this tendency. The truth is, my style is much more European—I like to journey into the past.

ADDING FRAGMENTS OF ONESELF

RB: The theme of self-representation attracts me, in an underhanded way. Formal platitudes cease to be a kind of performance.

TS: What do you mean by "underhanded"?

RB: I mean what's behind us. I care very much about this kind of work, there is an aspect of it that is connected to friendship, with personal implications. It's autobiographical, but not explicitly. The autobiographical part can be very interesting. The kind of work that Nan Goldin does, "projection," is fantastic because in reality it achieves an audio-visual of her friends in an incredibly vivid and emotional way. But you can't convert this into any kind of formula. Her life changed, she met other people, and now the result is not as interesting. I think she was/is very connected to her life experience, but it's com-plicated—if you start out doing a certain kind of work, and always do the same thing, after a while it begins to ring a bit false. The truth is that Nan Goldin produces images in the way she knows how, which she feels and transmits in a powerful way, but when you see an exhibition of her framed photographs, they lose some of their vigor. Perhaps she should be more explicit about how her works should be displayed.

TS: Your photography is notable for its aesthetic, in the sense that it appears extremely well conceived and constructed. Do you think photography today, when any kind of manipulation is possible through a computer, is becoming more about the form rather than what the form refers to, that is, the subject?

RB: There is a tendency in my work to want to transform the subject into something that it's not, into something that in some way offers ideas that transcend itself, into an image that carries you to another time. A picture of a boxing ring with mirrors, and with semi-agitated bodies communicates an idea that is not fully represented in the subject, and in a certain way, is an attempt to transform it, to bring about the percep-tion of another vision. It is no longer a simple representation of boxing. The ghosts are there, as well as the bodies.

TS: Do you think, then, that photography should continue stirring emotions in people?

RB: I think so, at least until the point when technology allows us to do the same thing with digital media. I don't have anything against using digital systems as long as they provide the same, say, quality of projection. The ability to hold a camera and control the

quality of a picture instantly, like a Polaroid, is very interesting to me. The immediacy of digital photography can also be interesting. When someone draws or paints, for example, in that immediacy you obtain absolute control and much more creativity.

TS: What kind of relationship do you have with your subjects? Do you consider them themes, pretexts, lines, forms, colors? Are they people? Friends?

RB: Lately, I've barely photographed any people. The last project I did with people was at the boxing academy. I went there regularly, did portraits, and obviously, you eventually make a few friends. The owner of the Santa Rosa school was absolutely charming. Most recently, I've been photographing nature, without people. Just a short time ago, I finished a project in Spain about people who died of natural causes. There's a museum from the nineteenth-century on the Canary Islands with a display of Cro-Magnon skulls and a room full of model sketches which were kept in exactly the same way as they were when they were created, in the same display cases. It was fascinating to see the variety of personalities, of the characters that were drawn. Each skull is completely different from the other, each smile completely distinct. In a kind of way, it is a death of nature.

In order to do a project that will interest me, I need to have time and feel implicated in the project. I don't try to do street photography anymore. In France, in 1981, '82, and '83, I did a series of these, but I'd be on the street snapping someone's photo, and they'd jump out of their skin, get pissed off, and curse me out—it was awful. When you do the same thing in Brazil, the people are much more receptive—they don't think you're exploiting them, using their photo to get rich. But it's much more interesting if the person already knows you. Street photography ends up being like a game of hide-and-seek that doesn't interest me very much.

TS: Many consider you to be a very shy person, distant, and even a bit neurotic. How does a person so detached achieve the kinds of portraits that you do?

RB: One may give the impression of being very shy. What happens is that, when I do those projects, I let my defenses down. Many people from professional backgrounds consider me a bit unfriendly because I get defensive about certain aspects of my work and because I have no desire to be popular or to impress anyone. Those who like me, like me; and those who don't, don't. I don't go out of my way for someone who does not like me and this, obviously, can create animosities. In the world we live in, I think there are many people who are motivated solely by self-interest, and this makes me somewhat distrustful of others. Friendship is the result of a process—it doesn't happen instantly. I won't attempt to explain how one develops intimacy with a person one is photographing because I don't know. Creating a portrait of someone requires empathy. I'm not there taking someone's picture to take advantage of them or to steal anything from them. Perhaps that's why I've never had the inclination to take anyone's photograph secretly—I only did it that one time in Paris.

The project I did in Pelourinho wasn't anything exotic for me. To begin with, I was considered one of them at that time, as I never had any money, I was always living on the edge. The people I photographed there were absolutely beautiful to me—they were

real, authentic, strong; they had their own kind of wealth. The women especially were very generous. They had character, we created a dialogue between us and there was plenty of empathy. I had no desire to do any kind of project on prostitution. I was seduced by the place, by the women, by the textures and the rhythms. I always felt the rhythms. I felt pretty much at home there; there had always been lots of children running around and I have many of photos of them.

Nowadays, I would feel much more inhibited in a place like that. At the time, I believed that my work could actually help people, but I don't feel so comfortable photographing certain situations anymore.

I had an exhibit not too long ago at the Greek Cultural Center of Oiticica in Lapa. Not far from this place, there is a red-light district where the prostitutes are all older. I could do a very interesting project about them—about old age and about sensuality in old age, but I don't feel the need so much anymore to make that connection between people and photography. My aesthetic motivations are very different now.

TS: When one looks at your work as a whole, one can see that it contains certain "code words" and that you construct an ensemble or a discourse around them. They recur throughout your work but always with a different proposal, as if they constituted a different project. Do you actually have your own vocabulary—that engenders your work? Do you use images as if they were words?

RB: I think so—and I do the same with colors, different kinds of light, things that end up repeating themselves. There are colors that come from the era of painting and I continue using them. When I create a version of one of my projects, it's similar to a game of telephone—you end up saying the same thing except what you say has clearly evolved. It's the same as what happens in music. For example, if you take a chord played by João Gilberto, first you have the melody, then he elaborates on it, subtly transforms it. It's not a radical change, like what happens when a chord goes from rock to samba or from samba to rock. He elaborates like Morandi. Morandi painted nothing but bottles, but they're all different bottles.

TS: Your painting of *capoeira* makes clear reference to a story. Would you mind telling that story?

RB: *Capoeira* is both a dance and a form of fighting. So it implies pleasure and pain at the same time, you know? For me, the sequence of images I did signifies life and death; it's a discourse created using the elements of drawing and painting.

TS: Have you ever done any more of this kind of series of photographs or shadow theater?

RB: No. I've done similar kinds of series, but *Capoeira* is the only one that truly has this kind of shadow boxing. It is very graphic but at the same time there is an emotion and reality that aren't visible. For me, this work is totally unique. I have three projects that are organized in a sequence: *Dialogue with Amaú*, another book which has a boy standing in front of a pink backdrop while talking, only with the characteristics of a portrait, a

portrait that speaks. The last is a work called *Chupete*, about a group of street children from Bahía, which is more pictorial. But the one I really like is *Capoeira*.

TS: Your latest works— I'm thinking of *Entre los Ojos el Desierto* [Between the Eyes, the Desert]—reveal the weight and inconstancy of the world of communication, which remind me of the fabulous catastrophes you see in films like *Blade Runner*. Is there any coincidence between your vision and other apocalyptic visions?

RB: In my case there is more melancholy. In *Entre los Ojos*, there is a sadness caused by the inability to communicate. The objects that I put before the projection are discarded things. I choose them randomly. It's similar to *Blade Runner* in the sense that it represents a decaying civilization; the objects are merely the remnants of that society. There's also a sculptural component to the work—the iron superimposed in this way pleases the eye, and in a certain way, clings to them.

I sold that work to two collectors, and one of the pieces became part of a Swiss collection, but I wasn't able to include the iron bars. I tried to, but the buyer told me he didn't want them because he thought they were too distracting from the piece. I like both versions, but I do prefer the more aggressive one. I had a need to kind of interfere with the piece using sculpture so it wouldn't be so plain, which is something that worries me about my painting. There certainly will be those who consistently prefer the "cleaner" version.

These interferences help create an urban dimension where there are urban images. But when the desert appears, the iron acts primarily as a metaphor. The desert has something interesting about it—its emptiness. This can be quite scary, or it can create a very strong impression. There are people who live in the desert because they love it, like the Tuareg of the Sahara, and there have always been those who go to the desert to meditate, to find themselves. The emptiness of the desert lends itself to self-examination. It's a place where there is nothing that can interfere with you.

TS: I have a reductive image of the evolution of your work. I see in it a parallel with the evolution of the novels of Hemingway. In part because of the gravity of the colors, the classic Spanish themes, the synthesis of your sentences. I also see how you have refined your style and concentrated the explication of your work using a minimum of symbolic discourse. And now, *Entre los Ojos* destroys an explication that seemed so clear. Could you comment on these digressions of mine?

RB: My projects always have a lot of information in them which unfold in other, more direct works. It's like a great catharsis for me—a stew made up of various new ingredients. Some pieces have already come out, like the one of the sharks in twelve images. From one of these works come many others, including those that can be made without photography. Obviously, this kind of work doesn't have only one interpretation, but it transports you on a kind of journey. It has expressive elements, elements of concentration, which are the eyes of the desert, and finally, elements of dispersion, including the very books onto which they are imprinted.

TS: A few questions about your method: how do you define yourself? As an artisan? A designer? A filmmaker?

RB: I work as an investigator, as a collector of moments and of objects, as someone who collects the bones that are left behind by others, like an archeologist. Nowadays, I see myself to a great extent as an archeologist who collects samples. My work no longer refers to humans but to their bones, to the remains they leave behind. I made a short film in New York once that was called Burning Gloves. It was three minutes long. I would go around during the winter and find abandoned gloves on the sidewalk, throw gasoline on them and film them burning. The result gave you the sensation of walking the streets of New York, and every now and then, you would come across a glove going up in flames. The theme of discovery is very much a part of my work. The idea of walking along, never knowing what you're going to run into next, having only some vague idea of the things that you would like to find, but without preconceived notions. In the end, my radar is always turned on, waiting for what I'm going to find.

TS: So you accumulate these found objects and you assemble them in such a way that they function as part of a project?

RB: I form these fragments and I make an outline with all the parts that I find. Each fragment, in fact, contains the whole, and could be perfectly sufficient on its own, photographically speaking, but from a poetic point of view, it needs other parts to complete a discourse. It has a lot to do with the kind of life I've lived, with the pieces that you leave along the way, the things you lose, and the attempt you make to reconstruct them. It's been a veritable patchwork, to which I'm always adding something. When I was living in Bahía and started painting again, I would walk along the beach and let my mind go blank, then I would see an image and then another, and that would give me ideas for developing textures, forms, and then I would transform them into paintings. Most recently, in Palmas, with the project I'm doing with Elba Benitez, I did the same thing. I would walk along the beach and see stones, footprints in the sand, things that would give me some comprehension related to the questions of time, of my life, the only difference being that this time I am dealing with photographs or perhaps—"photo paintings." It's clear that in the case of this project I'm developing for CPF, there are images I have in mind that I want to create, though I'm not sure I'll realize all of them. I've never done a knife in flames, the blade of a knife burning, for example. In any case, in the archives I already listed I'm adding the primary material in video which I will do in Venice, in Havana, or wherever; in my own house even, and then I will find the material to create the proper narrative.

TS: What place do books have in your life, I mean, what importance do you give to them?

RB: Books have a closed discourse. They are a collection of self-contained ideas and images. Obviously, we can leaf through a book going from the end to the beginning if we want to, or from the middle of the book in either direction, but books have a sequential order. As I said before, Sweet Bitter Sweat is based on revealing the link between pleasure and pain. Nakta is very reminiscent of the installation Little Reflections. This project began in 1988. I was involved in a car accident, which impressed upon me the

idea of death. There were also a lot of people around me dying of AIDS. It felt like death was hovering over me. I began with a project on bestiality that evolved into more of a reflection on our potential for dying of sadness, of feeling it and then provoking it. The book ended up being an extension of the installation so I only had to find a really good text to create a dialogue with the images that were already there (some of them were from when I started in photography in 1994). I found it when a friend of mine placed in my hands *Nuit Close* [Closed Night], by Louis Calaferte. On the surface, *Nakta* responds to a classical vision of joining images, but thematically, the images as well as the text are not traditional. The photos contribute in a much more focused way and I wish that each photograph could stand on its own—not like the installation *Little Reflections on a Kind of Bestiality*, where they were arranged in a slightly more complicated way. In terms of rhythm, the book has nothing to do with the installation, it only makes a commentary on it. Any attempt to reunite images in a catalog is, in some way, useless. It becomes very difficult to offer a good sense of what the exhibit is about. But I never leave aside the book versions, and sometimes, I have to explain a lot because of these questions.

TS: Do you think that CDs and DVDs will become the necessary complement to books?

RB: I think they will be, especially for some pieces. The CD-ROM was actually something that motivated my last exhibition in Brazil. I decided that the catalog would be small. I worked with Carlos Azambuja, who has spent many years dedicated to cinema and who has an incredible technical and theoretical knowledge. To work with him was very interesting because we complemented each other well. I chose images from some pieces of a CD-ROM and I gave them to him. He manipulated them and created beautiful effects of movement and juxtaposition. They are new elements that help people have at least some idea of what my installations are like, something closer to cinema than to photography. I'm at the point of publishing a book about the installation *Between the Eyes* (a triptych, actually) where the main component is a DVD, since it offers the kind of dynamic dimensions you get in film, something that a book, by itself, can never have.

In any case, no matter how seductive these new technologies can be, they seem to me to be very vulnerable to mysterious problems that just become a nuisance. I have a great desire to go back to creating projects that are born of the imagination that are created "ex nihilo," rather than through images captive to other realities. Works that depend less or even not at all on machines, maybe just a little on painting—that's it: painting.

Miguel Rio Branco was born in 1946 in Las Palmas, Gran Canaria. A photographer, painter, film director, and author of multimedia exhibitions, he studied at the New York Institute of Photography and the School of Advanced Industrial Design of Rio de Janeiro. He has worked as a still photographer and director of photography, and has directed numerous experimental films. At the same time he has developed a unique style of documentary photography, characterized by his use of color, which has been published in various media throughout the world. He is a foreign correspondent for Magnum. His work in photography as well as in cinematography has enjoyed international recognition and has been awarded numerous prizes. The film, *Nada levarei qundo morrer aqueles que mim deve cobrerei no inferno* [I Will Take Nothing With Me When I Die and To Those Who Owe Me Anything, You Can Pay Me in Hell] won the prize for best photography in the Brazilian Film Festival, and both the Special Jury Prize and the International Critics Award at the eleventh International Documentary and Short Films Festival of Lille in 1982. The installation *Entra Los Ojos* [Between the Eyes] was exhibited at PhotoEspaña 2001. Rio Branco is author of various books, the most recent, still a work in progress, corresponding to the installation *Gritos Surdos* [Bitter Screams] in the Portuguese Center of Photography.

Tereza Siza holds degrees in philosophy and education from the University of Oporto where she was professor of Secondary Philosophy Education, Social Communication and Photography between 1970 and 1996. She has commissioned various exhibitions as an independent curator and has been director of the Portuguese Center of Photography, an institution dedicated to raising awareness of Portuguese and international photography, since its founding in 1997.

SELECTED BIBLIOGRAPHY

Calaferte, Louis. *Nakta*. Curitiba: Curitiba Cultural Foundation, 1996.

Carmo Seren, Maria do. *Gritos Surdos* [Bitter Screams]. Oporto: Portuguese Center of Photography, 2002.

Duarte, Paulo Sergio. *Pelo do Tempo* [Hair of Time]. Rio de Janeiro: Helio Oiticica Center of Art, 2002.

Nouhaud, Jean Pierre. *Dulce sudor amargo*, [Sweet Bitter Sweat]. Mexico City: Fundo de Cultura, 1985.

Pedrosa, Adriano. *Entre los ojos* [Between the Eyes]. Text by Maria de Carmo Seren. Interview with the author by Marta Gili. Barcelona: La Caixa Foundation, 2000.

Strauss, David Levi. *Miguel Rio Branco*. New York: Aperture, 1988.

PHILIP-LORCA DICORCIA

speaks with Nan Richardson

PART I

Nan Richardson: We have basically forty-eight hours to do this interview and hand it in, so it won't be the most *reflective* of efforts, but it's great to see you anyway!

So, what are you up to now? Are you still teaching?

Philip-Lorca diCorcia: Yeah, I do still have some kind of relationship with Yale; I'll go back this spring. But I had to stop for a while. What I did was travel up there for a four hour period of review with a panel and students rotated their work for critiques.

What happened was just after September 11th, getting in and out of New York was just awful—everything was. And I found myself up in New Haven where there was no response whatever to what was happening in the world. Of course, it was a pretty over-whelming event to respond to, but there didn't even seem to me to be much discussion of it there. Added to that, the university couldn't care less about the art department, because they don't even consider an art degree a real degree. After all, it doesn't involve any discipline that can be measured: no tests or licenses or anything like that. I was asking for them basically to make it easier for me to teach there, and I got— nothing. At some point I realized I had worked there ten years and I couldn't even get a parking space. I don't even have an ID or pass that can actually open anything; it doesn't even get me through doors there. In fact my ID is stamped in large letters, 'TEMPORARY." This, after ten years. Just because I am not willing to live in New Haven

and deal with paperwork, they don't want me (though they are certainly happy to use my name to attract students there). So I said, "Not going to do it anymore. I'm not coming back." Then, well, I thought, maybe someday my son will want to go there. Of course it could be that Bruno's not Yale material, but then George W. Bush wasn't either, and he got in. Well, okay, he had connections. [*Laughter*]

NR: Are you still doing much fashion work, commercial jobs? Was that where you were earlier this month? Or was it an art gig?

dC: I'm just back from three weeks in Brazil. The word art and job are not supposed to go together, but yeah, it was kind of a job.

NR: And when's the new show happening?

dC: This next show I am having is in the Whitechapel in London in June 2003. The next gallery show will be at Pace Wildenstein in Chelsea in September 2003. The show is the content of the book that I didn't actually finish—it's just being finished now. It's work selected from twenty-five years of stuff. Not necessarily belonging to any specific project but work I tapped because I was interested in pulling things together that were unrelated and there seemed to be a kernel of something. And by going over a lot of work, both work I did on assignment and work I did on my own, I came up with the seventy-six images that comprise this book. To me it's one of those books that you almost want to include instructions with. Tell the reader, "Look, you have to start at page one and go through it chronologically because it's the order it requires." Now that's hard to ask and I don't know how I'll get away with it in the exhibition. But there at least they images are all lined up in a row and you're supposed start at A and end at Z. I just don't know if it's going to work that way in practice.

But in terms of production of personal work that's the only thing I've really done in two years. I can't really blame that on any particular thing. Initially it was my own resistance: "Okay, I've achieved some measure of success, why should I become a slave to it." But you do become a slave to it to some degree. You're now a servant of all the demands suddenly made upon you. Unless you want to establish yourself as a full-time professional artist (and I don't consider myself to be an art pro and don't really want to be one), it's not a comfortable position.

NR: Is that why you dabble in the commercial? Inoculation against art? Or is it the lucre?

dC: It's not that I do other things just because I need the money to support my art habit. I do other things because I find it interesting to be involved in that impure world of commerce. I find it very *uninteresting*, most of the time, to be involved in the art world. (Not that I don't like artists or anything like that.)

NR: Because it's self-referential? Tends toward bombast and pretense? Is too much of a small pond?

dC: It's all of that, sure. It's just hard to spend that much time and that much effort on

something that is enormously loaded with pretensions but everyone will admit has little or no effect on the world at large. Even politically correct art has little or no impact on the world. After September 11th that was an issue for me. I hate to say it, but whether I want to struggle through that uphill part of the curve (that is always the most difficult part when you go from finishing one thing and starting another) for something that has no traction of meaning. It's something I haven't quite resolved, to tell you the truth.

NR: September 11th must have affected you especially as you live downtown.

dC: Yeah, and the last project I did, the *Heads* series, had its opening September 13th. So that, in fact, there was *no* opening. That would have been the last new work I showed—if it had showed. Normally it takes two years to go through the process of developing a concept and executing some part of it so it's finished. Add to that that for one reason or another these last two years have been filled with attempts to do something else. Like video, which I've become interested in, and which hasn't worked out for pragmatic reasons, but made it clear to me that I don't want continue to do the *same* thing.

NR: Books tend to be complicated and circuitous, as I know well. How did this one happen to evolve?

dC: Long story. Sure you want to hear this? The book started long before the show, when a publisher wanted to do a retrospective. You might know him, Bernard Picasso?

NR: Sure, I met him a couple to times with Claude and Sidney [Picasso]. I thought he was a dealer, though.

dC: Well, he had a small press but had actually only published one other book: a three-hundred-page book of Picasso's ceramics. He is a big supporter of my work. So he said he'd like to do a book, but a retrospective kind of thing. And I said, "I'm more interested in doing something that's a project in and of itself, not just a survey, and if you do that one first, I'll do the other one down the line." He said okay, and then, as you've probably experienced, that fell apart for personality reasons—not my personality. [*Laughter*]

Then I ended up with Louise Neri being the editor and it went from one publisher to another as her publishing fortunes rose and fell and in the end I ended up with Jack Woody at Twelvetrees Press. He seems the least commercially concerned and least difficult person I've ever dealt with and I just did it. Most of the people I've met in publishing—at Taschen, Phaidon—just disappear. People come to me and want to do a book and three months later they're gone. The world of publishing the last few years has been in total turmoil. Then, too, I was pretty naïve on how much it involves. I thought it actually costs more than it actually does to produce a book. So I let other personalities involve themselves in a way that delayed this thing for a couple of years. It's a really boring, tedious story, I warned you.

The way it turned into an exhibition was equally almost passive. Somebody wanted to do a big show at the CNP [Centre Nationale de la Photographie] in Paris and I got a bit

uneasy with that. My reaction was, "No, I don't want to do this." It was a kind of retrospective they were putting together and a group of places were going to do it and in the end I felt like I was not ready for that kind of retrospective event, if it was just a limited survey. I know I can fill the same space with these seventy-six images but it makes the show a process and investigation and experiment. And it's a gamble—I will never even have seen it in its entirety before it goes up.

NR: What do you mean?

dC: I will never have seen the prints together. That is, no more than ten at a time, while checking them in production. Until I see it up I have absolutely no idea if it's going to work. It's going to five or six places afterwards in Europe and if it's a flop I just have to take responsibility for it. But it made much more sense in my mind to do it that way than to participate in the flogging of one's own name and career, which is what a lot of big retrospective shows amount to.

NR: Cartier-Bresson said to me once that he felt as a photographer if you take five good pictures a year, you are exceedingly lucky. Luckily Henri is ninety and can have a four-hundred-print retrospective (that was also at the CNP!).

dC: Yeah. But whatever they call mid-career—whatever they call what I am—they decide I have to do this.

The history of photography is so linked with pragmatic uses of the media that to ignore them would be impossible, and also undesirable.

If I were trying to make a point, it would be far less interesting than if I allowed myself to be sensitive to the point. That's how I try to approach the meaning of the projects I do. I'm full of regrets in hindsight. Like when I did the hustler pictures I made a very intentional decision to be theatrical about it, because it was in Hollywood. I had this other problem that I had established the parameters of. I had this one street on which to work, usually a hotel room, and within these parameters I had all these variations. So how was I going to do it every time? Sometimes I used the device as the activating principle—a light, something that wasn't material, just a photographic trick. And I did it purposely. I photographed ninety people for that project and the most I ever showed in an exhibition was twenty. And when I look back at that project I see the mistakes. They are simply mistakes of experience. Now I use that experience to do commercial jobs. Because in a way the commercial is the model those pictures were taken with.

NR: Sometimes what you call "mistakes" were not sui generis. They were due to the models, their lack of participation or response, weren't they?

dC: Oh, yeah, that happens a lot—they absolutely don't respond. The models in this case were hustlers and they were being paid. So I'd say, "Stand there," and some of them would do just that. They wouldn't bring anything to it. That's another negative example of what they call "the directorial mode," that buzzword of a year or so ago. Referring to people who set things up. The best way normally might be seen to have

interaction, but in the case of those photographs there's not really a point. Obviously, if you were to go establish some kind of punctum, I mean, if there was a character you were trying to portray, for example, the requirements would differ. But I was not trying to do that. I was just letting them have the chance to do something and if they were null and void, I wound up with null and void.

NR: But in the Times Square series, the people you photographed had no such option of self-presentation. They were not even aware they were being photographed—not until the moment of photography, right?

dC: Most of the time they weren't even aware of that.

NR: You had something else happening—if it was portraiture, it was clandestine portraiture.

dC: In the beginning of my photography I controlled everything: rearranging the room, lighting it, and telling people what to do and where to put their hands. By the last project, I was basically totally at the mercy of serendipity. There were so many things that could go wrong technically that that would eliminate a good portion of the images. The people themselves were not that interesting when you finally took their photographs, and then finding variety within that redundancy was difficult. (I could find a million pictures of people with dramatic lighting, but they all tended to look the same.)

NR: What does that mean—that you embrace the accident of life much more strongly now? Isn't that setting the bar higher for yourself?

dC: When I was doing the street pictures, just being in these cities—Tokyo, Paris, Rio— finding a place within them that was usable, waiting, and trying to be unobtrusive—all things were out of my control. In the case of the *Heads* a lot of stuff was in my control. I basically subsumed these people within this photographic structure I created.

NR: That structure was the grid they walked into. . . the trap you set.

dC: Yeah, they had to be in a certain spot in a certain moment or it wouldn't work. I couldn't actually see them when I took the picture. (You can't look thorough the camera since people in Times Square passed too fast.) So I had a mark on the ground and I knew that if the people were on that mark the flash would hit them. They might be too tall or too short but that's where they'd be in focus.

NR: A little like a shooting gallery—like the old Times Square.

dC: It was, definitely. It was a busy city street and people were crossing back and forth. And you stand there for four hours and after a while you can sort of sense things. That was something that brought me back to working on the streets. When I was just doing street pictures you could not quite concentrate on everything that was going around but you knew when something was happening. And you could remember at the end of the day that some specific things were good—whereas with the headshots you had no idea what was good.

NR: There is a moment in photography, like in performance, a physical sensation of losing yourself in the act of taking. When you feel you are close to the bone, when there is a consistency of connection between subject and the act of taking the picture—a zone. Did you feel that in the streets, at least on the good days?

dC: More than good days, I knew it on bad days when nothing was working right and everything was frustrating. But the good days were a little harder to define.

NR: Okay, the good moments maybe?

dC: Yeah. [*Laughter*] For one thing those pictures were highly dependent on highly tangential incidents, which I was not even aware of. Usually I have to focus on one central person or area and hopefully other things fall into place even out of your view. There is a certain energy that exists on the street and you can tell when there is a lot of it and that is to your advantage. If not (in this particular technique), people will just stare at you. One person or a couple see a man with lights and the camera will get the staring look. Whereas when things get chaotic nobody notices you. I almost had to have that. So it defined the places I could work and that project one way or another. I worked on it one way or another almost four years, but I only worked on it when I traveled. The rest of time it was fallow. I tend to function that way—going back to what we were talking about before. I mean, I do feel a certain compulsion to work but from the very beginning it has only be satisfied in bursts and then there are big droughts when I don't do anything.

NR: The fallow years.

dC: Fallow—yeah. Maybe I'm just cynical enough to think you're not supposed to be only working, that living has some part to play. There's something analytical about photography and I like that and I have honestly always felt since I was a student that you don't have the right to make judgments about, or offer observations about, other people if you yourself haven't had much of a life. And that can be just exposure. Not like everybody has to experience tremendous tragedy to understand it—but you have to have been near it.

In the period of the eighties in New York there was a lot of stuff going on, consistent with what everybody remembers from that time—drugs and AIDS, a lot of drama. Drama almost to the point to where you were numb to it. People forget how many people were dying in that period. That there were so many people dropping from AIDS for a while there that it was almost not news. Usually the disease takes a few years and so you would know someone had been sick and you had it in the back your mind that it was going to happen. So somebody would call you up and tell you and you didn't have much of a reaction. You'd just say, "So when's the service and where." So it wasn't surprising to me that I didn't really work very much during that time and then when I did, I wound up with the Hollywood project. It's not a direct link in the sense that I thought of it as a response to the deaths, but you do respond in some way and your work is and should be a response to your life and the things that are interesting to you. Which is why, I think, I end up with photography. Because it forces me to get out, to be a part

of things, to try and figure out things I wouldn't normally. I wouldn't normally be standing around on a street corner for hours on end. I wouldn't normally travel to places that I do for the sake of making work. Even in the case of fashion photography or something like that, it's not a world I socialize in. I don't know much about it; I don't really care much about it. It's just an opportunity that I can't really pass up because I find it consistently interesting. The product may not be as interesting as the process sometimes. But the terms you can do it under give you a lot of freedom.

NR: Someone compared you to Hopper—the quality of light, of emotional connection, of feeling. Something personal, a residue Hopper has, a kind of distancing that is private, generally solitary, frequently a scene of alienated souls.

dC: I guess that's been one of the plans; I've always tried to have some sort of emotional aspect. I would hope that the photographs have some emotional life of their own—but I try not to have the things depicted be in themselves emotional.

I was a product of a graduate school at a time. Now I teach in graduate school and part of what postmodernism wrought on the art world is this idea that you can develop a strategy for making art. Especially now in post-postmodernism you are supposed to connect that to some aspect of your life and racial or sexual identity. And so very brainy art (in some weird form of compensation) is supposed to be connected to the deeper wellsprings of that. But it is not something I ever attempted. I would actually argue against that, it seems phony.

But I think you know based on your life. Photography is an editing process. I don't think I go out looking for things and people who look alienated. I'm not trying to make that point. Perhaps in editing them they wind up that way. I do think I am attracted to situations in which people are loners. Maybe that's a nighthawk at a diner. The hustlers stand alone on the corner. The individuals that get picked out by the light in the photographs I do on the street, no matter which ones are shot, because of that particular technique are singled out and individualized, and separated out from everyone else. So it might seem that there's almost a point in doing it that way. I see in the process of creating the technique, I decide I like it, and I continue with it. So, yeah, there's a conscious decision involved, but it's more like: I like the way it looks, it's interesting, and it has possibilities. And that's it.

NR: But the academy that you've given rise to, the imitators you've spawned, are now legion. Like that director who said he copied your "look" in The Insider, that movie with Russell Crowe. With the light, the look, comes a homage to you. And there are acolytes; former students of yours, like my author Taryn Simon, all proving you've marked something. Can you talk about that?

dC: Graduate students arrive in some school, some program, out of their element and are forced to produce a product in some way or another. A product compelling enough to be at least noticed. They often devise strategies. A lot of art talk and art training these days is about developing those strategies and there is little or no hesitation in faculties of those schools to telling people, "Dig deep into something that makes you most

uncomfortable, wrap it up in some obscure formulation, throw it out there, and when no one who sees it can figure it out, give them the key." That describes a lot of art works these days. So much stuff is so cool and indirect and is meant to be dealing with issues like "gender differentiation," or whatever as compensation for the irrelevancy we were talking about before. We'll be talking about the genome here in my art class (as though anyone cares). Sometimes if you pay attention to all that, it can make you wonder why anyone takes it seriously. The people who consume it are equally duplicitous in insipidness. They are willing to sit there and have some curator sit there and tell them it's about Eve's relationship to Adam. They'll get behind it, they'll get the board of directors to buy it, and when they're doing the tour of the corporate office they'll explain it's all about Eve's relation to Adam, and I'm sure they're not totally convinced about it.

It's nice to have a market, but the reason there is a market is the money and flow into the art market in the last years. (Nothing wrong with that, of course.)

NR: Do you look at much work? Who interests you?

dC: I'm not trying to avoid it I'm not trying to seek it out, but if someone tells me there is something interesting, I'll go and see, it. But, look; I don't even go to my own gallery. Gursky and Sugimoto have a degree of consistency that is almost monolithic. They turn out this highly refined work time after time after time and have been doing so for ten years. I'm sure we don't work in the same way but Sugimoto's simplified code brings spirituality to all his work. It's always good to deal with fundamentals, which I like, and he has certain elements that, in some ways, are that. In his case, time is a big element in his work, as in the time it takes to project a wave. They are very long exposures of the ocean. In some ways a freeze-dried wax dummy is about time as well. Yeah, he took on a big one. Gotta give it to him for that.

NR: You are taking on big themes, too. But you are choosing—that look, that gesture. All these projects are permutations on gesture: the face, the pose, the anomie.

dC: Wait—the subjects are doing it, too! I can't emphasize enough that I don't coach it. Even in the editing I am not just saying, "Hey, there's some one smiling; throw that in the trash. No—it's the way it is. The one thing is that it is always a banal situation. There's nothing going on. The tradition of photography when I was kid was an image was supposed to epitomize the peak of the moment. It was about some transformative instant. A good photographer was one who was perceptive or fast enough to catch it. And I made a really conscious effort (for one, because I was never good at doing that) to develop a way of working where I wouldn't have to. I am not reacting to an instantaneous event. I am either making the event happen or choosing among one of many events that occur every day that are not that dramatic.

NR: Magritte captured banal reality also. But then what he would do was add a hat, a leaf, a lamppost. To trigger the banality, to make it more magical. You are triggering it somehow also, no?

dC: Well, when I was in art school doing conceptual work, photography was "The Miracle of Everyday Life." The other little conceptual thing I did was...do you know the cards the deaf people give out with the alphabet, on the subway? I had some made up that, instead of saying, "I am deaf," said, "I am an artist," and on the other side I rearranged the hands so it spelled out, "Life is art—sometimes," and I gave them out.

I was in first or second year of art school and I wasn't an art kid. Not the kind that took all the classes in high school. No, I had a rocky road in high school and art classes were not part of it. I wound up in art school almost by default and got interested in conceptual things then. But during that period people did a lot that was banal. The William Wegmans, the Dennis Oppenheims. The means to the result was tripped to the most minimal things that fit their concept of conceptualism. So I became interested in what I would call the banal, which transmuted into the domestic, which is how Family and Friends evolved.

NR: Can you talk a bit about how the ideas for Family and Friends emerged?

dC: I never have ideas in a flash—they always take place in pieces and at some point those pieces fall together in a way that seems extremely logical to me and I am always surprised at how logical it is. Either I'm cut off from some aspect of the reasoning process and I don't see the connections and then suddenly I see it all and I put all the pieces together and they're connected in a really obvious way.

NR: They are elements...

dC: The elements that call into question the normal relationship of appearance are for most artists of my generation tools to enrich the experience of the work rather than ends in themselves. I try to leave the meaning as open as possible.

PART II

New York City, 18 May 2003

NR: Does the experience of teaching stoke the fires of the creative—provoke you to put into words ideas that gain power as they are spoken?

dC: I don't know if I'm out of things to say but I realize I never thought it through to the point where I have formulated any opinion which I feel could pass for some sort of photographic ideology that I'd want to impart. That rationale is really half-formed.

NR: I wonder if you've had this experience, that when I have taught it frequently surprises me what comes out of my mouth, some things I never knew I believed—or half believed—so that as I say a fact, a truth, I am at the same time testing my own commitment to it—and watching a reaction to it at once.

dC: Well, yeah. It's a lot easier to react to something than it is to teach something and

teaching is using what you've already figured out to help somebody who hasn't figured that much out yet. Every once in a while you blurt something out that you hadn't articulated, even to yourself, but as you said it, I guess you have to take responsibility for it! And you know, it does seem to come back to you later. So, maybe you're right about that. As though you're having some sort of an interior dialogue with your unborn thoughts, which teaching, you know, tends to force you to give form to? I suppose that's one of the virtues of doing it.

NR: Maybe it's compensation—photography is such a solitary act, a wordless moment, and in teaching you have to share that with someone. Doesn't it provide some release or contact?

dC: It's not necessarily the virtue of talking about your work that provides a release, though. Unless you're forced to do it or talk about it on a regular basis and you work out a routine. It's all, you know, a matter of when they catch you. I don't know anyone who is capable of coming up with the same train of thought consistently or at least on a high level every time somebody puts the demand upon them.

NR: You do less lecturing than one-on-one teaching in any case.

dC: I don't have to lecture; I only have to react to what people do. And I have lectured, but the times I have done so it has been at a much more nuts and bolts level: A plus B does not equal C.

NR: More of a technical level, you mean?

dC: No, the history of art and photography or the evolution of certain thoughts within it are pretty easy to trace because it's there and no one is going to know what you are talking about anyway.

NR: It has the virtue of being a short history, photography, a blip in the art timeline.

dC: Yeah, but it comes down to the same thing, that your average person who knows art history only knows twenty great artists.

NR: Sister Wendy's list.

dC: So you get, yeah, the list. And being put upon, I guess most people could come up with their twenty favorite albums quicker. Twenty favorite photographers would be pretty straightforward. As long as you didn't have to really do it in hierarchical order it would be all right—but to rank them is the problem.

NR: Let's see: for me, Bellmer, Bravo, Cartier-Bresson, Frith, Rodchenko, Dritkol, Frank, Brandt, Munkasci, Muybridge, Klein, Man Ray, Moriyama, and Hosoe, oh, and John Heartfield, but it's hard to just name twenty, I am just beginning…and I like Misrach very much, too! It is a ridiculous exercise, anyway. When I was in school in Rome, at Centro per i Studi Classici, I had to memorize all the Roman emperors, in chronological order…

dC: Hmmm, empires?

NR: Emperors. And you know something? Their hairstyles could provide the clue to the date, within a radius of twenty years. This is an example of the futility of lists—or maybe of how once we were young and smart. . . and now. . .

dC: Yes, well. [Laughing]

NR: Let's leave that hanging. Moving along, then, is there an embrace of the academy—a natural conjoining of the gown and the art world, in this country particularly? Lots of artists teach as part of their day-to-day.

dC: But I'm not really involved in day-to-day machinations of academia. I show up, do my thing, and then it's over. I think there are a lot of people who make hay of their association with institutions and of course, institutions like nothing better than other institutions to validate any person who is seeking something. Most people know that. Whether it is money or privilege or access or whatever that they are looking for, that's how it works.

NR: You don't need the money.

dC: No, I don't teach for the money. Even at a big school like Yale it's not worth bothering about. Teaching there or anywhere like it. If you teach and live in New York City, you starve.

NR: Yeah, I saw that six-hundred-dollar weekly paycheck. So then, why do you do it? Is it nostalgia? Do you like the interaction with all those impressionable young minds that go out to make imitation P-L diCorcia pictures?

dC: Increasingly, impressionable young minds have another attribute—that they are aggressive. And in order to go to university these days (and an art school especially), which is basically preparing you for nothing. . .

NR: It never did.

dC: It never did, correct. But it never cost that much before. Now, if you go to a school like Yale you are really in debt when you get out. So you want to be successful right away, as it alleviates all your problems at once: financial, psychological, whatever. . . and I think it's a lot of pressure.

NR: But is that not antithetic to art—since the historic suffering artist is neutered. If you are going into art with the MBA approach, aren't you missing the act of living the life of "artist"? Is it a major cultural shift we are witnessing?

dC: People who go to art school are different socioeconomically than they used to be. They expect more from it. And it puts more pressure on the teachers because they not only are emotionally involved in the things you say (because you are in fact criticizing

the students and nobody takes that easily) but they are involved on many other levels—
as the students' well-being in some ways depends on their success.

NR: But there has to be some less mercantile raison d'être. Something personal
involved. Gilles [Peress] once said to me that if he hadn't become a photographer he
would have been a criminal. So what's your excuse?

dC: Do I need one? [*Laughter*]

NR: Well, how did you get there—you're from a middle-class family and a middle-class
state—to here, since you in some ways define a rebel artist's stance. Why did *you* go to
art school?

dC: It's hard to see my resume and think of me as an outsider.

NR: Ok, maybe it's your attitude—you're just "anti," by instinct and intuition.

dC: I think of that as a value judgment rather than a lifestyle choice! [*Laughter*]

Look, I haven't really been all that happy with the results of my choices. I don't know
how I fell into it. I don't know if it was a weird form of self-imposed romanticism.
The street-corner basketball world I lived in as teenager certainly seemed to be leading
nowhere. It was a lot cooler in that world. And yes, there was a totally criminal, drug
aspect to the people I was drawn to, that I would say has played itself out in some
aspects of my photographic career. The people I hung around with as a teenager were
always from a different part of the world that I grew up with, and you know I was in
trouble almost from the very beginning.

[*Phone ringing*]

dC: It's probably Trevor, my assistant.

NR: Take it if you need to.

dC: No, these days it's hard to get rid of people once I answer. Anyway, not to over-
romanticize or to novelize the situation but when I was a kid, everything was always
chaotic so it seemed a naturally perverse choice to be an artist. (If you grow up in a
middle-class world that seems to be perverse.) Now, of course, it seems to me to be
one of the most impossibly bourgeois things you can be. At that time it had all the
romantic associations, all the rebelliousness. The reason it is bourgeois is it is rebellious
without taking any real risks, actually. You are dealing within a very well-defined
system. You could fuck up, you could fail, but you didn't know that then.

NR: The chances of failing are quite high—it does seem a very kamikaze course when
you are doing risk assessment.

dC: But I never really thought about the risk and certainly not about the end result of

it. When I was a teenager it was the late sixties. The idea there was a future was. . .

NR: . . . Beside the point?

dC: Exactly: totally beside the point. And I took my decisions in a way that was honestly in the moment. If I could regain that capacity to think that way I would at any instant. It was totally without regard for the next step. And I still consider myself. . .

[Phone ringing]

dC: That's you this time.

NR: My husband; he just wants to know when I'm coming home. You were saying?

dC: Oh yeah, that I am in a state of perpetual adolescence in the sense of being something where you expect as a God-given right that all things are possible and you deserve all of it.

Now, I am not a particularly bitter person but I am just extremely disappointed that I am not going to get all of it or anywhere close. I went on for years and years thinking that it was all possible, that all I had to do was apply myself and I haven't really decided yet if it's not all possible or if I have never actually applied myself. And I don't want to figure that one out. Then you're really in big trouble—because that's the endgame right there.

NR: As the gates of hell say: "Here all hope is lost."

dC: Yeah. One thing flowed into another. My father was an architect. It wasn't as though I didn't come from a somewhat creative environment. My mother used to let us write all over the walls—we were allowed to take crayons to everything—and she was always encouraging us creatively.

NR: Crayoning walls is hardly bourgeois.

dC: We weren't, actually. We were something of pariahs in the neighborhood. I lived in the only modern house in the town I grew up in. We lived in a house that was very sort of southern California, Neutra, Schindler-style, one that opened out onto the lawn and that was very communal: we all shared all the drawers.

NR: That's positively bohemian!

dC: It was bohemian except that I lived in a world in which most of the people were poorer than me. My father's family was all bricklayers and masons. My mother's family had a judge—her father—but he had started selling fruit from a cart on the Lower East Side of New York and put himself through college selling shoes. It was a very self-made family and it actually engendered an oddly reverse conservative trend in them. They believed social ills were not really inflicted on the underclass; that they

were just lazy. So even if they lived bohemian (and my grandfather even had a little victory garden) he and they were rather right wing in their opinions—they were all very quirky.

NR: It's funny, when I first met John Malkovich, I thought of you, I don't know why; he has a soft voice, like you, for one, he's tall, like you, unflinchingly direct like you, and hearing you describe your childhood, I am thinking of him.

dC: People have told me that my voice is like his.

NR: No, it's more that he also comes from a family that's conservative in some ways, odd in others, from a small town in Illinois, Benton, where his family had a prominent position (a father who ran the town paper, a notable) with an eccentric, creative mother. But I have to check with him on the crayons. The difference is that you're from a big city in Connecticut.

dC: Half a million people is not that big.

NR: Well, maybe it's just that your outlaw citizen-of-the-world demeanor strikes me like John's.

dC: True. We have both had our intersection with fashion. Though I don't really wear it.

NR: Now he makes it.

dC: I heard that. And he is interested in it and that defies that intersection of purity people expect the world of culture is. I don't know, the model people have in their minds something that defines what "they," the fashion folk, are supposed to be like. Other than the fact that "they" are difficult which is a pretty consistent characteristic. Usually they are dependent on one thing or another. Either a sycophant telling them they are the greatest person on earth or else drugs and alcohol.

NR: Usually some combination of both.

dC: Right—sometimes you need the sycophants to go out and buy you the drugs and alcohol. But it's hard for a fifty-year-old eccentric comfortable person to deal with the realities of addiction. Most people thankfully don't have to. Though I have to say it's a pretty consistent factor in some aspect of lives. What is it that leads people who seemingly are accomplished to be so pathetically in need of comfort, whether it is chemical or psychological or whatever?

NR: My friend Didi (she's a shrink) opined the other day that the need for accomplishment in driven, successful people reflects a yearning for validation on many levels. Sounded like solid cracker-barrel psychology to me.

dC: I would say that's true…but the extreme cases of success in my experience don't lead that way.

NR: And what are extreme cases—neuroscientists who win the Nobel Prize?

dC: People who are the most successful have a sense that they are anointed. They are true believers in their own ability and what they are doing. They have total confidence. They seem to make judgments and move fluidly—this in combination with their own innate abilities—and in a way that does not reflect any hesitancy. A lot of other people seem to stumble through the process of getting things done in a manner that tortures them and those around them, but to the world seems a seamless factory of product. There are those two types.

NR: Of course there are both kinds, but there seems a certain dichotomy here. The world of art—I use that loosely, encompassing literature—and all manifestations of the human soul have doubt as an essential part of experience. After all, all of Russian literature is about doubt and hesitation and the incapacity for action—a quicksand of retracing moral steps. Look, every damn play by—everyone—pick any Russian—OK, Chekhov! Involves a dozen characters unable to get to Moscow. It's a description of the human condition, and therefore infinite grist for the creative, artistic mill.

dC: But I don't think the human condition is necessarily the subject for modern art. Though it is when you start to talk about photography because it necessitates inter-action with reality.

NR: But you, child of antibourgeois parents who allowed the walls in Neutra houses to be scribbled on, who chose to land themselves like people on the moon in Hartford, queen city staidness, of insurance companies, for Christ's sake. . .

dC: They were born there. But yeah, it's the insurance capital of the world.

NR: Though it's odd you are from there, it did have some native sons who were remark-able, out there, like Wallace Stevens, one of my favorite poets.

dC: He actually worked there. But Mark Twain lived there, too. Harriet Beecher Stowe.

NR: Fine native sons and daughters. But you chose a type of photography I am finding is the preferred term for your work while Googling all the stuff that's already been written about you. . .

dC: What's the Spanish translation for Google?

NR: Tricky translation challenge, that. Okay, here are some choice ones: "A crystal-lization of banal soul." So, why are you so attracted to domesticity?

dC: If we were talking about the difference between photography and art and art's assimilation of photography and photography's viral takeover of art for a little period of time in recent art history then that virus mutating into video and installation, projected visualizations and. . . whatever, well, these things really did change the nature of the way people and institutions are viewing art.

If you have to go to a public space to look at it these days you are not about to be satisfied with a one-on-one intimate experience with a fixed object anymore. Even if it is photography it can't be fixed. It either has to be so huge you can't see it from any one place or it has to be multiple in a way your neck gets a crink before you see it all.

NR: I saw some really big art recently at the Reina Sophia when I was in Madrid a week ago. But I had my best art afternoon at the Prado, actually. I was looking to reexperience a epiphanic moment I had as a student at nineteen, when the museum was the old Prado, unrenovated, and in a corner of the museum I found a room, a niche really, with a bench in it, where on my left was Fra Angelico's *Annunciation*, and I was facing *The Garden of Earthly Delights* by Hieronymus Bosch, and on the right was a Cranach of the Three Graces. I spent one entire day there looking, not moving from that spot. Now I went back two plus decades later looking for that niche and they had separated the paintings into logical order. All the works together. All the Dutch, all the French, all the artists grouped chronologically, or logically, anyway. Pity—the other juxtaposition was so— astonishing. But those Boschs stood out still—he's so incredibly modern.

dC: I don't want to feed cynicism—my own at least—about modern art but you are sort of setting me up for it. I happen to think that is one of the most amazing museums in the world. The Goya black paintings in the back and all that stuff, to me there is no way to approach that experience with what is now on offer. For one thing it comes from a place few people have visited. And it is accompanied by a technique that few people have achieved and it was intended for purposes that few people have anymore. Because it was not intended for anything. Some things were commissioned, but of the things I tend to gravitate toward, most were intended for some kind of private consumption.

NR: I heard that Philip the First. . .

dC: The guy with the big lips. . .

NR: He did have big lips, didn't he? Philip saw one Bosch painting and was so moved that he declared, "Anything by Bosch? I'll buy it." He was the patron always standing by, just as the last layer of paint was put on. That's why they have such amazing ones at the museum.

dC: Oh, I'm sure some art historian could tear this apart and say, Hieronymus Bosch was not so tremendous, he produced twenty-five paintings, almost identical, for different consumers and had a stock set of characters, like a egg head with a beak, consuming a sinner at the same time it was oozing some weird fluid.

NR: Love those oozing sinners. But besides there is the psychedelic aspect: don't you think he had some of the same inspirations as generations, centuries later—I mean, isn't there a direct line there to Dalí. Maybe Salvador was in the Prado one day and stopped where I stopped and. . . Eureka!

dC: As a matter of fact Dalí was shown, despite his Spanish roots, to be the weak link in the psychedelic. The Bruegels, I guess, don't come from the same corner of the

world but they are pretty out there, too.

NR: The Flemish always are, aren't they?

dC: I don't know why, but it has to do with religion—a deep fear engendered by a deep belief.

NR: Do we suffer from an absence of belief—does that make contemporary life, well, flat?

dC: Well, I do think that there's a lot of bad stuff that happened as a result of people being thrown into world wars and political conflicts that most Americans and most European young urban dwellers have not experienced. I think its greatly distorting to see that degree of violence. Clearly photography is one of the greatest protagonists in the desensitization of people in what goes on.

NR: Did you read the new book by Sontag on that desensitization issue?

dC: I read excerpted pieces and criticism of it—I thought it was a great thesis—I buy the thesis but find that her arguments were all over the place, which is unusual because it's usually the other way around with her.

NR: Her argument is usually narrow and deeply fought.

dC: Yeah…Her arguments are incredible and her thesis is fallible.

NR: You said you were interested in the intersection of the real. You didn't dislike the idea in commercial jobs because of your sometime impatience with the unreal. It was a challenge to you. Have you thought about covering ultimate reality—war—entering into that world of photojournalism, now dead and gone?

dC: I don't really no how to answer to that because I really don't know what it involves. A lot of people think journalists go out there and suffer mightily to get what they do.

NR: Some do and some don't.

dC: Yeah, just as many are on a kind of junket and wind up with a perfect opportunity.

NR: Matthew Brady had a camera not unlike yours.

dC: True, but Brady only had to deal with corpses after the fact.

NR: In Iraq there are quite a few—not that we saw any here in America.

dC: Okay, sure. In fact there are war photographers working right now who every time I see their pictures I think—that guy's really good—he's really in there.

NR: Who especially are you thinking of now?

dC: Tyler Hicks—the guy is good—he's all over the place. He covers all aspects of what it is. I appreciate it from the point of view of somebody doing a job. I'm not going to get into the obvious comparison with Gilles [Peress] because it seems to me you get the assignment, which is to do the thesis, and what you do is your take on this particular situation. I appreciate the fact that these people function in a very pragmatic way. They have a problem to solve. They have to turn in something that reflects a very varied reality and cannot really make the point too emphatically, otherwise. . .

NR: It will never get printed.

dC: OK, it will be seen to be biased—I guess that's why it wouldn't get printed. That kind of neutrality attracts me and brings it back to issues I deal with because I have been recently described as detached or cerebral in the way I approach the work I do and though I don't see it that way, one of the things I have always tried to do is have the work not be in any way about me. Not to name names but a great deal of art world work is centered around the personality of the artists and I don't think that's so interesting. That also comes with the territory. Besides being about the self-involved and self-reflective it is at this point made a cult of personality as much a qualitative judgment of quality.

NR: Everything needs its heroes—certainly marketing needs them. This is an age-old seesaw in art. To evaluate the art alone without reference to the life, then to elevate the cult of the life infusing the work, well, it goes in cycles, doesn't it?

dC: It hasn't reached the point that artists are cutting ribbons in shopping malls, but you know we are almost there.

NR: They do Gap ads or even worse.

dC: You get Dennis Hopper doing the Gap ads. He's the multifunctional persona: maker of art, collector of art, doer of art, participant in other people's art. Even has another personality for toe-dipping into art. In fact he's done some great things, and it's a Gap moment, taking advantage of all of them. [*Laughter.*]

NR: Do the commercial jobs offer that neutrality to you? Do they put you out in the world with an intellectual puzzle to solve, an image to make in a finite amount of time, with definable limits?

dC: That's the nut involved in the conflation of art and commerce. You can't really see them the same way. You just can't. I don't care how much people want to pump up one and deflate the other; they are never the same thing. Sometimes making something that exists in a way that you might describe as very easy in either realm is possible but the truth is the impetus to do the work is never the same.

There is something vague in that. But I wouldn't venture to guess what makes people do things for little or no return in a world that doesn't particularly value their efforts.

NR: Don't you think it's a compulsion?

dC: To return to what we were talking about before, it's not like the squeaky wheel always gets the grease, but insecure people tend to act out in ways that are not considered to be normally insecure. The loudest person, the most aggressive, you know it's a pretty obvious equation that's been going on for centuries, but the consequent warping of the result of getting people's attention because you're actually afraid of them is what makes the whole thing kind of interesting. Kind of an addictive thing when it's happening to them—suddenly someone is paying attention to them.

The deepest motivation for a lot of artists is obviously the one they all share: their great fear they are a fraud. It's a joke. In my case the problem is not that I don't question myself. It's just that I question other people even more, so I have to balance it out to the point where it's not a question anymore. And I guess that's sort of a compulsion.

Philip-Lorca diCorcia was born in Hartford, Connecticut, in 1951. Having graduated from Yale, he dedicated himself to photography in the seventies. From the work produced in the next decade emerged the series, *Family & Friends*, the result of an elaborate mise en scène. In 1990, his series of gay male prostitutes working on and around Santa Monica Boulevard was titled *Hollywood*. In 1993, he photographed strangers for his series, *Streetwork*, on the streets of New York and later in London, Paris, Tokyo, Rome, Mexico City, and more. His most recent work, *Heads*, is composed of seventeen portraits taken in Times Square, New York: they are simply busts with black backgrounds, which he emphasizes with strobe lights. Famous for his ventures into the fashion world with *W Magazine*, his work enjoys international recognition as he has had major expositions in Europe, the United States, and Japan.

Nan Richardson lives and works in New York. Over the last twenty years, she has worked as an editor (former editor-in-chief of *Aperture*), writer (collaborated on publications for *The Los Angeles Times Magazine, The Boston Review of Books, Stern, Granta, Allure, Interview, Art News, Artforum*, and *Art in America*), and exhibitions curator. In 1991 she founded the publishing company Umbrage Editions, dedicated to visual books, often with social and political edge; since then she has published more than seventy titles, among them: *Pandemic: Facing Aids; Speak Truth to Power; RFK Funeral Train; Havana: The Revolutionary Moment;* and *Born Into Brothels*.

SELECTED BIBLIOGRAPHY

Monographs

Brea, José Luis, and Noriko Fuku. *Philip-Lorca diCorcia*. Madrid: Fundación Telefónica, 2003.

Brea, José Luis, and Philip-Lorca diCorcia. *Streetwork, 1993-1997*. Salamanca: Universidad de Salamanca, 1998.

diCorcia, Philip-Lorca. *A Storybook Life*. Santa Fe, N.M.: Twin Palms, 2003.

diCorcia, Philip-Lorca. *DeBruce, 1999*. London: Whitechapel Art Gallery, 2003.

Galassi, Peter. *Philip-Lorca diCorcia*. New York: Distributed Art Publishers, 2003.

Sante, Luc. *Heads*. Göttingen: Steidl, 2001.

Collections and Catalogs

Bruce, Chris. *After Art: Rethinking 150 Years of Photography*. Seattle: Henry Art Gallery at the University of Washington, 1994.

Family Matters: An Exhibition of Works by Sally Mann, Vince Leo, Melissa Shook and Philip-Lorca diCorcia. Tempe: Northlight Gallery at Arizona State University, 1993.

Galassi, Peter. *Pleasures and Terrors of Domestic Comfort*. New York: The Museum of Modern Art, 1991.

Abigail Heyman, Alice Rose George, and Ethan Hoffman, eds. *Flesh and Blood: Photographers' Images of their Own Families*. New York: Picture Project, Inc., 1992.

Later, Paul, and Renee Riccardo. *Acceptable Entertainment*. New York: Independent Curators, Inc, 1998.

ALEX WEBB

speaks with Max Kozloff

Max Kozloff: Not that it's over, of course, but, Alex, over the course of your career—long career, went twenty-eight or so years long—you've had many international shows, in art galleries and museums, so that your identity as a photographer with an artistic consciousness is rather well established. But, right now, I'm interested in asking you about your qualities of observation and witness, as someone who moves through history, who encounters history as it unfolds. That is to say, the journalistic function of your work, which surely exists. How do you describe yourself as a contemporary historian?

Alex Webb: I see myself as a witness to history, but history in the largest sense, predominantly photographing the ongoing life of ordinary people. I'm not necessarily looking for the major historical events of the time. As a photographer I come at history from a specific and personal interpretive point of view. My view of history is dictated by my own passions, my own motivations, my own obsessions. In other words, I did not go to Haiti for the first time because I thought that ultimately there was going to be a revolution in Haiti, or that Haiti was the most important place to photograph in the world. I read Graham Greene's The Comedians. And I was fascinated and scared by the depiction of this little island nation. Then I read a little something in The New York Times about it, and I decided to go. But it had very much to do with some kind of personal motivation, not some supposedly objective evaluation of what was important historically. But they are historical pictures, certainly, at a certain level.

MK: Could it be that the heat of the tropic places you have visited, in Latin and in South

America, is some kind of literal corollary of the emotional heat and energy that you want to, in a sense, find a pictorial metaphor of?

AW: Yes, I think that's true. I'm attracted to the heat of these places, not just the physical but the metaphysical heat as well. There is something palpable about the energy on the street in a Mexico or a Haiti, there's something about the sense of life that's lived on the street and on the stoop, that's very different than the gray-brown reticence of my New England background.

MK: Well, that leads me to suppose that (certainly I'm no psychoanalyst) you're drawn on your travels to high-octane, warm-blooded places partially because you miss these aspects of existence, mostly urban existence, in our own country.

AW: That may well be true.

MK: But at the same time you are, as you visit the developing or undeveloped countries, a citizen of the world's largest technology, a representative of a superpower, of a hegemonic state. How then, psychologically, do you manage moving with that kind of cultural identity of your own through these often dispossessed and abandoned places?

AW: That's a good question. I guess that, though in many of these places, for example, particularly Haiti, there are terrible, horrific problems, simultaneously there is something intensely human—an overwhelming sense of life. I don't just perceive Haiti as a place of poverty and desolation, which it certainly is. I also perceive it as a place of emotional intensity and vibrancy and even a kind of twisted beauty. When I'm photographing in Haiti there've been times when I've felt simultaneously that I want to photograph there forever and at the same time I want to get on the next plane and leave. There is a kind of very special tension that I feel.

MK: Looking at your pictures, all kinds of killing zones and hot spots over the world, or problematic areas, I also feel not only the immediacy of your response to those situations where people are in great predicaments, but something about your own predicament, too. If I were to try to reconstruct in my own mind what it must be like to come upon people at your typically close range, almost point-blank range, but as a gringo, or a white-skinned interloper amongst them, I'd imagine that this is a very edgy situation. How do you manage it?

AW: First of all, though you speak of my photographing killing zones and hot spots, in fact most of the places I work are much more places of cultural conflict than of outright conflagration. (There are exceptions.) In such places I am continuously astonished by the openness of these societies to the outsider. In fact, if one approaches these places and these situations with a sense that somehow one does belong there, that one isn't just trying to take something away from the situation, but that there is a seriousness and a commitment to your response, then often people will allow you into their lives. There are many places where I feel that even though I'm totally different than those in the other society, it can be easier and more open than in certain segments of my own society. I find there are times in Mexico, and definitely in Cuba, where

people are very accepting and welcoming. Perhaps that has to do with the fact that someone is simply taking an interest in these peoples' lives where normally very little attention is paid—I don't know. But I am continuously astonished by the openness.

MK: There may not be only a different cultural but a different time zone involved in the exchanges you've had with people through your camera. In the 1930s in the United States, during the Depression, photographers going through depressed areas found it easier to bear witness to the plight of the poverty-stricken than would have been the case thirty or forty years later when there was much more sophistication about media interventions and transgressions. Perhaps in other areas, in Africa, in Latin and in South America, people are not so familiar with the idea of being exposed, perhaps, by strangers for exploitive purposes, and they are therefore more trusting. Is this trust something you feel you have to handle with delicacy, or do you really just barge in often enough?

AW: [Laughter] I don't think I really barge in. I try and approach as gently and as quietly as possible. I do it intuitively, in a way that works within the context of the situation in that society. There are some situations where I approach very slowly and quietly and don't photograph very much initially, sort of sidle on in. And there are other situations where I feel more immediate acceptance and can work more directly. Now it's true that I've sometimes been totally wrong. I've been occasionally surprised to find that a situation that I felt was very private and potentially difficult to photograph turned out to be easy, and vice versa. But generally speaking I try and approach as unobtrusively as possible within the context of being an outsider (and a gringo). And I move away when or if people are unhappy with the idea of my photographing. Except perhaps in situations where the military is doing something inappropriate and they don't want a photographic record of it.

MK: OK. We are speaking about choices of strategies an individual photographer makes in approaching a situation. We haven't talked yet about the situations themselves. I often come away from looking at your work with a feeling that so often what you do is redefine what the subject is. That is, there might be a nominal subject, a demonstration, say, or a parade, or a waterfront scene. But you choose to tell us and to give us information about things, not necessarily essential to understanding that particular event, but more about mood, subjective consciousness, something of your own. An approach coming in at a slant. Is this personal definition something you're working at all the time?

AW: Well, I'm working at it, but I'm working at it unconsciously or subconsciously. It's not that I look at a situation and say, "Oh, well, that's too obvious, I'm going to go off and do something on the oblique." It's that I'm drawn to certain kinds of things. If, for instance, I'm photographing a public manifestation or demonstration, I'm usually drawn to some little moment at the edge, some little human twist of some sort. I tend to be always looking for something more, something else that further qualifies whatever it is I'm seeing. In other words, it's not just that *that* exists, and *that* exists. It's that that, that, that, and that all exist in the same frame. I'm always looking for something more. You take in too much, perhaps it becomes total chaos. I'm always playing along that line: adding something more, yet keeping it short of chaos. There is a formalistic,

emotional integrity that the whole image demands, but I'm always pushing, pushing towards the edges. Edges are important to me, borders are important. On all levels: conceptually, physically, and visually.

MK: Timing is important?

AW: Timing is important!

MK: Opportunity is important.

AW: Yes.

MK: All right. Which leads one to ask this question, a question surely that traditional street photographers must have to consider: How often do they know what's actually before their lens? How conscious are they of, let's say, the configuration of different gestures and faces? Are they really more detached rather than involved and intimate with their subjects so that there's always a clear target? I often feel that there are targets in your work that have to do with your own empathies rather more than the actual situation as it unfolds. That you quite often construct through an awareness of the history of photography, your aesthetic, hyperpersonalized situations. Is this a fair kind of description of what you're about?

AW: Yes, that's somewhat true. I find things that intrigue me. How conscious am I of what is in front of my lens? Pretty conscious. Am I aware of every gesture? No, but in the process of photographing I often can intuit when a moment seems to work and when it doesn't, when all the elements come together or when they don't.

MK: All these suspended variables and features and aspects of a photographer's contact with the complex, perhaps even ominous situation leave a question, a larger question, hanging in the air. It has to do not so much with approaching history as it unfolds, but rather with one's consciousness of creating a picture, a picture that is on one hand satisfying to the one who takes it, even if it must inevitably be insufficient as a form of evidence. When the crunch comes for you, do you have to make a decision among those lines?

AW: You mean as to whether it is an interesting photograph or whether it's a record of history? Is that what you're saying?

MK: Well, at least some kind of credible account of something happening as compared to something you're inventing or creating through your own artistry.

AW: There's a delicate balance, and I often play along that line. I am always looking for something that on some level excites me visually and emotionally. But it is a response to a situation out there, a situation in the world. There is always a certain kind of tension that exists between the way I see, and what exists in front of me. I think most photography falls in that area, between the photographer's eye or the photographer's vision, and the content, the subject matter out there. Different photographers take

different stances in terms of how close to their own vision or how close to the world they are. And my work is certainly a highly interpretative presentation of the world, but it remains the world. I am interested in things in the world, I am interested in issues in the world. I couldn't work without the world, but I always have a very specific way of seeing it.

MK: It seems to me quite odd that it is also your world too, that is, the world that, while you didn't make it up, you've gone to some length to construct. For example, the sense that comes through so much of it of being by yourself, so that even when the situation is extremely busy, a viewer feels that the act of witness is a solitary one. However sympathetic and even solicitous of people's difficulties, that solicitude comes from across a distance, evolved through the eyes of someone who actually can't finally share in their tragedy; the tragedy of the subjects.

AW: Interesting perspective. I don't know whether I would go so far as to fully agree with it or not. Look, there's no doubt about the fact that I have always viewed photography as a solitary experience, even when I'm with people. When I'm actually in the act of photography I am in my own world, I am off in this other place, even if sometimes on the surface I may be interacting with others. When I was a teenager I played around with a movie camera making little films. At some point, I remember realizing that if I continued in this direction and did feature films, I would have to work with a hundred people. And I didn't want to do that. I wanted to be able to work by myself, and respond on my own terms.

MK: You know, one of the aspects of your work that continually draws me is the use you make of the full palette afforded through our new modern color materials, films. At the same time, you're working on, and I'm looking at, photographs, at a situation where the medium of choice for so many photographers who consider themselves very serious journalists is still black and white. You've been criticized for your seductive use of color and your aesthetic approach to it. How does that "thermal" character of your work fit into what we've been discussing?

AW: Well, I really became a color photographer in response to working in the so-called tropics. In 1975 I went to the U.S.-Mexico border and Haiti for the first time, and I worked entirely in black and white. And for the next couple of years I continued to work in black and white. But I began to feel that there was something that I was somehow missing. I began to realize that there was a sense of color in Mexico, in Haiti, embedded in the culture that I wanted to respond to. I wanted to address that somehow, to respond to that in my photography. As a result I started working in color in approximately 1979, initially in Haiti, then in Mexico, and I have never looked back. Now I work in color in other kinds of places where the color is perhaps less intense. But this decision really came out of a response to certain kinds of places in the world that excited me, intrigued me. Working in color is an emotional response.

MK: When going through the various periods of your work and remembering also where you took your photographs, whether it be in Africa or in Mexico or along the U.S.-Mexican border or in Turkey or in Cuba, I feel often that you accept the palette of

those places, and yet bring to the way that they are featured chromatically something of your own sensibility; that there is some kind of mixture between your appetite for a kind of chromatic environment you don't have here in the United States, but at the same time, a kind of willfulness in charging and exaggerating the scene that is all your own. At the same time, every port of entry, every fleshpot, every backwater town, and major capital is loaded with media supplied by the big media empire of the United States. It's as if somehow you travel thousands of miles simply to come home to what's back in New York. But in modified form. So that there is not only the light of, perhaps, that tropic zone, that longitude, there's also the light of color dyed and stamped by Madison Avenue. Do you find that somehow you have to thread your way through any of this, or how do you accept it or deal with it?

AW: There are places where color is somehow deeply part of the culture, on an almost spiritual level, like Mexico or Haiti. Whereas in Florida, for example, much of the color seems to exist because it's helping to sell something. Same with Times Square now. Times Square is a very colorful place, but its color is commercial color. I'm not uninterested in photographing that. I have done a book on Florida, and I have photographed a good deal in Times Square. But there are elements of the color that somehow don't have quite the same emotional charge as a result. They are decorative or willfully colorful versus part of something that feels like a much deeper expression, perhaps a more spiritual expression, of a society. It's a hard thing to talk about, but I do sense it. Hand in hand with that, my Florida work tends to be more ironic and much more distanced than, for example, my work from the Caribbean.

MK: When I consider what you particularly call the contrast between cultural color and commercial color, I see that this is a kind of warfare that runs through much of what you've seen and brought back to us. And it's something that, while it exists out there, it's nevertheless been appropriated by you, I believe, as a form of dramatic contrast. At the same time, I sometimes feel that cultural color is an endangered species and that your approach to it is almost recuperative, that we're looking through your eyes and your lens at something which may not be long with us if American power dynamics have their way throughout all our vast and overdeveloped media. Is there, in some sense, a nostalgic interest in your work that maybe consciously or inadvertently works through, operates through where you've been and what you've done?

AW: There are elements of nostalgia and romanticism alongside something more hard-edged and somewhat cynical. Different elements of these responses emerge in different projects. My Amazon book tends to be more romantic, perhaps, than some of my other work. It's softer. Whereas Florida tends to be somewhat more hard-edged and more blackly humorous.

MK: An implication of the approach you described with its doubts and its difficulties is that (like many photographers) you have kind of a resistant temper. For example, you're more inclined to look ironically upon our synthetic and plastic civilization in Florida, and be more solicitous in your regard for the down-and-out life along the Amazon, throughout a three-thousand-mile stretch of its flow. So, there's some politics I'm seeing as well as an aesthetic in your work. Does it vary from book to book?

AW: You're probably right. We're not talking about a coherent or rationally conceived politics. It's somewhat inevitable if one spends time on the streets of Mexico or Haiti or Brazil and then steps back into the United States to be much more inclined to have sympathy with people who are not just going through the psychological torment that [*Laughing*] all of us go through in our lives, but are actually having to deal with physical difficulties as well. We take food or various material things for granted: so many people out there have so little.

MK: The profession of the street photographer, the professional stranger moving through sometimes unexplored territories, is in many ways a detached calling. That is, someone who observes, who moves on. Events and, often enough, conditions, are touched upon but not necessarily studied. At the same time the opportunity to investigate becomes absorbed into the intrigue of the picture. Sometimes the pictures seem to tell stories, sometimes they only hint or whisper at moods. I see both going on in your work, and a narrative potential, but one that at a certain point must meet a kind of sense of your own displacement and your own privacy or contact. Does it vary according to, let's say, the difficulties you actually experience on the journey?

AW: Perhaps. There are some places where I haven't been able to enter enough into that world to really come away with photographs that suggest what I feel about the place. There has to be some openness. I remember being in Saudi Arabia and feeling that it was a totally impenetrable culture, that there was no way that I could do anything meaningful there. I could take some pictures that would look somewhat like some of the pictures we've seen of Saudi Arabia, but I couldn't enter into that world. I think perhaps one reason why I haven't spent more time in the Far East is that there is a part of me that senses I don't understand at all what's going on. Walking the streets of Tokyo I take interesting and complicated pictures, but I don't feel that the pictures have very much emotional charge. I don't really get what's going on on an intuitive level. Whereas, for example, in as extreme a place as Uganda, I seem to sense something deeply familiar (though also unfamiliar) about the culture. There's enough there for me to find an emotional and visual port of entry. In Brazil, for example, I can understand or at least sense something about what is going on. That doesn't mean I fully understand things rationally but there's something there, something primal. I intuit. Whether this reflects the fact that many of these places that I have photographed have had a colonial presence at some time, that has somehow stamped them with a Western imprint, whereas a place like Japan really didn't have that kind of history, I really don't know, as I am speaking of an intuitive, visceral response on the streets, not a rational coherent system of ideas. What I do know is that I need a visual and emotional portal to enter these other worlds.

MK: Yes, well. I notice various devices imaginatively maneuvered throughout a number of your pictures. Since I'm particularly interested in the dynamics of color, I can say that there are two dispositions, two tendencies, that seem often at work, sometimes separately, sometimes mingled together, in your pictures. One is the way you organize photographs, those contained fields, by a kind of collage sensibility that exploits strong contrasts, dark and light. The other is a much more luminous feeling one gets almost of chromatic gases at work in blurring or hyping a surface of field, an episode, often

influenced by artificial light when you work at nighttime. These seem to me almost ecstatic effects, when you take advantage of, let us say, the strange rays of green neon, constant along with whatever other forms of illumination there might be, to create, sort of unfamiliarity within the scene. However the problem I have with the first of these approaches, that is the collage approach, is that it emphasizes "value" contrast against chromatic saturation, and tends also to create a sense of the flattening out of the form, reminiscent of modernist aesthetics that go way back. You have a kind of suspended and unresolved approach that interests me very much because it's ambiguous. The other idea, the other intuition of color being formed of light, whether the light of full day or half-light, is one in which modulation takes over, and becomes a moment of poetic potential. So there's a difference between strength of contrast, total contrast, which has its design and graphic potential, and this other more tender, more modulated, more poetic possibility. Do they carry on consistently throughout your work?

AW: The first tendency that you spoke of—the collagist sense of strong light, intense contrasts, flattening of planes, and so forth, emerged first for me. It's probably particularly evident in my first book, *Hot Light/Half-Made Worlds* (though there are, as you call them, more modulated images in that book as well.) As a whole I'd say that that first book was a kind of emotional and poetic statement about a way of seeing in certain kinds of places, as opposed to some of the later books which I think have much more significant sociopolitical, as in *Under a Grudging Sun*, or anthropological, as in *Amazon*, tendencies. Looking back, that first book seems a statement from a younger photographer. As I have photographed longer, as I have seen more of the world, though I continue to explore this (as you call it) more collagist approach, I have begun to explore more other notes, both in terms of form and color and, as they are all inextricably linked, in terms of emotion and politics. My work is more visually, emotionally, and politically nuanced than it was some twenty years ago. I also think that there have been technological innovations that have enabled me to explore other notes. Partway through the Haiti book, a new film, Kodachrome 200, came out that enabled me to explore lower light and mixed light situations in a different way than I had before.

MK: One always feels that whatever other narrative or historical or political feature may play a role in the picture, the complexion of the scene is always well handled: its condition and its temperature as a perception of the moment. But now I'm interested in asking you not so much about the moment, but about sources, about how it happened that you came to develop the features, the style, the approach that we've been describing as a visual body of work. I know that photographers don't just get spontaneously born, they come from places. So, the natural question to ask is, what in the history of the media has affected you in the course of maturing?

AW: There are probably lots of different things that have affected me and there are probably lots of things that I've never even thought about that affected me. In terms of photographic influences, the first two books that excited me—and it's really almost a cliché to say this, because so many other photographers have said the same—were *The Decisive Moment* and *The Americans*. *The Decisive Moment* for that sense of balance, that French *mesur*, the moment, the totality of the frame, and *The Americans* for its spontaneity and its edge. There's a stream of street photographers whose work I've admired at dif-

ferent times, a pretty obvious stream, from Cartier-Bresson and Kertesz, to Frank, Klein, Friedlander and more. (It's interesting that I'm listing nothing but black-and-white photographers.)

MK: I noticed that.

AW: Black-and-white photographers were my photographic heroes. There's no doubt about it. I was a very serious and committed black-and-white photographer before I was a color photographer. When I started working in photography I thought color was crass, commercial; I thought it was something people did to make money but wasn't where the real heart of photography lay. But starting to work in Haiti and Mexico, specifically, transformed my sense of what was possible with color photography. As I suggested earlier, I discovered the light, color, heat, and energy of the tropics. When I came on color photography, there were a couple of contemporary color photographers whose work I saw that intrigued me: Miguel Rio Branco and Harry Gruyeart. They were dealing with some of the same kinds of issues and problems that I was beginning to deal with. But I would also say in terms of color and how I've evolved to see a certain way, there are other, deeper, and perhaps more significant influences. I come from a family where the visual arts are very important: my mother was a painter and a drafts-man (now a sculptor as well), my brother is a painter, my sister tried to escape and go into science but she ended up being an ornithological illustrator and does these remarkable pictures of birds. Art as a whole—my father is a writer and a publisher— was very important. And it continues in the family: my wife, Rebecca, is a wonderful and unique photographer. It seemed almost inevitable that I become some kind of artist; I happened to end up in photography. I absorbed a lot growing up, by osmosis, not directly. There are things that I never really thought about when I started photo-graphing or, in particular, started using color. But there's a little de Chirico, a little Braque, and a little Matisse stuck there in the back of my mind somewhere. But until someone pointed it out at me at one point, noting that there seemed to be a bit of de Chirico to my work. I never really thought of it. I was blissfully ignorant.

MK: I would say that de Chirico was a very influential idea.

AW: I remember loving de Chirico when I was really quite young. I went through a period of time, from eighth to ninth grade, when I thought I was going to be a painter and tried on various different styles. There was [laughing] a Magritte period, and there was a de Chirico period, and there was a Jackson Pollock period. Thank God the world was spared my efforts at painting!

MK: Look, I expected you to recite a very imposing list of predecessors and it never dawned on me that you would have really meaningful contact with them, and I'm glad to hear it. But now is the moment for me to ask you, since I know you to be a thinking man, and a reading man, what about the literary, cultural, or even the philo-sophical sources that have fed into your development as a feeling man?

AW: Max, I do want to say that I didn't bring these painters up to be imposing or to impress anyone.

MK: [*Laughing*] Sure.

AW: It's simply that I have realized in hindsight that these people's work has sat there in the back of my mind. But back to your question. There was a period of time, particularly when I was in college, where I really thought I'd end up a writer rather than a photographer, I did study literature in college. There are writers who have been really key in motivating me to go to certain places. I almost feel that some of my photographs are a little bit like the background to certain novels. My photographs don't deal with the specific dramatic or moral content of the novels, the plot or anything like that, but there's something about the atmosphere, the background of the novel. I would certainly say that my first book *Hot Light/Half-Made Worlds* was influenced heavily by a too impressionable early reading of Conrad's *Heart of Darkness*. Certainly my first trip to Haiti, as I mentioned before, was influenced by reading *The Comedians*. A number of Graham Greene's books have served as a kind of impetus for some of my work. When I was in the Amazon, I felt a bit like I had stepped into the background of a García Marquez or Vargas Llosa magic realist novel. So these are influences. They're indirect influences, but they are influences that have either propelled me to go to certain places or prompted me to respond certain ways. Often when I'm thinking about going to a place I put myself through a delicate process wherein, before I read too much of anything that deals with that place directly (historically or culturally), I will first read novels about it, to initially experience the more imaginative, more poetic approach.

MK: Look. The books you mention, or the authors you mention, write stories about the encounters white people have with people of color. And out of those contexts (often experienced at first hand by the authors themselves) there's fabricated narrative of cultural encounters, in which one side is clearly unequal to fending for itself against the other. So those are political authors, by and large. And they are also poets, too. Not simply involved in questions of social justice but of imaginative reinvestment in the lives of others. I think of your own photography, often, as a visual correlate of those narrative streams, in a funny way. I can't think of others who have a comparable ambition. Many estimable people working where you've worked and elsewhere, and in color too, are often engaged with, let us say, very immediate and distressing horrors of survival, for example, or a condition of work, or of something breaking as news. And we need that kind of witness. But I also think we need the more contemplative involvement, half aesthetic and half very concerned: work that you've provided us through your many books. I wonder how at this point you find there's some kind of public out there to receive what you're doing. Has it become more or less difficult as you've proceeded in life?

AW: I suppose it's gotten less difficult. But [*laughing*] it still remains difficult. Certainly the biggest struggle was getting the first book out. That took going to a lot of different publishers and being fortunate to find one editor who really loved it and eventually was able to do it.

MK: What was that?

AW: *Hot Light/Half-Made Worlds*. But it continues to remain difficult because to a large extent my books appeal to perhaps 3000?, 5000?, maybe 8000 people? 8000 people?

That said, 8000 people don't buy them, but maybe 8000 people experience them. And a lot of those people seem to be photographers or are specifically involved with photography. In that sense I sometimes feel that it's really not that different than poetry: poets write poetry for other poets. A lot of my work is most appreciated by other photographers or people connected with the world of photography. Now, it's also true that my photographs get out in other ways. They do get out sometimes through the mass media. We've looked at some of my more recent Istanbul work. A number of those photographs, some of the best photographs in that body of work, were published by National Geographic. But they were published very much in the context of the Geographic, which gives them a different sense than, say, if I published my own book on Istanbul. The context changes the meaning. But I am happy to say that some of the more complex, suggestive, evocative atmospheric photographs were published in the Geographic and hence have been seen by a many people. How many people out there respond to them I really have no idea. I would like to think that my books do contribute to some kind of general dialogue about the place that I am photographing, or about seeing, or about photography but [laughs] it's a very quiet dialogue because there aren't that many people out there who see the work. And I accept that. We don't exist in the most visually literate of worlds. The bulk of people in this society look at a lot of television, where there is a head in the middle of the television that tells them what is going on. Most of those people probably aren't so excited about the more ambiguous nuances or complexities of my photographs. So I accept the fact that in doing this sort of work I am on the periphery.

MK: I asked you about the adventures you've had with publishers, and the problematics of finding book outlets for your work. There's obviously also a correlate of that in the experience you must have been having over these many years dealing with younger photographers in workshops, and presenting your work there, and hearing of their work. How do you estimate or judge the situation might have changed with younger people coming up, adopting the aesthetic and the consciousness that you yourself have developed?

AW: Look, I think it's harder now to emerge as a young photographer than it was when I came up. There are fewer outlets for interesting photography than there used to be. It's true that when I became a professional photographer, which was in 1974, it was shortly after the demise of Life and Look, and everyone was wailing: "This is the end of photojournalism." And for many people it was. You weren't going to be a Life magazine staffer anymore. I suspect that Life staffers had a presence in the society (maybe in the late fifties and the early sixties) a bit like being a prominent television reporter today. You could be a major cultural figure. Your potential influence was somewhat comparable. And that's certainly not true for the vast majority of photographers these days. It looks to me like it has definitely gotten tougher. I suspect there are people who are not going into still photography and are ending up in video as a result of the limitations of the market right now. I'm worried all the time about how I'm going to find funding to go do what I want to, have to, what I feel I need to, do. On the other hand I have to say that those worries have always existed, and I've found, as is true I'm sure of many freelancers, I've had to be flexible, to bend, and do certain kinds of things to survive that perhaps I don't want to do. There was a period of time, for instance, in

the early eighties, when very little magazine work directly supported what I wanted to do. And I ended up, for three or four years in a row, working on a couple of annual reports every year, and then would go to Mexico on my own with the money I made from that. The late eighties and early nineties in particular were quite good for me in terms of finding magazine or art commission work that supported what I cared about doing. In fact since 1989, I would say that I've found more acceptance of who I really am as a photographer in the mass media, even though my photographs are not necessarily always ultimately published just as I would most like them to be published.

MK: Reviewing your work and moving figuratively along with you on your travels throughout the world, it often seems as if you're visiting places, groups, societies that appear to be communities but one is not so sure when one goes close. When one gets closer with the work, people seem trapped or isolated, even while in proximity to each other, in their own space. It's as if loneliness exists multiplied in the areas where you find yourself. Is this something you've noticed, or something that you would somehow appear to have discovered, or invented, or what?

AW: I certainly don't think it is something that I've consciously noticed. Do I think, ultimately, that loneliness is one of the key states of human existence? Maybe. Maybe I'm drawn to that. Maybe I find it for that reason. That's hard to say.

MK: But people seem somehow at odds, or facing difficulties when they want to create togetherness in your work. It doesn't seem somehow there's an adhesive quality in many of the pictures you show of islanders, or tribes, or even modern-day passersby in major cities. Why is that?

AW: There are a couple of things. I may respond personally and be attracted on some level to a kind of sense of emotional disjointedness. Perhaps that goes hand in hand with the fact that I am drawn to places where there is some kind of cultural mixture or cultural dissonance. I'm very attracted by borders, places where different cultures come together. Sometimes they fuse, sometimes they remain separate, but meld in interesting ways, almost in layers. For example, the U.S.-Mexico border. I find it really fascinating, walking down the street of a Mexican border town, how on one block you feel like you're deep in the heart of Mexico, and in the next block you're in some strange place that is somewhat Mexico, but also part of the United States. I just think that I've always been intrigued by places where there are these kinds of cultural conflicts, these kinds of dissonances.

MK: It seems, just on the basis of the visual evidence you give, that we also know this to be the case in reality. There are a number of terrains throughout the world where people, even those with roots, no longer sense that they have a stable identity, that it's eroding. In some sense your pictures are a process record of that erosion. The input of modern technology and media has a presence, but it's not complete. The hints and vestiges of an older traditional culture abound but do not dominate. And so that there is this ambiguous sense of displacement, of a culture's being misplaced before your very eyes, that seems to animate so many of your pictures.

AW: It's partially for that reason that I called my first book *Hot Light/Half-Made Worlds*, to suggest rawness, dissonance, displacement. I know that the second half of the title (a phrase coined by V. S. Naipaul) is a somewhat loaded phrase, and I know that some people have objected to it. Some feel that the notion of something not being fully made is pejorative. But if you look at it in descriptive rather than pejorative terms I think it does suggest a quality about places where an indigenous culture is overlaid by an intruding northern culture, and how those cultures manifest themselves in that climate. Those are the kinds of places that really intrigue me.

MK: You don't actually make judgments about the state of affairs, but you absolutely take note of them.

AW: I'm not into making judgments. I'm really more into asking questions and, as you say, taking note. That's a key issue for my photography. I may have, I certainly do have, moral stances about things, and I have sympathies with certain peoples. But I'm also intensely aware of the fact that the world is a very complicated place. For instance, in Haiti, during the period of time from 1986 to 1988, the people whom I was sympathetic to were the people of the streets, the peasants and poorer people in the cities, who were being killed by the army or paramilitary organizations. But I was also very aware of the fact that when these people had a chance to retaliate against their oppressors they would mutilate the body of their enemies. They learned to act like monsters from their enemy. I sadly and reluctantly accept that as sometimes the way of the world. Despite my sympathies, I'm not going to hide that. The most graphically violent image in my Haiti book is of a mutilated hand, an act committed by the people I'm sympathetic to. Even more disturbing is that there was uncertainly whether the man depicted in this image was in fact a collaborator with the enemy. The world is a complex place and there are great dangers when you start looking at everything in terms purely of black and white.

MK: Maybe that accounts a little for the impression that some of your pictures give, even perfectly serene and pacific pictures, of a certain sinister, underground reality. Of the offstage but imminent pressure of power from the outside. It seems to me to have affected some of the characters you depict. It isn't as if one can call them outright victims, but their lot in life is not really a happy one. But rather they seem sunken-in, not exactly resigned, but introspective enough about things that are heavy upon them and lower their emotional horizon. Could there be a certain pessimism in your vision as a result?

AW: I don't know whether to call it pessimism or [*laughs hard*] to call it realism. Look, I'm very suspicious of easy solutions. Again, the example of Haiti: I knew a number of people, journalists, sympathizers with Haiti, who immediately embraced Aristide as a savior of Haiti when he appeared on the scene. All along I always sensed, as did a few of my friends, that Aristide was not the answer. Yes, I certainly think that Aristide is far better than Papa Doc, absolutely. Certainly there are good things about him. He is far more aware of the plight of the poor than most past Haitian leaders. But he's no democrat, he's no champion of free speech. I never thought that this one man was going to be a savior. I'm suspicious of saviors, I'm suspicious of people who are put up as heroes. I think we're all deeply flawed, we all do things for very complicated motivations.

MK: You're suspicious perhaps due to your own moral understandings and values, your awareness of the way things are arranged in imperfect and flawed societies. But is your suspicion at all related to your aesthetic?

AW: It's very hard to evaluate. How does one come to a specific aesthetic, a specific way of seeing. I do think that the way I see does reflect the way I feel. You can't divorce the two. And so there are always all kinds of psychological factors in the way I see, the way I put together a picture, the way I see color. Seeking out visual complexity may be tied to a belief in moral and political complexity. And color isn't just color. Color is emotion and psychology as well. But I've never sat down and specifically analyzed my way of seeing. Is it a pessimistic way of seeing? I don't know. I suppose that it is a way of seeing that embraces numerous possibilities.

MK: All right. Scratch that. But think of this. I have the idea that color in your work operates, not as a distracting but as a deliberately misleading element [*laughter*] because it is so magnetic, seductive, powerfully sensual that it's very difficult for the eye to resist its invitation. And as that happens, it is often only gradually revealed that the scenes you're describing are often radically unhappy ones. So there's a dissonance in your work, I think a conscious dissonance, if not an outright strategy, that keeps the work not only resonating in your consciousness, but also unresolved as a way you can figure out your own reactions, yes? Now, I wondered if that wasn't at the same time a contrast with the work of some rather famous photojournalists. To name some names, Eugene Smith earlier, or Sebastião Salgado now. Their work strikes me as very operatic finally, with the sense they give of huge epics and grand themes and powerful momentum. Massed figures. Magnified sorrow. All of which seems editorialized in a way designed to lead the viewer to very specific conclusions about, let us say, the miseries of the world, or the pressures of injustice. I don't sense that pressure in your work, but it seems that, around the edges, a comparable force is implied.

AW: I'm not sure I entirely understand what you mean by comparable forces. I do believe that these places I photograph are important to photograph. Important, as you put it, to note. We should be aware of them and not just sit in our North American cocoon. And I agree with you absolutely that there is often a specific editorial point or stance to Gene Smith's work, or Sebastião Salgado's work. I think the best of their work goes somewhere else and takes us beyond the editorial point to something more mysterious and complex. But through a lot of their work, as is true of much photojournalism, points are being made, evident stances are taken. What I do is quite different: I see myself as going out and exploring, and finding, and discovering. I go back to this notion of asking questions about the nature of things: how can this and this and this and this all exist, and in the same frame? I don't think that most of Gene Smith's pictures are asking questions. They're announcing: this is pain, this is misery. They are defining. The approach is distinct.

MK: This is a permanent order of things. There's a constancy.

AW: Right. For example, I didn't go to Haiti because I wanted to photograph the poor, or show that Haiti was poor, the way a number of photojournalists might. I went to

Haiti to explore an interesting and complicated society, poor and desperately tragic, yes, but at the same time full of life and vibrancy. In that sense I wanted to explore the totality of that world. Running through a lot of traditional photojournalism there is an overwhelming sense of. . . pictures that say something, that define something. And I'm not doing that. I'm not trying to define things, I'm trying to explore things. I'm trying to ask questions.

MK: Well, the questions well up in the individual choices that you make from frame to frame. But if it were only a matter of asking a question the viewer might well say, "What is the worth of the question? And did it need to be asked?" And I think that the pictures often go past that initial phase of doubt or puzzlement, suggesting that the unresolved state of the people and the cultures which you visit and which you depict is part of a larger predicament we're all in as the ground shifts under our feet, in this country as well as elsewhere. That is, we don't know anymore that…stable course to our established goal, we don't know anymore that we're protected or secure. We know about the central presence of our surroundings and the surroundings of other people, and the combination you make of those surroundings, and the quest for certainty or the lack of certainty seems somehow to speak out past that individual scene. I don't know people who do that very often. In one sense it seems to answer to feelings that there are others who are in our own predicament, or our own trauma. We say, "Yes, that is the case." Some more, some less comfortable, some more, less materially secure. But the lack of certainty seems to me a positive character of the work?

AW: No, I agree. I do think that probably one of the reasons I have gone to the places I've gone is that there is something that I need to deal with that is somehow unsettled. Is it that I have to go somewhere unsettled to get my photographic juices running? I don't know. But I am drawn to places where there is uncertainty, a mixture of cultures. Does this need of mine reflect a larger awareness, a kind of social anthropological awareness, of the ongoing mutating nature of the cultures of our modern world—that this is the state of the modern world? Probably not on a very rational level. Maybe on a more intuitive level. All my major projects suggest this notion in some way or another. But they suggest, they don't define. Whatever ideas emerge out of my photographs emerge out of the streets, out what I am finding, out of the process of responding photographically in the street.

MK: There's a kind of electrifying enigma that runs through some of this approach, which is not necessarily a contradiction of terms, but an order of dissimilar things put together in a surprising way. To look at good examples of street photography or, let's go further, such examples in color, is to be confronted with a certain problem. How could I phrase it? The viewer is unconvinced that anything of lasting value has been established in a fragmentary glimpse, with a powerful, sensual, and material presence. But at the same time, absorbed into this view, coming to realize that whatever is imagined has a constancy to it, whatever is miscellaneous can repeat itself. That the possibility of one particular photographer's pictures lying around the corner is never realized until the photographer is there. It's one of the enigmas of photography.

MK: I'd like to ask you about your current project. It's still obviously in progress. The

pictures you took in Istanbul, which perhaps you have some plans to issue in book or permanent form. I take it that Istanbul is one more of your border territories, insofar as it is replete with both Western European and Asian sociologies, signs, manners, politics. And also that, somehow miraculously and yet almost inevitably, some of that duality seems to get into your pictures. Would you like to talk about that?

AW: I went to Istanbul somewhat by chance on assignment in 1998. And I was very intrigued by it. This place that lies between Europe and Asia, the apparent contradictions of a culture that is secular and Islamic, quite unique in the world; a place with a deep sense of history and layer upon layer of various empires. I went back in 2001 several times. I find something very visceral and intense about Istanbul—the kinds of contrasts: the way one can feel at one moment that one could be in a bar in Barcelona; and then one goes down a street and thinks one is in a bazaar in Central Asia. Finding people who are extremely westernized alongside people who are Islamic fundamentalists. It's also a special place physically. The city is divided by the Bosphorus, so that it's on two separate continents. And the sense of water, the way the Bosphorus opens up the city. If Istanbul didn't have the Bosphorus it would feel more like Cairo, dense and enclosed. I've found it exciting and surprising working there. And I feel it's a slightly different direction for me than some of my other work.

MK: Yes, but how, given these circumstances, the features—topographical, cultural, constructed—of the city, verging (in your account) on the incoherent, certainly the hybrid, do you organize that encounter into an integrated body of work on the city? What devices do you use? What approaches do you employ to make that perception both a true one to itself, and yet integrated within your own work?

AW: Well, first of all what I'm saying about Istanbul is as much the result of hindsight, having spent time there and photographing, as it is anything else. My general sense of my work is that a lot of times I can't say much of anything about what it is that I'm doing or where it is that I'm going until I'm fairly well immersed in a body of work, because my experience of the place and my feelings about it come out of being there and responding. I didn't go to Istanbul with the idea of photographing a city both Asian and European. I went to Istanbul, and I wandered around Istanbul, and I started perceiving certain things. This is always my approach, to let the experiences of the street speak first and foremost. I step off onto a journey, yet it's a journey with no specific destination. I don't know where it will end. And how do I get there? I get there more than anything else by walking—either physically or figuratively. (In the case of Florida especially it'd be figuratively because it was really driving.) But it's about wandering: wandering and wandering and re-wandering, and returning to places, and absorbing, and just experiencing.

MK: Yes, but this wandering which typifies everything you do, and is necessary for you to do it, while it suggests that you're at some outsider's distance to what you see, nevertheless is contradicted by the intimacy of the glimpses you have, the close-up to character, the feeling of being or taking the viewer into and being immersed with the circumstances of the subjects.

AW: It's not such an alienated form of wandering. I may wander into a situation, and I may meet some people, and they may take me somewhere else, and that takes me to something else. So, there's an ongoing photographic dialogue with that other world. There is a kind of back and forth. I'm not just an alien creature who drifts in and drifts out. I talk to people. I meet people, I sometimes go with them to places when it seems appropriate. Some days I may just wander around and not say anything to anyone, but there is always the possibility of some kind of more direct relationship.

MK: The social description of an internal process, which is what we find surfacing in your pictures, the internal process, that you might have a conversation here and there, strike up a mild acquaintanceship, is all very well, but perhaps doesn't account for the feeling we have of closure with subjects without knowing those subjects.

AW: One of the things about photography is that a photographer, if they're attuned to their own visual responses and can really respond on their nerves, intuitively, can take surprisingly perceptive pictures of places that they know little about. And in fact I sometimes think that there's a danger even of knowing too much, at least initially. In other words, when I decide to go off to a place, I go through a very complicated process of reading material about the place, but not reading too much. I need to know a few pragmatic things for that first trip. I'll read some guidebooks. But prior to that first trip I don't want to read too deeply about the history or the culture of the place. I need a few signposts initially, but that is all. Perhaps that's why, as I mentioned before, I sometimes will just read a couple of novels set in the place. Because I want to remain open to whatever kinds of possible intuitive responses I can have. And it's only after I work deeper into a situation that I begin reading more and begin balancing my visual and intuitive understanding of the society with a more rationalistic historical understanding. For instance, to give you an example, my Haiti book. All my books have some kind of overriding construction to the way the pictures are laid out. The Haiti book works almost as a circle, or as part of a spiral. The opening picture of the Haiti book is a landscape, and the last picture in the book is a landscape, and they're very similar, in a certain way. Both of them show stark silhouettes against a very bleached-out background. I can show you [pulls out the pictures]. That's the opening picture. That's the last picture. This book felt to me, emotionally, that it should come full circle. It's a book that starts out with photographs that are somewhat timeless and that could have been taken anytime in between, perhaps, 1960 and 1986. Then it moves into pictures of greater political significance. It goes into pictures of violence that could have only happened at that particular time. So it becomes a kind of sociohistorical record of a particular period of Haitian history. Then it moves back to more timeless pictures, ending up with this picture at the end that's very similar to the one at the beginning. This felt to me intuitively right, visually right, emotionally right when I put the book together. Very shortly after I put it together I had this revelation that this structure corresponded almost exactly to what a Haitian political scientist, Leslie Manigat, used to say about certain periods of Haitian history: he talked about these periods as moments of nudity.

MK: Nudity?

AW: Nudity. When the skeletal structure of Haitian society is revealed. Each time there

is an election, Haiti goes through this circle from calm to increasing disorder, and back to calm again. I see this book as one of the circles in the ongoing spiral of Haitian history. But I didn't set out to structure this project this way; it evolved visually and intuitively. But in fact this structure has a certain historical and rationalistic logic as well. That's the most glaring example I can think of in my work where there is that direct correlation. I believe strongly in the primacy of the initial visual response, the initial visual exploration of a place. Building on that, going back to the place, coming back and looking at the work, going back and building, and so on. And in conjunction with that process, reading more and more, so that my rationalistic knowledge of a place jibes with my visual knowledge of a place.

MK: As that begins to happen, obviously it's a process through time, you obtain more knowledge of the area, or the topic, but not so much as to perhaps deform your work through prejudgments.

AW: Exactly.

MK: Or the presence coming in of one of those cliché possibilities. Nevertheless, in so many of your pictures, there are naturally enough certain recurrent little situations or motifs. They happened, and you fastened upon them, not such that they overwhelm others. I have in mind one in particular which appears in the book more than once, and since you just mentioned it I must draw your attention to it. It appears elsewhere, in all your work. It's the presence of a figure or figures with outstretched arms, their hands holding on to something, an upright beam. Sometimes the figure seems to be holding on for dear life and has no other visible support than the banister or the pole or the pillar. That suggests further that the space out there is one that really isn't so supportive [laughter], and sometimes, people seem lost in their space. Or a much more common situation for you than that they're in command of it. Any ideas about that?

AW: I see exactly what you mean. No one's ever really pointed that particular motif out to me, but it's an interesting one. It's definitely true that I respond to uncertainty, and I'm attracted by uncertainty, and I don't know exactly what that means or why that is. But there is something to what you say. I actually thought that the motif you were going to mention was the pole. Many viewers have pointed out to me how I divide the frame up with poles. One friend said about the Haiti book that the prevalence of poles dividing the frame suggested the presence of the poteau-mitain, which is the pole that goes in the middle of the voodoo peristyle around which ceremonies take place. I think this is a little too much interpretation.

MK: They brought that up? What was it that became the issue, with that kind of comment? Can you elaborate?

AW: No, it was a comment, it was not a criticism; it wasn't an attack.

MK: No, I understand, but it's a comment about the way a picture's space is organized within a frame, whereas the thought I had was about the situation of the people.
AW: Yes, yours is more of an emotional motif, perhaps, rather that a structural motif.

MK: That's right. Exactly.

MK: Then there is a correlate to this sense you often give of people clinging or holding on to inanimate objects, and their relationship to objects anyhow, which seems often enough precious; in their world they don't have too many things. But I think, issuing out from that is the idea of the contrast between the presence of the people within the frame, howsoever they're disposed, and the implications of people who are not in the frame but whose shadows appear within your field of vision.

AW: Really within the frame, you mean?

MK: Yes, the shadows in the frame.

AW: You're talking about the actual, physical shadows, you're not talking about metaphorical shadows?

MK: A device which allows you to exert pressure on the edges but also to imply continuities beyond the intact and already tightly wound-up configurations you give us. But I think there's also something further, there's a psychological character to the idea of there being shadows as well as substance.

AW: Yes, I think there is a psychological character, but I'm reluctant to characterize it too much for what it is or isn't. One of the problems, always, with a photographer talking about his or her work is that the photographer isn't the only person who is looking at that work, and the photographer has his or her particular feeling or stance about whatever it was they were doing, but in fact it may have little to do with what a given viewer finds in that picture. I sometimes find the vast variety of different kinds of responses to the same photograph that viewers will have fascinating. The viewer is yet another eye that is part of the compact that makes a photograph what it is. Yes, the shadows are there. Yes, they may have emotional implications. I think they do, but I would hesitate to say just what they signify. Because for some people they'll be one thing, for other people they'll be another.

MK: Yes, but, since we're discussing shadows, let's not overlook the fact that they played an important role in de Chirico, who figured earlier in our conversation. He used shadows to suggest impending and unknown presences offstage, which nevertheless might just have influence upon the fate of the actors onstage. That's what I think the shadows often do, not only in his work but in a very different way within yours, too. They suggest for example that some of your people are actors and that there are choruses—there's a chorus outside, looking in: there are unseen witnesses.

AW: That's an interesting perception.

MK: People looking as you're looking, but of course not with the same intent and not described. Just as you often imply the character or the bearing of a person by a silhouette, a shape. You see? Regarding the point of view, yours sometimes varies from being normal eye-level, but often from beneath, too. Finally, though, there is that quandary

we're all in when we look at the photographs, namely: the question they beg as to whether a situation described (an extreme situation) is one that is somehow criticized or offered for new forms of concern. Is it (do you see what I mean?) something that does not somehow suggest the unequal power relations between viewer and viewed, because in fact it is a common situation for much of the world? Or is it something that implies a judgment outside, towards people within the picture? And I think so often what we call documentary photography poses this question without resolving it. I think this is the beginning, not the end, of what you've been doing. That is, you go further in saying yes, we understand that perfectly well, but it's taken for granted, and then explore where one might be personally, psychologically, individually. . . I don't know.

AW: I'm not sure I have anything to add to that.

MK: Alex. Regarding our discussion about the mixing and the adulteration of cultures adjacent to each other—or sometimes further away—there's one of your images that's kind of startling in this regard. It appears in your Amazon book, and we're looking close-up at four or five figures who are topless male figures, blindfolded, with hula skirts, bound to trees sprouting from an endless sort of alluvial stretch of Amazonian water. And they're dressed in rather wild and fanciful native-looking costumes. What on earth are we looking at?

AW: This was one of the strangest events I have ever come across, and when I look at this picture think it typifies one of the reasons why I photograph, and don't, say, paint or write fiction. Because I could never have imagined anything so remarkable. This is one of the true gifts of the world to a photographer. These are North American real estate salesmen and they're on a junket. Every year their company takes its fifty best salespeople somewhere in the world—or at least it used to. One year they went to Egypt, and they rode on camels near the pyramids. Here they are performing a mock initiation ceremony for their best new salespeople, their best first-year salespeople. A crazy idea! I came down into the lobby of my hotel, and there were these white guys, with body paint and dressed in grass skirts. I said, "What's going on?" And they said, "We're going across the river for dinner." And I said, "Can I come?" They assented. They continued to paint themselves on the boat going across the river. When we got to the other side there were more of them, handcuffed to the trees. Very strange.

MK: What was the point of the rite? Was it some kind of initiation, or reproduction of a ritual?

AW: These guys were simply having fun. That's all it was, and no more than that. But very peculiar. Even more complex too, is that a couple of years later I received a call from a gallery that represents me, and apparently one of these guys, totally independently, had bought one of my prints from Haiti. And he later came into this gallery, and asked whether any of the photographers they represented had been to the Amazon. The gallery said, yes, Alex Webb. And then he realized it was the same photographer, and bought a print of the picture of himself. So peculiar and convoluted, to have this prior independent relationship with this person [*laughing*] through buying a print. Very, very strange.

MK: [*Laughing*] You just burst with curious possibilities, with reversals and coincidences!

AW: Absolutely, absolutely.

MK: A young person grows, begins to form an idea of life, gathering meaning. In your case it was the profession of photography. I wonder at what point when, as you were coming into your own, it became a possibility for you. That is, who might have affected your thinking, encouraged you to do the work?

AW: Well, it's always very hard to analyze exactly why one makes certain decisions in one's life. Decisions just sort of seem to happen, and then you look back and sometimes maybe you understand why it happened as it did. I actually learned photographic technique, at least black-and-white technique, when I was in fourth grade, from my father. When he was struggling with writer's block he did some photography. And he took some good photographs, street photography as well as informal portraiture. But I was not initially taken with photography and didn't really return to it until I was a sophomore in high school. I started photographing around the streets of Brattleboro, Vermont (I was going to school in Vermont). Certainly very influenced, as I've suggested, by Cartier-Bresson, Frank, and Kertesz, as well as by Harry Callahan's street photographs and some of Ray Metzger's Chicago street photography. I struggled initially in college with my photography and after my sophomore year in college took a workshop with Charles Harbutt. Charles really encouraged an appreciation of this kind of intuitive work. He's a very good and subtle teacher. He urged me not only to continue exploring my own photography but made me realize that photography could be a way of survival and a means of supporting the kind of work that I cared about. Two years later he brought me into Magnum. I didn't come out of college with some great idea of being a professional photographer. I just backed into it. I knew that I cared about a certain kind of photography, believed in it, wanted to continue doing it. Charles helped open up this opportunity for me.

MK: Alex, I've always wondered, but more often recently, about the place you might be said to have in the media. After all, you are a media person, you've worked for a famous and prominent photojournalistic agency, you have commercial jobs. How do you size yourself up or estimate your role, your function now as within the network of complex (in this case visual) media communications? Do you think that you're an honest broker or do you think that, in a sense you're rather devious, or do you play different roles with as much confidence as required by the circumstances? How does it work?

AW: That's a difficult and complicated question! Like many photographers I perform this kind of dance, giving the publication that hired me what they need as well as simultaneously trying to do what I care about doing. If we speak of the Istanbul work again, even though that project was published within the context of *National Geographic*, and hence does not look the way it might if I had put it in one of my books, none the less, I'd like to think that there are published pictures there in *National Geographic* that have different nuances from what people might expect in a *National Geographic* story on Istanbul. I'd like to think that that my photographs might make viewers understand the city in a different way. I don't know.

MK: Let me get at it a little bit more specifically, since you mentioned Istanbul and *National Geographic*. You've had a lot of experience working for *National Geographic* off and on these many years. So it might come as a natural question for me to ask you: of the pictures of yours that they have chosen for publication for a specific story, would they have been likely to be the ones you yourself had chosen or could agree upon easily enough? Or were they at odds with the ones you thought were the best? Because this would tell us more about your relationship with the media in a one-to-one way.

AW: Surprisingly enough, I would say that *National Geographic* publishes a comparatively high percentage of my better photographs when I do a particular project for them. I would say that sixty to seventy percent of the pictures that ran, for example, in the project I did for the *National Geographic* on the Amazon River, appear in my book. Quite a high percentage. Now, *National Geographic* is a little unusual in that, unlike other magazines, it asks the photographer to come to Washington and work on the layout. You can push for pictures that you care about. I push for those that tend to deal with the emotional and psychological geography, versus the physical geography, of a place. Inevitably, with any magazine there are certain pictures that have to go in for editorial reasons. The agenda of a magazine is almost always different than that of an individual photographer doing a personal project. I accept that I have to take certain kinds of less personally satisfying photographs to make a project work for a publication. I'm professional about that. There are other magazines I've worked for where very few of the pictures that I care about go in. But at this point I have to say that most of the magazines, at least the picture editors, hire me probably because there is an expectation that I may come up with something that will be a little unusual and a different. The picture editors may at least want to see what I will come up with, even if they can't use it in its purest form. I remember years ago, having an unusually good layout in *Stern* magazine. It was not an assignment, they just picked up some of my Haiti pictures and ran seven double spreads, with very little text. Underneath each picture they wrote a German word: Angst, Traume [*laughing*], etc. But it was great! A number of those pictures are among the best pictures in my Haiti book. And I remember going to the then art director afterwards, thanking him and suggesting another project. And he said, "Alex, your style is too distinct. We really can only use you once every four years."

MK: [*Laughing*] In other words, a little of you goes a long way!

AW: Or only a little of me is acceptable. But, it's okay; it's just that my work doesn't necessarily fit into the mainstream of the magazine business. Most of the time magazines want to see fairly direct pictures that show something fairly evident going on. The photographically more interesting magazines run pictures that have some real visual life to them; the less interesting magazines run pictures that are really illustrations of pieces of text. Usually magazines don't want too much ambiguity, too much enigma, too much mystery. They may accept some, so sometimes they'll hire me.

MK: Once again, an ill-fitting kind of media person.

AW: Right. And I think you could look at it another way, and say I'm a little ill-fitting in the art world, too. Perhaps because my pictures deal a little too directly with the

physical world. They don't deal evidently in obvious, easily definable ideas. They don't work as conceptual pieces. They deal with the messy contradictions of the world, albeit in an aesthetic manner. I don't think this is unique to me. I have always felt that a lot of the most interesting work, not just mine but other people's, falls into this nether area, somewhere between the worlds of documentary and photojournalism (two very vague words) and the world of art. I think a lot of street photography falls into this nether area. It doesn't quite fit into the magazine world, but it doesn't go quite so easily onto walls, or maybe only goes onto walls after the practitioners have been dead a certain number of years.

MK: That's good.

Alex Webb was born in San Francisco in 1952. He graduated from Harvard University with a degree in history and literature, and went on to join the Magnum agency in 1976. He is the author of four books, which have gained enormous recognition for his delicate use of color, complexity of composition, and vision toward various tropical cultures. His fifth book, *Crossings: Photographs from the U.S.-Mexico Border*, which was released in 2003, is the result of twenty-six years of work on the southern frontier. In the process, Webb has received several important awards, including the Leopold Godowsky Jr. Color Photography Award (1988), the Leica Medal of Excellence (2000), and the David Octavius Hill Award (2002). His work has shown in museums and institutions internationally, such as the International Center of Photography, The High Museum of Art, and the Whitney Museum of American Art.

Max Kozloff, a professor, art critic, and photographer, was born in Chicago in 1933. His work as a critic was cultivated primarily within the pages of *The Nation* and *Artforum* magazines, he was executive director of the latter from 1974 to 1976. He is the author of two books, *Cubism/Futurism* and *Jasper Johns*; two compilations of critical essays, *Renderings* and *Cultivated Impasses*; and three books of essays on photography, *Photography and Fascination*, *The Privileged Eye*, and *Lone Visions/Crowded Frames*, along with a monograph on Duane Michals. In 1976 Kozloff began to dedicate himself to color photojournalism, with a focus on urban themes. He has had individual expositions in the United States, Great Britain, and India, and was curator of the *New York: Capital of Photography* exhibition, organized for the Jewish Museum of New York in 2002.

SELECTED BIBLIOGRAPHY

Individual Catalogs and Books

Amazon: From the Floodplains to the Clouds. New York: The Monacelli Press, 1997.

Armendáriz, Lola Garrido, and Juan Ramón Yuste. *Alex Webb. Fotografías: From the Tropics.* Madrid: Sala de Expositions del Canal de Isabel II, Comunidad de Madrid, 1989.

Dislocations. Cambridge, Massachusetts: The Film Study Center, Harvard University, 1998—99.

From the Sunshine State: Photographs of Florida. New York: The Monacelli Press, 1996.

Hot Light/Half-Made Worlds: Photographs from the Tropics. New York: Thames & Hudson, 1986.

Crossings: Photographs from the U.S.-Mexico Border. (Essay by Tom Miller.) New York: The Monacelli Press, 2003.

Under a Grudging Sun: Photographs from Haiti Libere. New York: Thames & Hudson, 1989.

Joint Books and Collections

Endure. New York: The Rockefeller Foundation, 2001.

India: A Celebration of Independence. New York: Aperture, 1997.

In Our Time: The World as Seen by Magnum Photographers. New York: Norton, 1989.

Mexico Through Foreign Eyes. New York: Norton, 1993.

Miradas de fin de siglo. Barcelona vista por... Madrid: Fundación Cultural Banesto, 1994.

Miradas de fin de siglo. Madrid visto por... Madrid: Fundación Cultural Banesto, 1993.

Miradas de fin de siglo. Sevilla vista por... Madrid: Fundación Cultural Banesto, 1994.

New York September 11, 2001. New York: Powerhouse, 2001.

On the Line: The New Color Photojournalism. Minneapolis: Walker Art Center, 1986.

BERNARD PLOSSU

speaks with Juan Manuel Bonet

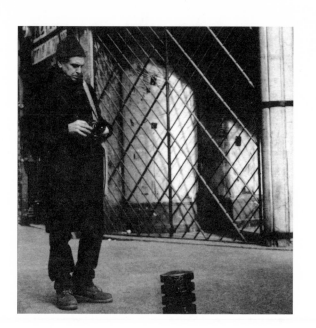

Madrid, 10 January 2002

FROM THE 'FILMOTECA' TO MEXICO

Juan Manuel Bonet: I'd like to begin by talking about lists. Like Octavio Paz I am a big fan of them. When I published *La ronda de los días* and *Café des Exilés* I sent them to him and what he most enjoyed was how I celebrated the idea of lists. My contribution to your catalog for the IVAM [The Valencia Museum of Modern Art] exhibition was to invent a kind of dictionary based on your universe, structuring it by making a list. I see our conversation here in similar terms: reviewing your life and your work by making lists of the things you love, or that we both love. Last night I took out all of the catalogs and books of yours I have in my bookshelves and there were more than thirty publications. It was an illuminating journey. I ran into photographs that were like lost loves. I also encountered things I had not paid enough attention to before, seeing them as if for the first time, like the picture you took of the flowering almond tree.

Bernard Plossu: In Niger, from the book *Les années d'Almeria avec l'appareil-photo de jouet* [The Almeria Years with Toy Camera].

JMB: It was sublime, literally like I was seeing it for the very first time.

BP: That's amusing because those pictures are of the desert.

JMB: More like an oasis, I would say.

BP: All right, an oasis of stones. They are the continuation of the pictures from Le Jardin de Poussiere [The Garden of Dust], that I made while I was walking through the mountains of the American desert. The almond tree picture is different, because it also speaks of man who is capable of planting a garden, a fertile one. It's an optimistic image and it is amusing to think that I shot it in Niger. The lists sound like an excellent idea though difficult, because you and I are people with an enthusiasm that is. . .

JMB: Constant!

BP: Usually as people get older they lose some of the enthusiasm they had during their youth; like wanting to see all of the films of Carl Dryer! I do the best I can to not lose interest in other people's work, much as you do I'm sure. It's the key; to not be exclusively enamored of one's own stuff.

JMB: That's called curiosity.

BP: And a form of love, of understanding that you are not alone in the world. Or one is jealous or one is in love. I think they are two different ways of living.

JMB: Now that we are prepared to begin on a journey of recollection I should say I first saw your work at the Fotocentro exhibition in 1976. I had no references but I went ahead and wrote an article about it for El País, which I don't think you read at the time, because I was just bowled over by the pictures. I can't remember whether it was after or before this when the Nueva Lente monograph appeared.

BP: It was later, in 1979. I remember because that issue reached me in Taos, New Mexico, where I was living far away from everything on a mesa 2,200 meters high. One morning after a heavy snowfall I went to the post office along a muddy road and there it was in my postal box. On the cover was a drawing of me done by Carlos Serrano. But the incredible thing was to get it there in Taos. Experiencing this kind of strange mixture seems to be the story of my life, because the people in New Mexico have Spanish blood. On the other hand, and this can go on the list, living in far away places affords one many things. There was an artists' colony in Taos and a lot of rich people donated books to the local library—that was wonderful. There were numerous books of Mexican and North American art I had never seen in Europe. I went to that library all the time.

JMB: I knew about your work thanks to the Fotocentro show and to the Nueva Lente monograph but we did not meet each other until much later. I wrote that first article about someone unknown to me and then later I discovered your were friends with Pablo Pérez-Mínguez and Carlos Serrano whom I knew as well. But going back a bit further. Your first photographs, that you published a little while ago in catalogs, are: an image of the Sahara with cars and people, and one taken in Algeria of some buildings, and what is so curious for me is that both these pictures are pure Plossu.

BP: They were my first pictures and my first journey was to the Sahara. My father loved photography and dry countries and he bought me a Brownie Flash camera. Everything

began for me with that trip of a young boy from Paris arriving in the Sahara. It was my first truly significant experience.

JMB: You had hardly seen any photographs at that time; Denis Roche says in his *Le Voyage Mexicain* [The Mexican Journey] that the only pictures you had seen were in *Paris-Match*.

BP: Yes, the magazine omnipresent in the typical bourgeois French household. But in an issue from that time there was a photo report about Tierra del Fuego with pictures taken by Sergio Larrain that made an impression on me.

JMB: But had you seen anything else to do with photography?

BP: No. At age thirteen? Not yet.

JMB: You had knowledge of a book we have talked about from time to time, *Sortileges de Paris* [Sorceries of Paris], by François Cali, a beautiful volume with some topical images perhaps, but with contributions from some excellent artists, like Brassaï.

BP: Exactly. That was due to my mother. She had no idea what it was I was going to end up doing but she derived great pleasure from photography.

JMB: During the sixties you became a professional but always reserving for yourself somewhat the category of amateur. Perhaps we could define your attitude then using terms Juan Ramón Jiménez, our great symbolist poet, used when he spoke about "trabajo *gustoso*" ("fun work" or "work that is pleasant to do").

BP: Confucius says that someone who loves their work never works. It's the same idea. Work for me is when I get caught up in stacks of papers, bills, office obligations, but not when I am taking pictures. There is a Spanish term I just love. When I went to live in Almería I went to get some help with my papers, my legal status and all that and the fiscal officer I sat down with said to me: "Work like the kind you do is called "photographer of the outdoors." That is exactly my condition.

JMB: Doesn't your first epoch as a professional photographer coincide with what you once referred to as your "hippie years"? This is when a book was published you don't usually show—you showed it to me although I have not read it—that is a kind of memoir of a hippie. What was the idea that captivated you amongst the hippies of the *Nouvelle Vague*?

BP: That is/was my generation: post-Godard and prehippie. We arrived after the *Nouvelle Vague* and before the hippies. I had the great luck of going to Mexico where I met numerous beatniks. In Mexico there were lots before the Nixon era and there was lots of marijuana. I became great friends with one of them, Bill Coleman, who asked me if I had ever been to the United States, and I, who was twenty-one at the time, said no. He took me to California, to Carmel, and to the famous Big Sur. At that time I thought all of America was like Big Sur. I had found a place and a generation I could relate to, just before the Haight-Ashbury hippie explosion that took place in 1966. The

beatnik rebellion had the biggest influence on me; how to love Nature, what it meant to live. I visited with Henry Miller and we had long conversations. It was a very significant period in my life, similar in impact to the ecological revolution that would come later, filled with many interesting people. Few people know for instance that the actor Peter Coyote was one of the founders of the San Francisco Diggers, a collective that helped people with basic needs—food and shelter. And of course I ended up visiting Ferlinghetti's famous bookstore.

JMB: City Lights.

BP: And what was in the window of City Lights the day I walked in there? A book by René Doumal, an esoteric French writer, an American edition of *The Analogous Mountain*.

JMB: He was part of the surrealist group Le grand jeu [The Great Game].

BP: Exactly. *The Analogous Mountain* was one of those books American beatniks had a cult relationship with. These encounters for me had a magical quality to them, meeting people like Joan Baez and Allen Ginsberg or Peter Coyote, and being able to take photographs of them was wonderful.

JMB: It's curious because although *Le Voyage Mexicain* marks the beginning of your career it feels to me like your book *Surbanalisme* predates it.

BP: What happened is that with *Le Voyage Mexicain* I was a young Frenchman fresh out of the Paris filmoteque. My youth, from ages fifteen through twenty, consisted of me going to the filmoteque constantly seeing all of the classics. I would say I was going to school but in fact I was skipping out to watch all these films.

JMB: Playing hooky.

BP: Exactly. I went to see all of the greats, like Carl Dryer, Buñuel, Eisenstein, Bergman's *Wild Strawberries*. I arrived in Mexico bursting with film. At the same time I took pictures and I shot film with a Super 8 camera. I have an hour-long film of that trip I took to Mexico. I have never shown it but it exists. I took pictures without any notion that one day I would become a photographer.

JMB: Nevertheless the pictures themselves are pure—don't you think?

BP: Perhaps. They express the excitement of leaving and arriving. But the influence that film had on me was important, not to mention the influence that painting had thanks to three books my godfather gave me.

JMB: Which books?

BP: On my thirteenth, fourteenth, and fifteenth birthdays he gave me monographs on Kandinsky, Klee, and Mondrian. With those books I learned how to see and how to frame. It was a great stroke of luck.

JMB: In *Le Voyage Mexicain* I perceive a lot of film influences but also literature, especially that of Jack Kerouac. Had you read him by then?

BP: No. I arrived in Mexico in 1965. I read Kerouac in August of 1966 and I thoroughly enjoyed it.

JMB: Do you think your book reflects that attitude? It's Plossu *On the Road*, just like that cover photo, the car, and those arms hanging out of the back window. . .

BP: Sure, but I should say that for me Kerouac was a confirmation, not a revelation. The real revelation for me were the songs of Bob Dylan.

JMB: The lyrics of the songs?

BP: The lyrics and the music. The moment when he began to play the electric guitar on *Desolation Row*. Dylan and all of the music of the later sixties affected me much more than Kerouac. The beatnik literature also had some tremendous poetry; the book that most impressed me then was Ginsberg's *Howl*. In terms of the quality of writing, the great writer who began to bring about all of this change was Malcolm Lowry, who was not a Beat writer, but who was a huge influence on them. *Under the Volcano* left an immense stamp on things.

JMB: Getting back to your first book, one of the pictures I got to appreciate all over again is the one of the propeller plane in Chiapas, that looks like a painting by Dis Berlin. Looking at the book again I realized it has a tremendous erotic charge as well, the way you photograph women.

BP: I am a firm believer in that the key to eroticism is to not show anything, maybe just a look or a gesture, a small detail of someone's neck. . .

JMB: Because those things reflect sensuality.

BP: You say it is a book where sensuality is very present. It would be hard for me to talk about that but I do believe you are correct.

JMB: I see it in photos like *Mexico City*, of a man next to a pair of legs, or another of just a woman's knees that my friend José Carlos Llop used for the cover of his novel *Talk to Me About The Third Man*.

BP: Shortly after that time I got back to France with the color photos of my trip through the villages in the Chiapas jungle. I get back and I was twenty-one years old and I have no idea what to do. I called up some travel magazine editors and I got a job on one of the magazines, *Atlas*. They sent me to various places with jobs like taking pictures of the island of Ceylon or the Mississippi River. These jobs, taking pretty color pictures, tired me after a while. I wanted to enjoy myself and so, looking for models, I adopted the cartoonist Chaval as a maestro.

JMB: He was a humorist, dark humor. Chaval committed suicide, no?

BP: That's him. I was attracted to the idea of doing small stories as a kind of homage to his style. They weren't perfect and I shot them with a wide lens. I wanted to show just simple things, almost banal things with a surrealist air and I called the whole series *Surbanisme*.

JMB: But this is a work you have shied away from.

BP: I was quite annoyed by the reaction of the press, who said it was very bad.

JMB: Understood, but you rejected it yourself, no?

BP: I think the part of it that relates to the influence of Chaval is quite honest. It was an amusing thing to try. The film director Sergio Leone liked it quite a bit, who was someone I ran into during that time, taking location pictures for one of his westerns. When I showed it to him he laughed and said, "I'm going to write a text to accompany it." It may not be a great book, just a little something I tossed off five years after my trip to Mexico.

JMB: Did you publish a lot of photographs in magazines?

BP: Yes. I have a bookshelf full of them at home.

JMB: And a book as well.

BP: A bad one I should say. But the good fortune I had to be able to work for a living as a professional photographer gave me sufficient experience to know that photography is a job, not an art. These young people who want to be artists right away now scare me. It's very dangerous.

JMB: You seem to have handled it very well, because in fact you continue to take on jobs. I believe you see it as a challenge.

BP: Yes, but these jobs I take on now allow me to go ahead and do work using my own style and my own criteria, I don't have to work in color or with wide or tele-photo lenses.

JMB: Yes it is true that conditions now are much better, but the fact that a good part of your work comes out of these jobs you take on calls attention to itself. It seems you have no problem taking them on.

BP: But it does imply risk, because if you don't do a good job the critics just sweep you away. Keep in mind that I have three children, I have to work, I can't live on my artistic work alone. I try to as best I can but it is a battle. Continuing with the story, then, after *Le Voyage Mexicain* and *Surbanisme*, what upset the apple cart occurs in 1975, in Agadiz where I met a group of nomads, *peuls bororos*, and a group of Tuaregs. I realized that in order to

capture Niger, which is such a strong place, one has to give up all tricks. I went back to the 50 mm lens, like the one I had used years earlier in Mexico. In March of 1975 I made a momentous decision. I decided to stop making easy pictures and to dedicate myself exclusively to more difficult ones. It was a huge change of course and some years later in my garden I burned all the photos I had ever shot with a wide lens. It's amusing because my first exhibition in Spain was at the Spectrum Gallery in Barcelona, at the beginning of the seventies, and they were all pictures from the *Surbanisme* period. The negatives no longer exist, there is not a trace left of those pictures.

JMB: Another picture from this period I love—perhaps because it is the most ingenuous—is one where you are "on the road": an image of your shadow while driving.

BP: That was taken on the Big Sur highway. It hasn't changed a bit. It's still a small coastal road.

JMB: How do you view the Plossu that you see there in that shadow now? Do you see yourself or someone you have left behind?

BP: It's a self-portrait. On that occasion I bought a gold colored, second hand, Oldsmobile convertible for eight hundred dollars that was fantastic. Driving along the Big Sur highway I saw my shadow and snapped the picture without even looking. It is dangerous way to take a picture, but that particular photograph represents for me the key to liberty; we're moving, we don't know where, but we're in motion. . .

JMB: Why is it you have hardly any pictures from New York?

BP: I don't know. I can't describe it exactly, but there is something there I don't understand. Everyone there is a bit mad, they're always running. What I love is beatnik America, the nature that can be found in America, the California Sierras and the poetry of Gary Snyder. New York is not for me. It's a city with the same problem that Paris has: they think they are the center of the universe. There are other great cities, like Brussels or Madrid, that don't consider themselves to be the center of the planet.

JMB: Let's go to another continent, Africa. A book of yours I love is *Lettre pour un tres lent detour* [Letter for a Long Detour], which has images of Mali. There are some photos of the desert that are almost abstract and with trees that look like they are drawn.

BP: It's a very white photograph.

JMB: That's true, the adjective is "white." Like the photograph of the cinema Sudan. There is another excellent one not in the book that was published in color in the IVAM catalog: the one of the boat in the Niger River, an image of great quietude.

BP: One can see that it was taken just before a sandstorm. I should say two things about the work I did in Mali: the book has a text written about the wonders of travel by the French author Joël Vernet that is marvelous. And Mali for me was a return to living in the African desert after ten years in the dry American West. In America I published a

book called *The African Desert*, with photos from Egypt, Niger, Senegal and the frontier between Mauritania and Morocco, where I had spent long periods of time during the seventies. The Mali book is different. It doesn't only have desert pictures in it. It has urban pictures as well, and images of the night, of swans, of Timbuktu Street.

JMB: Continuing with the desert theme and coming back to America, your pictures of New Mexico remind me a bit of the paintings of Georgia O'Keeffe. Was that a reference for you in any way? Did you ever go and visit her?

BP: I like her work but I never went to try and meet with her. Georgia O'Keeffe for me is like Matisse, on the decorative side. They are not my favorite painters. I like Braque more, or a less well known painter, Agnes Martin, who lives in Galisteo, a wonderful village in New Mexico. [Translator's note: Agnes Martin died in 2004.]

JMB: And how about Taos? I have never been there. Is it as quiet and peaceful as they say?

BP: Not any more. They've put up traffic lights at the street corners! But when I was living there you could feel the silence of winter.

JMB: A metaphysical silence.

BP: Not really. It was a tough place. The Taos years, with the snow and those winters. I don't want to make comparisons because in those days I did not think of it, but there are some Robert Frank photographs of Mabou, in Nova Scotia, that have the same sort of silence I am talking about. It is not just the silence of a place but also one that goes with a way of living. You live in a place and it's like you are just another stone there.

JMB: Some of those images show enormous concentration. I am thinking of the photo in the *Le Jardin Poussiere* book of some cloud shadows passing over the desert. That is "silence."

BP: There is nothing there, it's very Zen. It's hard to talk about, but it is part of who I am, what I have learned from my generation. It's not necessary to romanticize the desert: it is a dry place, and more than give you tranquility, it teaches you things. I live it constantly. Why did I go to live in Cabo de Gata? Because it is the desert of Europe. When I walk there with my friend Oscar Molina, a free photographer, moving through the sierra, it's like walking in the mountains of Utah or Arizona.

JMB: The generic title that groups together so many deserts, *The Garden of Dust*, where did that come from?

BP: One morning with my son Shane. . . I called him that for the western, *Shane*—remember the end with Alan Ladd when Shane is riding away on his horse and you hear, "Come back Shane, Shane, come back"? Well that's why I named him Shane. I wanted to walk through the deserts I had seen as a young boy in the Paris cinemas, the westerns of Robert Aldrich like *Apache*. I went out looking for the spirit of the Indians.

JMB: Did you find it?

BP: I believe so. But, get this, in *Le Jardin Poussiere* [The Garden of Stone] there are thirty-three photographs made over a period of eight years. The text is written by Stuart Alexander, who I met in Arizona.

JMB: But the concept takes in a great many things.

BP: A whole life—and what I have learned from that story, as a photographer, is that in order to show something as powerful as say the desert—something so large—one should not make large photographs. The idea of great spaces is better captured using a smaller format, because there is a condensation of light at that size that speaks to you of what the desert is.

JMB: Have you always liked to walk and hike through nature?

BP: Yes. It's one of the things in life I most enjoy, apart from my children. It is key.

JMB: You were telling me where the title came from.

BP: I had gone with Shane to France to see my parents who have a garden with very green grass. On the first morning after returning to Santa Fe, I picked up a fistful of sand and said, "Look son, this is not a garden like you find in Europe, it's a garden of dust." The phrase became the title of the book. It's a story that has to do with him and with the passing of knowledge from fathers to sons.

JMB: It appears that you have abandoned all of those trips, the ones to America and to Asia or Africa. I have encouraged you upon occasion to visit Buenos Aires, but we might say that these days you are in a more European mode.

BP: Fundamentally it's about returning to southern Europe to discover my own roots.

JMB: As if you did not have a need anymore to visit faraway places.

BP: At this point in my life I would prefer to be able to return to some places to live there, not just to quickly visit them. I went to Mexico and to New Mexico and to Cabo de Gata to live, not just to visit. And I would like to be able to do the same going back to Atacama in Chile, or to spend a year in Amman, Jordan; or to go back to Almería.

JMB: So then you do plan to keep on making journeys outside of Europe?

BP: Speaking today I would say I would like to be able to live once again for a time in some faraway place. If I stay here I would like to go back to Cabo de Gata to take lots of long walks.

CALM AND DELIRIUM

JMB: Let us return then to Cabo de Gata. How was life in Níjar?

BP: Marvelous, thank you.

JMB: You said at one point that for you it was like a paradise.

BP: I still feel that way.

JMB: Then why did you abandon paradise?

BP: Spain is an incredible story in my life. My first contact with Spain occurred through the Fotocentro exhibit, and afterwards I married Françoise Núñez, whose father is from Almería and I wanted to go visit the place he came from. When I arrived it seemed just like the American West. It fascinated me. We went everywhere until one day we said to ourselves that we had to stay there. We lived in Niger for four years. The people in the village were wonderful to us, making us, Françoise, myself and the children, feel completely at home. While living there I took part in a project organized by Manuel Falces called *Imagina* that was all about the province of Almería. Afterwards I returned to France because it was important to me to spend some time with my father before he died.

JMB: I am quoting you here: "Madrid is my favorite big city." What do you see in Madrid? Does it seem like a very dynamic place?

BP: Yes. The dynamism in Madrid is not pretentious the way it is in New York. I like it for the same reason I like Brussels, they are both cities you can walk around at night, there are people everywhere and things going on all the time. I really enjoy the rhythm of the city.

JMB: But if I were to do a brief anthology of your photographs I don't think I would find a single one that defines Madrid. It is curious that your relationship with Madrid is different than what you seem to have with some other cities. You have some very representative pictures of Marseilles, Brussels, or Rome, but not of Madrid.

BP: I arrived in Madrid in the seventies on a visit to see Pablo Pérez-Mínguez and Carlos Serrano and their friends and that is when my relationship with the city began. When I moved to Almería I would come to Madrid all the time, so much so that the photographer Juan Pedro Clemente refers to this time as my "Madrid years" rather than my "Almería years." Apart from that group of friends the person I met there that had the greatest impact on me was Luis Baylón. Each time I came he would meet me and we would walk around all day talking and taking pictures. In fact I have loads of pictures of Madrid from the seventies, eighties, and nineties that I have never developed.

JMB: What is your favorite photograph of the city?

BP: One of a white wall with an abstract shadow on it that was never published, but

which speaks to me of what I most love about Madrid, the violent light there. It's a much more violent light than you have in Italy because this is a much drier city. Very black and white!

JMB: Why is it you have taken so few pictures in Barcelona?

BP: I have traveled less to Barcelona. I went when Alberto Guspi ran the Spectrum Gallery and I knew Pep Rigol. During my stay in Almería I used to visit Chantal Grande and David Balcells quite often. I have photographs, but fewer than I have of Madrid.

JMB: Speaking of Catalunya, among the books you were hired to do I really liked *Urbs Tarraco*. It seems like you filled yourself with Roman classicism and a certain quietude.

BP: Yes. *Urbs Tarraco* has a lot of Catalunya in it, if only because it was a project commissioned by the Archeological Museum of Tarragona, but Rome also appears because the ruins are Roman ruins and as you know Rome totally sends me. I used a 50 mm lens and many of the images are reproduced in miniature. I have taken many pictures in Catalunya.

JMB: And they are nicely printed. You really take care of that aspect of your work when you are able to.

BP: When the pictures are badly reproduced it is very hard.

JMB: Sometimes it can be amusing.

BP: There was a case where this woman published fifteen photographs of mine in a poetry magazine in Japan. She didn't want to show it to me and I told her I was sure that it couldn't be all that bad. When she finally relented I saw she was right, it really was awful, but I said to her: "It is the best thing I've ever seen, a marvel," because it actually fit in quite well with how I feel about my pictures. The reproduction of the ship in Marseilles harbor was not good at all but I loved it. Sometimes you do not do yourself a favor using the best quality printing paper. It's like using too much matting. The important thing is the photo! I'm made uncomfortable by photographers who try to achieve a poetic aesthetic putting irregular black borders about their prints, making them look more accidental, like they were Polaroids. Some photographers in fashion do these kinds of things trying to make something fashionable to look like art. One has to be very careful with these kinds of tricks and to learn how to see without them. Reality is more difficult and it is the key to everything.

JMB: I used the word "quietude" before in mentioning a book you did about Tarragona, but I would use the same word to describe another you project you did on Rabelais and his territories that you did with texts by Michel Butor: *L'oeil de Frere Jean* [The Eye of Brother John]. I think it is one of the most French books you have done; not just because you did it there but because of its French classicism.

BP: It's true that they are classic pictures. They came after *Le Jardin Poussiere*. It shouldn't surprise you to learn that during this period I paid a lot of attention to Corot. I think

classicism can be very modern. Butor and I met many years earlier in Albuquerque, New Mexico. Our second book, *Paris-London-Paris*, about the train that runs that route, was commissioned by the Transmanche Mission. The key to modern photography for me is what Butor calls "intermediate landscapes" that are seen briefly from the window of a train and that come and go in an instant. I love seeing these sorts of images in motion from cars or trains.

JMB: It's curious that you speak to me this way about Butor because in your book you almost disguise yourself as an anonymous photographer fulfilling the task of representing the landscapes of Rabelais, losing and incorporating yourself into the countryside and architecture of deep France.

BP: That was the idea. But the book is also an homage to Butor. And my life has much to do with that kind of quick vision.

JMB: I would say the contrary is true.

BP: But the equilibrium is that when I am walking through the mountains everything happens slowly, there is nothing hurried and I usually do not take a lot of pictures. It's as if I live in two worlds: one of constant movement and taking lots of pictures, and one of tranquility, ambling amongst mountain boulders, taking the occasional photograph, a drawing maybe, very little. They are experiences that complement each other.

JMB: I think you express that tranquility very well. One of your greatest photographs in my opinion is the image of birds in a tree cut against a very pure sky; it's called *Vitré* [Glass].

BP: That was done for a job! . . . for a city of the same name.

JMB: Well, that photograph is like a symbolist poem for me.

BP: It was raining constantly. I arrived carrying my Agfamatic camera that is like a toy and when they saw me they said: "You're not going to work using that thing are you?"

JMB: They didn't take you terribly seriously in those days.

BP: No. But when they saw the result they thought the pictures were perfect. It was just another game. Something I have learned perhaps from my friends at *Nueva Lente*. They were pushing a way of playing that did not exist in France, with the exception of *Contrejour* edited by Claude Nori. In those years France only put out publications with horrendous covers, nude women and that sort of thing. *Nueva Lente* changed everything and its influence was not limited to just Spain.

JMB: The *Vitré* image makes me think. That type of photography, with such a sense of repose. A minute ago I said I thought it was symbolist but it also brings to mind Japanese poetry.

BP: That is an honor! The maestros of Japanese sensibility are the painters Hokusai and Hiroshige. And for me the great filmmaker, the only one whose films are comparable to the literature of Balzac when speaking about women, was Mizoguchi. I consider him to be the author of modern classicism. Just fantastic.

JMB: Have you ever been to Japan?

BP: I've been invited a few times but, no, I have never gone.

JMB: Well I really believe you have a Japanese side to you. I remember when I was in your house in La Ciotat working with you on the IVAM catalog, you showed me some books by Samivel that had been given to you by your father, an amazing French artist and writer who, like your father, was a mountaineer. And perhaps it was he who put you on that road, the one filled with snow, purity, the person lost in the immensity of it all. In the book La Vallée [The Valley] are some of my favorite photographs of yours. That one of your friend Daniel Zolinsky walking on this vast white surface. . . it's the quintessence of the Japanese image.

BP: It's not a well-known book. It was just a little thing proposed to me by the Fotohof and Fotoforum galleries. They asked me if I could take pictures of the Tyrols and I said, "If there's a village there without skiing and bars, I'm off."

JMB: There is nothing there!

BP: That's because they looked for such a place for me and Daniel and I walked around there for a week in that cold.

JMB: Might it be thought of as your most essential book?

BP: I think they are like the Le Jardin Poussiere pictures, but with snow. It was difficult because the days were very short. We got lost one afternoon and had no idea where to go. We found a car on a road finally who gave us some directions. We were lucky.

JMB: Going through things of yours I found a quote in which you claimed that what you like to do is combine calm with delirium. How does one do that?

BP: To take photographs one has to be like a monk, to achieve a maximum degree of concentration, like with meditation, and at the same time possess a delirious disposition. This is why I say that photographing is a meeting place for that sort of delirium and absolute peace. Photography is made up of those two moments. They combine to create dynamite.

JMB: Although there are works of yours in which I can see that combination there are others, like the ones taken in the snow I just referred to, or the pictures found in Le Jardin Poussiere series, where it is the calm that predominates. Maybe it is with your urban landscapes where a dose of chaos is more noticeable. It's in the city where delirium counts more than calm for you, no?

BP: Absolutely. There is no peace. But I do believe that the two experiences complement each other, the experience of nature and those of the city. I like both of them.

JMB: We were speaking earlier of Butor and of when you first met him in New Mexico. Writers who are close to you—that's a theme we should touch on. First of all, the literature of your friends: Michel Butor, Denis Roche (who is also a photographer), Daniel Odier, Serge Tisseron, Jean-Christophe Bailly, Bruno Bayen, Nicolas Bouvier (another great photographer), Robert Creeley (who you met early on in America), Jean-Claude Izzo (who died not that long ago and who has mythological status in Marseilles), Max Rouquette (with whom you did another "calm" book, *Le Bout de Monde* [The End of the World]), and you reminded me that in your youth you knew someone who has always fascinated me, Dominique de Roux, a novelist friend of Ezra Pound who was also a great writer.

BP: And who published Allen Ginsberg in 1967.

JMB: Is there a type of writer who would have a special affinity with you or are these people different from each other? What do they share in common?

BP: I would mention two things: literature, reading, for me, is the key, like writing with a pen. Better to write with a pen than with a computer. Better to read than watch television. These things form part of the battle against imbecility, the rebellion one has to keep up. On the other hand something has happened that I was not looking for, and that is that some writers know my work and because of that we have come to know each other. It is a wonderful stroke of luck that this form of friendship continues to be part of my life. Perhaps it is due to the fact that I practice a very literary sort of photography, one that is closer to literature than to the plastic arts, although I'm not really sure.

JMB: But a photo can be literary and still be very much part of the "plastic arts" world at the same time. Painters who we will mention later, like the young Spanish metaphysicians, I always defend them as being literary affirming that it is a good thing and coherent with their vocation as painters. Do you read much poetry?

BP: I mostly read novels.

JMB: But you have published some verse.

BP: Poems of mine from *Le Jardin Poussiere* were published in Spain and in the magazine *Amén* where you published them as well. Seven poems in seven years.

JMB: How do you feel about Pound? You mention him in various places.

BP: There is a wonderful phrase of his that goes: "Curiosity, advice to the young." Dominique Roux gave me his *The Spirit of Romance* but I was never able to get very far into it. I have not read it as thoroughly as you have.

JMB: For me he is a key author. On the one hand he pulls you into a chaotic and

labyrinthine sort of experience with the *Cantos*, but then on the other hand he throws those very short and precise and cutting poems at you like 'In a Station of the Metro': "The apparition of these faces in the crowd;/Petals on a wet, black bough."

BP: It is my impression that much of literature is filled with photography. When you read *Under the Volcano* by Malcolm Lowry, you are overwhelmed with imagery. But it also happens to me with literature written in other languages, like Italian. An author like Carlo Emilio Gadda for example, one you know I like, seethes with photography.

JMB: Céline is also a point of reference for you.

BP: That's right. His *Journey to the End of Night*. But I am also interested in *A Barbarian in Asia* by Michaux where one finds the idea that when you travel you are more seen than you are capable of seeing. That book is like the life of Max Pam wandering about Asia taking pictures.

JMB: And when you travel? You were telling me that you often take Balzac along.

BP: When I was fifty I tripped over a paperback edition of Balzac's *Portraits of Women*, and it is so well written! His knowledge of the soul fascinates me. He is a classic.

JMB: As for more contemporary authors you once spoke well of Bruce Chatwin, who was also a photographer.

BP: Not a very good one. His writings are very interesting, but the only writer who is also a good photographer to my mind is Denis Roche. After stating, "poetry is unacceptable," he grabbed a camera and dedicated himself to making pictures. He delved into the world of photography coming from the world of poetry, being a well-known poet in France. It's an interesting story.

JMB: Let's turn our attention to film. Reviewing one of your more recent books, the one dedicated to Brussels, I loved a photograph in it of a shop window showing old copies of *Cahiers du Cinéma*. It is a beautiful gesture, similar to a picture you took of your woman friend standing in front of the Cinémathèque of Paris. It shows your Truffaut side. Your list of filmmakers starts with the *Nouvelle Vague*.

BP: Someone once said that I was a *Nouvelle Vague* photographer and I am in agreement with that. It is an interesting observation from the perspective that I am not American. Many people associate me with Americans but I am very European. I like the United States as a place to travel through and to live in from time to time but my roots are here. My picture of the glass in the Etruscan Museum in Rome is an image made by a European photographer, not an American one.

JMB: That's very clear. What other kinds of cinema do you consider to be essential?

BP: Apart from Mizoguchi the other maestro is Satyajit Ray. One has to also mention Robert Bresson and the courage he showed by not including music in many of his films.

And we cannot forget the power of the western. I hate bad westerns. I don't like John Ford or John Wayne but I do value people like Aldrich, who are on the Indian's side, or Samuel Fuller's *Run of the Arrow*, that's about a white man who wants to live with the Indians. We have the great poetics of those open spaces. I went to America to see the country of Cochise! I met his grandson who was already an old man. I walked all over that part of the country to take pictures for *Le Jardin Poussiere*.

JMB: Are there any recent films you like?

BP: I can't really given an opinion because I have not gone to see a film for some time. When I returned to Europe I would go and see a film if it was something good, but I've become a real homebody. I read every night.

JMB: Then let's switch to metaphysics.

BP: We're already there!

JMB: In painting and in photography. There's an image that I think makes for a fine ironic introduction to the theme of metaphysics: the photo of the pyramid in Rome in front of which is passing a truck with the word "Chirico" on it, the name of a company. . . a way of poking some fun at metaphysics. In any event it's clear that Giorgio de Chirico is one of your painters, Morandi as well, and some lesser-known Italians like Mario Sironi.

BP: Yes, the whole Roman school, and Carlo Carra and Massimo Campigli.

JMB: These are people hardly ever mentioned any more but you continue to be a great admirer. Then there is Hopper, although I know you like his work less, but Yves Bonnefoy says that his work is directly linked with Giorgio de Chirico, both of them metaphysicians, both painters of twilights and shadows.

BP: Hopper is a maestro without a doubt, but yes, I like his work less. One painter whose technique fascinates me is Marcelo Fuentes, an artist from Valencia whom you introduced me to.

JMB: We were mentioning the historic ones. And after that there are the neometaphysic Spaniards: Dis Berlin, Pelayo Ortega and Marcelo Fuentes especially. You feel some connection with these painters?

BP: Why not, and with Angel Mateo Charris. But there are painters who work in different styles whose work I also enjoy very much, like Miguel Angel Campano or Isabel Esteva, an artist from Barcelona who really understands Mediterranean light. I know Campano through his brother, our friend Javier. I also like the Madrid painter Miguel Mansanet who was my neighbor in Níjar.

JMB: But returning to the metaphysical angle you mentioned, why have you insisted in naming those painters specifically? Is it because of a certain affinity they might have

with a particular zone of your work?

BP: In metaphysical painting there is a magical realism that has a lot to do with pure photography. In metaphysics one feels the passage of time. It's seen, it's noticed, like that clock of Giorgio de Chirico, or his trains. . .

JMB: Cocteau has a wonderful phrase I quoted in your IVAM catalog: "Chirico, or the hour of the train." The curious thing is that you are a photographer who has documented the chaos of the city and then made photographs of Rabelaisian landscapes that define pure classicism. You are also a photographer of slightly out of focus images taken from a train and then others that are quiet and exact resembling Morandi still lifes. It is interesting to point out the metaphysical dimension because there might be people who, with only a glance would think that Plossu is not like that, but just a photographer who takes the fast-moving fuzzy pictures, which is the side of you that has been most copied.

BP: That's because it is the easiest. I think the soul can also be fuzzy sometimes and thus one's photographs as well. But it is not a trick I use. It happens when there is not a lot of light, you are forced to use a slow speed, like a quarter-of-a-second exposure, and the camera picks up a bit of movement. It is not the result of intentionally taking the picture out of focus.

JMB: But when we talk about metaphysical photos they are ultimately, almost always geometrical. For example, a photograph of yours that I would categorize as metaphysical would be L'escalier a Porquerolles [The Porquerolles Staircase], where we also see a cactus plant, a plant associated with magical realism. Or the abandoned factory in Lucainena de las Torres in Almería, included in the The Almería Years with Toy Camera catalog, that you did with Rafael Doctor. I think that that dimension is present in many of your photographs, especially in your visions of the Mediterranean world.

BP: The metaphysical is not just defined by a passage of time but also by the violence of the light. Architecture and the sun: this is an explosive mixture. Among my Mediterranean metaphysical photographs there is only one with rain in it.

JMB: They're very dry.

BP: They're dry, but more than dry, they are white! And that forms an essential part of the Mediterranean universe. It is a metaphysics very different from that found in surrealism.

JMB: We haven't spoken about surrealism yet.

BP: A parenthesis perhaps! I think that the most important surrealist artist of the century is. . .

JMB: Let's see if we agree.

BP: Cartier-Bresson!

JMB: Wow, well no, that would not have been my choice. I think the best surrealist painter was Tanguy.

BP: As a painter, but the young Cartier-Bresson is very similar to Álvarez Bravo. People who, using real objects from the real world, have made surreal art. They are great maestros.

JMB: Do you like Tanguy?

BP: Yes. I appreciate his work. But within the world of surreal creations I prefer Magritte's photos, for example, over his paintings. Of my ten favorite photographers, three of them are not even recognized as being photographers but rather painters or sculptors: Magritte, Wols (he has a photograph of sugar cubes on a tabletop that is marvelous) and the great sculptor Brancusi. The three of them have made exquisite photographs that form part of the medium's history, and they are not photographers.

JMB: Returning to painting—not metaphysical necessarily, just in general—Corot is perhaps one of your favorites.

BP: He is the Morandi from the century before Morandi.

JMB: Might Gauguin be of interest to you because of how far he went away from home? Maybe more for the literary quality of it than his paintings?

BP: For both things. He was well understood by Jean-Marie Dallet, a writer friend who has written some wonderful books about Gauguin. The non-decorative painter who best captured light and the essence of the South of France was Bonnard.

JMB: Bonnard! He was next on my list. A jubilant artist.

BP: Thinking about the South of France I also like Soutine. His zigzagging streets are amazing.

JMB: I agree but Bonnard is much bigger, no? Bonnard is Rothko *avant la lettre* in some things. Do you like Rothko?

BP: Yes, but the person I believe who created modern painting is Malevich. I like Rothko a lot, but the prices for his work are so insane that it irritates me. It's an American craziness to think that, the better the work the more expensive. I am also blown away by what I see happening in the photography world these days. There is a photograph of mine, taken thirty-five years ago, that's worth eight hundred Euros, which I think is quite a lot of money, but there is another taken by a photographer two hundred years younger than I am, large-format color pictures, that are worth ten times that. It confuses me. I don't understand how that can be or who controls that. I don't want to get into it because these price difference that makes the work or Edouard Boubat worth much more than the work of Thomas Ruff really get me going. I am lost in that world and I prefer to remain lost rather than to have to enter into it.

JMB: When discussing painters, you have also mentioned Matisse upon occasion and you have some lovely pictures you took of the Matisse Museum in Nice.

BP: I really liked him once upon a time. Many of Matisse's paintings are too beautiful for me. Braque speaks to me more convincingly. One whose work I really love is Zoran Music.

JMB: The paintings of Venice, of the Giudecca Canal and the Punta della Dogana—so dark, yes, they are excellent. How about Torres García?

BP: He is a maestro. You gave me his catalogs—I liked everything I saw! He and Malevich are really modern. When people ask who is the most fundamental painter of the century the immediate answer is Picasso, but I think Malevich and Torres García are better answers. They aren't famous but the great fundamental changes came from their hands.

RETURNING TO EUROPE

JMB: We were speaking about "calm and delirium" before. Would you also use the word "emotion"?

BP: I don't think so. Would you? I have never thought about it. In French the word émocion has a certain romantic connotation and I don't think of myself as a romantic. Perhaps in the sense of loving something with intensity and that, as a result, produces a strong emotion.

JMB: Which comes back to this attitude of yours of the pedestrian, the man in the street, who is moved by something or whose attention is caught by something he sees. Tell me your theory about the arrow's flight from a Zen bow as applied to photography.

BP: It isn't really my theory. It belongs to Cartier-Bresson who always compared photography with the aim of a Zen bow. I agree with him, but I can't really speak to you about it because it was Cartier who saw it that way. Rather than going into the world of Zen, a world I very much like, I will express to you a thought of mine which I do not mean in jest, which is that I feel better being a photographer of "indecisive moments." I share the energy of the street photographer, but not necessarily to catch someone running along. For me it would be to observe say, a wall or other static things removed from the world of action and from the necessity to capture things at precisely the right moment.

JMB: I hear you, but, all of a sudden, you see a truck one night in Marseilles making a turn at just the right moment and you capture it in the instant that most favors your composition of the photograph. I understand that the very following instant might render a slightly more banal composition and that you might like it just as much.

BP: Thinking about the concept of the indecisive moment, I think that photography speaks about moments that don't appear to have any importance but which in fact do. Moments made from nothing.

JMB: Like poetry.

BP: Of course. Sometimes you remember things of no apparent significance, things of no interest, but which really are. How can these things be captured or revealed in photography. This is what I try to do.

JMB: Perfect! I completely agree! I would like to talk about Europe. One country that is not Mediterranean but which is metaphysical is Belgium. Your photos of Antwerp are wonderful, specifically the one of the old car in the rain.

BP: It's like something from Tintín.

JMB: Totally. And speaking of that image, why is it one finds so many old cars in your pictures, old Renault trucks and those forward traction Citröens? Does it respond to something from your youth?

BP: I think so. Dinky toys. As a French child, they formed part of my childhood.

JMB: They formed part of mine as well.

BP: Time passes so quickly and we don't notice it and when you look at a picture I took thirty years ago, the car in it is already an antique.

JMB: Yes, but you also seek out old cars when you are taking pictures.

BP: I'm going to tell you a story about luck and chance. There are people who ask you: "What is luck and chance for a photographer?" Once upon a time I was doing a panoramic photo in La Ciotat at twilight in front of a restaurant called La Vague. I had a cheap plastic camera and there was little available light and in the instant that I snapped the picture a while, a forward-traction Citroen appeared.

JMB: White!

BP: It was incredible. I only had time to take just one picture and it came out well. But sometimes it can happen like that and you are filled with an emotion so strong you forget to actually take the picture and the moment disappears, puff, adios! [Laughter]

JMB: Speaking of Belgium, we should mention comics, the ones you made reference to earlier. I will remind you of a phrase of yours from the prologue to that book: "It is the clean line that, without a doubt, has formed my eye."

BP: I was talking about the maestros: Hergé, E. P. Jacobs, and Franquin, the author of Spirou, who is the absolute best drawer of cars. The "clean line" enchants me. And when I lived in Niger I really enjoyed Mortadelo & Filemón. There exists an excellent translation into French.

JMB: The "clean line" is the best! [Laughter] Speaking of that aesthetic, the fifties come

to mind, the years of your childhood and adolescence, the *Cahiers du Cinema* and *Nouvelle Vague* that have always constituted your visual school.

BP: In my youth, yes, for sure. But years later I ran into the so-called New York School, greats like Robert Frank or Saul Leiter. Before that there had occurred two powerful moments in the art world that also left a significant imprint on me: L'Estaque, who represents the birth of the modern landscape, at the beginning of the twentieth century (Cézanne, Braque, and Dufy), and the transporter bridge in the port of Marseilles that many of the great photographers in the twenties took pictures of, like Moholy-Nagy, Florence Henri. . .

JMB: And Germaine Krull.

BP: Exactly. That story takes you into the thirties and to a painter/photographer few people ever mention, Ben Shahn. His photos are not well known but they were the first to break with "horizontalism." He and Walker Evans were good friends. They are pictures taken from 1932 until 1936 and comparable to the films of Helen Levitt of the streets of New York, just as fine. All of this took place twenty years before the work of the famous photographers of the fifties and it marked the true beginning. There are other photographers who are not Americans who also did absolutely contemporary work during that decade. I am thinking of Héctor García and Nacho López in Mexico, Carlos Pérez Siquier in Almería, all of the great photographers from the Afal group and Sergio Larrain during the sixties in Chile. Also my friend and maestro, the Frenchman Boubat, who was another great modernist and not a humanist. It's ridiculous to call him a humanist.

JMB: In truth almost all of those photographers who have been called humanists are very modern.

BP: Not all of them. Another good one is Izis.

JMB: Marcel Bovis, for example, is included in the humanist group and he has some wonderful things. Labels don't say very much.

BP: An important female photographer was Lisette Model whom I know very well. She was a key figure in the thinking behind the New York School and she was the mentor of Diane Arbus.

JMB: Let's continue with another country: Italy. Italy to me is happiness and Stendhal, a "Stendhalian" sense of Italy. You have photographed Rome by night, Palermo with a palm tree in the window, the little islands. . .

BP: I went to live for a while in the Italian islands with my wife and two children, Joaquin and Manuela. Our base was on the island of Lipari.

JMB: The one thing that grabs my attention is the total absence of anything taken in Venice.

BP: I have some photographs taken there.

JMB: One of the Café Florian, but perhaps they are not among your most representative pictures.

BP: The place that has the most visual strength in the world for me is Palermo. It is the definition of a visual city, total madness. But allow me to interject a small parenthesis: the truly best metaphysical photographer of all times is the Italian Giuseppe Cavalli, a figure from the fifties whose images are all in white. There are not many pictures but he is the absolute master of metaphysical Mediterranean photography.

JMB: There is a country I think you are in synch with in a very special way; with Spain of course, but perhaps the country you might chose would be Portugal.

BP: I like Portugal very much. It's true. But I really do love all of the countries we have mentioned so far. There is not one I would hold in higher regard than the others. They are all different.

JMB: But somebody who does not know you very well would probably associate you with Portugal over other countries in Europe.

BP: Perhaps that is because Tereza Siza published an enormous book for me about Portugal, O pais da poesia [The Country of Poetry], which is a very apt title.

JMB: A picture not in that book but which is one of my favorites taken in Lisbon, is one of the tram at night with the advertisement for the O Diário newspaper. It is a classic image for me, within your body of work and in absolute terms as well. Who has taken pictures like that of Portugal? I don't know of any.

BP: Oaulo Nozolino has taken some wonderful ones.

JMB: I agree, but Le pays de la poésie [The Country of Poetry] which is a relatively recent book, is, I think, an extraordinary achievement filled with wondrous things even with the omission of the photo I just mentioned, and I believe the following comments made by Vincent Jacq in the introduction beautifully describes it: that you have fashioned around Portugal "a secretive work, light and fraternal."

BP: Another writer I feel very close to, Vincent Jacq.

JMB: Now let's move to the other end of the continent. Is Poland the only country you know in eastern Europe?

BP: The only one. I once reached the Ukranian border. I went with Pierre Devin and we met up with the photographer Wojciech Prazmowski. We took a long car trip that winter and I quite enjoyed it. Poland reminded me of Portugal.

JMB: It is like a journey back in time. They are two countries that seem somewhat stuck in

the fifties and perhaps they still conserve parts of the past no longer visible in other places.

BP: For me it is the sensation that they are two peaceful places, devoid of the madness found in Italy, Spain, or France.

JMB: There are four European countries I do not find in your work and I ask myself why.

BP: Which ones?

JMB: England, London specifically…

BP: I have some photos, though not too many.

JMB: It's curious, because Sergio Larrain has photographed there a great deal, and Izis as well. Didn't you go to London during the hippie era in the sixties?

BP: Very little. I have like ten pictures taken in London that nobody even asks me about.

JMB: Germany?

BP: I made some interesting pictures in Saarbrück.

JMB: Were they ever published?

BP: No. But, in my opinion, one of the most powerful photography books ever published is Les Allemands [The Germans], by René Burri. The Americans by Robert Frank is also a monumental work but America fascinates everyone. Burri has done the same job with a country that is not fascinating to anyone. I believe it is the strongest of all these kinds of books. Many people do not mention it when listing books important to the history of photography and so I wish to do so here. It is like the The Americans—they were published as part of the same collection in fact—but done within a visual context much less appealing.

JMB: You have not done much work in Austria either, although you have some pictures taken in Innsbrück. And another absent country in spite of its centrality to Europe, is Switzerland, especially given the fact that it was so beloved by Hergé.

BP: Very few pictures, it true.

JMB: Let's go back to France then and speak about one city in particular: Marseilles. One of your classic photographs, it is twenty-seven years old, is one of an open window through which one can see a ferry leaving the port. It's an image one never tires of looking at. For me it is the closest thing to a painting by Marquet you have ever done. Would you agree with that?

BP: It is like a Marquet, I agree.

JMB: It transmits a sensation of happiness, the first blush of joy, along with an invitation to travel.

BP: The picture is about travel. It is like an invitation to go on a journey because the very next morning I took a boat just like that to Morocco. I was only in Marseilles for one day.

JMB: And your book *Marseille en autobus* [Marseille by Bus] has just come out.

BP: Done with Gil Jouanard, another writer I forgot to mention before.

JMB: Consider him mentioned. And now we move to Paris. You mentioned before the collective book from 1952 *Sortileges de Paris* [Sorceries of Paris], that was the first one you were given as a present. What surprises me is that there is still not a book like this about Paris done by Bernard Plossu.

BP: There's no hurry. *[Laughter]*

JMB: You have some magnificent Parisian pictures in the book *nuage/soleil* [cloud/sun]. There is a beautiful one of the Parc Montsouris that I have compared with the early work of Steichen. What is the picture of yours you most prefer of Paris?

BP: The ones I took with the Agfamatic, the toy camera that makes square shaped pictures. In *nuage/soleil* there are many pictures taken with this camera. I like this camera because it is quicker than your eye or your thought process. Nothing happens, just the sudden "click," and there it is: adios! *[Laughter]* You have fun like a child.

JMB: Something everyone associates with Paris is the poetry of Baudelaire and in particular the poem called *la passante*, the "woman walking by." What place do women— quite a bit I think—occupy in your work?

BP: I love the *les passantes* one finds in all cities.

JMB: *[Laughing]* Not only in Paris. . .

BP: Taking those pictures is a form of affection. You pick up the camera, you click the picture. . . they're gone. I remember Poland: the woman were all covered up, with sweaters, overcoats, fur hats. . . you couldn't see anything, but even so it felt to me like the most sensual place.

JMB: It was winter! *[Laughter]* The little book you dedicated to your wife, Françoise Núñez, is a love letter, no?

BP: Yes, from the Mestizo collection *Lo mínimo*. They are pictures of her made over the course of many days from our life together. Françoise is a good photographer and, on top of that, I am in love with her. It's a story that is like a movie. Many of my pictures in this book seem like stills from a film. You can see the influence of Godard in his Anna Karina

period that I still hold vividly in my head.

JMB: Of the books covering the region you live in now, one I like especially is dedicated to the little islands of Porquerolles and Port-Cros, where you say on the back cover: "When one walks along the paths on the islands of Porquerolles and Port-Cros, one feels far away."

BP: The idea of being far away has always interested me. I did it during my youth, in Mexico and then later in Taos, New Mexico, where I lived. Cabo de Gata represented the same thing to me. I go to live in places like these to absorb energy and to disconnect from a world that is in an agitated state and that is often false. I like to do this, it breathes life into me. In those places there is nothing fashionable, there is no hurry, and one of the keys to my thought processes, if I may say so, is that it is only fashion that is in a hurry, not me.

JMB: A final French picture is that of the unfinished hotel in Cerbere, near the Spanish frontier. It is a marvelous photograph of uncompleted construction, and one of the most reproduced.

BP: The two of us are in love with hotels—in art, photography, in literature and in films. They're places where you can leave everything behind. Changing from one room to another is like changing rolls of film in a camera. They're like islands, you take little with you and you change your sense of rhythm. For me they are the symbol for travel.

JMB: Associated with hotels we also have trains and train stations at night.

BP: Trains are deep in the heart of my photography and they adapt to the rhythm of my life. It is a passion I share with two other people: Pierre Devin, the director of the Transmanche Mission, and Christophe Berthoud, a young photography historian. Both of them are crazy about trains.

JMB: They're "train-o-philes!" [Laughter]

BP: Exactly, and you are too.

THE SPIRIT OF STRUGGLE

JMB: One list we haven't made yet is one of loved photographers. I would begin with Josef Sudek, of whom you once said to me, "He is photography." Why is that?

BP: A photograph may seem beautiful, and if it has strength it can also be poetic, but when it is made by someone like Sudek, each powerful photograph is a show of rebellion. I do not believe there is art without rebellion. For a photo to be attractive, intelligent and strong, it cannot be conventional. Sudek, with simple elements, speaks exactly from where the strength of photography resides. In his case we can use the word "emotion" in an incisive way. His work transmits that type of emotion—of just the right

sort—with very little. He can do it with a panoramic shot of Prague, a picture of a street, his own house I am fond of saying that I do not need exoticism in order to photograph. I also take photographs in my own home.

JMB: He didn't even need to leave his own city.

BP: I love that about him. One can construct a body of work both powerful and modern without having to go anywhere. I love to travel, but it is not the only ingredient. Sudek is the great maestro.

JMB: Atget?

BP: I am more interested in Heinrich Zille, a photographer who has done portraits of anonymous people and of gypsies and who pertains to the same period, the beginnings of photography.

JMB: I prefer Atget. Another photographer you and I do not agree on is Stieglitz. I know he is not one of your favorite photographers but he is for me, because he draws me—the same way that Steichen or Coburn do—into the fog they exist in that derives from symbolism. It is the moment in which the representation of the city tips the balance in favor of the modern and the neat edges of modernism appear. Coburn in particular has some extraordinary photographs of this type.

BP: Yes, there are some very strong images, but, as you know, some works grab you and others don't. Speaking historically, Lewis Hine's pictures of the immigrants, of those children selling newspapers, the workers building skyscrapers, are very powerful. He took pictures of children from a very direct point of view, very simple, with the same perspective seen in some of the early portraits done by Duane Michals in 1958. They are taken from the same distance. This is why I like the 50 mm lens because it puts just the right distance between you and your subject. Another artist whose work I love and who is not well known is Frederick I. Monsen, who traveled through Hopi and Zuni villages in the American west with a Kodak camera—the first instant camera, a proto-type for the modern 35 mm ones that came afterwards—at the end of the nineteenth century. He took the most natural sort of pictures of the Indians in a very modern style but over a century ago. Nobody is posing, there is no forced exoticism. He could have taken much more typical shots. But these have all the force of modernism, done perhaps without his even being aware of it.

JMB: Paul Strand?

BP: I really like his work—there are many maestros I love. Now for example I am reviewing the work of Bill Brandt, who is fascinating. There is also another side of photography that has the power of what is reality based, pictures taken for ethno-graphical reasons. Lévi Strauss took photographs of the Indians of Brazil reflecting the closeness of the families, the affection among the men, women and children. The images of Edmond Bernus, taken of the Tuaregs in the African desert in the fifties and sixties pertain to this same school.

MB: I owe you a photographer, Gotthard Schuh. You once told me you felt him to be one of your predecessors.

BP: He was another great maestro whom Robert Frank knew when he was young. He took a picture of fog on a highway in 1936, many years before my work, a picture I would have loved to have taken!

MB: We have already mentioned Frank. Then there is René Groebli.

BP: His pictures of trains are extraordinary. We can't forget the powerful photos from the forties of New York taken by Louis Faurer. Pierre Devin introduced me to another fine photographer from the fifties, Jean Marquis, who took many pictures from a truck of highways. Devin has a good eye for finding people who are not that well known, like Wojciech Prazmowski from Poland, for example, a contemporary of ours whom I consider to be one of the best photographers working today.

MB: You took a picture of Álvarez Bravo turned away from the camera in a London street when you were twenty-six years old.

BP: It was a stroke of luck to have run into him.

MB: I also owe you Sergio Larrain. We did his exhibit at the IVAM at your suggestion. Who else from your generation do you have contact with?

BP: I have had three powerful encounters that made a great difference to me. The first was with Max Pam at the beginning of the seventies. I saw his pictures in *Creative Camera*, a British magazine published by Peter Turner. We sent each other many letters until he finally came to France and we were able to meet face to face. He also visited me in New Mexico afterwards and, through the years, he in Asia and I in Africa, we have made a parallel journey that has brought about a great friendship. He is a great photographer with great sensibility and a great sense of humor I am a great devotee of his work. At the beginning of the eighties I met a French woman whose father was Spanish from the flamenco world, Françoise Núñez, who, as you know, is now my wife. Her photographic vision is very expressionist, related to her connections with flamenco.

MB: Max Pam, Françoise Núñez, and the third one?

BP: The third one was Luis Baylón. When I was living on the coast of Almería I would travel to Madrid frequently. I met with Baylón and after seeing five of his photographs I realized I was in the company of a master of sensibility, with whom everything is true without an ounce of falsehood. It is a photography similar to that of Diane Arbus who is another essential person for our list. If I only could mention two photographers I think it would be Josef Sudek and Diane Arbus. She understands what it is to live and to be a part of the world: she gets close to people and never robs their souls, she always offers a gift instead. Baylón works in the same way, he has a shyness about him covering great affection.

JMB: We have put the label "Plossu-ian" on a number of Spanish photographers. Do you like that? Do you even agree with it?

BP: It doesn't bother me. I don't think they copy me. They have their own personality.

JMB: Speaking more concretely I have written texts for Vari Caramés, Javier Campano, and Luis Vioque in which I have made references to you and none of them disagreed.

BP: They didn't complain? That's good then.

JMB: They are people who recognize what they owe to you. It's as if we were to say that Oscar Domínguez owes things to Salvador Dalí, or Dalí to Giorgio de Chirico. They are generational links. These photographers I mention are young and you have shown them the road: within the panorama of Spanish photography they practice a discipline that is quite poetic, urban, and with many references to the past and to memory. I see no problem in recognizing that debt. By the way, I was in the Pompidou Center a few days ago observing the installation of their permanent collection and I was so pleased to see twenty photographs of yours there.

BP: It is a curious phenomenon to see my little square black and white photographs hung next to large contemporary painting. It was a decision made by the curator Alain Sayag. Another theme, apart from the photographers and the places. Just look at Spain: Cartier-Bresson worked here in the thirties, Frank in Valencia during the fifties, Koudelka, who has one of the best eyes of this century, worked here in the seventies. There are places that elicit the best from you.

JMB: You certainly have had a very Spanish destiny.

BP: It was not in the cards, because my maternal grandfather was Italian, at school I learned English—my parents did not choose for me to study Spanish—and it is quite possible that I arrived in Spain because of Mexico. Everything was quite a fantastic accident.

JMB: But I believe you are very integrated into the cultural landscape of our country. You've had exhibitions in Valencia, Barcelona, Tarragona; in Madrid and various other places. . .

BP: And it has been here that I have found my source of energy. In order for things to favorably evolve there needs to be a spirit of struggle. In the seventies we had the work of Alan Porter in *Camera*, who published first time photographs taken by all kinds of people, giving them some international recognition. That spirit continued with *Contrejour* in France, *Contretype* in Belgium, and *Creative Camera* in England. In Spain it began with *Nueva Lente* in Madrid and with the Spectrum Gallery in Barcelona. Meanwhile, in California, where I spent a lot of time during those years, a number of very creative photographers appeared who brought new angles to photography: Jerry Burchard, Larry John, Steve Kahn, and many more. Can you believe it? Coming back to Spain in the eighties and nineties we had the work of Eduardo Momeñe with *Fotografías*, Adolfo Martínez, Ignacio González and Joan Fontcuberta with *Photovision*, David Balcells with the

rimavera *Fotográfica*, Paco Salinas with *Mestizo*, Julio Alvarez with *Spectrum* in Zaragoza, ₹afael Doctor in the Canal de Isabel II gallery, Myriam de Liniers with the PHotoBolsillo ollection, Josep Vicent Monzó at the IVAM, Alejandro Castellote at the Círculo de Bellas Artes workshops. . . I'm sure I am forgetting many more. We are talking about the truggle to perpetuate the discernment for photography.

Bernard Plossu was born in 1945 in Dalat, South Vietnam. At age thirteen he made a first journey to the Sahara with a Brownie Flash camera given to him by his father. During his early youth he assiduously attended the Paris *Filmoteque*. In 1965 he traveled to Mexico and ever since then he has taken photographs in a great number of countries, with special emphasis in North Africa, the African, American, and Euro-Mediterranean deserts. In 1988 he had a retrospective exhibit at the Mussée National d'art Moderne Centre Georges Pompidou and received the Gran Prix National for photography in France. In 1996 he had an exhibit *Los años almerienses con cameras juguete* [The Almería Years with Toy Cameras] in the Canal Isabel II gallery in Madrid, and in 1997 the IVAM (The Valencia Institute of Modern Art) organized a large retrospective exhibition of his work. He participated in PhotoEspaña 2001 with the projection of *La Europe del sur contemporánea* (Contemporary Southern Europe).

Juan Manuel Bonet was born in Paris in 1953. He is a writer and critic of art. He is the director of the *Museo Nacional Centro de Arte Reina Sofía* in Madrid and before that he was the director of the IVAM in Valencia. He is the author of various monographs on Juan Gris and Gerardo Rueda, the *Diccionario de las vanguardias en España* (1907—36), author of three books of poetry—*La patria oscura* [The Dark Country], *Café des exilés* [The Exile Café], and *Praga* [Prague]—various bibliophile volumes, a diary—*La ronda de los días* [The Succession of Days]—and of critical publications on Rafael Cansinos-Asséns, Saulo Torón, and Rafael Lasso de la Vega. Among the exhibitions he has curated are *El surrealísmo entre Viejo y Nuevo Mundo* [Surrealism between the Old and the New World], *El poeta como artísta* [The Poet as Artist], *De Picasso a Dalí: Las raíces de la vanguardia* [From Picasso to Dalí: The Roots of the Vanguard], two shows around the figure of Ramón Gómez de la Serna, and diverse retrospectives of artists, including the one at the IVAM (1997) dedicated to Bernard Plossu.

SELECTED BIBLIOGRAPHY

Le Voyage Mexican 1965-1966, Contrejour (text in French by Bernard Plossu and Denis Roche), Paris, 1979 and 1990.

The African Desert, The University of Arizona Press (text in English by Bernard Plossu), Tucson, 1987.

Paris-Londres-Paris, Centre Regional de la Photographie Nord Pasde-Calais y Editions de la Difference (text in French by Michel Butor), Douchy-Les Mines-Paris, 1988.

Les Paysages intermediaires, Contrejour y Centre George Pompidou (text in French by Alain Sayag and Denis Roche), Paris, 1988.

Le Jardin de Poussiere, Marval (text in French by Stuart Alexander), Paris, 1989.

Route Nationale 1, Centre Regional de la Photographie Nord Pasde-Calais (text in French by Jean Christophe Bailly), Douchy-Les Mines, 1992.

nuage/soleil, Le Centre de Photographie de Lectoure and Marval (text in French by Serge Tisseron), Lectoure-Paris, 1994.

Francoise, Mestizo (text by Jean Manuel Bonet), Murcia, 1996.

Los anos almerienses con camaras juguete, Comunidad de Madrid (text by Bernard Plossu), Madrid, 1996.

Bernard Plossu Fotographia, IVAM Centre Julio Gonzalez (text by Jean Manuel Bonet and Josep Vincent Monzo), Valencia, 1997.

O pais da poesia, Centro Portugues de Fotographia (Introduction by Tereza Siza, text by Phillippe Arbaizar and poems by Vincent Jacq), Oporto, 1999.

Lettre pour un tres lent detour, Filigranes Editions (text in French by Joel Vernet and Phillippe Arbaizar), Trezelan, 1999.

L'Europe Du Sud Contemporaine, Images en Manoeuvres Editions (text in French by Jean Louis Fabiani), Marsella, 2002.

Tropico Mexicano, Fundacion CajaMurica, 2002

Forget me not. Bernard Plossu inedito, Tf editores (text by Rafael Doctor), Madrid, 2002.

JAVIER VALLHONRAT

speaks with Santiago Olmo

Madrid, Javier Vallhonrat's study, 7 November 2002

PHOTOGRAPHY AND REALITY

Santiago Olmo: One of the things that seems appropriate to start this conversation would be to ask you about the why of photography. Photography implies a real training of the eye—a way of constructing by breaking something down and then reconstructing it. It's a process in which many things are filtered, especially one's own perspective. Maybe we can start by analyzing what this process means for you? In other words, how has your initiation into photography helped you visualize and conceptualize reality?

Javier Vallhonrat: OK. Something that is relevant to say is that the first project I approached as a series, in the summer of 1982, dealt with painting, or, specifically, with the relation between the body and culture. It was somewhat similar to Body Art—it was a small performance with a dancer, Marisa Teigell, with paintings by Enrique Vega, who painted fabrics which were then shaped a certain way by Agatha Ruiz de la Prada. It was a big step for me, an initial approach to challenging what for me was a reference to photography at the time. Remember, these were the early eighties, when there was a sense of determined purism (which in my opinion belonged to the history of the medium). I mean, I defended an orthodoxy I didn't understand, because it placed photography outside of any possible dialogue with art and outside the general context of creativity. It seemed to me that it placed photography in the realm of discipline (to put it one way), but in this first project what I wanted to do was implicate myself fully, to recognize myself as an *auteur*. It was a project with the human body that allowed me to relate to a present and tangible reality, and at the same time, with another parallel

decontextualized reality that made photography possible: a hybridization, cross-breeding, and rupture of the documentary context. It was important for me to break with the formal purism of photography.

These are the initial references which I set out to do. The next project, *Homenajes* (1982-1983), was basically the same. With this one, I became very clear about what (I think) will be a constant in my work: the idea of photography as a construction, or the relation that exists between construction, perceived reality, and photography. Along with photography, it also calls into question painting. In some way, it was a preoccupation that corresponded to a particular time—I had finished my studies at the Fine Arts Academy, I had begun my thesis for my doctorate, and I was beginning to get interested in the murky area between photography and painting. All of this allowed me to align myself, perhaps unconsciously, with the postmodern idea of the landscape that we recognize as reality. I gamble by choosing the landscape of cultural and pictorial references. I'm interested in approaching them not simply as models of reality, but as reality itself, both in their production and material. In this sense, I place myself in an intermediate world—a world that straddles painting and photography but is neither. It is more of a look from one to the other, and vice versa. But I'm not sure if I've answered your question.

SO: Yes, and this gives us an opportunity to talk not just about photography itself, but about art in more general terms. There are many different kinds of photography, and each of them can, in a way, be traced to parallel emotional, intellectual, and conceptual attitudes. How do you interpret all of this? Does one's attitude towards reality really define photography?

JV: To answer your question honestly would imply that I could say that my work in photography allows me to see everything I've done in perspective. You're talking about a territory I identify with, the result of a process of painting a changing landscape from which I draw conclusions, but a posteriori. From the beginning, I recognize the lines of a more or less systematic exploration. I ask myself questions that challenge myself, my sense of reality, and the medium. . . I converse. In terms of my own perspective or point of view, without a doubt they are omnipresent in every project in one way or another. There is a constant need to understand the use of the medium, an attempt to elaborate what could be defined as a language, which photography has allowed me to put permanently in a state of tension. As much the "what" we say about the world and the discourse we build around it. As much "how" it is constructed (from our need to constantly describe and articulate a language) as the act of having chosen the medium of photography as a tool from a hybridized perspective or a process of cross-fertilization.

From the very moment we choose a specific language, we define the limits of the world we are able to describe. This limitation is at once both identification and definition. The language that can describe the world of words is—the word; that which can describe the image is—the image. Photography obviously also has this characteristic, which for me is very interesting. In the last series, I begin to talk more about the construction of reality, as much via the medium chosen as in practice, in the elaboration of spaces, in the construction of a house. On the one hand, a psychological orientation is implied, but there is also another that has to do with real, physical, even social, circum-

stances parallel in our lives. These aspects are defined to the extent that the series does so, in the same way the awareness of an attitude is shaped. When seen together, one can appreciate significant changes and crisis points which involves the opening and closing of chapters. Each chapter allows me to respond to certain questions, and at the same time opens a door to others, where occasionally I reconsider a question that was unresolved. They are always related to my self-questioning, which is the least explicit part of my work, like an inevitable parallel interrogation: the idea of the individual and his construction—and the tools I use in any given moment to undertake such a project.

The language we use to refer to reality, which is necessarily mediated through this instrument, always interests me a lot, because it constantly generates the possibility of putting something in doubt. It's what motivates me most, to open a crack in something that seems sealed—that act of constant prying. This is what I recognize as my "perspective." In the beginning, you come to it intuitively, but later, to the extent that a project progresses, it mutates into a clear direction.

It began with the trilogy series (though it seems a bit pretentious to have called it a great trilogy) formed by *Autograms* (1991), *Objetos Precarios* (1993—94), and *Cajas* (1995).

SO: Already at the beginning of your work an interrogation appears related to style. You then move on to critique it, dismantle it, or elevate it. You pause to analyze the tools and language of photography.

JV: Yes, the analytical aspect (almost like a scientific project) started after 1990. Before that you could see my overwhelming need to question my identity as an individual and as a photographer and through this point of tension, to define what my place is. I progressed, discovering simultaneously, almost accidentally. The consequence of undertaking this project, was in a certain way, a definition, and I ended up being the most surprised by it. In every way, the beginning of a series always implies a clarification of the territory one is approaching, more or less accurately. There is a prior conceptualization, perhaps greater than what comes after the project—which allows you to redefine your conclusions. For me, a series allows me to wonder at, among other things, how images, through their materialization, define something that didn't exist before. They allow me to retrace my steps and say, "From this moment, what has this process done for me?"

SO: Of course, from this moment you are aware of the development of a process of personal formation and maturation, or is it simply formation?

JV: This is the whole project. From the moment one speaks and expresses oneself, one is defining—and is defined—in a precarious and provisional way, but without a doubt, it leaves footprints. They don't echo so much one's initial decisions, but are a consequence of their existence. Things, in being made, delimit a territory that later obliges us to identify and "unidentify" ourselves, and this distancing is also a project in itself.

SO: Decisions are made which open doors to what you are talking about, to new projects and series?

JV: Of course. With respect to style, which you mentioned, it's a question I ask myself, to the extent that the series materializes and produces changes. Perhaps there might be a formal coherence relative to each series, but there's also an element of chance in abandoning a set of constants from one series to another, precisely because I don't have the need to understand the style as if it were a precise identification. More than anything, it's occurred to me that the photographic project—because of characteristics such as its relation to reality or its mechanical condition—puts into doubt questions linked to the moment in which I was born and to the beginning of the post-industrial era. It participates in all the questioning of the edifice of knowledge prior to the post-modern era. In some way, a certain experience was created when I was twenty-two or twenty-five years old, which is when I read books about these themes. Of course, I don't mean to say that I only read them at that age, but it's coincidental and I can't avoid the fact that this is the time, the era, I am living in. It's odd, because photography is a child of the Enlightenment par excellence, a prosthetic that allows for the writing of history and reality in a certain way, and, of course, its manipulation. I came on the scene at the moment when this whole structure was being questioned. It's inevitable that one needs to test for oneself what it means to question the value of communication, of language, of words, and what is the space that we concede to relativize the principles that govern the appearance of tools like photography or cinema. In other words, to question the value of narrative, description, certification, and of so many things that we consider the foundation of the reality in which we live.

At the beginning, you asked me the question: "Why photography?" Possibly because of this—because I allow myself to consider the question of truth. It's a scientific invention, that in the hands of some photographers, and a society that needs to document their movements, functions like a legitimating instrument, like so many others. I'm speaking of 1850. One hundred years later, I am born and this continuity doesn't cease. Then, it turns into an instrument of crisis in a convulsing world. I think this awareness of imbalance is very palpable in the last few generations, and it's interesting that the exercise of reconstruction is accomplished through an instrument that was invented at the cusp of a prior era. In some way, in the political, social, and economic constructs through which we live today, we perceive a crisis of impending doom, of reality.

SO: Photography also has a versatility that probably doesn't offer other techniques in the actual context. It's a tool that is useful for many different things and that can transport one to many different places. It is not a univocal language or a closed language. It is open in the extreme.

JV: What you've just said is very interesting. For example, photography allows us to situate ourselves in an intermediate point—between the purely quotidian and the instrumental. That is, it can be conceived as an instrument of persuasion in a society of consumption: Walter Benjamin described it perfectly and explained how it functions very well. But at the same time, it allows us to act with a radically opposite intention: such as the drive to use the artistic project in order to make possible the experience of constructing the self. It's situated between these two points of view— the purely banal and its utilization from personal commitment.

SO: Between the instrumental and the near-transcendent.

JV: In some way. It works powerfully for both. By its own characteristics, it offers a marvelous possibility of absolutely reversing this legitimating character and showing what has been achieved by one of the most enduring trends in photography in the last twenty years. It is precisely its effective use in that reconstructive process that allows one to transform. . .

SO: . . . Truth?

JV: The *idea* of truth—something so important. And by extension, the very concept of reality. By being a legitimatizing instrument, it ends up becoming a delegitimizing tool of the strategies that permit us to base ideas in truth or reality. As such, between banality and transcendence, between what can be confirmed as a true version of reality and its opposite, photography exists. And how can one not be fascinated by an instrument that has this power?

SO: Perhaps all of this manifests itself much more clearly today, when both aspects—analysis and documentation, the instrumental and the expressive—occur both simultaneously and in opposing directions. Most recently they appear overlapping and joined in the same work.

JV: Without a doubt; with photography located in that very precise enclave. Look, I'm very bored with my titles: *Intermediate Spaces, Precarious Objects*—but what happens is they don't only allude to a determinate materiality or to the inclination for defining territories that in some way are subject to opposing tensions. They can also be a simultaneous reference to the cinema and painting (and to neither of these at the same time), to objectivity and its negation in the same work, or to representation and its impossibility in the world of photography. I think the instrument itself makes the germ of contradiction implicit in what society and culture actually live. It's what has always fascinated me about photography.

THE ICONOGRAPHY OF THE PRESENT

SO: From my point of view, there's a tendency in your work which contains, in a very explicit way, this germ of contradiction that you mention, a critical perspective that deals with many aspects of contemporary culture. The use you make (and have made) of different photographic explorations puts you in a situation of control and analysis of the language of the medium, and from there, the use of the contradiction is very prolific, both in ideas and formulations. I am talking also about the influence your work as a fashion and publicity photographer has had on your development as an artist. I believe this has played a more important role than being merely an opportunity for experimentation. The commissioned works you did in the eighties had a unique style and they came out in mass media magazines. From your personal perspective, then, how do you value this experience in relation to the artistic bent to your work?

JV: I'm very suspicious when I speak of fashion or publicity. More than suspicious, I'm also very critical. And more than that, I am reticent [Laughter].

SO: That's why I brought it up [Laughter].

JV: Before anything, I should say that there is always a contradictory aspect to fashion photography. I speak from the perspective of a photographer who views his work as dealing with the issues that we touched on in earlier questions. To start with, fashion defines, not so much the how of what we are talking about, but the what of the reality we create through a series of constants, in dialogue with the representation of the body or with the idea of identity, but in some way clinging to a relation with the body. It also dialogues with the sensual and to a lesser extent—something that has emerged more than anything else in the last few years—with the social, as is the case with Nan Goldin and others. I think my work addresses with intensity many of the formal questions from the eighties, but then it moves on, abandoning this identity in the nineties, even though my preoccupation with form is a constant.

I can't avoid making repeated references to definitions and redefinitions of issues like seduction or the representation of the erotic...or how to escape from the tremendous weight of certain illusions when you work with themes like the representation of the body as an erotic space, or the issue of the depth you achieve in portraiture, or of the common space that is supposed to be constantly talking about the body of man and woman exclusively as an object of desire. This is always limited by the fact that the projects appear in publications that require vehicular determinants, involve industrial interests, etc. This is the part that bothers me a bit. I've never had the feeling of escaping it, nor have I seen anyone's photography who could. It's possible that, on some occasions, the personal work and the space conditioned by fashion coincide in the work of the photographer. They are the exceptions, cases in which one says: let's do it—this is worth the effort. But it's clear that they are rare.

Without a doubt, whenever I've accepted a fashion project I've approached it in the most radical way possible. They've put the clothes in front of me, and I've used it as an excuse to embark on determined explorations, but within certain boundaries in which the rules of the game (as much as we might like to disguise ourselves in order to try to change our essence) are strictly defined. I doubt that any photographer that works in fashion doesn't do it from a professional perspective, I mean, with the logic of the market, and that exercise is undertaken with certain given viewpoints. Every photographer linked to the fashion industry accepts them. More or less consciously, with more or less radicality, but even those who play at the margins accept them. Every once in awhile, someone tries to propose an act of rebellion and to try to break the rules, but they don't do it and they are immediately absorbed by the machinery and are either re-integrated—or thrown out.

That's how I see, from a general perspective, the world of fashion [laughter]. But if you can get me out of this pessimistic and skeptical view and perhaps deal with concrete issues and specific discoveries, you might be able to get me to forget what I've just said and express other opinions. It's a trick, because I'll tell you: whoever says otherwise is

under your spell, but for myself, it's very difficult. I rarely say anything else when I talk about fashion photography.

SO: The influence that manipulated images exercise today is so powerful that it annuls or anesthetizes the visual skills most critical for seeing, those that allow another way of understanding photography—constructive attitudes, critiques, etc. I would also include, within the same orbit of fashion photography, both publicity and the media, in the way in which they encompass all day-to-day visualization. I think the situation fifteen or twenty years ago was very different from what it is today. All of this world was immersed in a process of transformation, and it seemed possible to create it in ways different from those belonging to any field. But given the actual circumstances and the actual results, it's clear that this hasn't been possible because the media and publicity machine are much more powerful than any desire for transformation or subversion—both internal or external.

It's very symptomatic for me, for example, to reconsider from this vantage point your series *AnimalVegetable* (1985), where there is a deconstructive approximation and critique of the fashion world focused (more than anything) on style. Nevertheless, it's possible to better understand now than before, to the extent that that world has changed, that it's become much more rigid and has permeated every sphere. It's no longer concentrated in its own space. On the other hand, among all the current photographers today who consider themselves fashion photographers, there are very few who ask deeper questions. What's instead common is a very banal result, a kind of canonization of the established formulas. No will to break with commercial images now exists. By definition, the entire media machine promotes visual models and models of behavior that are much more rigid than what might seem to be the case. What I wanted to ask you was, having both participated in this process and having looked at it from a critical perspective, how do you view this situation today? Not so much the fashion industry itself, but more the world of references that has changed so much and which you used to a certain extent in a certain period in your career, and which after many years, can be given different interpretations?

JV: You mention the work *Animal Vegetable* as a possible axis for reflection, and also an aspect that seems to me essential, which is how fashion is understood as a machine for creating referential models—of the body, of attitudes, etc. Models also that are apparently subversive, or that in a given moment are sold as having the potential for subversion but at the same time are rigid and are constantly controlled by this machine. When I did that series, I was at the same time defining my work as a fashion photographer. There was a serious contradiction in that. You, from the outside, view it in one way, and I, from within, lived it in another way. In my work in fashion, *Animal Vegetable* allowed me to define myself in alternative ways that don't respond to this canonization of formulas, but allowed me instead to elaborate and express my own formulas. It deals with interior models that act decisively in my own construction. They are something of a first attempt at building my own vision. After having done *Homenajes*, which is a work that focuses more on the medium and the form, in *AnimalVegetable* there is a strong stylistic slant and also, a priori, psychological self-examination, not necessarily explicitly formulated, but very much latent in the work. More recently, since 1999, it comes

back to the surface again. Since then, I've been a bit preoccupied with other questions. It's a possible alternative to talking about the body and the images that generate as much the attitudes, the behavior, and the referential models that I don't find in fashion but that I want to find. The exercise of fashion keeps me from being able to integrate that possibility of everything. As such, I see the rupture between both tendencies more than their connection, although it's possible that it's an inevitable given. There is a successful recuperation of my efforts in *Animal Vegetable*, but then in *Espacio Poseido* I enter a period of total separation. These were the nineties, when I was doing fashion photography and at the same time began three series: *Autogramas, Objetos Precarios,* and *Cajas.* In *Cajas* the distancing is absolute, which is to say there is a kind of photo-negative through which I speak of the world. The series responds to a period of crisis on a personal level. And it affirms a renunciation of this need for the image to be a vehicle of immediate seduction. The fashion industry is constantly conditioned by its need for immediacy, as much in the moment of the viewer's interpretation (as a consumer, by definition) as in the themes that are dealt with. There is no space for a wider margin, because the effectiveness in terms of the market is only defined by the relevance of immediacy. If the parameters that define fashion coincide in any way with those of the world of artistic creativity, I use that work, but only with the evanescent character it possesses. All one has to do is observe their methods. The photographs of any given artist are going to have value in the fashion world for six months, or maybe a year, during which time the work might be relevant. It has no more validity beyond that nor to the reality of fashion to which I refer. What the pages of a fashion magazine propose is not a deepening of the work of any given artist, but more a momentary relevance afforded by coincidence. In other words, the artist speaks of reality in some way that fashion can utilize punctually in order to propose a model of behavior as well as an "alternative" look, but with the idea of the alternative that's typical of all fashion trends: relevant only during that six-month period which serves to generate the illusion of change. A change which, because it is so rapid, seems to be motionless, like the revolutions of a bicycle wheel when you can't see the spokes so it looks like the wheel isn't moving.

Perhaps my work is the fruit of that contradiction, resulting from two opposing tensions. As a professional exercise I can be fascinated and frustrated at the same time. I've always lived it that way. During the time I was considered a fashion photographer in terms of form and style, I was less skeptical because I was participating in that utopian fantasy of the possibility of change. Ever since the divorce that I mentioned, a curious phenomenon appeared. In some way, I've assumed the contradiction and I can integrate it more naturally. More and more, my projects reflect a character a bit more distanced from the actual moment. Perhaps they don't maintain such a narrow relation with references to the visual culture of the moment as before—and that position does not seem to me to be exempt from self-interest. Without a doubt, this whole vision of the phenomenon of the use of the image within the fashion world doesn't stop me from approaching my projects with total enthusiasm. This is my position as soon as I accept a commission: I go to work on the task of integrating all those contradictory elements with passion, because they are offering me an opportunity and I accept it as such. This is my approach to fashion photography. I understand that I'm going to be confronted with a contradiction that I won't know how to resolve, but nevertheless, I keep trying, though I can't say for how long.

SO: What I wanted to say was that in *Animal Vegetable* there was a very critical under-current, which wasn't as visible then as it is now.

JV: Undercurrent critical of what?

SO: Critical of the system of values that was creating fashion. There seemed a certain intention to subvert it, to be both critical and self-critical. That's the way I saw it.

JV: *Animal Vegetable* is a bit on the dark side, the side as we say. . .

SO: The "other" side.

JV: But not intentionally. At the time, I was trying to define myself as a photographer while figuring out what my position as an artist was. I was trying to do it with the same level of intensity for both, trying to be clear and understand the needs appropriate to each issue. I mean, it didn't make any sense for me to say: "I'm a general photographer." I do one type of work when I do fashion photography, because I'm conscious that the medium imposes a kind of inertia, a terribly oppressive dynamic. There are those who say: "My work is artistic and equally valuable to the fashion industry." Without getting into definitions of what is and is not art, I would simply say that the two are worlds of action in which I am critical of regarding the possibility of achieving an internal coher-ence, or of rigorously articulating their diverse elements. To pretend that fashion photography, which promotes an interpretation of reality of visual immediacy with a burden of seduction so powerful in all its images, allows us to position ourselves in such a way as to be able to observe our own processes. No, I think that fashion, pre-cisely in its work of seduction, attempts to *eliminate* this distance as much as possible. This is where the radical difficulty lies. In *Animal Vegetable* I tried to realize that and achieve a project defining both actions in such a way that they would be equally valid.

I would say now that I continue to do projects in the fashion industry knowing the value of the ordinary. For me to work with the magazine *Big* has been extremely exciting in the sense that Marcel Jünemann, its editor, proposed a very interesting idea. Here's how he explained it: "One thing is the fashion industry and the other are the fashions themselves—the moments in time." What fascinates him is creating a maga-zine, not about the fashion industry, but about time. From the moment you speak about your own time, you're speaking about fashion at the same time, but there's no need to talk about the industry.

SO: In that sense perhaps it's not necessary to talk about the objects of consumption that constitute the most visible aspect of fashion.

JV: Exactly. Even though inevitably, they do appear. The magazine is talking about other things, but at the same time, does so about a particular time in the form that we speak of it, in the way in which the images are arranged, constructed, and by what this dis-course introduces implicitly. For example, in the work of my brother Valentin Vallhonrat for *Big España* (and of some other authors, but especially Valentin's), these most basic levels are their way of talking about reality. What's relevant in a given moment is

converted to a commentary on their time. It's no more than that—fashion is a defini-
tion of its time, short-term, and with an extremely precise chronometer. With the use
of the flash in photography, the approximation, the detail, an entire range of things
(there is much more fashion there than in a thousand fashion images) is very clear to
me. If you want to talk about my work from a documentary or cinematographic point
of view, I think I'm responding to my own time, more than with the form in which my
models are dressed. You also have interpreted it in this way.

SO: You are referring to the project. . .

JV: For Big España. In that project I attempted to distance myself by thinking of my
personal work being printed in magazines and sold at newspaper stands where it was
going to stay for a month. I tried to produce the work from a purely personal crite-
rion, distancing myself from all these questions about what is fashion, what's not
fashion, knowing that my work would appear in the month of April 2001 and that
was going to be one or two months in the newspaper stands. It was not going to stay
there at peoples' disposal for three years, the way a book can. Its life was subject to
a strict temporality.

SO: Moreover, it's a project conceived in terms of its publication.

JV: Conceived exclusively in terms of its appearance in a magazine. If the work later
transcended or outlived its medium of publication, it's because there was some weight
or passion or power that's allowed me to rescue the images. Jünemann is someone who
understands this aspect of fashion photography. The question of temporality is the
determining factor. Even if it's already in the pertinence of the language you employ
or in its form, it is its relevance that gives it the character of fashion. For this reason
there are images in which fashion isn't a component, but that define a way of seeing
and an attitude. There are others where you have clothes that have been out of fashion
for many years and perhaps never even were in fashion.

SO: So it sounds like this magazine deals with narrative values more than anything, of
photographic trends that don't respond to the model of the image in the way the media
machine defines it. It speaks to the interior psychological realm, properly speaking,
more than to external appearances. In some way, it deals with the reuse of language for
talking about radically distinct things. There is no banality there, whereas when we
observe works in the world of fashion, in general they tend to describe something more
banal or presentient, a kind of glamour or simply a façade.

JV: There are many other examples. In the last ten years there has been a profusion of
alternative magazines of very high quality. I'm talking about Nylon, Purple, Crash, Double,
Wad—a whole assortment of magazines that have surfaced beginning with The Face. They
are creating a space where they can directly challenge the image and its potential to
anticipate and define a field of attitudes of vision, of looking and also of representation,
but more than anything, of seeing and of looking. They are definitions of the language
of photography that, in some way, collectively critique a moment or an era. I think
these magazines intend, logically from their own self-definition, not simply to be

vehicles for the objects produced by an industry. They are like a visual perspective of the present without any need for the object. They provide a platform for people in photography who are interested in the analysis of the moment. This is the idea behind the work I'm doing for *Big*. How does this make me feel? Do I accept the challenge or not? I accepted it and I did the project. What happens is that some of the images speak to the moment and at the same time pose questions that don't have so much to do with a defined period: the preoccupation with other languages, for example, or the references to documentary photography and painting.

SO: To light, also.

JV: No doubt, that's why I speak so much of painting. All those aspects are present in my work since 1980, and they continue to be there with the same intensity. They allow me to speak about what I've been doing for twenty years and at the same extend myself to my current interests, like narrative, or photography's relationship to cinema. I'm also interested in investigating how I can cross the barrier of photographic visualization and introduce myself into a performance piece that deals with the creation of the work from within and from without.

They are questions that deal with issues that have interested me from the time I was eight or nine years old. And at the same time for some reason, I think that they are relevant today. I think that it's because of this that the magazines all share a similar perspective (*Big* and others) where they give that space and I take advantage of it. In fact, I'm using the material from *Big* to re-elaborate it, renourish it, and allow myself to extend it in another direction.

SO: This appears in some way in the last video projects. Not in a direct way, but yes, as a basis or platform.

JV: *Big* is an excuse for me to declare a set of interests that I've been developing for some time now: cinematography, experimental videos—which you know very well since you've seen them from the beginning—documentary and the pictorial, and also the constructive elements of photography, that is, the models and representation of reality as a construction. They are questions present in almost all my current projects. They give me a point of departure that allows me to experiment, and I do it with the help of something I consider very positive in my relation to the world of fashion, which has allowed me to approach the projects with a kind of spontaneity and indiscretion because I know they're only going to last a month and then it doesn't matter. I want to say, I accept responsibility as one of those who create the images that surround us, while at the same time, I understand this platform is going to be available to me only a short time and so I treat it as an experiment.

This is why in the last series I showed you, *Acaso* (2002—03), I allowed myself to be more frivolous, in the sense that I also gave a certain amount of space for the non-essential. It introduces a more recreational character both in the images and in the action that's happening in them. There is a more spontaneous construction, less subject to the idea of "scenery" that might bring the past to mind. I set up the position of the camera

and the framing following the documentary model, giving it the look of something exterior to myself, though I create the action. It's helped me explore other avenues, as opposed to earlier projects dealing with the idea of construction, perhaps closer to painting. There is an important element of the use of color and light in the pictorial sense, but also cinematographic and documentary as well. I've enjoyed these experiments very much.

A POSSIBLE ZONE ZERO

SO: Now that you've alluded to painting and the pictorial, I'd like us to tackle the question of why is it that after *Homenajes*, where there exists a very evident connection, the series that seems to me most clearly linked to the idea of painting is *Autogramas*? Is there a reduction of the language of photography to a "zone zero," parallel to the gesture of tracing a figure or a line on a blank piece of paper? It's like painting black on white, and in photography, the metaphor would be making light visible. It seems to me to be a work quite appropriately pictorial because in the rest there is a greater distance from painting.

JV: I like that what you define as an "empty gesture" or "zone zero," is for me what constitutes doing photography. In that case, it consists of flashing a light and imprinting a sign within in a space. That minimum light allows the photograph to exist. In some way, I'm referencing to experiments in performance art, like the work of Bruce Nauman. In my work it helps to distinguish aspects of the possible pictorial component: the first deals with conceptual issues; the other has to do with expatriation, by which I mean the attempt to remove photography from its immediate environs and place it in a more immaterial world, associated with aspects of painting. The attempt to connect it to itself, by definition. All of my projects are permeated with this attempt to a greater or lesser extent. The color or the light in my images defines an impalpable atmosphere that situates you at a point from which you can observe simultaneously both the referent and the language that permits it to exist. When I say language, I refer to an element such as light, color, etc. These problems are present in *Autogramas* and also in the other series. They are a way of situating myself at a distance so I can observe the reality I describe as well as the tools I employ to describe it. That is the unique character in my work. I think, in varying degrees, there always exists a certain element of artificiality or whatever you want to call it.

On the other hand, you have the conceptual aspects, which you describe as the act of writing. I'd have to think about that a little. For me, *Autogramas* is a kind of protolanguage. When I look at those images, I think what I'm doing is creating signs that arise out of a conception of the body and of space that allow me to define it. They're like turns of the wrist or matches that cover the distance between my outstretched hand and the floor. I don't need to see them to know them, they are interiorized like gestures, given that it is I who am before the camera with closed eyes. For me, it was necessary to go through this exercise of incorporation. Can we understand how that gesture is painted that I consider written? I mean, when we think of Cy Twombly or other gesture painters?

SO: Henri Michaud?

JV: For example. No doubt that reference is present. But, strangely enough, I'm thinking at the same time of Bruce Nauman—in *Self-portrait as a Fountain*—and in Twombly. You haven't seen it, but I can show you one of my images that's basically a Cy Twombly. Aside from the fact that the entire painting is filled, is impregnated, with these gestures so that they acquire a chaotic character and display a certain kind of neurotic writing. But in the end, in the image I'm speaking of, that component of performance and its mise-en-scène don't end up simultaneously defining a situation of the body, space, light, and time through minimal gestures. In some way, the series is governed by a very strong demand: if it's a painting, it's prepainting—it's the writing of a gesture, it's light in space. Of course, the idea of writing with light appears as some primordial evidence. What happens is that I see the series replete with other concerns that don't make me think of painting first. Rather I think of the "zone zero" of a photographic writing in which the elements are necessarily light and time, which is to say, those elements that define the photograph. That's why I say that the demands of this project in a conceptual sense come before the idea of painting. Later its subjection to a defined space appears as an expressive formulation, which is what determines the framing of the camera and the referent, which is, no doubt, myself, my physical presence. I either let go of the match or I describe with it a physically incorporated gesture. That's why I discount the neurotic writings of Cy Twombly, in the sense that they don't respond to a physical interiorizing, but more a psychological one.

How do I describe a situation in which the foundations are time, light, space, and the presence of a referent? Lighting a match where light and time act simultaneously, a condensed time that moves from the beginning of combustion until it goes out. This match lasts a very short time—until I burn my fingers or just extinguish it. The idea of duration not inserted in the dispositive mechanism of the camera, but in the action itself, allows me to conduct a literal and metaphorical exercise of the construction of a photographic image from its zone zero. Curiously, my body being that which that defines it, creates a gesture that can be understood like a drawing; in fact, it is the creation of a visual sign within a defined space. Of course, there is an absolutely immediate association with the idea of a drawing. Perhaps this idea is one that should be associated with writing as much as with zone zero, that is, the first sign which I'm guessing must have surprised primitive man when he noticed his footprint as a sign of his own presence. It implies going beyond oneself and writing a sign. As a first gesture, it brings you to a great quantity of references. It's odd, this is the first time you've made me reflect on its relation to painting. More than anything, I saw it related to things like time, light, space, or presence, and its connotation of performance. I'm still referring more to Nauman than to Twombly who doesn't impress me much.

SO: When we've spoken of the constructive in your work, it's been in terms of space, but I've also appreciated this aspect applied to time. The idea of photographic time that appears, quite logically, after *Objetos Precarios* seems to me very central to your work. It's another kind of zone zero of representation that's related suggestively with all the problems of *Autogramas*. I would like you to elaborate a little on that idea of photographic time in general, and then, on time as an important dimension of your work.

JV: It's impossible to tackle a photographic project without addressing time as a central question. In *Autogramas*, I treat it as an essential element from the perspective of the limits that it imposes. I mean, photography exists because of the limits of time: it inaugurates and encloses a specific moment. Perhaps because it tries to present the entelechy of what can signify an instant. But in my case, I try to challenge this idea further. In *Autogramas* I substitute "instant" for the condensation of a process—the creation of an image on a surface. The image that it contains is already immobile and subject to another time, which is that of our observation. The "during" of the construction is transformed simultaneously to the interpretation, together with the particulars of time of the interpretation of each viewer and the process of the perception of any object in which the instant doesn't exist either. But these themes of perception in the physiological sense aren't really relevant. Conceptually, there's a transformation of a "during" in temporal suspension. In the series *Objetos Precarios*, that reflection leads me not so much to investigate the idea of time, as in *Autogramas*, but to anticipate something else: the narrative tension representing the precariousness of photographic time. I introduce in the images an element of temporal tension, of the precariousness of the object. I avoid references that could evoke metaphors external to what is being represented and I try to shape myself to the materiality and the physical laws that surround it. When I was photographing an object subject to a powerful temporality (like the law of gravity) the contrast of this dynamic to that, which is subject to the act of photographing, to its transformation into an image, presupposes my own confrontation with the idea of time. There is a strong narrative tension when what I show is the phenomenology of the process and its transformation into an image. It's a narrative about the physical phenomena to which a given object is subject. I like to speak of the objectification of the photograph and through it I can contrast the physical component of the photographed object and its image converted into a representation. This work anticipates questions which I return to later in *Cajas*. Nevertheless, the element of temporality addressed in *Objetos Precarios* allows me to explore their distinct aspects. Temporal tension and narrative come one after the other. Before *Autogramas*, where I didn't raise the question of temporal tension understood as narrative, *Objetos Precarios* allowed me to develop this idea. In *Autogramas*, there's no waiting period. It's a process initiated and ended, whose central argument is condensation. It doesn't have anything to do with the component of anticipation that is given in *Objetos Precarios*. This time of anticipation of photography allows me to later introduce an element of narrative tension.

SO: In *Intermediate Spaces* (1998—99).

JV: In *Intermediate Spaces* in a very direct way, yes. Also in ETH (2000—2001) more metaphorically, and of course in the projects that I'm involved in now, that are more associated with cinematography.

SO: *Objetos Precarios* can be a "zone zero" of representation.

JV: In a narrative sense, you mean.

SO: Of course, it's pushing the limits.

JV: It could be a zone zero of narrative, of a representation of the "able-to-be-narrated."

SO: Yes, we say that the ice, which is transparent, is going to melt, and so it has a limited duration, everything that is on the verge of ending.

JV: The candle that is about to go out, the ball that is about to fall. In its immobility, the object on the wall is speaking exactly of this contradiction, I mean, of its encapsulated narrative potential. The construction of a complete sentence is not enough. It's like a word that implicitly carries this narrative tension. But in the cinematographic sense it doesn't constitute "phrase," understood as the foundation of the passage of time.

SO: You mean, "phrase" in the musical sense?

JV: Exactly. It's only one note or one chord but it carries implicit within it the tension of continuity. We hear one chord and we wait for the next. In other works, I construct an image that has more of the sense of a musical phrase, but that incorporates the same temporal suspension already present in *Objetos Precarios*. I think it allows me to give it a lot of recognition. To the extent that I submerge myself in a kind of autism in the work of *Cajas*, I come out of it wanting to speak to the world, and I have no other way to do it but from that temporal suspension of the narrative. As much in *Lugares Intermedios* as in other later series, I do this exercise of writing sentences that always end in an ellipsis. In the cinematographic and videographic works that I'm doing now that include text, the exercise isn't as much about ellipses but the limits of narration. I make a real attempt in three of the five videos that I'm producing next to construct through the use of tension, feeling through narration. People are constantly bombarded by circumstances that converge in the development of video and we are confronted with a very strange topic in relation to the possibilities of narrative or of the same communication. There is a lack of communication of a psychological nature, but also a particular approximation particular to cinematographic time. Maybe after having explored the theme of photographic time so much, perhaps I was interested in another dimension.

SO: I wanted to return briefly to the theme of the pictorial (not of painting) in relation to these three series, all of them very abstract—*Autogramas, Objetos Precarios,* and *Cajas*—where there is almost an attempt to empty them of all content. Is that the place where you would situate the pictorial foundation of photography? Not as representation but in its material aspect—texture, etc.

JV: A possible materiality of photography, which in some way. . .

SO: For example, the images in *Cajas* are presented like a series of photographic optical illusions that refer to the painting, but at the same time are sculptures. They are not superficial where there might be color or forms, but they deal with hidden surfaces. For me, the pictorial condenses a series of qualities that are always hidden, always camouflaged.

JV: Perhaps I'm raising questions that are related to painting and photography at the same time. I've tried to enter into a coherent reflection about representation. Basically, *Cajas* is the conclusion of a process that made me distance myself from narrative. I like

that you define it as hidden because it's a moment in which I want to avoid talking to the world. Perhaps when any reference to the world appears, nothing more remains but the materials that constitute it and that are denied the possibility of doing it. Nothing else exists but visual materials. I'm showing what is practically the palette of a painter, because I deny myself the ability to elaborate any gesture that might be construed as writing. I only want to ask myself if one can, through photography, speak while being silent. I don't know if the metaphor is too transcendent and romantic.

SO: No, it's very powerful.

JV: It seems indecent to me the way photography speaks of reality nowadays. Now, I go back to give permission speak of it. But then, the form in which the images refer to the reality in their external sense, that discussion that I was formulating (I speak of myself, not of the work of other photographers) I found it to be indecent. Perhaps it was because of personal questions, but I reclaimed as my own the right to do a legitimate project in which I could continue with that radical perspective. It's a bit pretentious, but it carries with it a deep desire to get to the bottom of the question that was important to me then. In a certain way, the three are zone zero projects. *Cajas* is probably the most radical. When I was struggling to describe a possible zone zero it wasn't only from the narrative of photography, but also its visual aspect. Nothing was left but the material and its representation.

SO: What you say becomes very suggestive when thinking of some of the images from the Musa Museu project of Barcelona in 1992 (which hasn't been seen by many) where there seems to be a deliberate concealment of what we suppose is the theme. Let's say the photos that you present show an architecture of interference with the paintings that on many occasions appear partially darkened.

JV: It's a work aimed at the obscuring of the apparent subject by the photographic images. At the moment, I am between *Autogramas* and *Objetos Precarios* and I'm thinking a lot about the value of narrative. Specifically, in something that seems to me extremely complicated, like knowing from what perspective I can speak about a painting or what I can say about a picture with a photographic image. It's a collective work about museums, and each artist takes a particular perspective on it.

SO: It's important to remember that this is commissioned work.

JV: Yes, of the Primavera Photographica. It was commissioned by Chantal Grande, who asked us to do a series of photographs to create a project about the museum as muse. My role was to investigate in relative terms how photography approaches the activity of painting or writing.

SO: And you chose the Tapies Foundation.

JV: Tapies proposed themes like the relation of matter to the word and other questions that seemed interesting to me.

SO: But the theme was museums, not paintings. You could have chosen the Naval Museum, the Textile Museum, or an archeological museum—they're also museums in Madrid.

JV: The choice was completely mine, and each one could have contributed to the project in a different way, from its own perspective. I chose a museum in which I am going to have to enter in silence. In a certain way, I've taken on an impossible task. What possibilities exist apart from reproducing a painting or of making a photograph from a painting that comes out like those that appear in a catalogue? That was the challenge. I was very interested in the alternative exercise of putting myself in front of something about which I could say very little and at the same time challenge the language of photography in narrative terms. I was aware that the project was going to require me to show those aspects of the nature of photography, and that it would surface in all its evidence, inasmuch as this project is related to the series *Objetos Precarios* and *Cajas*.

THE WORLD OF MODELS

SO: Another theme which I find fascinating in your work is the way in which the series goes about investigating problems. It's like the doors which you referred to earlier, that close so that others can open. *Cajas* is already in itself an "intermediate space," because it brings together volume, sculpture, and installation, and moreover it is exhibited. In the exposition, there was a large space with different pieces that created an almost metaphysical landscape—very sculptural, given that the pieces are objects. In addition to including aspects of painting and sculpture, this implies a change in platform. Afterwards came *Intermediate Spaces* which was already presented as construction, because first there exists a prior intervention that creates the model and only later does the image appear. From *Cajas* to *Lugares* there is a fairly radical transformation from the figurative to the narrative. How does that happen?

JV: The key is the figure of the little house, the different houses. What you describe as a "metaphysical landscape" is interesting to me, because it makes me think of Giorgio de Chirico and also of those wooden structures that children make that are purely metaphysical. They are like the blocks that children play with. Within the highly conceptualized surface of the series, there exists at the same time a recreational component that is manifested in those elemental books. Those books have the same value as the text of *Autogramas*. There is a statement by Jorge Ribalta (they are my critical references, that say things that I find very useful, that talk about something very interesting.) In the showing of *Objetos Precarios* in the Santa Monica Art Center (it was exhibited in Barcelona in 1996, when *Cajas* already existed) Ribalta correctly spoke of the renunciation of representation, more and more evident, until I arrived at the production of *Cajas*. It's as if the scenery of the work had been empty and there was only an empty space which was waiting to be filled at some future time. In other words, there's nothing but an empty space, understood as pure space, which, in terms of photography, returns to the previous explication: the only permanent aspect of the work is the materials that constitute the image, formulated in quasi-pictorial terms. There are two poles: the space which is at the service of the narrative, and the use of the most elementary materials in visual terms. And, finally, add the exercise of construction, an activity positively recreational,

that allows my hands to function, but only because I need them to.

From these three elements emerge the aspects of temporal tension in *Objetos Precarios*, and through them appears, in some way, the rationale of the little house. In that first empty scenery, the outline appears as the representation of a mental process that I touched on in *Espacio Poseido* and which had already interested me in *Homenajes*. I mean systems of representation understood as languages. Language is one more system; it is no coincidence that we studied a subject called "systems of representation" at the Fine Arts Institute. Suddenly, I have the needs of an architect or an engineer to work within a system of representation that allows me to order the world in a precise way, from a male perspective. This is a virtual representation made up of the components of reality, in their depth, height, and length. This dominance of the three axes of space in both a visual and mathematical sense struck me as a fascinating metaphor for the power of language. I used this to pervert the idea of truth, constructing small anamorphoses which, when seen through a photographic lens, appear as axonometric constructions when in fact they are completely the opposite—pure chaos.

SO: But in those pieces, what looks like a painting in the image, is actually a model. They are not real as such, but are pure constructions. Returning to what you were saying earlier, you destroy the evidence—the very idea—of truth, all through a series of very stable and assumed concepts.

JV: That forms part of a space that I share with many artists. After having analyzed the limits of language and having arrived at a kind of "zero point" as I do in *Cajas*, I'm left with nothing to say. It's a reductive process that has a definite ending point. In *Lugares Intermedios*, if I decide to employ words after having observed for years these limitations of language, it's only to say, "I'm going to express this, because in this moment, I have the need to do so," but integrating what I've learned from earlier projects that lead me to relativize in an extreme way the type of situation about which I can and want to speak. In one sense, I emerge from this silence burdened with irony, bringing to light the character of those truths that permit photography. The notion of truth begins to separate itself from the construction of reality. I mean, if the word is already a representative system, reality cannot be something other than representation. This theme appears in later series.

SO: Do you think the "conceptual movement" has been influential in your work?

JV: A total influence! [*Laughter*] It's inevitable. Perhaps not directly in a stylistic or formal sense, though in my last series, *Acaso*, I include various points in the scene that parody emblematic moments of the conceptual, as if they were works by Richard Long or Dan Graham. I understand the conceptual as a series of tendentious strategies that minimize the weight posited in the objective character of artistic production. It makes the aspects of analysis of language primary and manifestations of the work as a concept and not so much as a physical reference. The deconstructive proposals and the work of Joseph Kosuth in particular, are for me, absolutely emblematic. These influences are very present, starting with the series *Autogramas*. They are works that are determined from a less immediate interpretation because it's more complex to perceive the contents that make the work understandable beyond the image itself. These strategies afford me

the luxury of a certain exploration of photography in that the conceptualization reinforces its potency or meaning.

In my latest project (which hasn't yet been exhibited), *Acaso*, there are allusions to recreation, references to other auteurs that allow me to give it a lighter tone. In the same way I made allusions to sculpture in *Objetos Precarios* and *Cajas*, here I begin to make references to the cinema, to romantic painting, and to documentary photography from the early twentieth century. The idea of appropriating aesthetic models emerges, and I help myself to some that already exist.

SO: The use of the model has created a climate of reflection and complex criticism in the last few years, given that it has been used in different contexts, in sculpture and installation art and now in photography. As its use has evolved, many prior elements have been incorporated including architectural, engineering, and even urban planning. How do you see your work within this context and the function or role of these elements?

JV: When I think of the use of models, I return to certain emblematic photographers, like, for example, James Casebere or Thomas Demand. In the case of photography you can take different approaches. One of them is photography as fiction. I think constructed photography addresses in a tangential way the type of work that appears in opposition to spontaneous photography from the eighties: the idea of mise-en-scène, which acquires a distinct slant in later works of the following decade where models are already being used.

SO: In some way, in that development there is a continuity through the idea of mise-en-scène.

JV: Yes. Gradually, they become out of place with the emergence of other forms, such as the kind of photography that addresses the issue of the public versus the private. Some of these works include aspects of mise-en-scène, but not necessarily. Most recently, the approaches are linked to cinematography, as you see in the work of Jeff Wall, Philip-Lorca diCorcia and many others. I think they more directly address the value of the documentary and the cinematographic than that of the mise-en-scène as a construction. They incorporate techniques of the cinema and they view the mise-en-scène in those terms.

Perhaps since *Lugares Intermedios* I have the desire to destroy my idea of truth while simultaneously working within a recreational world marked by childish fantasy. This pushed me to create images that question in psychological terms what inevitably surfaces from childhood memories. The bridges that appear in ETH establish a connection with this later work, *Acaso*, which is marked by the aspect of a children's game, and also by powerful psychological elements, like references to play and to worlds where memory is very oppressive.

SO: The model is a tool of engineering and architecture whose function is to support a constructive project. It is an initial visual step that anticipates a final product. But in works that you've referred to and in your own works it acquires a radically distinct meaning.

JV: For me, the basic idea of models is that their use as a formula is extended to other areas where the authors and artists don't use them physically, but what they represent and are supposed to show is an ideal world. Every artist who addresses the sociological issues of suburban life—and there is an extensive body of this kind of work—in some way extrapolates their observations in relation to reality as a construct. In my own work, this idea of an ideal world is present in ETH, where half of the series are models and the other half are real landscapes. But the latest ones are also representations. Symptomatically, what they show is a reality constructed by ourselves—the creator and destroyer of our reality—of the romanticized landscape par excellence. It's ironic that the bridges in ETH, in their colossal insistence, come into being in the very areas where Goethe, in his travels through Italy, wrote of that indomitable power capable of creating and destroying. It is the homage to the birth of the modeling world in history, that seems to me brutal. I am truly impressed, when I discover those bridges, by the powerful symbolic character that they have.

There is a group of artists working with this internal world. There is a whole range of magnificent works, observations of the suburban world, that are pure models: the representation of the city understood as a decoration, something created on the drafting table of an architect or the urban planner. From different perspectives, what they're putting in relief is the idea of the construction of reality from the drafting table of the planner, economically as much as socially and artistically. It's not a coincidence that these projects emerged in the same moment as Rem Koolhaas, who as architect and urbanist, undertook projects of astronomical dimensions that to this day have not been surpassed, in my opinion, and are now considered archetypes.

SO: The strange thing about Koolhaas is that he always creates a preliminary documentation of his urban projects that end up in books. These publications contain and express a certain idea of the model. What fascinated me in ETH was to see how digitalization acted as a modeling tool. What do you think?

JV: It reminds me of a book by Borges where a man who is completely obsessed with making a faithful representation of the world, creates a map the same size as the world—with a 1:1 scale. This is his delirium. The extreme opposite of the same metaphor is the obsession with mapping out the world, through the construction of a map by humans and then a map of that map. The map is governed more than anything by a unity of measure. Scale is the relation between the unity of measure and representation. This obsession is determined by the ordering function of the human brain, and an instrumentalization of the idea of representation. And there you have both extremes; the story of Borges and its opposite—the atomization of the world—which has been a human obsession since the beginning of the twentieth century, to reduce the world to a map that can be measured. If you add to this the concept of simulacrum, which is essential, you have the key tool in the world of models. That's why I'm so interested in fusing these two methodologies: the pretechnological, which corresponds to the artistic fabrication of the model, and the post-technological, with its inclusion of digital technology, which throws into doubt in a completely distinct way the very idea of truth. The latter emerges at a time when this question has already been raised by photography, in particular due to its linguistic character.

To all the deconstruction of what is seen as subjected to photographic representation of the world—through semiotics, linguistics, political thought, feminism, gay art, etc.—the world of digitalization is suddenly added. Digital technology allows for the reconfiguration of representations in which the pixel is imperceptible and the virtual character of the image is confused with reality itself. At the moment reality is susceptible to becoming verisimilitude without actually being real, and the very notion of truth collapses under its own weight. What follows is a time in which photography has prepared the way for a more conceptual analysis.

SO: And what would be your thoughts on the potential implications of this kind technology on what today is called photography. Do you think these trends are going to alter our perception and the situation of photography as we have perceived it up to now?

JV: It's going to be interesting, as in some way it liberates us from that need to situate ourselves in one place or another. It's clear a great many artists can speak from a position of authority. We no longer speak of having a "vision" or "perspective," but of what we can create with the myriad possibilities for representing the world, knowing that no single representation is either true or a lie, but that they coexist because all of them exist.

After we realize there's no point in further discussions, we will get on with this project of making possible experiences of construction, perhaps from another space where upheaval and change are a given. And perhaps in a more decisive way, moving from common experience to the world of possibilities. If these perspectives allow us the experience of a upheaval of the mind, spirit, or body we will live it, and do so with a deep ethical responsibility, which itself is another topic for discussion. For me right now, what I enjoy most is playing at work, I like shaking things up. I no longer have the desire to talk about what disillusions me, but about what fascinates me, and what has the potential for spreading this capacity for wonder. Is it possible? To explore other human questions, to increase the human capacity for wonder and intrigue that we all have, which is surely very powerful and something outside of the mind?

SO: Would that also explain your current focus on videographic or cinematographic works?

JV: Perhaps. They are very new projects. I'm very slow, in the sense that I only take responsibility for my projects once I've finished them. I have an idea of what I'm creating, but it evolves over time, and the answers emerge in the end. In my cinematographic works, I don't pose the kinds of questions that I do with photography.

SO: No, because the moving image is already a pure fiction. But also, the cinema speaks of emotions and sentiments in a very immediate, very direct way.

JV: Perhaps what I need now is a language that allows me to challenge the viewer from a place close to the emotions, without eluding other aspects that are also present.

SO: It has to do with the transformation of perception. The way we perceive today is more associated with the moving image than with the still. I think because of the speed of our cinematographic and TV culture. . .

JV: . . . many things are thrown together and confused. But also in art, the idea of the opus as an object has been called into question, and from that starting point, other aspects related to installations or performance art, which reuse elements from action, are also questioned. Some artists are creating the most radical propositions in the realm of action without warning the spectator they are doing so, or that he is watching a filmed action or video that breaks with the idea of performance. New attention is given to certain works that were created in a certain context but that, nevertheless, acquire a new relevance.

SO: It seems very strange to me to compare how, on a democratic level, where technology is commonly shared, the instant camera has been substituted by the digital camera which records and at the same time permits you to see images and to select stills. But that's a movie, and it's also a very significant change.

JV: It's obviously changing our ability to relate to reality. The popularization of video cameras and photography, no longer as instruments, but as those things which imply and are made possible as representations of reality—I think well, many surprises still await us. Many I haven't thought enough about, but that are without a doubt, important.

———————————

Javier Vallhonrat was born in Madrid in 1953. He received his degree in fine arts from the Universidad Complutense de Madrid. A well-known author in the art world, his work is known for its regular interdisciplinary inquiries. His work has been exhibited individually in Spain since 1983, and since 1985 in international galleries such as Les Somnambules Gallery in Toulouse (1987), Abbaye de Montmajour in Arles (1989), and Hamiltons Gallery in London (1992). In 1996 he exhibited in the Centre d'art Santa Monica de Barcelona and in 1997 in the Gilbert Brownstone Gallery in Paris. More recently, he has shown his work at ARCO with the Helga de Alvear Gallery (2003). He has been a visiting professor at Los Encuentros Internacionales de Arles in 1989 and professor of the Facultad de Bellas Artes de Cuenca in 1997, and has held positions in various universities and institutions, among them the Ryerson Institute in Toronto in 1992. He has received numerous prizes for his work, among them the Silver Award from *The New York Times Magazine* in 1994 and the National Photography Prize in 1995.

Santiago Olmo was born in Madrid in 1958. He has worked freelance since 1986. Author of numerous artist monographs, he has collaborated as an art critic in various publications. He formed part of the editing team of the magazine *Lapiz*, and was its editorial coordinator until 2002. He was director of the Spanish Exhibition at the Graphic Biennial of Ljubljana in 1995 and at the XXIV Biennial of Sao Paulo in 1998. He is author of the critical text included in the book dedicated to Javier Vallhonrat in the PHotoBolsillo collection (No. 20).

SELECTED BIBLIOGRAPHY

Autogramas. Kehayoff, Gina. Munich: 1993.

El Espacio Poseido.[The Possessed Space]. Kehayoff, Gina, Manuel Santos. Munich: 1992.

Maza, Blas. *Cajas* [Boxes]. Murica, Spain: Editorial Mestizo, 1996.

Ribalta, Jorge. *Trabajos Fotograficos* [Photographic Works]. *1991-1996.* Madrid: Editorial Lunwerg, 1997.

Serraller, Calvo. *Animal Vegetal.* Madrid: Abril y Buades, 1986.

Vallhonrat, Javier, and Santiago Olmo. *PHotoBolsillo.* Madrid: La Fabrica, 1999.

Acknowledgments

Our grateful acknowledgement first and foremost to all the artists and photographers in this landmark volume, whose vision and understanding of photography make this a remarkable book in many ways, and the many other talents who we were unable to include because of constraints of space and time, but who hopefully we will incorporate in a future volume.

We also want to thank Inigo Garcia Ureta and Nacho Fernandez for their encouragement and generous assistance. While editors at la Fabrica they pioneered this collection. We also thank Camino Brasa of La Fabrica who was so helpful in the partnership this represents.

We would not have succeeded in completing the project in the limited time and under the considerable constraints we had without the committed efforts of Umbrage friends and staff: translators Brendan Kolbay and John Healey, editor Emma Bedard and design director Tanja Geis, as well as copyeditors Elaine Luthy and Rebecca Bengal.

We hope you find these interactions as fascinating as we did and that this will be the first of several conversations to come.

— Nan Richardson